VANCOUVER
remembered

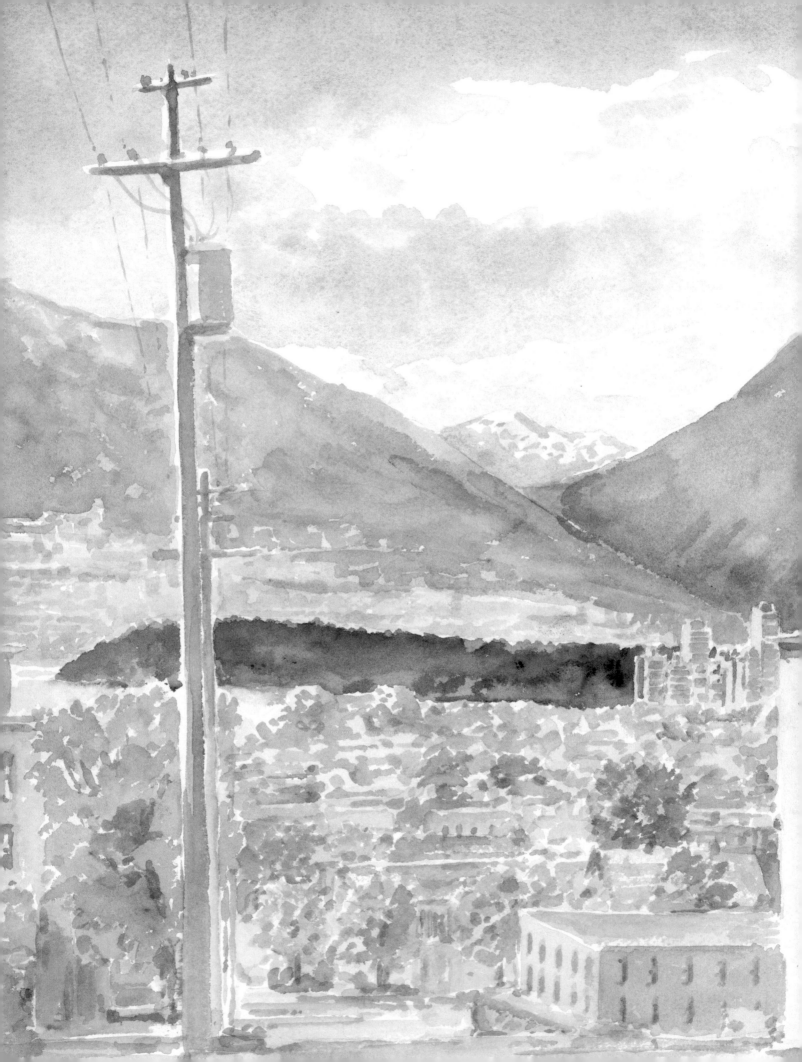

VANCOUVER
remembered

MICHAEL KLUCKNER

whitecap

Edited by Elaine Jones
Interior design and paintings by Michael Kluckner
Design assistance by Five Seventeen
Cover design by Michelle Mayne

LIBRARY AND ARCHIVES CANADA CATALOGUING IN PUBLICATION

Kluckner, Michael
 Vancouver remembered / Michael Kluckner.

ISBN 1-55285-811-1
ISBN 978-1-55285-811-0

 1. Vancouver (B.C.)—History—20th century.
 2. Vancouver (B.C.)—In art.
 I. Title.

FC3847.4.K593 2006 971.1'33 C2006-900708-X

The publisher acknowledges the support of the Canada Council for the Arts and the Cultural Services Branch of the Government of British Columbia for our publishing program. We acknowledge the financial support of the Province of British Columbia through the Book Publishing Tax Credit.

Printed and bound in China by WKT

For more information on Whitecap Books and other titles on Vancouver and its history, please visit www.whitecap.ca and www.michaelkluckner.com.

As always . . . For Christine,
my constant companion

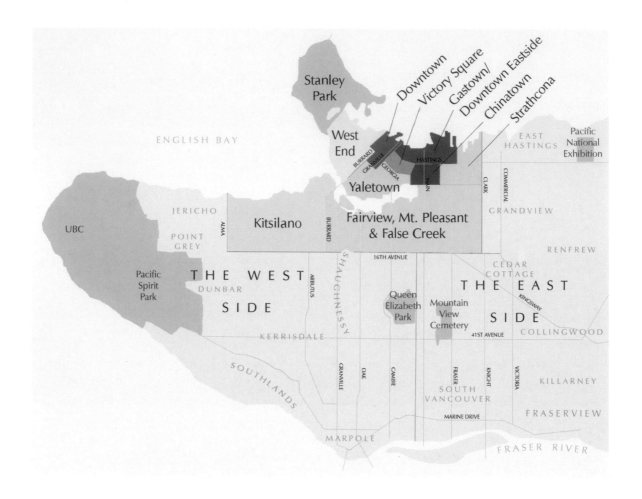

MAPS AND VIEWS

CONTENTS

Preface

In the 22 years since Whitecap Books published the first edition of *Vancouver The Way It Was*, I have learned much more about the city, partly by observation and study, partly from people who contacted me in response to the book, and the rest by perusing the landslide of Vancouver writing that has appeared since. *Vancouver Remembered* continues in the vein of the earlier book, exploring impressions and memories in a way that, I hope, paints a meaningful, evocative picture of the city, focusing on the decades between the Second World War and Expo '86. Such a book needs a narrative overview: the Introduction beginning on page 15 provides a chronological history with links to pages in "scrapbook" chapters on different areas of the city.

Due to the amount of Vancouveriana, it has become quite a challenge to create a book that presents relevant new material, without making something too specialized or arcane for the general reader. Because the city's "golden age" – the Edwardian boom of the first dozen or so years of the 20th century – has been so thoroughly gleaned, recent writers have focused on specific events, personalities, photographers, street railways, architects and buildings. Fans of buildings should start with *Exploring Vancouver*, in three separate editions by principal author Harold Kalman (UBC Press, 1974, 1978 and 1993). Those interested in architects as much as their creations should read *Building the West*, compiled by Donald Luxton (Talonbooks, 2003). A spate of books, including *The Vancouver Achievement* by John Punter (UBC Press, 2003) and *Dream City: Vancouver and the Global Imagination* by Lance Berelowitz (Douglas & McIntyre, 2005), analyzes and congratulates the new Vancouver. Nostalgia for the old entertainment scene animates *Backstage Vancouver: A Century of Entertainment Legends*, by Greg Potter and Red Robinson (Harbour, 2004). Names and places get their own books, the best of which is Elizabeth Walker's *Street Names of Vancouver* (Vancouver Historical Society, 1999). John Atkin has used walking tours to explain the city in *Vancouver Walks* (which I co-authored) and *SkyTrain Explorer* (Steller Press, 2003 and 2005). Perhaps only Chuck Davis, principal author of the landmark *Vancouver Book* in 1976, and subsequently editor of the *Greater Vancouver Book* (Linkman Press, 1997), is still trying to record the city and region in a single-volume "urban encyclopedia."[1] Detailed histories of Vancouver neighbourhoods by various writers, including me, appear in the *Greater Vancouver Book*.

Because these books and many others are now so easily accessible through libraries and for sale on websites such as www.abebooks.com, I have annotated my text to make recommendations for further reading and library-building and, also, to save space here by not duplicating already published material.

[1] on the web at www.vancouverhistory.ca.

The dust jacket of the 1974 edition of Alan Morley's classic city history.

Bob Spence, on a film shoot at English Bay in 1982.

Yet, in spite of this outpouring of words, no true Vancouver history book has been published in a generation. Humorist and *Province* columnist Eric Nichol wrote a pretty good one, succinctly called *Vancouver* (Doubleday Canada, 1978), but his predecessor, the newspaperman Alan Morley, wrote the classic: *Vancouver From Milltown to Metropolis* (Mitchell Press, 1961; 3rd edition, 1974). It contains the combination of chronology, politics and human affairs that puts the "story" into history. None of the current generation of journalists, who have collectively covered city hall for decades, has stepped forward into the breach.

Bob Spence could have written well about the city, given his knowledge of the police and fire departments and the city's entertainment scene. Born in Kitsilano in 1947, he had a normal, middle-class boyhood until age 11, when his policeman father suffered a heart attack and died after a gunfight in an East Hastings hotel. His mother went to work taking care of Firehall 12 on Balaclava Street in Kitsilano, where Bob hung around after school. A journalist and advocate for the downtrodden and the Nisga'a First Nation, he lived hard and died too young, of cancer, in 2001. I worked with him from 1982–86 at CKVU-TV and CJOR radio.

All books reflect the backgrounds and class prejudices – as academic historians call them – of their authors. I'm a baby boomer, born in 1951 to an eastern Canadian couple who met and married overseas during the war and decided to settle in the west once they returned home. My father was a musician who joined the BC Electric personnel department, my mother a nurse, both from lower middle-class backgrounds. My older brother Paul was born into a small bungalow at 40th and Ontario – the first home my parents had in Vancouver. My paternal grandparents had retired in Winnipeg in the depths of the Great Depression, then moved west to the cottage at 2322 Cypress in Kitsilano. My parents had just reached the level of optimism to buy a $12,000, 20-year-old house in Kerrisdale when I arrived.

Each working day my father walked the four blocks to Granville Street to catch the trolley and often found himself accompanied by other men from the neighbourhood, including Gordon Wyness from across the street, who managed the renowned James Inglis Reid butcher shop downtown. The neighbourhood mothers all stayed home and raised their children, of whom there were droves. Every block had legions of boys, rampaging around in back yards and, like us, playing road hockey on the quiet street. When we noticed girls, they were usually walking together in groups – what they did the rest of the time was a mystery. Although the cliché stereotypes Vancouverites as reserved and insular, our homogeneous neighbourhood was a friendly place where people looked out for each other. Like the vast majority of children in Vancouver, we walked unaccompanied to the local public school: Maple Grove, a half-mile away, for elementary grades; Point Grey, more like a mile away, for junior high; then Magee, next to Maple Grove, for high school. My Vancouver childhood winters involved chilblained hands and soaked shoes; the girls, who were not allowed to wear pants to school, suffered worse than we boys did. Fewer than 10 "rich kids" had cars in high school and ostentatiously drove them there each day.

Our family did not have a car until about 1956 or 1957, and I have vague recollections of travelling with my mother on trams when she went shopping. Our car purchase coincided with the opening of the Oakridge shopping centre with its Woodward's Food Floor, an experience my mother took to like a duck to water. On Sundays, wearing our Sunday best, we joined the flow of Anglicans on Wiltshire Street going to the little church on 57th near the tracks.

There were a half-dozen Jewish children in my class, one Canadian-born Japanese girl and one Chinese boy who lived with relatives above the Granville Market grocery store on 41st. The rest of us were white and mainly Protestant (devoutly Catholic parents sent their children to private Vancouver College). In about grade four a family moved into the area from Iran, no doubt fleeing persecution from the shah, and the boy joined our class; the "phys-ed" teacher asked a group of us to teach him how to play baseball after school so he wouldn't feel left out.

Children in that era grew up almost entirely in their neighbourhoods, so my experience of the rest of the city was very limited. True west-siders didn't even know what the Lions were, as you had to be at least as far east as Cambie to see them. Only the Pacific National Exhibition each August took us across the great divide between west and east. However, some Saturday mornings (part of the office work week in the 1950s) my brother and I went with our father to his office in the BC Electric building at Carrall and Hastings. His window looked out onto the roofs of Chinatown; sometimes we ate at the Ho-Inn or the Ho-Ho before returning home on the bus.

In the spring we played on a softball team of company employees' sons at the newly reclaimed False Creek Park at Heatley and Prior, next to the old city garbage dump. On the way I stared at the Georgia Viaduct with its antique globe streetlamps, the old gasworks, the unpainted Strathcona houses and the poor old men standing outside the Main Street beer parlours. I had never seen grown men riding bicycles and had to reason my way through to the fact that they didn't have enough money for a car. On Remembrance Day we went to the Cenotaph, but I was as fascinated with the worn old buildings and people nearby as with the sharp uniforms and pageantry of the soldiers. Sometimes even the Norris cartoons in the *Sun,* such as the ones on pages 31 and 111, could open a door for me onto a part of the city I hadn't seen.

In 1957 my father's office moved uptown to the new BC Electric building at Burrard and Nelson, and my view of the world outside changed. Next to the gleaming office tower were streets of decaying rooming houses, shabby apartments and auto repair garages. In those years my mother got her hair done in a converted old house on Beach Avenue about a block from Stanley Park, and as I waited for her I used to watch the construction cranes transforming the West End skyline. All my early memories of the city were of a place in transition, the old making way for the new, except, of course, in Kerrisdale, which seemed tranquil and increasingly bland.

The rate of change increased when, as a teenager, I discovered hippie Kitsilano and the gloriously faded Embassy Ballroom, then called the Retinal Circus, on Davie Street. I was a little too young and cautious to become fully engaged, as it were, in the goings-on of 1967 and 1968, but what stuck in my

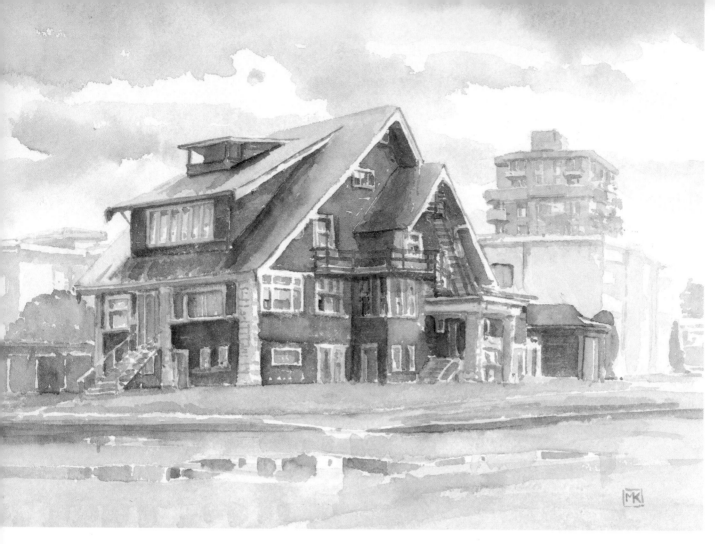

mind's eye as much as the plumage of the brightly coloured people was the peeling, picturesque quality of the neighbourhood. It could not have been more different from my parents' tidy realm and seemed to reflect what had been happening to us socially. We were just on the cusp of moving from formal high school proms, dance cards and convertibles to pot and crash houses; suddenly, the orderly progression from high school to university to job to marriage seemed optional.

From 1972–75 I lived in a series of rooms and basement suites, mainly in Fairview Slopes and Kitsilano. From the porch of 1346 West 6th, a crumbling house with black-painted walls I covered with cheery Indian cotton bedspreads, I watched the demolition of old False Creek's industry. One winter I lodged in the rooming house at 1696 West 11th ($50 a month), then found a basement suite on Walnut Street on Kits Point, then moved to a cheaper basement suite ($85 a month) at 2121 Macdonald.

The last was about 300 square feet with its own door from the side lane and about six feet of headroom between the beams. The tiny kitchen had a double hot plate, a cracked sink and an old fridge that buzzed all night. "The heat pipes just cough" as in Dylan's *Visions of Johanna.* The toilet and shower were in the unfinished basement outside my room, among the cardboard boxes, spider webs and bare light bulbs of the landlord's domain. But it was cheap and, for better or worse, I could devote myself to my attempts at becoming an artist and writer without having to take a job and do what somebody else wanted me to do.

In retrospect that was part of the brilliance of Vancouver in the 1960s and 1970s. It was *so* affordable and, as long as you could tolerate the rather basic conditions, you could shelter yourself from the housing crunch that was pushing up prices for proper apartments every year. Later I "inherited" the attic of 2204 Macdonald (page 185), one of those places that passed from tenant to tenant through an informal network of friends and acquaintances. The landlord, who lived in Kerrisdale, was informed of each change but seemed happy with the situation as long as the rent cheques came in on time.

Fairview, Mount Pleasant and Kitsilano, where old houses waited quietly while businessmen and city planners dickered over the substance of redevelopment, provided a milieu and a muse. The way these neighbourhoods wore their layers of change, like a wardrobe of Value Village clothes, became the subject of much of my painting in books like this one and *Vanishing Vancouver* (Whitecap, 1990).

A few writers have tried to capture the transitional nature of Vancouver in that era and its influence on them. Stan Persky wrote about the poets and artists living in the Worth Block at Yew and York in Kitsilano, the nexus that created the *Georgia Straight* in 1967 (page 181).[1] In his story "Buying Leo Dinner and Other Missed Bohemian Opportunities of a Vancouver Afternoon," Norman Ravvin described the West End, his neighbourhood in the 1970s, and the bohemian characters who thrived in its low-rent places. He quoted the curator of the Or Gallery, Reid Shier, describing what happened to the Hastings Street blocks near Woodward's in the 1980s: "The area was shit but livable, so artists moved in. The area became worse, so artists moved out."[2] As Vancouver has gentrified in the last 20 or so years, the creative underclass has been pushed eastwards, with many now occupying old warehouse buildings like 1000 Parker near Clark and Venables – ground zero for the annual East Side Culture Crawl. As these areas continue to change, it will be hard to guess bohemia's next stop.

The state of some of the Vancouver places I remember was close to the sort of Third World conditions I witness now while travelling abroad; with their demise, residents have either become gainfully employed or homeless. Homelessness got kick-started by the recession in the early 1980s, then picked up speed when Granville Street and the Downtown Eastside began to gentrify, initially with the conversion of old hotels to prepare them for Expo '86 visitors.

During my own trudge toward respectability, I have watched the city gradually lose these edge conditions in its old neighbourhoods. It is harder now to read the layers on the landscape. The city looks almost finished, dominated by shiny new buildings. Nearly a century ago at the end of the great Edwardian boom was the last time it looked neat and finished, or so it seems from the photographs of the time.

Affordable Vancouver – my illustration for "Cheap, cheaper, cheapest" by Phil Hanson (Vancouver Sun, November 15, 1979). In response to skyrocketing house prices, the Sun surveyed available houses in that time of 15 percent mortgages. For $37,500, a two-bedroom bungalow on a small lot on Salisbury Drive in Grandview could be had. There were 60 houses for sale in East Vancouver at $54,000 or less; the cheapest west-side place was a Marpole home for $72,500. Five years earlier, a two-storey and basement house on Stephens Street in Kitsilano, with an eight percent assumable mortgage and $800 a month in rents from its two suites, cost $44,000.

1 See "How Poets Redeemed a Prim City," *Georgia Straight*, May 8–15, 1997.

2 *Hidden Canada: an Intimate Travelogue* (Red Deer Press, 2001).

Vancouver's long decline and slow rebirth are the main themes of this book. Following the introduction, chapters describe the city's different downtown areas, using images from a variety of sources to illustrate the city in the years before Expo '86. The north side of False Creek is examined in the Yaletown chapter while the south side and Granville Island become part of a chapter describing Fairview and Mount Pleasant – neighbourhoods linked historically by the streetcar belt line of 1891. Strathcona, the West End, and Kitsilano/Jericho get separate chapters. The various communities of the west side and east side are rolled together into the two concluding chapters.

The paintings are mainly small watercolours done over the past few years of places in the city still in a state of "becoming." Compared with the watercolours I painted many years ago for earlier books, these ones are rather simplified and unfinished, for I have decided that paintings have to leave a lot of room for the imagination. It would be fair comment to say that my point of view has become more detached than it once was; I seek high ground and long views in order to witness the obliteration of the Vancouver I remember.

The bird's-eye views are intended as illustrations more than documentary-quality maps. They are a kind of freehand isometric drawing that defies much of what I learned from the Renaissance, and probably have their genesis in my occasional dreams of flying over the city. But however much of a guessing game they may be, neither aerial photography nor standard maps nor Google Earth could deliver the kind of information I wanted to convey. John Atkin loaned me his copy of the Vancouver Fire Atlas of the 1925–55 period, which helped greatly with their research.

I seem to have spent my career summing up places. *Vanishing Vancouver* focused on the values and priorities of residents during the immediate post-Expo period when the city was tearing itself to pieces. *Vanishing British Columbia* (UBC Press, 2005) is a set of as-found sketches of the rural parts of the province that are being abandoned due to urbanization and globalization. And *Vancouver Remembered* tries to sum up the pleasant seaport that existed before it became the self-congratulating "Dream City" and host of the 2010 Winter Olympics. It closes the circle I began in 1984 with *Vancouver The Way It Was.*

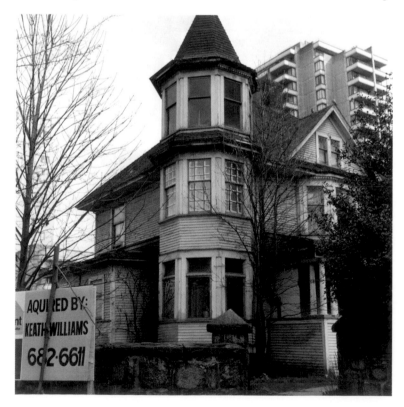

The rooming-house West End awaiting demolition about 1980. I recall that I took the picture because of the misspelling of "acquired."

Introduction

From our modern, recreation-oriented perspective, Vancouver has a beautiful location with easy access to pristine water and wilderness, perfect for the outdoorsy west-coast lifestyle that attracts new residents and keeps most of the old ones fit and active. Its airport is a natural hub for both international and regional travel. It is a crossroads in the transpolar world of commerce and tourism, a diverse, tolerant place with such an international flavour that it sometimes seems to be part of a utopian future world without borders. So attractive has the central city become that it has had to enact bylaws to freeze the conversion of commercially zoned land to residential, to make sure enough jobs remain in the core to ensure its long-term vitality.

To the more practical 19th-century settlers, the location was equally good but for slightly different reasons: an ice-free port gave easy access to the ocean for shipping, and natural resources nearby fed its sawmills and canneries. Adjoining it was fertile land along the Fraser River (including the airport site), a hinterland for dairying and market gardening essential in the era before refrigeration and long-distance trucking. There was plenty of easily serviced land for housing. And even the picturesque setting was soon recognized as an asset, its natural (and, indeed, Aboriginal) charms marketed to tourists across Canada and the United States.[1]

Location also made the area significant to First Nations for at least 6,000 years before the arrival of European explorers and settlers. For the Coast Salish, the important corridor was the Fraser River, along which they occupied fishing grounds and gathering places on their seasonal rounds. Permanent settlements grew at Khwaykhway in today's Stanley Park and at Cheechilwhik on the North Vancouver shoreline; their Musqueam cousins lived near the mouth of the Fraser River.

As with other Pacific Northwest nations, the Coast Salish lived amid a natural bounty of edibles and "buildables," most notably the western red cedar *(Thuja plicata)* that was easily crafted into ocean-going canoes, split into planks for sophisticated post-and-beam dwellings, and carved into ornaments, ritual objects and totem poles.[2] Their hunters and gatherers easily produced a surplus of food for the community, allowing people of artistic talent to enrich the culture to an incredible extent. Trade took place over a complex, sophisticated network linking First Nations all over western North America.

Their loss of control over their environment and destiny began by stealth with the arrival of the greatest weapon in the arsenal of the European invaders: disease. About 1780, Spanish colonists brought smallpox into Mexico City. Two years later, it had made its way along the trade routes all the way to the Fraser River. The resulting epidemic killed at least two-thirds of the population in less than six weeks.[3] By comparison, the famous episodes of the Black

1 Michael Dawson's *Selling British Columbia: Tourism and Consumer Culture 1890–1970* (UBC Press, 2005) gives a good overview.

2 Hilary Stewart's nine books on Northwest Coast Native culture are a good reference.

3 See *A Stó:lo-Coast Salish Historical Atlas* by Keith Thor Carlson, p. 30.

Death in medieval Europe are said to have killed about half the populace in cities where it struck.

In BC's interior, the Aboriginals' first direct contact with Europeans was with traders, not military forces. In the 1790s, explorers working for the North West Company erected a chain of posts and began to trade, tapping into the Aboriginals' long-established networks and using their trails. One of its employees, Simon Fraser, made it all the way to the mouth of his namesake river in 1808, arriving at the villages of Stselawh and Mahli on what is today the Musqueam reserve. The 75 post and beam houses there, home to about 2,000 people, were built so close together that Fraser thought he was seeing a fort about 500 yards in length.

By sea, the Vancouver area had been discovered by Europeans a generation earlier, in 1791, by the Spanish navigator Jose Maria Narvaez. The following year, Royal Navy Captain George Vancouver, confirming and expanding on the information from James Cook's Pacific voyages of the 1780s, charted the coast and coincidentally met with another Spanish expedition off Point Grey.

Spanish Banks, the beach near UBC, commemorates that chance meeting, and local and regional place names such as Langara, Valdez and Galiano recall Spanish attempts to expand their empire northward from its California outpost. Vancouver named Burrard Inlet after a British admiral and Point Grey after a fellow officer. A subsequent naval survey in 1859 noted the strategic potential of the peninsula at the first narrows and reserved it for military purposes. Like the Presidio base at San Francisco's Golden Gate, it later became parkland – Stanley Park, honouring the governor general who is mainly remembered today for his donation of a hockey trophy. Aboriginal names in anglicized form stayed on the landscape or were added to it: Siwash Rock in Stanley Park, for example. The Capilano River recalls a chief of the Squamish Nation, as does the Kitsilano neighbourhood.

The Aboriginal population in the Vancouver area and in the Fraser Valley settled onto reserves which, to a large extent, reflected their pre-contact villages, although the big Stanley Park village of the Squamish Nation, Khwaykhway, was wiped out, the shells from its midden used to pave the first round-the-park road. Sun'ahk, their settlement near the mouth of False Creek (page 146), was a significant village until a century ago.

So dominant was the immigrant society and so explosive Vancouver's growth that most Aboriginal people quickly abandoned their traditional way of life and found industrial jobs, encouraged by the residential school system into which their children were forced. Many men living near the city's waterfront became longshoremen – most famously Chief Dan George (1899–1981), who was also a sometime logger before becoming an actor. The lumber mills along False Creek and the canneries on the Fraser River also employed many men and women; in the eastern Fraser Valley, Aboriginals worked in the summertime in the hop fields that were once common there.

The Musqueam people allowed the federal government to lease on their behalf (ostensibly for their benefit) much of their land, first to Chinese farmers, then to Shaughnessy Golf Club in 1957 (page 206) and to upscale homeowners in subdivisions along South West Marine Drive in the 1960s. In more recent

decades, this newly empowered First Nation has renegotiated the leases at market rates, causing much controversy and unsuccessful litigation. The Squamish Nation left Sun'ahk in 1913.

GEOPOLITICS ARRIVE ON THE WEST COAST

The Hudson's Bay Company (HBC), which had amalgamated with the rival North West Company, began to trade along the west coast in the 1820s. It established Fort Vancouver (that is Vancouver, Washington, adjoining the city of Portland) near the mouth of the Columbia River and Fort Langley on the Fraser. Soon, however, its employees at Fort Vancouver began to clash with American migrants moving westward over the Oregon Trail.

By the early 1840s, the credo of manifest destiny was the major political issue in the United States. Militant American expansionists thought the USA should extend west to the Pacific and north as far as Russian Alaska, the line at 54 degrees 40 minutes north latitude (just north of today's Prince Rupert). They rallied in the 1844 presidential election around the slogan 54-40 OR FIGHT! The British believed the HBC had established a claim to the area around the Columbia River through its trading posts and farms.

After a period of posturing and sabre-rattling, the two countries decided not to go to war and the 49th parallel, already accepted as the international boundary across the central prairie of North America, was extended to tidewater. As the HBC had wisely established Fort Victoria in 1843, Vancouver Island remained British territory and became a colony in 1849. On the mainland, a vast region unclaimed except by the First Nations, Burrard Inlet was the nearest harbour north of the new border.

In the same year that Vancouver Island became a colony, a gold strike in California started the first of the frantic rushes that moved a rabble of humanity across the continent, to Australia, and eventually to the Yukon and Alaska. Prospectors discovered gold in the 1850s along the Fraser River and a wealth of minerals in the Kootenays. In response to what could have quickly become a de facto republic, as had happened to Spanish California, the British

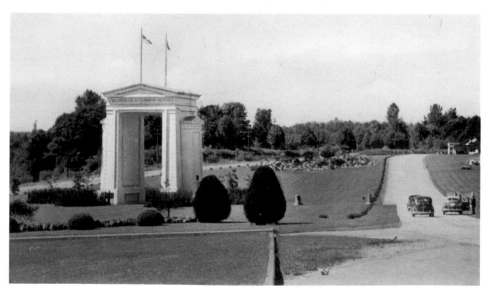

The Peace Arch, erected in the 1920s upon the completion of the Pacific Highway, became a symbol of friendship between the two countries. The arch is emblazoned with the slogan "Children of a Common Mother" – I always resented the inference that my mother was common. It has also represented the deep divisions between the two countries, as on May 18, 1952, when American singer Paul Robeson, whose passport had been pulled due to his Communist sympathies, gave a concert from the back of a truck on the American side to an audience of 40,000 on both sides of the border.

administration in Victoria moved to establish control of the mainland. Named British Columbia, the new colony was founded in 1858 at a ceremony held inside the palisades of Fort Langley.

The following year a city, imaginatively named New Westminster, was established on the Fraser River at the strategic point where it widens into a delta, thus ensuring control of river traffic attempting to get to the goldfields. As the colonial capital, it was the most important place on the mainland for 30 years, even though it lost its status in 1868, two years after BC amalgamated with Vancouver Island and the government decamped to Victoria.

The Fraser River and Cariboo gold rush had little immediate impact on the Vancouver area. However, disillusioned gold seekers soon returned to the coast. By the mid-1860s there were sawmills operating on Burrard Inlet, one – Stamp's Mill, later known as Hastings Mill – just east of the foot of modern Main Street. The loggers, like their compatriots in Oregon and Washington, had discovered extraordinary stands of Douglas fir *(Pseudotsuga menziesii)*, a tree second only to the California redwood in stature, and were soon exporting shiploads of lumber from Burrard Inlet. On the fertile Fraser River flats and on Sea Island, a handful of farmers began producing food and milk and rowing it upstream to market in New Westminster.

Meanwhile, late in the summer of 1867, while far-away Canada was celebrating its nationhood, a barkeeper named John Deighton came ashore just west of Stamp's Mill with, it is said, a barrel of whisky and another of nails, and invited the mill workers to help him build a saloon near a large native maple tree. Deighton was garrulous, a windbag, bearing the nickname "Gassy Jack." Additional stores and saloons sprang up along the shore just west of what became known as Maple Tree Square. Sleepy little Gastown, as it was commonly known, officially became Granville in 1870 when it was surveyed into a grid of blocks from Maple Tree Square at Carrall west to Cambie, and Water Street south to Hastings (page 38).

Canadian politicians soon began to negotiate to bring the isolated west-coast outpost of monarchism into the fold. As a carrot, they proposed a wagon road, an offer quickly upgraded to a railway, to connect the Atlantic with the Pacific and, hopefully, ensure a sovereign British dominion forever able to withstand the republican pressures emanating from the south.

British Columbians – concentrated in Victoria, New Westminster and the fading Cariboo gold town Barkerville – agreed to become a Canadian province in 1871. Had the will of the people triumphed, Victoria would have become the railway terminus, with the line descending to the coast through the central coastal mountains and somehow crossing the Strait of Georgia to Vancouver Island north of Campbell River. But the Canadian Pacific Railway's directors decided on the southern route through the Kicking Horse Pass, mainly to try to forestall American efforts to sneak spur lines into the province to ship away resources. The terminus they chose was Burrard Inlet.

In the 19th century, any city of any substance needed a railway. A big city needed not just a railway but a railway terminus. And a really significant city needed multiple railways. Vancouver ended up with four: the CPR in 1887, the Great Northern (now the Burlington Northern Santa Fe) in 1904, the Canadian Northern Pacific (now the Canadian National) in 1915 and the

1 The best overview is Jean Barman's *The West Beyond the West,* p. 69.

2 Barman, pp. 91–98.

Pacific Great Eastern (later BC Rail, now a part of the CNR system), begun in 1912 in North Vancouver and connected through to the interior in the 1950s.

Thus, Vancouver is in a sense an "accidental city." There might have been no international border only a few miles to the south, but that was settled in 1846. In the 1850s, British Columbia could have been lost to a takeover by American miners.[1] There was further uncertainty in the late 1860s when British Columbians decided to join Canada instead of remaining a British colony or becoming American.[2] And as a final historical twist, the new province of British Columbia almost seceded from Canada in the late 1870s over the question of whether the railway would reach the provincial capital at Victoria. But the tide of history ran in Vancouver's favour and, besides, the location was too good. It is interesting to speculate on which city, Seattle or Vancouver, would have been pre-eminent, or indeed would have grown bigger than a town, if there had been one country in the Pacific Northwest instead of two.

THE CREATION OF VANCOUVER

Little happened along Burrard Inlet during the 1870s while far-off financiers and politicians haggled over the railway and its proposed route. But once the CPR decided on its terminus, Gastown woke up to a new destiny.

CPR general manager William Van Horne visited his future terminal city in 1884, met with local businessmen and land speculators (losing heavily at poker with them), and was delighted with everything he saw. Except the name. As the story goes, he reached back into his stock of historical lore and intoned, "I name thee Vancouver." The new city was incorporated in April 1886, with the CPR's surveyor, Lauchlan Hamilton, as one of the aldermen. His vision of city-building, backed by the railway's chequebook and profit motive, directed Vancouver's growth for generations.

By the following May 23, when the first through train from eastern Canada reached Vancouver, the city had rebuilt from a fire that had destroyed old Gastown and was expanding as fast as nails could be hammered into boards. The CPR itself had been busy, laying out its new downtown centred on the corner of Granville and Georgia, building the Hotel Vancouver and planning an opera house nearby (page 78). To extend its reach across the Pacific, the CPR first chartered sailing vessels, replaced them with ex-Cunard steamships, then in 1891 launched the first of

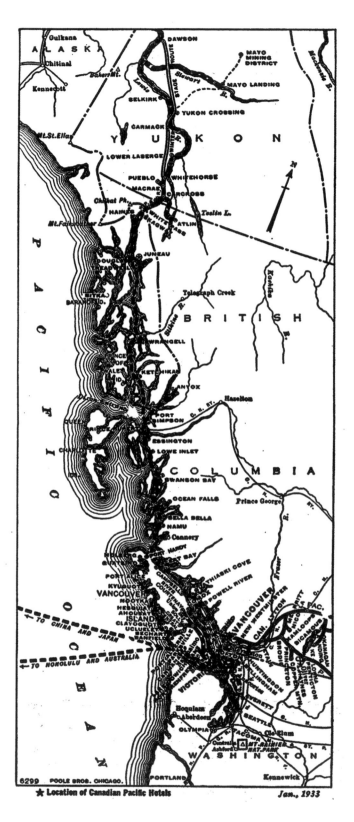

A graphic description of Vancouver's strategic location as the hub of the province's transportation network – in this case, a Canadian Pacific ship and rail route map from 1933.

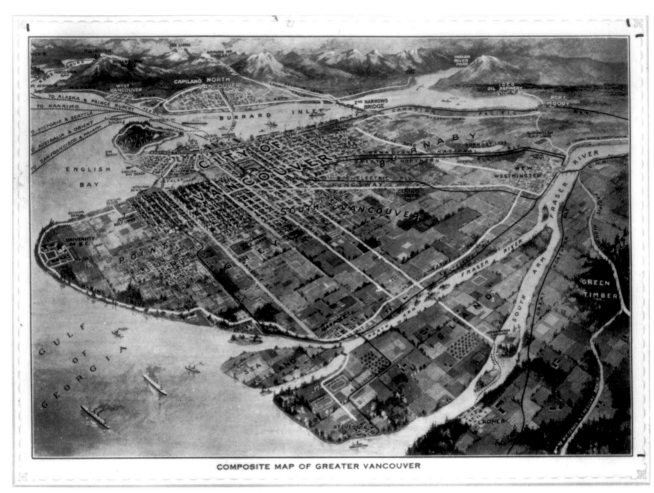

COMPOSITE MAP OF GREATER VANCOUVER

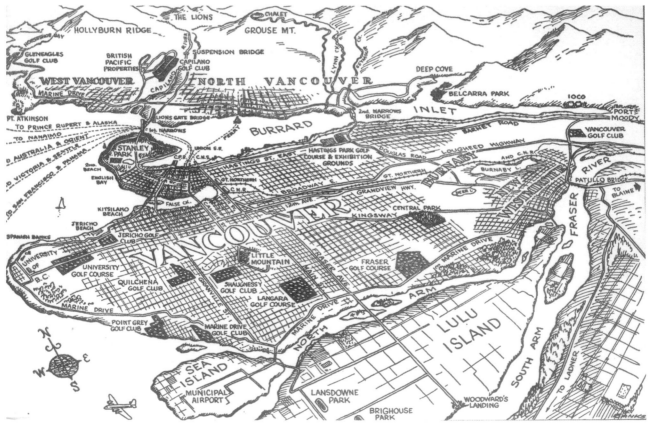

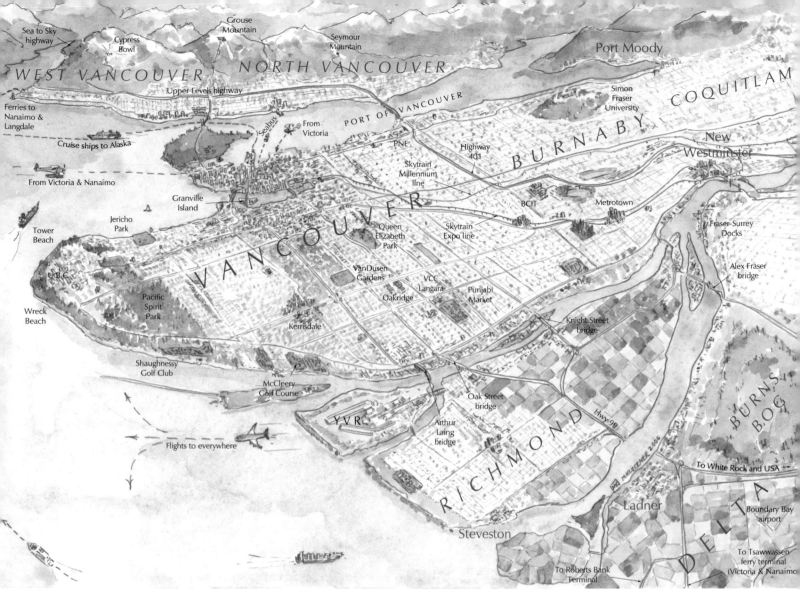

its signature ocean liners, the *Empress of India*, which arrived in Vancouver that April.[1] Similar ships crossed the Atlantic.

The *Empresses* were fast, reliable and luxurious, at least on the upper deck, and the flow of first-class tourists, mainly English, many travelling to see the empire on which the sun never set, added sophistication to a fledgling Vancouver typified by mud puddles and board sidewalks. With its north Pacific routes, the CPR had a shorter run to China and Japan than its American competitors and was soon able to dominate the shipments of silk and tea, the most lucrative of the non-human cargos of the day.

Vancouver's port quickly became the hub of the western economy. Flatcars left the city loaded with "Vancouver toothpicks" – beams a yard square by 20 yards long – the kind of timber that supported the floors of brick warehouses such as those built on the sites of the burned saloons and hotels of Gastown. One load of beams even left Burrard Inlet in 1884 for Beijing's Imperial Palace. Boxcars of tinned salmon from canneries on the Fraser River left by train and ship.

In the late 1890s, British capital amalgamated the city's early street railway and power generation systems into the BC Electric Railway Company (BCER, page 44), which created a state-of-the-art electric interurban system connecting the agricultural Fraser Valley with the city. By 1900 there were about

PREVIOUS PAGE *Two bird's-eye views of Greater Vancouver. The top one, by the H.E. White Art Engraving Company, is from 1927 and shows the recently established University of BC and a city still dominated by rail and ship connections. The one below, by the popular illustrator W.M. Banks, appeared as end papers on C.P. Lyons's 1950* Milestones on the Mighty Fraser. *Golf, horse racing and roadways dominate this artist's view.*

ABOVE *A contemporary update from the same point of view.*

1 See Robert D. Turner, *The Pacific Empresses*, 1981.

David Oppenheimer (1832–97), wholesale grocer, land developer, second mayor and philanthropist. His wholesale building at Powell and Columbia was restored in the 1990s by musician Bryan Adams as a recording studio.

CVA PORT P. 1790

25,000 inhabitants, and boosters erected banners on the streets poetically proclaiming that IN 1910 VANCOUVER THEN WILL HAVE 100,000 MEN! They just made it.

The electric streetcar was the great tool of the real-estate speculator in the 19th century, as blacktop was in the 20th. With a streetcar track and, usually, piped water and telephone wires, an area could be transformed from useless bushland into a suburban paradise in a matter of months. The BCER – the predecessor of today's BC Hydro public utility and Translink – effectively created Vancouver's neighbourhoods, expanding them beyond the old walkable inner-city areas such as the West End and Strathcona.

THE EDWARDIAN BOOM

The first dozen years of the 20th century defined the city's form. In the downtown, the landmark buildings that today define the old city sprang up along the main commercial streets of Hastings and Granville. Workers and their families crowded into houses in Strathcona and on the streets south of Victory Square. In the streetcar suburbs, including the West End, Kitsilano, and along the Fairview "loop" of Granville, Broadway and Main, middle-class families pursued the dream of a bungalow with a garden on a quiet street far from the city's factories. New satellite cities in North and West Vancouver started ferry services for their commuters. In the summer, throngs of people went to English Bay in the West End (page 132) or took the streetcar across False Creek to the new beach at Kitsilano (page 172).

As the city grew and newcomers flocked in, the wealthy abandoned their fine homes on so-called Blueblood Alley (today's West Hastings Street), first for new mansions above Sunset Beach in the West End (page 118), then for the curving streets of the CPR's Shaughnessy Heights (page 198). Along the streetcar loop of Davie-Denman-Robson in the West End, shops lined the sidewalks, family houses became rooming houses and apartments began to appear. Areas rapidly became less desirable as they evolved, but there was always more land and new subdivisions to be marketed, so the old ones tended to be left behind to decay slowly and picturesquely. The excellent streetcar system ensured that Vancouver could be a city of homes rather than tenements, although along the grimy waterfront, especially in Coal Harbour and on the edges of False Creek, poor people lived in shacks and floathouses with only primitive access to clean water and sanitation (see maps, pages 105 and 148).

Many of the city's early property owners, some of whom received outright land grants, were government officials or "friends." What today would be seen as corruption or graft was then called boodle and was simply the way that society worked – the rush for spoils that historian Martin Robin used as the title of his book on BC in that era.[1] To the east of Ontario Street, syndicates of property owners drew and quartered plots of land which, while still respecting the general premise of a grid plan, developed a crazy quilt quality with multiple houses on single lots and jogs in roads where hasty surveys didn't match up.[2] The west side was very different, for it was dominated by the CPR's huge land grant, given to it by the provincial government in 1884 as part of the public gratitude for the end of BC's isolation.

1 Published by McClelland & Stewart, 1972.

2 Bruce Macdonald's *Vancouver: A Visual History* contains maps which deftly trace the ownership changes from the 1860s through the 1880s.

Downtown Vancouver – that is, the former Government Town Reserve between Burrard and Carrall, officially District Lot 541 – became a crown grant to the CPR, actually given directly to president Donald Smith (Lord Strathcona) and vice-president Richard Angus. Similarly, the huge, 5,800-acre District Lot 526, stretching from False Creek south almost to the Marpole area between Ontario Street and Trafalgar, was technically Smith and Angus property but in effect became the CPR's development reserve, which it opened up, neighbourhood by neighbourhood, from the 1890s through the 1950s. Only one renegade plot marred the CPR's seamless fiefdom: District Lot 472, the Douglas Park area between Oak and Cambie south of 16th. Its pre-emptor, William Mackie, did his paperwork properly and got official title to the land a decade before the CPR came calling. A number of others, most famously Sam Greer of Kitsilano Point (page 169), thought they had title but were denied it on technicalities.

Hindsight, especially seen through rose-coloured glasses, says the CPR grants were an outlandish giveaway to an oligarchy of already rich capitalists. A more practical review might note that the CPR acted almost as the planning department of a modern city government. It provided a semblance of vision, due to its vast wealth and ability to wait and time its land sales, that in the long run benefited the city. Ironically, the chaotic capitalism of east-side areas like Strathcona, Mount Pleasant and Grandview created quirky, interesting neighbourhoods that have since been favoured by activists, artists and other

Selling the west side in 1912: Alvo von Alvensleben streaked across the Vancouver firmament like a comet for the decade before his spectacular crash in 1914 (page 66). The map shows Point Grey in a rather distorted fashion, suggesting residential streets in the area that is now the campus and the university site itself south of 16th Avenue, a road not cleared through to Marine Drive until the 1960s. Chaldecott Avenue is the original name for 25th, a.k.a. West King Edward. (Advertisement from British Columbia *magazine, 1912.)*
VPL SPECIAL COLLECTIONS

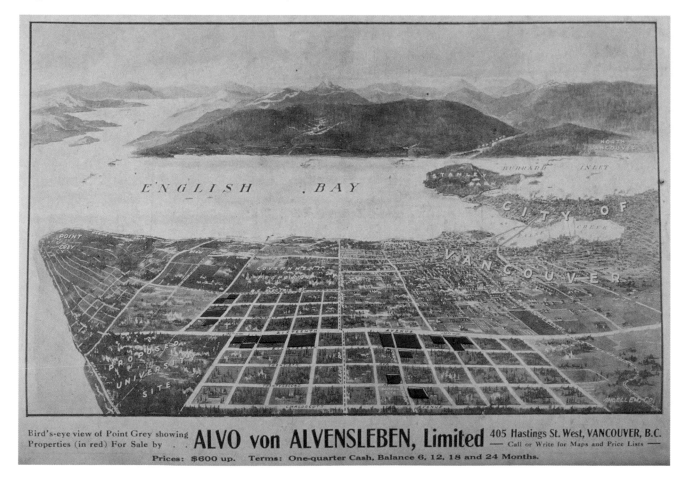

Bird's-eye view of Point Grey showing Properties (in red) For Sale by . . **ALVO von ALVENSLEBEN, Limited** 405 Hastings St. West, VANCOUVER, B.C. — Call or Write for Maps and Price Lists —
Prices: $600 up. Terms: One-quarter Cash. Balance 6, 12, 18 and 24 Months.

non-establishment members of society. Conversely, the stolid CPR land department produced mainly bland suburbs, such as Kerrisdale, Oakridge and Arbutus Flats, which have been the bastions of the middle class (and, historically, safer bets as investments).

West of the CPR's land grant, through the Southlands, Dunbar and Point Grey neighbourhoods, landowners generally fell into line with the orderly methods of the railway's land division and produced neighbourhoods of generic houses and gridiron lots, albeit on paved streets planted with fine shade trees and edged with concrete sidewalks. So enamoured were the west-siders of this neat system that they seceded in 1908 from the old Municipality of South Vancouver, the political entity created in 1892 to represent the people living south of Vancouver's original 16th Avenue boundary. The latter, which had its town hall on Fraser Street at 43rd, enforced few standards on development and was rather slipshod at tax collecting, prompting the provincial government to place it under trusteeship during the First World War. No such humiliation ever threatened the Municipality of Point Grey. Regardless of their differences, both amalgamated with the City of Vancouver in 1929.

Of the CPR's real-estate developments, a few left interesting marks on the landscape. Its railyards on False Creek have been obliterated except for the roundhouse, now part of the local community centre. The diagonal right-of-way of the English Bay line through Gastown and across Hastings Street has survived and is becoming a greenway (map, page 57). Its rail line to Kitsilano Beach is gone, although the slightly raised roadbed is easily visible on Kitsilano Point streets just north of Cornwall and the infill housing on the right-of-way is distinctive (map, page 179). The Fairview industrial area along the Steveston railway line has pretty well vanished, replaced now by condo developments (map, page 175). Its rail line to Steveston, used for a half-century as an interurban line by the BCER and now called the Arbutus Corridor, still exists as a potential transportation route, although it was not chosen for the RAV (Canada SkyTrain) line connecting Richmond and the airport with downtown Vancouver.

The CPR neighbourhood of note is Shaughnessy Heights, especially the earliest part between 16th and King Edward avenues. With its curving streets, parks and gracious homes, it is a magnificent period piece, the equal of any high-end subdivision in western North America. The first southern extension of Shaughnessy (Second Shaughnessy), from 25th to 37th, is much less impressive and blotted by too many 1980s-era "monster houses." The final Third Shaughnessy, between 37th and 41st, is a gracious reminder of the prosperity of the late 1920s (page 198) – a more modest age for wealthy homebuilders than the earlier decade that created the Heights.

As an incentive for new settlers as development slowly spread southward, the CPR leased land for golf courses: Shaughnessy and Quilchena (page 205), and Langara, the only one that still exists (as a city-owned course at 49th and Cambie). When the leases expired the land was sold and developed, but a few traces of the old courses remain in VanDusen Botanical Garden and Quilchena Park. One of the few Vancouverites who was able to purchase a sizable piece of land from the CPR was sugar refinery owner B.T. Rogers, a golfing partner of western superintendent Richard Marpole and the husband of Richard Angus's

The mature landscape of Old Shaughnessy: plane trees, stone walls and dappled light along Angus Drive.

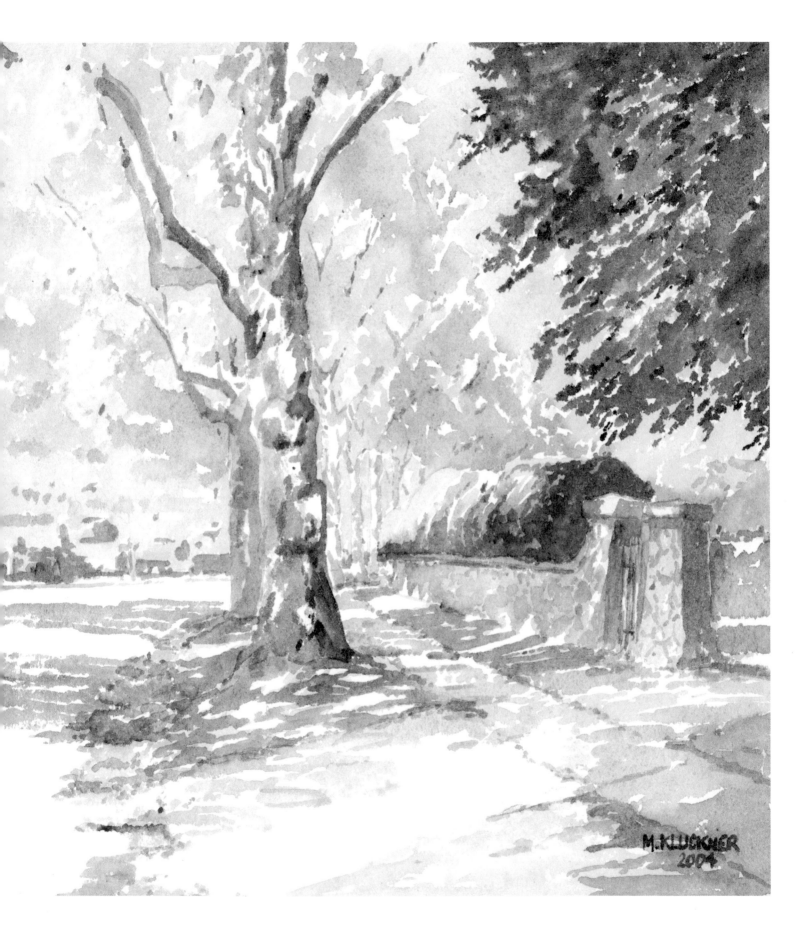

niece; he created the Shannon estate at 57th and Granville, but died before the house was finished (page 208).

It is still easy to see how the streetcar system over-expanded in the first great boom of 1900–14. There was so much land available for sale that few neighbourhoods were filled up before the war-depression-war cycle stopped city growth. Of the middle-class areas, only parts of Grandview around Commercial Drive and First, Mount Pleasant between Main and Cambie, and Kitsilano around Macdonald Street retain the kind of architectural consistency of city neighbourhoods in eastern North America, where change was more gradual and the economy more stable. The infill in most old Vancouver neighbourhoods, among the taller wooden houses of the 1900s to 1920s, tends to be small stucco bungalows, built in the 1930s and thereafter for families moving west to start new lives.

Ethnically, the soggy Shangri-La was white and predominantly British. Where it wasn't English it tended to be Scottish rather than Irish. (In an old saying, England gave Canada its institutions and Scotland gave it its people.) It was church-going and mainly Protestant but not church-*building*, at least compared with older Canadian cities – for example, Christ Church at Georgia and Burrard, the Anglican cathedral of the city's Establishment, is more like a rural English parish church than the grand edifices in Victoria or Toronto. Non-British migrants headed for Strathcona, south of the Hastings Mill and the port: a Jewish street here, an Italian one there, and so on (page 108).

There were Asians, too: Chinese, Japanese and Sikhs. As the Union Pacific Railroad in the USA had done in the 1860s, CPR contractor Andrew Onderdonk brought Chinese workers to the Fraser Canyon to build the roadbed. When construction ended in 1885 they drifted to the coast, but few had enough money to return home. Vancouver's Chinatown developed next to the city's red-light district on low-lying, swampy land between the Hastings Street commercial district and False Creek (map, page 57). There were few women, as a head tax made it all but impossible to bring in wives or concubines. Formed into tongs (family societies), the Chinese built some substantial brick buildings along Pender Street and tenements on the side streets and in narrow alleyways. Legally manufactured opium and illegal gambling occupied some of them – and the police – and fascinated the newspaper-reading public. Many Chinese were market gardeners and, in the 1930s and thereafter, ran the corner stores that once dotted Vancouver's neighbourhoods. The H.Y. Louie Company, founded by an immigrant a century ago, grew to become a major business in the city; once the late founder's son Tong assumed control, the business grew further to include IGA grocery stores, Dominion stores and, since 1976, London Drugs.[1] The head tax issue – that is, the demand by some Chinese Canadians for a formal government apology and reparations – was resolved by the federal government in 2006.

In 1907, a hiccup in the midst of the economic feast caused disaffected whites to rampage through Chinatown, breaking windows, destroying businesses and beating anyone who couldn't get out of the way. The threat of Oriental labour was always a flashpoint for unionized white labourers. But when the mob turned and tried to do the same to the nearby "Japtown," they were met with armed resistance and forced to retreat.

1 The biography *Tong: The Story of Tong Louie, Vancouver's Quiet Titan* (Harbour, 2003) by Ernest Perrault paints an evocative portrait of the challenges faced by Chinese Canadians in the last century. An earlier book, *Saltwater City: An Illustrated History of the Chinese in Vancouver* by Paul Yee, Douglas & McIntyre, 1988, reprinted 2006, also pulled back Chinatown's jade curtain.

Unlike the Chinese, who had come to "Gold Mountain" to make a fortune and then return home, the Japanese came as settlers and, because of Britain's military alliance with Japan, were not subject to head taxes. Proud of their country's defeat of Russia in 1905, they were highly organized and disciplined and attracted the enmity of the mainstream, partly due to their success in fishing and market gardening, partly because they began, early in the 20th century, to insist on the right to vote. Their community occupied the blocks of Powell Street east of Main (page 55), but many more Japanese lived along False Creek near Granville Island and on the Fairview Slopes (map, page 148), as well as on the Southlands flats (page 194), in the Steveston area of Richmond, and as market gardeners, fishermen and loggers in the Fraser Valley and the Gulf Islands.

The third Asian group were Sikhs, referred to usually as "Hindoos," whose presence in Vancouver also reflected Britain's far-flung empire and alliances. Typically, in the early years they worked in the sawmills along False Creek and lived in small houses nearby (map, page 148) in what UBC geographer Walter Hardwick described as an "East Indian ghetto."[1] For most Vancouverites, the Sikhs were out-of-sight, out-of-mind, but they were nevertheless disenfranchised in 1907. Seven years later the *Komagata Maru*, a chartered Japanese ship filled with potential Indian immigrants, arrived in Vancouver harbour. After a lengthy and ugly standoff, it was refused landing.

Politically, Vancouver's councils and mayors during the city's early years swung back and forth on their attitude to the CPR, which was either "great benefactor" or "hated monopoly." The significant early mayor was David Oppenheimer, in office from 1888 to 1891; nicknamed "the father of Vancouver," he was the city's biggest landowner after the CPR. Oppenheimer headed a syndicate called the Vancouver Improvement Company, which laid street-railway tracks and provided power and light in the years before the BCER was established. A bust of him graces the Beach Avenue entrance to Stanley Park.

There are two buildings that symbolize this struggle for influence. The first is the Carnegie Library, now the Carnegie Centre, at Main and Hastings (page 40). One of the bequests of American steel magnate Andrew Carnegie

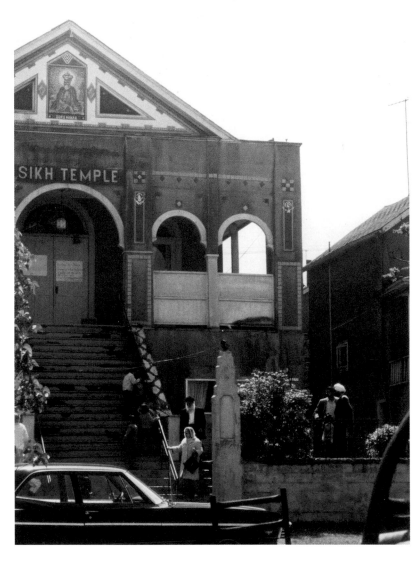

The Khalsa Diwan's first gurdwara, built in 1908 at 1866 West Second Avenue in Kitsilano, photographed in the late 1960s shortly before its demolition. An apartment building now occupies the site. (Photo by Sajiw-Terriss)

1 *Vancouver*, Collier-Macmillan Canada Ltd., 1974, p. 93.

to North American cities, the library was built in 1902 on the east side – definitely not in CPR territory. Five years later the CPR triumphed when the new provincial court house, now the Vancouver Art Gallery, located on Georgia Street just west of the Hotel Vancouver.

WAR, DEPRESSION & MORE WAR

Vancouver lost a generation of its youth in the First World War, while not benefiting to the same extent as eastern cities from munitions manufacturing and shipbuilding. Then the Roaring Twenties merely squeaked along for several years, picking up as the city began to ship grain through the Panama Canal. The must-see landmark from that era is the Marine Building at Burrard and Hastings (pages 89 and 91).

No sooner had prosperity returned than the Great Depression began. Drought on the prairies and industrial collapse in the east put thousands of men on the road, and the majority of them hopped freights west to the Terminal City. A makeshift relief system helped for a time, but once the heavy-handed federal government forced the unemployed into remote work camps, their militancy increased. A near-riot at Victory Square in 1935 began the On-to-Ottawa trek to demand work and wages. Three years later, the unemployed occupied the art gallery, the post office (now Sinclair Centre) and the Hotel Georgia until police forced them out on "Bloody Sunday."

The rise of fascism in Europe coincided with the collapse of real-estate prices in Vancouver. Sensing the potential of another European war, Guinness brewing interests in Ireland sought investments far from the potential fray. In the early 1930s it bought the Marine Building and several thousand acres of forest on West Vancouver's Hollyburn Mountain for an exclusive development called the British Properties. To connect its land with the city, the company completed the Lions Gate Bridge in 1938 with a roadway through Stanley Park.[1]

The Guinness plans anticipated a car-oriented future very different from Vancouver's streetcar past and inconceivable to the majority of residents who were impoverished by the Depression. But like the CPR, Guinness could afford to wait; in fact, in order to get permission to span the federally controlled First Narrows, Guinness had to out-wait the 1930–35 tenure of Prime Minister R.B. Bennett, whose Conservative Party was the traditional friend of the railway company, which didn't want competition for its own unsold land. Following the Second World War, the end of rationing and the return to prosperity, the British Properties went into high gear; Park Royal shopping centre, developed by Guinness, was an integral part of the scheme and provided a model for new developments elsewhere for decades to come.

In 1939 when the Second World War began, Vancouver was once again far from the action. But two years later when Japan attacked Pearl Harbour, the city found itself potentially exposed to invasion. As in the western USA, Japanese Canadians were stripped of their property and forced into internment camps in the BC interior, only beginning to return to the coast after restrictions were lifted in 1949. A handful of wartime buildings survive today on the army base at Jericho, two having new roles as a youth hostel and a theatre.

1 The definitive work is *Lions Gate* by Donald Luxton and Lilia D'Acres, Talonbooks, 1999.

VANCOUVER REMEMBERED

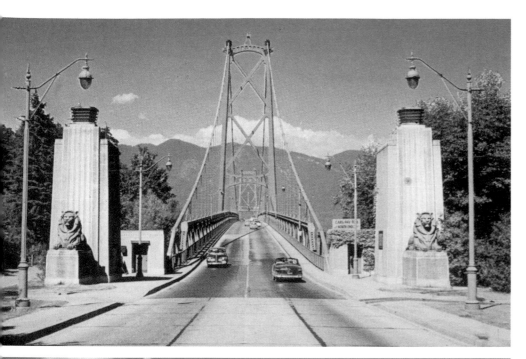

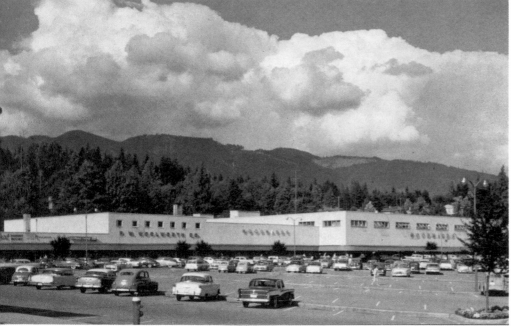

ABOVE *A Sunday drive on the Lions Gate Bridge in the 1950s. The yellow sign states,* CARS PAY TOLL AT NORTH END. *The bridge, built by Guinness interests in the late 1930s and bought by the province in the 1950s, continued to charge tolls until the early 1960s, when all were removed from Lower Mainland bridges as an election goodie from the Social Credit provincial government. (Coast Publishing)*

BELOW *Park Royal was a regional shopping centre that sparked a revolution when it opened in 1950. Designed by C.B.K. Van Norman, it demonstrates the traits that have become familiar to North American shoppers in the decades since: undistinguished architecture and lots of parking. Like McDonald's restaurants, malls redo their facades on a regular basis – Park Royal hasn't looked like this for decades. The anchor tenant, Woodward's, was forced into bankruptcy in the early 1990s (page 72). (Photographer unknown, Natural Colour Productions)*

There is nothing left of the Little Mountain Army Camp, located north of 41st Avenue between Oak and Cambie. The wartime shipbuilding operations on the north shore of Burrard Inlet and False Creek have disappeared (page 164). Evidence of the city's defenses include the "gun tower" observation post on the beach west of Spanish Banks (page 189). During the wartime housing shortages, even the single-family bastion of Shaughnessy Heights saw some of its grand homes converted into rooming houses (page 199). Returning soldiers also faced a strangled housing market; many lived in the abandoned Hotel Vancouver for a couple of years (page 78) until the opening of new areas such as Fraserview (page 230) offered them permanent, if jerry-built, homes.

Politically, the era was defined by a flamboyant pair of mayors, Louis D. Taylor and Gerry McGeer, interspersed with more practical, workmanlike office-holders. Taylor was the newspaperman who built the World Tower, better known as the Sun Tower (page 69); during five terms in office, he campaigned for the amalgamation of Vancouver with South Vancouver and Point Grey and for creating the city airport (now YVR). McGeer (page 150) was the closest thing Vancouver has ever seen to the larger-than-life demagogue mayors of big American cities – Richard Daley of 1960s Chicago comes to mind. Both are significant and colourful enough to have had book-length biographies published.[1]

MODERN TIMES

By the 1950s, with its population growing rapidly again, Vancouver was finally able to dream of itself as a modern city. The model it and everyone else in North America chose was Los Angeles. In rapid succession, the aging streetcar and interurban systems were dismantled, replaced by an underfunded system of trolley buses (see cartoon, page 45). A new highway bridge crossed the harbour at the Second Narrows, a high-level bridge at Oak Street replaced the old Marpole swing span (page 211), a tunnel under the Fraser River opened up suburban lands to the south, and the public became captivated by the idea of a family home on a cul-de-sac in Richmond, Delta or Surrey. The city's old residential areas were rezoned for apartments, and blocks of houses near downtown were demolished and paved over for parking – an interim use that lasted nearly until the millennium.

The West End went high-rise during a dramatic transformation in the decade bracketing 1960 (page 126). Shopping malls opened in Burnaby, Richmond and Vancouver's Oakridge – the last major undeveloped piece of the CPR's domain. Modern houses by young architects like Hal Semmens, Douglas Simpson, Ron Thom and Arthur Erickson began to dot the streets of the University Endowment Lands and the rugged slopes of West Vancouver, harbingers of a new West Coast lifestyle. More prosaically, the "Vancouver Special" – a boxy house with a flat, two-storey front, living areas on the second floor with glass slider doors opening onto a wrought iron balcony, a low-pitched roof and, usually, brick veneer on the ground level with white stucco above – became the house of choice, especially in the eastern half of the city, doubling the floor space of the hipped-roof bungalows of the '30s and '40s.

Politically, the to and fro of the old days was replaced by a left-right split. The business-oriented Non Partisan Association (NPA) dominated city politics from the time of its founding, in reaction to a perceived threat from the left, in 1937. The NPA was (and is) an alliance of conservative-thinking people from the Liberal and Conservative parties – thus only technically non-partisan – that endorsed candidates it felt were acceptable. In the early days its aldermen were able to bury the city's ward system, ensuring the west side's control of the city due to the higher voter turnout there; every time the issue arose, whether in the 1970s, 1980s, or 1990s, NPA councillors argued strenuously against it, and finally, when it came to a referendum under a left-wing council in 2002, it was soundly defeated.

1 *LD: Mayor Louis D. Taylor and the Rise of Vancouver,* by Daniel Francis, Arsenal Pulp, 2004; *Mayor Gerry: The Remarkable Gerald Grattan McGeer,* by David Ricardo Williams, Douglas & McIntyre, 1986.

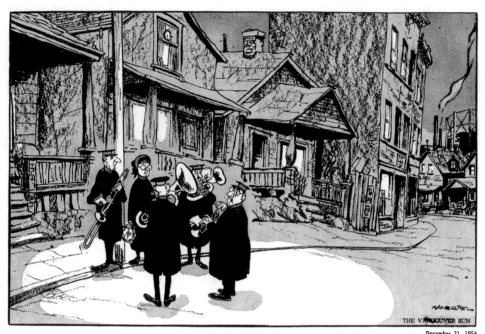

December 21, 1954

"You don't suppose if we play 'Peace on Earth' we'll be regarded as a Communist front organization . . .?"

Cartoonist Len Norris caught the Cold War atmosphere of the early 1950s, as well as the look of an imagined old neighbourhood like Strathcona, with the gasometer in the right distance (which he could probably see from his office in the Sun Tower), and the chilly damp feel of pre-Christmas evenings when the Sally Ann band went from neighbourhood to neighbourhood, playing sonorous carols and collecting donations door-to-door. The only part of the drawing not typical of Vancouver is the picturesquely curving street. His cartoon neighbourhoods typically featured narrow lots, rank grass, picket fences and white stucco bungalows occupied by harried couples with mutinous children. Norris (BELOW) joined the Sun in 1950 and produced a huge volume of cartoons until his retirement at age 75 in 1988. He died in 1997. (Sun photo).

CARTOON: USED WITH PERMISSION

Postwar, political issues included slum clearance, transportation and the fate of False Creek (page 101). Mayor Charles E. Thompson, in office 1949–50, found himself stricken with Cold War paranoia and demanded that all city employees be screened for Communist sympathies. His successor Fred Hume kept more to local issues; a popular figure and former New Westminster mayor, he lived in a large West Vancouver house with a dramatic Christmas light display easily visible from Stanley Park and the Lions Gate Bridge (owned by businessman Jimmy Pattison in recent years).

A handful of progressive mayors achieved office: J.L. Telford in 1939–40, Tom Alsbury from 1959 to 1962 (endorsed by the NPA), and Mike Harcourt from 1981 to 1986. As described below, the other progressive, Art Phillips, became mayor when the electorate finally gave up on the NPA after the 1963–72 terms of Bill Rathie and Tom Campbell, the era that saw downtown redevelopment and the great freeway debate dominate the public agenda. The end of Harcourt's term saw the election as mayor of Gordon Campbell, BC's conservative Liberal premier since 2001, and the beginning of the dramatic changes to the city triggered in a symbolic way by the Expo '86 celebration.[1]

In the changeover from old to new in the 1950s, Hastings Street suffered the most. It lost thousands of daily visitors when the interurban line closed and the North Shore ferries were cancelled. The BCER abandoned the area entirely, moving uptown to its sleek new office building at Burrard and Nelson (page 86). Only the venerable Woodward's department store at Hastings and Abbott acted as a bulwark against the deterioration and abandonment of the blocks to the east (page 72). The old warehouses on Gastown's narrow streets became obsolete as businesses migrated to the suburbs with their 18-wheelers (page 43). Plans were drafted for a waterfront freeway system, entering downtown from the southeast and razing historic Gastown, Chinatown and Strathcona, all home to poor people with little political voice. Urban renewal – the demolition

1 Brief lives of all of the mayors of Vancouver, written by Donna-Jean MacKinnon, appear in the *Greater Vancouver Book*, pp. 239–42.

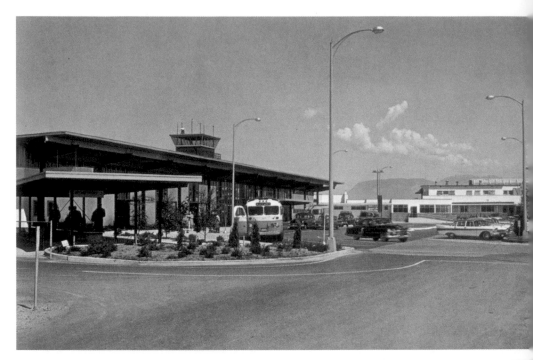

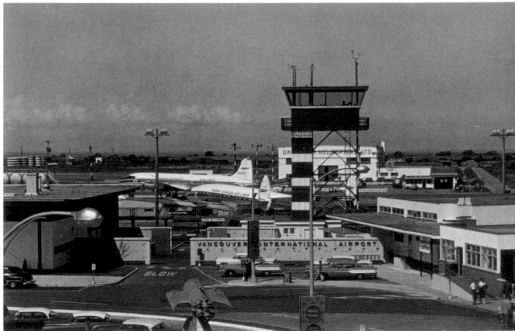

Vancouver airport – what is now the South Terminal – on Sea Island in the 1950s, at the end of the steamship and railway eras. Twin-prop airliners such as DC-3s were standard for regional flights, with thundering four-engined behemoths such as DC-6s and Super Constellations used for longer ones. Seven years into the jet era, in 1968, the new terminal opened, relegating this one to its current role for small regional airlines. Visible at the bottom of the lower image is the sheet metal rocket ship designed in 1936 by Lew Perry for the PNE; after 37 years in the centre of the airport's traffic circle it was refurbished by the Sheet Metal Workers Union Local 280 and installed in 1986 by the Vancouver Transportation Club at the south end of the Cambie Bridge. (Photographers unknown)

1 The most graphic treatment of the period is the *Historical Atlas of Vancouver and the Lower Fraser Valley* by Derek Hayes, pp. 146–59.

of old housing and its replacement by towers set in green space – would complete the package.[1] The flight of retail to suburban malls became enough of a concern that the city, prompted by downtown business interests, began to plan for the Pacific Centre, a megablock of offices and an underground mall – a model already successful in Toronto and Montreal – for the strategic corner of Georgia and Granville (page 81).

But then Vancouver got lucky again. Its position way out on the edge of the plate, both geographically and politically far from the Ottawa power centre, made it slow to get the freeway and urban renewal money that had already

disfigured Toronto and Montreal. Meanwhile, activists observed what had been happening in the USA, especially in nearby Seattle. Accordingly, by the end of the 1960s when the government machinery was finally in place to transform downtown Vancouver, the times they had a-changed.

Like San Francisco's Haight-Ashbury, Kitsilano was a declining neighbourhood awaiting redevelopment – the perfect venue for communal living in cheap old houses. Fourth Avenue blossomed in 1967–70 with head shops and coffee houses (page 179). At the same time, young entrepreneurs began fixing up Gastown and opening art galleries and boutiques (page 45). The arch-conservative civic government, with its hippie-baiting mayor Tom Campbell, was a perfect target for the poets, folkies and American war resisters who read and wrote for Dan McLeod's *Georgia Straight* newspaper.[1] Militant cyclists and nascent environmentalists found common cause with antipoverty activists in the fight against urban renewal and the freeway, beginning with the Strathcona Property Owners and Tenants Association (page 112); they received help in 1971 from an unexpected quarter when the Social Credit government of W.A.C. Bennett used a provincial statute to protect Chinatown and Gastown from demolition. The year before, the Amchitka nuclear test galvanized Vancouver activists into founding the organization that evolved into Greenpeace.

The year 1972 was a watershed for the city. Sustained protests persuaded the federal government to withdraw its support from the freeway plan. That summer, voters threw out the Social Credit government of W.A.C. Bennett, which had been in office for 20 years, and replaced it with the New Democratic Party led by Dave Barrett. Late that fall the NPA-dominated city council was also shown the exit, replaced by a group of liberals and academics under the TEAM banner with new ideas for the future.

Modern Vancouver really began that year. In turning away from the waterfront freeway system, the city concluded it could also rethink the old False Creek industrial area. From my perspective 35 years later, Vancouver divides into "old" and "new" over the issue of False Creek. It represents symbolically the state of mind of a city that turns its back on inner-city industrial employment and re-imagines its lands as a home and a playground. Not that Vancouver was ever a serious industrial contender: its remoteness from the population centres of North America ensured that. The grandest of the city's industrial trial balloons were all launched in the first quarter of the 20th century – docks and a rail terminus on Kitsilano Point, an industrial area and docks occupying the entire west end of Richmond – but the population never grew quickly enough, freight rates were too high and the economy too fragile for any of them to get built. The city also had the banks of the Fraser River, somewhat out-of-sight of the urban areas, for the sawmills and works of the forest industry, the province's major employer. Thus, the city itself remained relatively unspoiled and easy to clean up once the wind of environmental change blew the ship of state onto a new tack.

The guiding spirit for this new era was Walter Hardwick, a Vancouver-born UBC geography professor who had argued for the transformation of False Creek for a decade. Elected first to council in 1969, he was a minority voice for three years until his compatriots on the TEAM group, under the leadership of

1 See *The Georgia Straight: What the Hell Happened?* by Naomi Pauls and Charles Campbell (Douglas & McIntyre, 1997).

Art Phillips, took office. His distinguished career included the founding of the Urban Studies Program at UBC. He was instrumental in the hiring of Ray Spaxman as director of planning for the city in 1973, replacing the business- and development-oriented planners of the previous decades.

Hardwick wrote one workmanlike book on Vancouver, relatively early on in 1974, but unfortunately never did another.[1] Evidence of his legacy has nevertheless continued for the generation since he left politics in the humanist planning vision of Spaxman and his successors and in politicians like Gordon Price, a city councillor from 1986 to 2001. Another politician whose efforts had a lasting effect was Ron Basford, who died in 2005 at the age of 72. The Liberal MP for Vancouver Centre, he was one of the few influential westerners in Pierre Trudeau's cabinets of the early 1970s. As Minister of State for Urban Affairs from 1972–74, he picked up the pieces after the cancellation of the federal government's failed freeway/urban renewal strategy for Vancouver. One legacy is the Neighbourhood Improvement Program, which started in Strathcona with the idea of renovating, rather than demolishing, the existing housing; another is Granville Island, which transformed itself from a federally owned derelict industrial area (as Community Arts Council activist Evelyn MacKechnie noted sourly, "Basford had millions for Granville Island . . . but didn't have a cent for Gastown"[2]).

Walter Hardwick was able to conceptualize the practical implementation of the planning ideas that became known as "Vancouverism" or the "Vancouver Achievement."[3] "Walter led the intellectual and political arguments about 'good planning' through the late '60s into the '70s and '80s," Spaxman wrote. "He came and met me in Toronto in early 1972, where I was deputy planner, and we 'clicked' on the need for revision in planning principles, urban design, neighbourhood planning, quality of place, review and approval processes, citizen involvement and so on."[4]

One of Spaxman's significant innovations was the preservation of view corridors in the city, a risky move as it challenged the development community's belief in its ordained right to control the future shape of the skyline. As quoted by journalist Shawn Blore, he said, "My first visit to the city was in 1972 for a management course at UBC. They put me up in the Walter Gage Residences, and I went up the elevator and into the room they'd given me and there in the sunset was downtown in the distance, and it just hit me that there are very few places that have this sort of miraculous view."[5] During Spaxman's time in Toronto, neighbourhoods had been overwhelmed by enormous, slab-sided towers, causing extraordinary citizen unrest.[6] The slim towers with townhouse bases that are typical of contemporary Vancouver's Yaletown and Downtown South are a direct result. The use of discretionary zoning, including transfers of density to save heritage buildings and create amenities, and an urban design panel have all helped create some very livable new neighbourhoods.

Spaxman insisted on citizen involvement, first in Toronto, then in Vancouver, where he started Local Area Planning Committees and local planning processes, the first of which operated from a storefront on Fourth Avenue in Kitsilano in 1974. He recognized that the streetcar-era shopping streets of the 19th century could provide an excellent urban environment a century later. Having survived the car-dominated thinking of the previous decades, streets

1 Hardwick died in June 2005, after a long illness.

2 Quoted in "Gastown plus ten," by John Braddock, *Province*, September 23, 1978.

3 *The Vancouver Achievement*, by John Punter, UBC Press, 2004. In Ray Spaxman's opinion, this is the best book describing Vancouver's development during the last quarter of the 20th century.

4 Correspondence, 2006.

5 Smileyville, *Vancouver Magazine*, November 1999.

6 An entertaining, radical view of that time (for both Vancouver and Toronto) is James Lorimer's *A Citizen's Guide to City Politics,* published in 1972. Donald Gutstein's *Vancouver Ltd.* (Lorimer, 1975) gives a similar interpretation of Vancouver development issues.

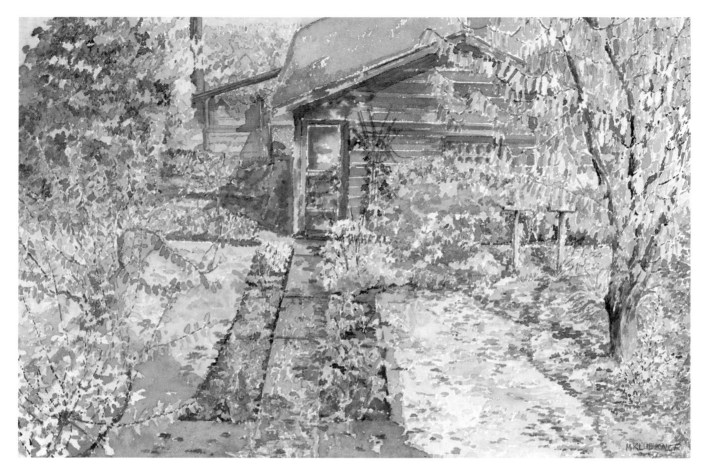

like 41st Avenue in Kerrisdale and Broadway in Kitsilano were zoned for apartments above shops – reflecting Spaxman's English background (he is from Liverpool). I remember him clearly, wearing his overcoat and huddled on a metal chair in the unheated back office of the Mount Pleasant Information Centre on a winter night in 1974, describing animatedly to a small group his vision of a local planning process with citizen involvement. Vancouver's urban form – its lively streets, restaurants, sidewalk seating areas, bars, all the diversity and the pleasure of city life – dates from that time. The changes in liquor regulations brought in during the NDP stint from 1972 to 1975, which among other things allowed for neighbourhood pubs, helped too.

Old Vancouver backyards were narrow, dotted with fruit trees and divided into sections by flower and vegetable beds. Garages were small, often lacked doors, and were connected to the house by a narrow concrete sidewalk. At the lane, the lot would have a low, decaying picket fence, often swarmed by blackberries. I painted this view in 1986 from the upstairs studio window of our house on 42nd in Kerrisdale.

ALMOST YESTERDAY

In the 1970s, Asians began to immigrate in unprecedented numbers to Canada and transformed both rich and poor areas. Vietnamese arriving in the wake of the war were followed, once Britain had set a timetable for giving up Hong Kong, by large numbers of wealthy Chinese who settled on the west side of Vancouver and in Richmond. South Asians gravitated to the houses of South Vancouver and to new suburbs in such satellite cities as Surrey. Compared with the monoculture of my youth, especially in the middle-class west-side areas where I grew up, the city became a rainbow of diverse peoples.

Urbanist and former councillor Gordon Price has described Vancouver's true heritage as its 19th-century street grid, rather than any particular sets of buildings, his argument being that the streets and blocks have allowed the city to reinvent itself in response to the changing needs of its populace. In the years since Expo and the Centennial, the downtown parts of the city have almost completed their transition from the Edwardian boom of a century ago. There is less derelict space, fewer lots are held for speculation, and the new downtown residential areas have been very successful.

The transformation of the neighbourhoods was much less successful. A generation of fine wooden homes, mature trees and gardens suffered under the onslaught of redevelopment in the 1980s. No grid could save them. The sheer ugliness and cheapness of many of the huge new houses demonstrated how flawed the city's vision was then for its single-family areas. Recent home building, especially on the west side of the city, has been of a much higher quality, although it hasn't addressed the broad environmental need to retain the energy value of the existing buildings and mitigate the impact of their disposal.

Before the 1970s, the city was redeveloping using a modern model: that is, publicly funded urban renewal with the utopian ideal of improving the lives of the poor by slum clearance and high-rise housing projects. It was the urban equivalent of clearcutting a forest, a tabula rasa on which architects and social planners could create a brave new world. Since 1972, the city has changed to a postmodern development model, changing the city incrementally using mainly private development money and controlling its evolution so that some evidence of its historic layers still remains.

The city's main failure has been the Downtown Eastside. The decline of Hastings Street in the 1950s, mentioned above, received a further kick when Woodward's, the department store company, lost its way in 1992 and was taken over by the Hudson's Bay Company. The flagship store at Abbott closed, and the city's long-standing drug problem crept west from its base around Pigeon Park and the unit block of East Hastings. As a seaport, Vancouver has always had its mean streets, but they began to get meaner around 1980, when the de-institutionalization of mental patients and the exit of provincial and federal governments from public housing construction coincided with the gentrification of the downtown and its neighbourhoods. The pre-Expo conversion of old, single-room-occupancy hotels added to the problem. As a result,Vancouver has a concentration of homeless, drug, gang and property-crime problems that are as "world class" as its celebrated cultural achievements. And then there is affordability of housing or the lack thereof for even middle-income people, a constantly repeated theme in the real-estate boom of 2005–06.

It is a much more have-and-have-not society than it was even in the 1970s and 1980s. But is there a city anywhere that has done better?

Commercial Vancouver

M. KLUCKNER
1989

Gastown & the Downtown Eastside

1 His biography: *The Enterprising Mr. Moody, the Bumptious Captain Stamp,* by James W. Morton (J.J. Douglas, 1977).

2 See *Eyes of a City: Early Vancouver Photographers 1868–1900,* by David Mattison (Vancouver City Archives, 1986), pp. 24–28. The CAC publication is *Gastown Revisited,* edited by Elizabeth O'Kiely, 1970. "E.B" O'Kiely, as she was known, was a long-time supporter of the Vancouver arts and museum community and wrote two books using her maiden name, Bell-Irving.

Gastown and the Hastings Mill area imagined as it was about 1880, before any announcement that it would be the terminus of the transcontinental railway. Photographic documentation of the early settlements was very spotty, with the first good panorama of the buildings along Water Street taken in 1884–85. A 1970 artist's rendering, by Beverley Justice for the Community Arts Council, shows just the buildings in the Granville Townsite.[2]

Vancouver's birthplace is Gastown, the strip of land along Water Street on Burrard Inlet. It is still and has always been called Water Street, in spite of the fact that the shoreline is now a few hundred yards north of where it was in the summer of 1867 when "Gassy Jack" Deighton built a saloon at the water's edge. As described in the Introduction, Deighton saw a business opportunity in the thirsty workers nearby at Stamp's Mill.

Edward Stamp was in his 40s and captain of a vessel sent to Puget Sound for a load of lumber when he first saw the forests of the Pacific Northwest.[1] With English financing, he opened a mill on Alberni Inlet on Vancouver Island in 1861. Six years and a couple of bankruptcies later, his mill on Burrard Inlet went into production. He had worked with logger Jerry Rogers – whose name survives locally in the "Jerry & Co." of Jericho – to find a good location for a steam-powered mill that could beat the production of the water-powered Moodyville mill on the North Vancouver shoreline.

He first examined the Stanley Park peninsula, envisioning water from Beaver Lake and a mill site near Lumbermen's Arch in spite of the fact that the latter was almost on top of the village Khwaykhway. The Aboriginals there shrewdly pointed out the swift tides that flow past the shoreline there and convinced him to set up on the first peninsula to the east, at the north foot of today's Gore Avenue, a place they knew as Kumkumalay ("broad-leafed maple trees" after the indigenous *Acer macrophyllum* that grew there).

Looking for a new water source, Stamp first dammed Brewery Creek near Main and 7th in Mount Pleasant (page 167), but his flume never worked properly. Casting his eye further afield, he chose Blackie's Lake, now known as Trout Lake, near Victoria Drive and 12th Avenue in East Vancouver, and constructed a flume overland to the mill. It was an excellent choice, as its slightly acidic water helped keep the mill's boilers clean. The flume survived for a couple of decades until water from the new Capilano reservoir arrived, by which time Stamp was long gone (he died in London in 1872 while raising money for a salmon cannery venture).

His legacy, by then known as Hastings Mill, had entered a new era of corporate ownership. Under John Hendry's management, it was amalgamated in 1889 with a New Westminster mill and, later, its old Moodyville rival to create the BC Mills Timber & Trading Co., the forerunner of the modern forest companies that dominated BC's economy in the 20th century. Trout Lake, today's popular East Vancouver beach, farmers' market and gathering place, is formally named John Hendry Park due to a donation from his daughter Aldyen, whose marriage to the young Eric Hamber gave her father a worthy successor. Hamber had an illustrious career, including a stint as

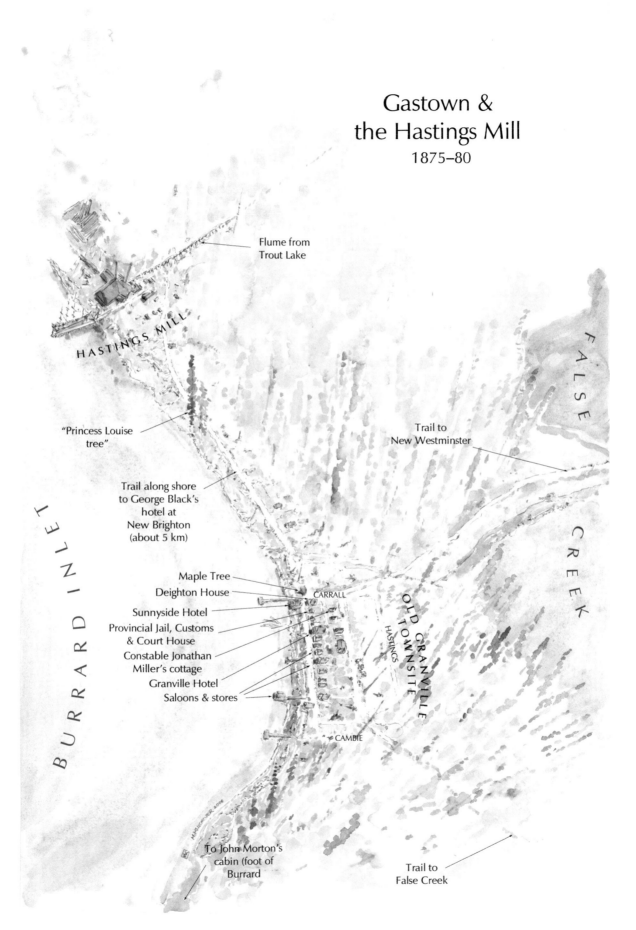

Gastown &
the Hastings Mill
1875–80

Flume from
Trout Lake

HASTINGS MILL

"Princess Louise
tree"

Trail to
New Westminster

Trail along shore
to George Black's
hotel at
New Brighton
(about 5 km)

BURRARD INLET

FALSE CREEK

Maple Tree
Deighton House
CARRALL
Sunnyside Hotel
Provincial Jail, Customs
& Court House
OLD GRANVILLE TOWNSITE
HASTINGS
Constable Jonathan
Miller's cottage
Granville Hotel
Saloons & stores

CAMBIE

To John Morton's
cabin (foot of
Burrard

Trail to
False Creek

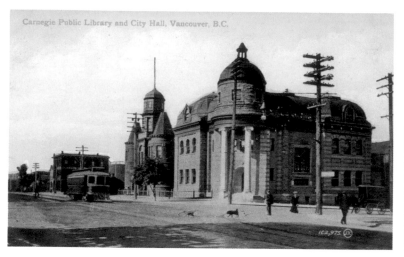

Carnegie Public Library and City Hall, Vancouver, B.C.

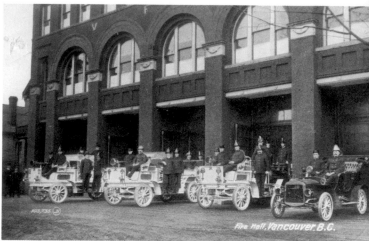

Fire Hall, Vancouver, B.C.

LEFT *Hastings and Main early in the 20th century, with the City Hall and Public Market on the left of the Carnegie Library on the corner. One of the hundreds of libraries built using grants from the American steel magnate Andrew Carnegie, the library is a George Grant design of 1902. The legendary Major Matthews developed the city's archives in the cold, dark attic of the city hall, a room that came to be known as the Deserted Chamber.[1] The library was renovated into a community centre by Downs/Archambault architects in 1980.*

RIGHT *Vancouver's former main fire hall at Cordova and Gore is a 1905 building, converted in 1976 by architect Roger Hughes into the Firehall Theatre. The postcard shows entirely motorized fire trucks, a changeover that began in earnest in 1908 with the building of Firehall Number 6 in the West End, which made no provision for horses. When the Dominion Trust Building opened on West Hastings in 1909, the department bought a 75-foot Seagrave Aerial Ladder. (Photographers unknown, John Valentine & Sons postcards)*

1 A biography of Matthews by Donna Jean MacKinnon appears in the *Greater Vancouver Book*, p. 50.

lieutenant-governor 1936–41; his name survives on a school on the old Shaughnessy Golf Course (page 206). The mill continued operation until 1929. Its original store, built in 1865, was saved by the Native Daughters of BC when the mill site was cleared off, floated by barge to Kitsilano, and re-erected as a museum at the foot of Alma Street.

Gastown became a registered town on March 10, 1870, named for the Earl of Granville, the British colonial secretary. Future lieutenant-governor Joseph Trutch surveyed it into a straightforward grid of Water Street, Cordova and Hastings from north to south, and Carrall, Abbott and Cambie (as they are now known) from east to west. It became known as the Old Granville Townsite or OGT. The survey showed Deighton House sitting in the middle of what is now known as Maple Tree Square, and seven other buildings strung out to the west. Subsequently, Deighton built a new hotel on the southwest corner lot of Carrall and Water that was much less of a shack: two storeys with a gabled front and a balcony that shaded the porch area in front of the saloon doors. Other cabins and false-fronted frame buildings soon joined it along the waterfront. As late as 1885 it was little more than a clearing extending 300 yards along the shoreline. A large native maple like the ones at Kumkumalay stood at the eastern end of the clearing next to Deighton House and was the town's public place, its Maple Tree Square.

Today's Gore Avenue follows the approximate route of a skid road supplying logs to the mill, which explains why it is off the rigid grid of the rest of the Downtown Eastside. A trail that eventually became Wall Street went east from the Hastings Mill to New Brighton in the Hastings Townsite (on the waterfront near the Pacific National Exhibition), also the terminus of a road from New Westminster. Another road headed in a southeasterly direction and followed a military trail toward New Westminster – it evolved into Kingsway. There was also a trail running southwest that was often used by duck hunters to reach False Creek near the foot of today's Granville Street. Other residents on Burrard Inlet at the time included John Morton, whose shack on the bluff near the north foot of Burrard Street was the only evidence of the Brickmakers' Claim made by the "Three Greenhorns," of whom Morton was one (page 114). And there were Aboriginal people with their spouses, some of European descent, who had lived in the area since the 1860s at the so-called Kanaka

Rancherie at the foot of Denman Street on Coal Harbour and along the shore of the peninsula near Brockton Point.

Like every other shantytown in the west, Gastown was an unruly place although not really a lawless one — at least not compared with its American counterparts. Constable Jonathan Miller's jail conveniently occupied the strategic lot west of Deighton House (Gaoler's Mews in today's Gastown) and was evidently occupied mainly by drunks. Prostitutes and a few Chinese men lived in scattered shacks on the outskirts of the townsite. Road work, land clearing such as the Cambie Street Grounds (Larwill Park) and, later, the tending of gardens at municipal buildings was the job of prisoners chained together into a gang. John Clough, a one-armed regular at the jail, was often left in charge of these work crews.

The pending arrival of the Canadian Pacific Railway put a sense of purpose into the citizenry. In 1885, CPR surveyor Lauchlan Hamilton laid out the Vancouver townsite, fitting it to an axis that benefited the company's pending terminus near the foot of Granville Street and causing the jog in the streets between it and the OGT. As with Broadway in New York City which cuts diagonally across the Manhattan grid, the jog in the Gastown streets created a few flatiron lots that were developed with three of Gastown's signature buildings: the Horne Building on Cordova at the lane west of Abbott Street in 1889, the Holland Block at Water and Cordova in the early 1890s, and the dramatic Europe Hotel on Maple Tree Square in 1909.

Vancouver incorporated on April 6, 1886, and held its first election within the month. Realtor Malcolm MacLean defeated the patrician Hastings Mill manager R.H. Alexander. There was a definite undertone of racism in the election; Alexander was among those Englishmen who believed Canadians (i.e. people from Ontario and the Maritimes) to be inferior to people like himself and called them "North American Chinamen." White workers forged residency permits and drove back a contingent of Chinese mill workers, allowing MacLean to win by 242 to 225. The following February, a white mob sacked a Chinese camp along False Creek, causing the provincial government to suspend briefly the new city's charter and put it under the control of provincial police.

May 1886 was exceptionally hot and dry. CPR crews engaged in clearing the downtown peninsula for settlement and the False Creek shore for railyards and a roundhouse were using a "nine-pin" logging method, whereby the smaller trees would just be sawn through the back and only the big Douglas firs and cedars cut all the way through. The crash of one of those forest giants brought down perhaps 20 or 30 smaller evergreens into the tangle of underbrush. A solid wall of wood and brush more than 10 feet deep waited to be burnt. On June 13, a slash fire got out of hand and, with the help of a freakish gale, swept northeast from False Creek across the city, burning everything in its path. About 1,000 buildings vanished in less than an hour. It spared only the sawmill and one Water Street hotel, whose occupants soaked blankets and beat out the sparks. At the end of that horrific day, 21 sets of human remains were gathered and placed in a makeshift morgue in the Bridge Hotel on the downtown end of the Westminster Avenue (Main Street) bridge; only three, found at Hastings and Columbia, were identifiable by their features. Vancouver's frontier days were over.

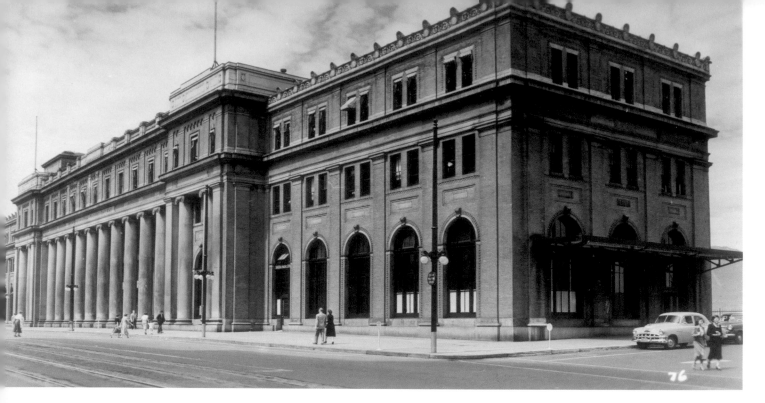

Waterfront Station, as it is now called, is the old Canadian Pacific Railway station at the foot of Seymour Street. Built just before the First World War, it is the third CPR station in Vancouver. The first one near the foot of Howe, in front of the deepest water in that part of the port, was an interim wooden structure, and was replaced in 1898 by a turreted chateau at the foot of Granville. Perhaps construction problems (allegedly poor-quality brick) doomed it, or else it was too small, but it lasted barely 15 years. With the creation of the government-run VIA Rail and the collapse of rail travel by the 1970s, this station was slated for demolition, but once Project 200 (see page 45) was shelved and the area rethought around the Gastown historical model, it was restored as the transit, rail and Seabus hub. The SkyTrain uses the CPR's 1930s Dunsmuir Tunnel to travel under the downtown. (Postcard photograph by J.C. Walker)

1 See Gerald Rushton, *Echoes of the Whistle* (Douglas & McIntyre, 1980).

In retrospect a fine example of urban renewal, the fire forced the survivors to adopt safety codes, establish a fire department and begin to rebuild their downtown buildings with more permanent materials. In the two dozen years after the 1886 fire, Gastown again became an important part of the city. Its streets were lined with hotels and warehouses – the domain of the commercial traveller. However, it never recovered its status as the centre of anything; a combination of port development, the CPR's real-estate strategy and the machinations of the Vancouver Improvement Company ensured that it was always on the edge of bigger, more important developments.

The CPR used its piers A (just east of the Immigration Building at the foot of Thurlow, see photo on page 89), B-C (at the foot of Howe, today's cruise ship terminal and Canada Place convention centre) and D (at the foot of Granville) for a combination of coastal and international traffic. Its railway station at the foot of Seymour Street, actually the third one it built along the waterfront, became the symbolic crossroads justifying the city's appearance on the world map. The railway's passengers, from first class to colonist, arrived there. Carriages and cabs took the wealthier of them to the Hotel Vancouver at Granville and Georgia (page 79); migrants and international travellers arrived and left on Empress liners or more lowly steamers.

Farther east, the Union Steamship Company's sheds and docks occupied the foot of Carrall Street, the site of the city wharf in the pre-fire Gastown days. Union Steamship was the "coastal streetcar service," shuttling from mill to cannery to island up and down the Strait of Georgia and points north.[1] The CPR's coastal service served the outer coast as well as points north, as seen on the map on page 19, as did its railway rival Canadian National Steamships, operating from a pier at the foot of Main Street. In between at the foot of Columbia Street, the North Vancouver ferry wharf (and until 1947 the West Vancouver wharf) brought cars and people to the city via a subway underneath the CPR tracks. Evans, Coleman & Evans Company owned a deep-sea wharf just to the west of the ferry slip and was the city's largest fuel and cement supplier; George Coleman's West End home is pictured on page 120.

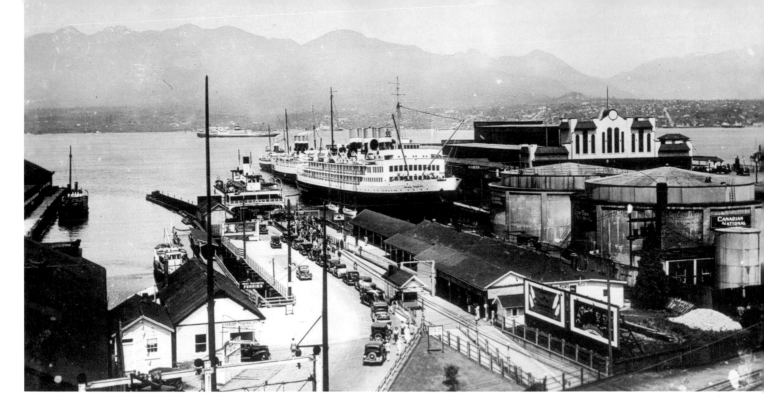

Thousands of people had business on the Gastown streets every day or passed through on the way elsewhere. Many arrived and left the city two blocks south of Maple Tree Square at the BC Electric Railway Company's interurban depot, where trains departed on the New Westminster line (today's SkyTrain Expo line) and thence, if they wished, through the Fraser Valley as far as Chilliwack. Woodward's Department Store at Abbott and Hastings was the preferred grocery provisioner for many upcoast families dependent on Union Steamships or the CPR coastal service.

The centre of the city was the corner of Hastings and Main, two blocks east of the BCER depot. The Carnegie Library stood next to the city hall and public market building. Cafes did a roaring trade, hotels were full of travelling salesmen, and cinemas and burlesque houses drew audiences by streetcar from all over the city. Hastings Street all the way west to the Spencer's/Eaton's department store (today's SFU Harbour Centre campus, page 73) was the best place to shop. It had its rough side, as does any seaport, but in the main there was comparatively little crime other than drunkeness and prostitution, rather like its rustic ancestor of the pre-railway era.

However, in the wake of the Second World War, when the public's pent-up demand for change was finally unleashed, Hastings Street and Gastown were hit hard. Following the lead of the United States with its burgeoning interstate highway system and 18-wheeler trucks, wholesale businesses began to relocate to the outskirts of town where there was more room to park and turn and load. Although the Lower Mainland was slow to start its own freeway system, companies like Kelly Douglas, which had built and operated the building now known as The Landing on Water Street, moved its wholesale food operation to Kingsway in Burnaby next to the Simpsons-Sears distribution centre on today's Metrotown shopping mall site. Within a decade, the Water Street warehouses that had been the city's pride a half-century before were technologically outdated, unable either to be rented or sold. Urban renewal looked like the only way for the city to move forward.

In this 1930s photograph, cars are lining up for the North Vancouver ferry that crossed to a dock at the foot of Lonsdale. On the left, the small West Vancouver passenger ferry dock is visible, and in the right background the ships and Spanish Colonial-style pier of the Canadian National Steamship Company. The latter had a brief farewell in the 1970s as the Oompapa Restaurant and Happy Bavarian Inn. Access to the dock was by a subway under the CPR tracks at the foot of Columbia Street, visible in the foreground. Ferry service to the north shore ended in 1958. (Photographer unknown)

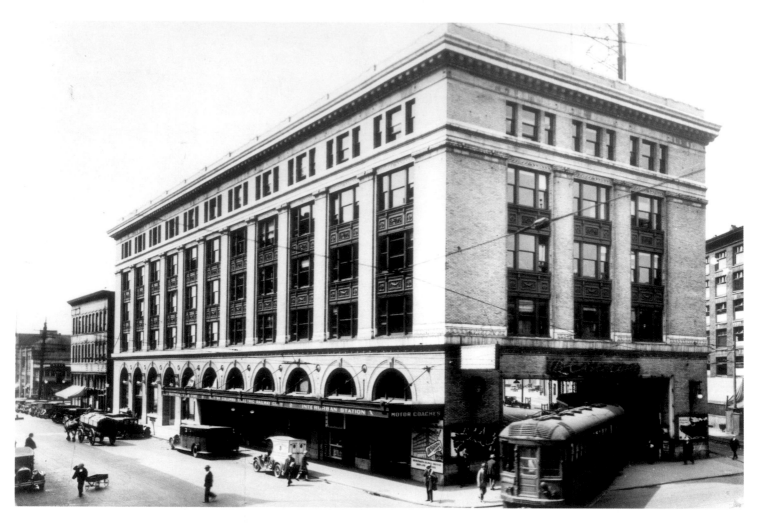

Carrall Street and the BC Electric Railway Company headquarters in the 1920s. An interurban from New Westminster is entering the depot from Hastings Street. When the BCER shut down its interurban system and abandoned this building in the 1950s, it hastened the decline of the area from busy commercial shopping area into the Downtown Eastside skid-road or tenderloin of recent times. The building still stands, the old train portal bricked up, and a Bank of Montreal branch occupies the main floor. (Photographer unknown)
METRO TRANSIT MUSEUM

1 A former camp boss, who worked with Larry Killam in Gastown in the late 1960s, related the expression.

The other sea change in the area involved its transportation system. The BCER shut down its streetcar and interurban system in the early 1950s, replacing it with underfunded trolley buses. Then, in 1957, it closed the Carrall Street depot and headquarters and moved uptown. The North Vancouver ferries stopped running in August 1958, in anticipation of the opening of the new bridge at the Second Narrows. Gastown and East Hastings were all but abandoned by the middle class. The other stratum, of transient workers and skid-roaders, as they were called, moved into the vacuum. Not since the Depression had Hastings Street's neon shone down onto so much poverty.

Loggers hiring agencies were a big feature of the area. The economy thrived on the pool of itinerant labour that yo-yoed from the Downtown Eastside to the camps and back. At one float camp, the loggers' expression was "Wine and dine, it's Smilin' Buddha time," telling the camp boss to phone Vancouver for a chartered Beaver floatplane and issue a cheque for all wages owing.[1] Down to the Big Smoke the logger would go, to blow his hard-earned wages on whores and lavish good times, a spree that would often end with a penniless, hung-over man signing in with a logging agency and starting the cycle all over again. Eventually unable to work at all, many ended up surviving on the civic welfare pittance in the old commercial hotels. A lot were alcoholics, hooked on Bay Rum shaving lotion, Chinese cooking wine or Lucky Lager, the workingman's beer. Old men hung out on the benches of Pigeon Park at Carrall and Hastings in front of Honest Joe's, the main floor tenant in what had once been the gracious Merchant's Bank Building.

The Smilin' Buddha at 109 East Hastings was noteworthy among the raucous joints along the strip for its neon sign, but otherwise was typical of the beer parlours and dives that fleeced the area's underclass. It had a final blaze of glory as the favoured club of the rock band 54-40, which played there in the 1980s.[1]

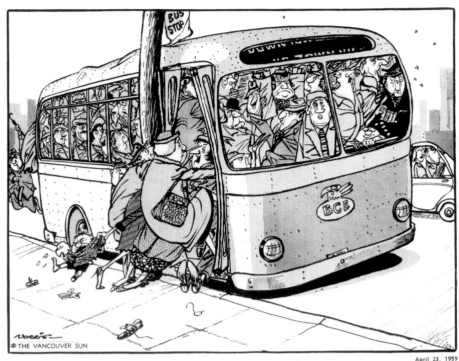

April 23, 1959

"I notice that silly fad of seeing how many people could get into a phone booth didn't last long . . . "

People still knew the name "Gastown," but there was little reason to go there. Hunters and fishermen patronized the outfitting stores like Harkley & Haywood, at the northwest corner of Cordova and Abbott, and Edward Lipsett fishermen's supplies, tents and awnings, on Water Street next to the Dominion Hotel. The Army and Navy department store on Cordova west of Carrall was a workingman's destination.

On Hastings Street, Woodward's attracted both middle class and working families, as did Wosk's Furniture nearby. The last surviving grand cinema, the Odeon Hastings (originally a Pantages Theatre), a few doors west of the BCER building at Carrall, closed and was eventually torn down in the 1970s. The original Pantages Theatre, latterly known as the Avon, at 142 East Hastings, was home in the 1950s to the Everyman Repertory Company whose production of Tobacco Road was shut down by the vice squad. In the 1970s it screened second-run art films as the City Nights Theatre.

There were only a few glimmers of interest in Gastown in the 1950s and early 1960s. In the wake of the province's centennial in 1958 and its restoration of Barkerville, a few historians made enquiries with the government about Gastown. As the years passed there were rumblings of pending change along the waterfront, notably an urban renewal proposal by the CPR's Marathon Developments called Project 200, which would dovetail neatly with a waterfront freeway connection to Highway 401 and to the north shore via a new "Third Crossing."[2] Like the Pioneer Square historic district in Seattle, Gastown was a homely frog awaiting its prince.

A young entrepreneur named Larry Killam was the first to see the commercial possibilities of renovating the old buildings. After working briefly in the advertising business and helping a realtor friend named John Yuill sell a nearby building, he decided he would try to buy the granite-faced Boulder Rooms at One West Cordova Street. It was listed for $49,000 and had no takers; after lengthy negotiations, Killam ended up buying it for $19,000 in September 1966. He became intrigued by the letters OGT on the property's deed and set out to find all that he could about the Old Granville Townsite.

The final "flat-wheeler" or "rattler" streetcar in Vancouver ran in 1955, by which time the conversion to Brill trolley buses was well underway. Considered to be the wave of the future, the bus system was nevertheless an unprofitable afterthought for the BCER in an increasingly car-dominated city. Len Norris's cartoons in the Vancouver Sun *in the 1950s reflect the public's disenchantment with the new service; in his "best of" compilations from 1955–60, there are several cartoons about slow service, overcrowding and ever-increasing fares.*
USED WITH PERMISSION

1 John Atkin describes East Hastings in detail in "Coffee Shops of the Downtown Eastside," *Vancouver Walks,* 2003, 2005. The band 54-40 and the rest of Vancouver's rock and punk scene of the 1970s and 1980s is well-chronicled on the web. A picture of the sign is at collections.ic.gc.ca/neon/exhibit/buddha.html.

2 See the maps in Derek Hayes's *Historical Atlas of Vancouver and the Lower Fraser Valley,* pp. 150–59.

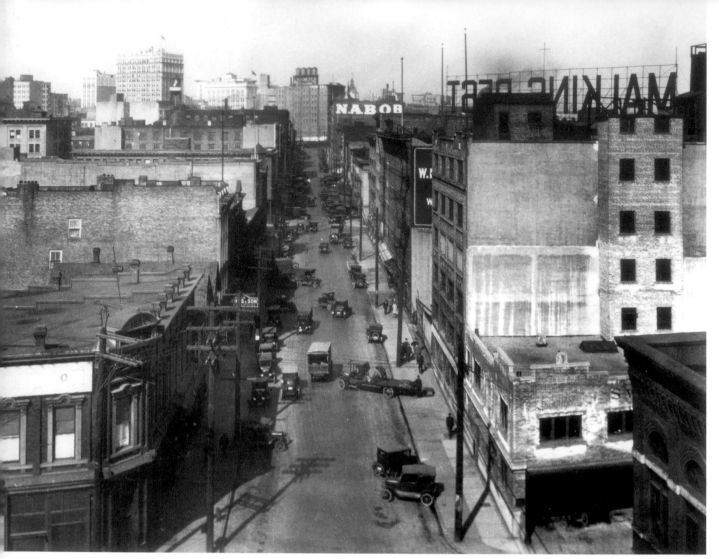

ABOVE *Water Street in the 1920s, seen from the front of the Europe Hotel, a graphic explanation of how it had become outdated as a warehouse area in the 1960s era of tractor trailers and long-distance trucking. The Alhambra Hotel is on the left. (Photographer unknown)*
VPL 8740

RIGHT *The Alhambra about 1970 at the beginning of the Gastown revival. (Undated magazine photograph, collection of Larry Killam)*

Killam's family were part of the Vancouver Establishment. Originally from Yarmouth, Nova Scotia, his grandfather Lawrence came west in 1920 to be a mechanical engineering professor at UBC, then went on to develop pulp mills at Woodfibre and Port Alice; his great uncle Izaak Walton Killam was a very successful investment banker in Montreal with Royal Securities Corporation; his father, also named Lawrence but usually known as Lol, was a noted yachtsman who started the Victoria-Maui yacht race. Larry and his six siblings grew up in the house at the northwest corner of 49th and Larch, a 1912 R. Mackay Fripp design for Henry A. Stone, the founder of the Vancouver Art Gallery and an early promoter of Caulfeild.

The family home stood near the escarpment above the Southlands flats, in Killam's youth the farm of the Logans, descendants of pioneer Fitzgerald McCleery. He spent his boyhood helping on the farm and tending his registered muskrat trapline, and he became imbued with a sense of the area's beauty and historical importance. In June 1954, following years of tax pressure from the city, the Logans capitulated and sold. A couple of years later, when Killam was in grade 11, work began to turn the farm into a golf course and he was shocked to see the Vancouver Fire Department burn the barn down as a training exercise. Then, after some debate over whether the farmhouse – built in 1873 and the oldest building in Vancouver – should be kept, the Park Board decided to demolish it. "I actually thought of sitting in the house with my .22 to keep them away," he recalled.

After completing a UBC degree in Fine Arts and English, Killam set off to travel for two years, ending up in Toronto in the winter of 1964–65 where he worked in a bank and lived in Yorkville, which was just then fixing itself up and becoming a boutique and coffee house area. "I noticed how the rents were going up," he said. When he returned to Vancouver he soon found himself wondering what he could do in Gastown.

He realized that he would have to buy the old Alhambra Hotel on the site of Gassy Jack's saloon. Built right after the 1886 fire, it was a key building to recreating Maple Tree Square as the heart of a new Gastown. After lengthy negotiations, he bought it in 1968, but the ink was hardly dry on the deal when city council voted to approve a downtown freeway that would smash through Chinatown and run down Carrall Street on a deck elevated 30 feet above the road. With his interior design and architect colleagues, including Rudy Kovach of Birmingham and Wood (founder of Vancouver's street banner program), Killam set out to rally opposition against the freeway. Working with his brother Eugene and some hired workers, he got the Alhambra cleaned up and moved his Town of Granville Investments office into the second floor at the end of 1968. After buying the Chevron garage next door, he gained control of most of the frontage on the east side of Carrall from Water to Cordova.

Meanwhile, the Community Arts Council had become interested in the area and drew attention to it in the summer of 1968 with walking tours and an advocacy campaign headed by former social worker Evelyn MacKechnie, who had worked in "skid-road territory," as she described it, from 1936 to 1939. Their study of the area culminated in 1970 with the publication of *Gastown Revisited*, edited by Elizabeth O'Kiely. The sad state of many of the old residents also drew attention: May Gutteridge (no relation of suffragette and trade

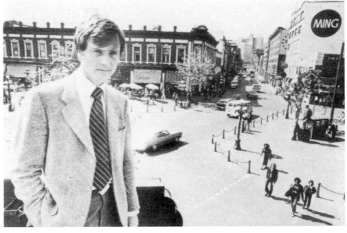

ABOVE *The alley that became Gaoler's Mews in 1968, while Larry Killam was renovating it for shops and offices.*

BELOW *Larry Killam in 1973, photographed for an article in* TIME *magazine.*
LARRY KILLAM

Gastown about 1971. The postcard on the top left shows the commissioned Gassy Jack statue and Ace Aason, a retired logger who played the role of Mayor of Gastown in return for food and lodging. (Postcard photographs by Peter Rodger and Ian Monsarret; advertisement by unknown photographer, printed in Maclean's Leisure Guide, *Larry Killam collection)*

1 A social worker, May Gutteridge founded the East Enders Society in the early 1960s. Her name survives in the May Gutteridge Hospice, part of the St. James Social Service Society. She died in 2002.

unionist Helena Gutteridge, who was Vancouver's first female councillor) ran self-help and money-management workshops for them.[1] Architectural historian Hal Kalman joined with community activists urging the reuse of the New Fountain and Stanley hotels on Cordova Street as public housing and invested in them to help with their preservation; owned by the Army & Navy stores, they were slated to be bulldozed for parking lots.

The Gastown zoning – M2 industrial – was an impediment to its reuse. Main-floor retail was a non-conforming use. Killam was opposed by Mayor Tom Campbell, a real-estate developer in his own right who was pro-freeway and pro-Project 200, but found allies in city planner Allen Parker and Morris Wosk, then chair of the Board of Variance. After hearing the arguments, Wosk brought down his gavel and announced, "Relaxation approved" – the green light for the "boutiquing" of Gastown.

By 1970, everyone was talking about Gastown – the new place to visit, the successor to Chinatown and "Robsonstrasse." Businessmen including Ed Keate and Jack Leshgold bought buildings and renovated them. The Vancouver Antique and Flea Market at 26 Water brought throngs of Vancouverites to the area on Sundays, wandering and browsing in the only area of town that wasn't shut up tight as a clam (professional sports had only been legal on Sundays since 1958; Sunday drinking didn't become legal until Expo '86). The Dominion Hotel advertised that its beer parlour had been restored "to its original olde fashioned Gastown pub-like atmosphere." That March, Peter Pulos's Old Spaghetti Factory and Trident Imports opened in the former Malkin wholesale grocery warehouse at 53–57 Water. Jean Claude Ramond opened La Crêperie at 81 Alexander; Le Petit Montmartre opened at 217 Carrall, the former *Georgia Straight* office, with the latter moving across the street to 56 Powell. There was Cost Plus Imports at 150 Water and Kego Imports (the "House of Ming") in the old Swift's building across the street from the Alhambra, where Jelly Beans for Jeans became the main-floor tenant. Other nightclubs and restaurants included Pharoah's Retreat, Gassy's Joint, the Medieval Inn, the Town Pump and Brother Jon's. There were two "high-art" galleries: Henk Vander Horst's Exposition Gallery at 131 Water, and Jytte Allen's Galerie Allen at 213 Carrall.

Suddenly, everywhere else in the city seemed dull. Basement-suite and garret outfitters like me bought Indian cotton prints as bedspreads and wall

hangings, Japanese ironstone teacups and plates, incense and peppermints in the myriad boutiques. As Killam had predicted, rents were climbing. A group called the Residents of Gastown began to campaign for rent control.

As part of the marketing of the area, Killam, Robert Saunders and Howard Meakin commissioned sculptor Vern Simpson to create a statue of Gassy Jack for Maple Tree Square. With a sketch by Frits Jacobsen from the only presumed likeness and donated materials, including a salvage buoy from Capital Ironworks for the base, the work was completed for $1,100 early in the winter of 1970 in the unfinished Gastown garage next door to the Alhambra. Killam had it wheeled out onto the square as a Valentine's gift to the city. Mayor Campbell wanted it removed as a traffic impediment but backed off. Later in the year it was decapitated; the merchants offered an award and garnered a lot of publicity before the head was found in an alley by a man named Wally Stonehouse.

The next challenge was the illegality of Sunday shopping. On November 16, 1970, Attorney General Leslie Peterson ordered the area's merchants to close their businesses on Sundays beginning December 6. One possible way around the law was to designate the area an historic site, like Barkerville, which potentially could trump the Lord's Day Act. With a municipal election in the offing, the TEAM party actively campaigned for historic status. Early in December, a delegation from the city, including aldermen Ed Sweeney, Marianne Linnell, Brian Calder and planning director Bill Graham, met with provincial cabinet ministers to request historic designation. Granted in February, it was a mixed blessing, at least from the standpoint of many of the merchants. It removed the threat of a freeway and gave Gastown a small advantage over competing retail areas, but it essentially froze their assets for a generation. Chinatown, which also needed a boost in its fortunes, was also designated with much the same results.

Interviewed in 1978, Heritage Canada's lawyer Mark Denhez reflected how in other countries heritage designation comes from government planners on high, "but in Gastown it was quite the reverse. Grassroots interests [whom he described as a loose coalition including Killam, Keate and the arts council] conceived the notion of a historic district, which in fact contradicted government policy. The whole thing is extremely unusual."[1]

Left unresolved was the matter of the freeway and the antagonism between Tom Campbell, his key supporters, and the youth culture that was settling in Gastown, crashing in the upper floors of the old warehouses and hanging out on the streets. The summer of 1971 saw the clash of values boil over. The Gastown Merchants Association had been working with consultants Birmingham and Wood on a $1 million beautification program, which city planners Max Cross and Allen Parker got to council in May. By late in June they took their frustrations to the public, claiming that senior city staff (especially city commissioner and former planning director Gerald Sutton-Brown) were delaying in order to defeat the beautification plan as it would impede the movement of vehicles from the Third Crossing to the Quebec-Columbia corridor (a block east of Carrall). Allen Parker resigned on July 24.[2]

Meanwhile, Gastown had become the "soft drug capital of Canada," according to the mayor. Headlines and editorials urged him to do his job and

From the Gastown Gazette, *June 5, 1971: Mickey, who had "built up a fantastic reputation as being the grand ol' cat of the street ... It is said he passed away as a result of a liquor infested liver. So long from all of us here in Gastown!" The newspaper maintained a friendly relationship with the local "rubbies" while touting the Gastown businesses that were changing skid road forever. The Gazette's publisher was Terry Willox, a versatile businessman who had founded Olde Stuffe, an antique importer and retailer. According to his on-line biography, he co-founded* Western Living *magazine, then published the* Gastown Gazette *and co-founded the Gastown Merchants Association and the Gastown Improvement Association. He left BC for Alberta in 1972 and entered the shopping mall business. (Photo by John Williamson)*

1 John Braddock, "Gastown Plus Ten," *Province*, September 23, 1978.
2 Fifteen years later, his firm completed the city's first heritage inventory.

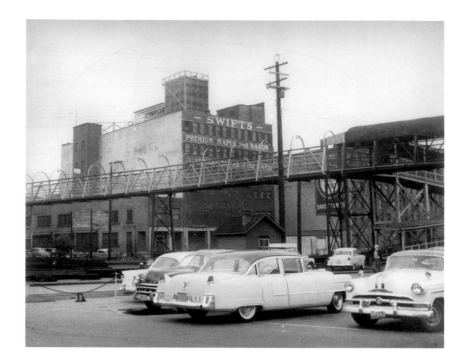

THIS PAGE *The foot of Carrall Street about 1960, looking back toward Gastown. The overhead pedestrian walkway crossed the CPR tracks to reach the Union Steamship Company wharf. Larry Killam's plans for a fishermen's wharf there came to naught.*
LARRY KILLAM

NEXT PAGE *The view from the roof of 120 Powell Street in the spring of 2006, looking west toward Maple Tree Square, with the modern city in the distance.*

clean the place up. Beautification approval was being held up by the drug problem, it was said. One headline blared, "Making Gastown score as easy as buying beer," and the mayor mused that there would be a riot if the police cracked down on drugs. Nevertheless, two days later on July 24 a 20-man drug squad, focusing on the Gastown Inn at Cordova and Cambie, began making arrests.[1]

Two *Georgia Straight* writers, Ken Lester and Eric Sommer, began organizing a classic piece of yippie-anarchist agitprop, a marijuana "Smoke-In and Street Jamboree" for Saturday, August 7. As the mayor both predicted and provoked, it turned into a riot when mounted police charged the partying crowd. In the ensuing inquiry, the police were blamed for over-reacting and the organizers, while not exonerated, gained some of the public's sympathy. The merchants, led by Killam and Keate, promptly organized a "peace party" for the following Saturday, which about 15,000 people attended. All in all, it was another nail in the coffin of Tom Campbell's political career. He announced in the fall that he would not seek re-election.[2]

W ith the election of the TEAM council under Mayor Art Phillips at the end of 1972, beautification went ahead and Gastown settled in to a period of relative stability and prosperity. Larry Killam, by then operating as Town Group Limited, owned eight properties and unsuccessfully floated the idea of a Fisherman's Market on the old Union Steamship Company wharf at the foot of Carrall. In a final dispute over the future of that part of the waterfront, Killam and his supporters, including city councillors Walter Hardwick and Geoffrey Massey (Arthur Erickson's architect partner), went up against Bill Rathie, Tom Campbell's predecessor as Vancouver mayor and chair of the federally mandated Port Authority.

Rathie touted a container facility stretching from Pier B-C to Ocean Terminals, 110 acres that would have re-industrialized Vancouver's signature

1 Newspaper clippings, mainly from the *Province*, in Larry Killam's collection. Other information from interviews with Killam in 2006.

2 See page 81 for more about Campbell. I was travelling and missed the summer's excitement, only hearing about the riot when I wandered into the reading room of British Columbia House in London late that August. Later, I got to know Ken Lester when he edited *Terminal City Express*, the *Mount Pleasant Mouthpiece* community newspaper and the *Straight*. He subsequently went off to manage the punk band D.O.A. A good overview of newspaper clippings and commentary on the riot appears in the "Summer 1996" back issues section of www.cannabisculture.com.

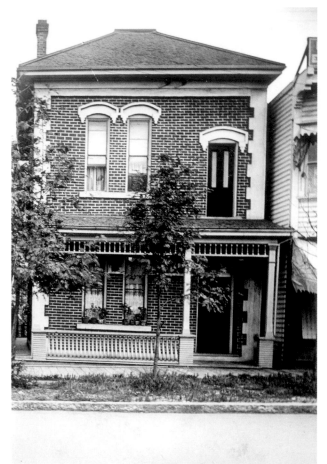

Three pictures showing the evolution over a century of a Downtown Eastside house.

ABOVE LEFT *William Francis and Marguerite Thomson Granville built the first brick house in the city at 447 East Hastings Street in the late 1880s. Granville was originally from England or Scotland and came to Vancouver from Tacoma, arriving soon after the devastating fire of 1886. He was a contractor and built the first Woodward's store at Main and East Georgia in 1892. The backyard of his house was several feet below Hastings Street and contained a chicken coop and apple trees; a cistern in the basement provided household water, suggesting that the house predated the creation of the city's water system in 1888. The photograph dates from about 1910. Some kind of family scandal sent the Granvilles back to England and they never returned.*

ABOVE *A photograph from 1969, showing it with a coat of stucco. (Information and photographs from granddaughter Irene Woodman, 1991)*

LEFT *Abandoned and boarded up, the house as it appeared about 1990. It was torn down in 1992 and replaced with shops and apartments.*

harbourfront. That March, Rathie proposed a four-lane truck route from Pier B-C to Second Narrows. Although his project never went ahead, neither did Killam's; federal minister Ron Basford took the fisherman's market idea and ended up investing public money entirely in Granville Island a few years later. By that time, Killam had sold his Gastown interests and moved on.

Competition from elsewhere in the Lower Mainland and a fickle public looked to be killing Gastown in the late 1970s. One of the biggest drawbacks to any progress was the problem of how to convert the upper floors of Gastown's characteristic buildings into housing; a dozen years later, in the early 1990s, developers and architects began to infill some unused sites and, with the aid of amended zoning policies, convert unused buildings. One of the biggest developers in the adjoining blocks of the Downtown Eastside was DERA – the Downtown Eastside Residents Association, formed in 1973 and led by activist Bruce Eriksen (1928–1997), a former alcoholic and long-time resident. Elected to city council first in 1980, Eriksen was an authentic conscience for a city wallowing in prosperity and a witness to the decline and despair in the Downtown Eastside; his work and ideals were complemented and continued by those of his wife, the councillor and Vancouver East MP Libby Davies.

Under the dynamic leadership of Jim Green, also later a councillor and twice a mayoral candidate, DERA built new structures and renovated old ones to create good quality low-income housing. Among the places converted was the office tower at 16 East Hastings – the interim city hall in the years between the abandonment of the old one next to the Carnegie Centre and the opening of the new one at 12th and Cambie in 1936. The Carnegie Centre was a model

The CNR rail line to the port runs from False Creek north through an industrial area along Raymur Avenue. The gap between the buildings offers an excellent, unexpected view of the Lions, and a grove of maple trees have established themselves on a small vacant plot next to the tracks. The massive BC Sugar Refinery buildings occupy the waterfront along Powell Street in the right distance.

conversion of the old city library and, for a time, seemed like a calm centre in the eye of the storm developing around it.

Every push forward was met by an equally forceful pull back. The drug problem exploded on the Downtown Eastside in the 1980s and worsened in the 1990s, becoming the main election issue in 2003. Area revitalization plans include facelifts for the old Pantages Theatre and the Merchants Bank Building at Pigeon Park. The longest-running saga of all – the Woodward's redevelopment – was approved in 2005 and pre-sold to eager condo buyers in 2006 (page 72).

Gastown has since faded into the background, its issues scarcely noticed in the whirlwind of the contemporary city.

Evidence of the Alexander Street red-light district survived into the 1980s, with this tiled entrance-way into a rooming house at 658 Alexander. Dollie Darlington was the madam at 500 Alexander, originally and appropriately the British Sailors Home; 502 was registered to Ruth Richard, 504 to Roma Graham and 508 to Mildred Hill. A few old buildings survive today on the south side of the street, but the north side is dominated by the American Can Company buildings, now a design and architecture centre.

PROSTITUTION

The drug trade and prostitution were two sides of the same coin in the evolving Downtown Eastside of the 1980s and 1990s. The sex trade, as it came to be called, had been part of the Vancouver landscape since the beginning, but never had it involved so much despair and violence and so many desperate, exploited women, especially Aboriginals and former mental patients. In 2006, the commencement of the Picton trial promised to close a chapter on the disappearance and killing of dozens of Downtown Eastside prostitutes.

Vancouver's first red-light district was the shore of False Creek just west of Main along a half-block known as Shore Street; it was demolished for the construction of the Georgia Viaduct in 1913. Other brothels occupied Dupont Street, a block south of East Hastings along the False Creek tidal flats. It was the poorest land available and was thus shared by Chinese. In the style of the time, police considered them "restricted areas" and confined them rather than attempting to eliminate them. With the opening of Pender Street from the west, creating the East Pender of today's Chinatown, the madams moved east to the edge of Japantown. The block of Alexander Street east of Jackson was convenient to the docks and the Hastings Mill and by 1912 had become the city's red-light district. However, city police buckled under to pressure from morality champions, such as Jonathan Rogers and future Conservative cabinet minister H.H. Stevens, and arrested more than 200 "inmates" and 100 "keepers" of bawdyhouses in 1912. Nineteen "frequenters" also appeared on arrest rolls; a half century later such men were known as "Johns" and the action had migrated to Seymour Street and the Penthouse Cabaret (page 98). But prostitution never really left the Downtown Eastside.

JAPANTOWN

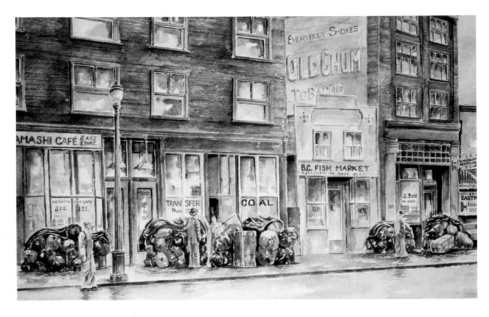

The Alexander Street red-light district bordered Japantown on the blocks of Powell Street east of Main. It was the heart of a scattered community of about 20,000 people of Japanese ancestry who had migrated to the province, beginning with Manzo Nagamo's arrival in New Westminster in 1877. They were settlers, and very successful at it, quickly attracting the enmity of the mainstream society. But the provincial government was powerless to ban them or to erect barriers like the head tax it had imposed on Chinese people, due to the Hayashi-Lemieux agreement of 1908, which reflected the Japan–Britain military alliance of the time. Many were fishermen, although when the federal government changed its rules about who could hold a license, they spread into the logging and lumbering industries.

British Columbia's anti-Oriental public policy more reflected the sentiments of organized labour than large capital, which wanted low-wage workers. Although anyone of the Chinese race was banned from immigrating to Canada after 1923, local Chinese people began to receive sympathy in the 1930s due to the Japanese army's brutal adventuring in Manchuria and Korea and its economic control over Shandong province. Local politicians, including Tom Reid, MacGregor MacIntosh and Halford Wilson, agitated for restrictions on Japanese businesses and settlement.

As the 1930s ended and a Pacific war seemed inevitable, the federal government ordered all Japanese Canadians to register with the RCMP and, as of August 12, 1941, to carry identity cards. The day after the attack on Pearl Harbour, December 8, the government impounded the entire Japanese-Canadian fishing fleet and shut down ethnic newspapers and schools. In January 1942, it began to establish the administrative machinery to remove everyone of Japanese ancestry from the coast. Eventually, more than 12,000 went into internment camps in the BC interior, including the Kogawas in Marpole (page 214) and the families along False Creek (map, page 148).

Japantown became a ghost town practically overnight and never recovered. After 1949, when the final migration restrictions were lifted, Canadians of Japanese ancestry returned to the coast but never re-established the tight communities of the pre-war years. They disappeared into the mainstream of the new, more racially tolerant Canada. Each summer the Powell Street Festival at Oppenheimer Park on Powell Street revives something of the past.[1]

My illustration from Vancouver The Way It Was, *1984, based on newspaper photographs of "Little Tokio" – Powell Street east of Main – during the evacuation in March 1942, when the sidewalks were piled high with personal belongings. On February 26, the federal government initiated the largest forced evacuation in Canadian history, whose only equivalent is the expulsion of the Acadians by the British in colonial times. Everyone of Japanese or mixed-race ancestry was ordered into Hastings Park, where they were marshalled and then shipped out to internment camps in the interior.*

1 See *Vanishing British Columbia*, pp. 38–39 and 99–104. The most comprehensive reference on the period is Ken Adachi's *The Enemy That Never Was* (McClelland & Stewart, 1976).

Chinatown

...

A visitor to Chinatown today might wonder how it came to be established in what seems to be the middle of the old downtown, as if the Chinese were a parallel, equal society to the dominant Canadian one. The fine old buildings along East Pender Street are as substantial as those on Hastings, for example. But a closer inspection of the street pattern indicates clearly that it was the ghetto of a minority in a discriminatory age.

The land stretching south from Chinatown toward False Creek is one clue. It is flat reclaimed foreshore, crisscrossed by arterial roads and the elevated ramps of the Georgia Viaduct and the SkyTrain. In the 1880s it was swampy, and at very high tides a canoe could be paddled between False Creek and Burrard Inlet along a slough west of Columbia Street. The BC Electric's gasworks were established on land at the end of Carrall Street south of Keefer. Farther east, in the first decades of the 20th century, the tracks of the Great Northern Railway crossed False Creek on a trestle and a small railyard spread across the block west of Columbia; its terminus was a brick building on East Pender at Columbia, later the Marco Polo restaurant.

The low land between Shanghai Alley and the escarpment a couple of blocks west was similarly swampy: thus, East Pender was a separate street called Dupont and was notorious as much for its Chinese opium dens as for the brothels with which they shared the street. Regrettably, there are very few documentary photographs of Dupont Street; there was no market for such photographs at the time, and photographers had less interest in recording the wild side of life than today.

West Pender Street was part of white Vancouver's business district and was pushed across the swamp to meet Dupont in 1912. When the latter was widened, it left a fraction of a lot, less than six feet wide, on the south side at Carrall. Its owner, Chang Toy, a businessman who controlled the multi-faceted Sam Kee Company, had no voting rights or access to the city's power structure, but figuratively thumbed his nose at them by building what is usually considered to be the narrowest building in the world. Now occupied by the Jack Chow insurance company, the Sam Kee Building is a triumph over adversity as much as it is a quaint piece of architecture, with bay windows on the upper floor and a basement "areaway" illuminated by glass blocks set into the sidewalk to add usable space.

The colourful descriptions of Chinatown a century ago tell of an exotic society hunkered down for security against a suspicious, hostile world. Many of the multi-storey buildings erected along Pender Street housed benevolent societies that grew from a need for mutual help and protection. The societies were very similar in their broad aims to those to which many whites belonged, such as the Masons, Moose, Eagles, Oddfellows and Sons of England.

Chinatown and Gastown as they were around 1950. A half-century earlier, the False Creek foreshore extended all the way north past Keefer Street. Chinatown was hemmed in by industrial plants on its south side, especially the gasworks and railyards of the BCER and, until about 1915, by the tracks and station of the Great Northern Railway. The diagonal cut was a CPR line extending from Burrard Inlet to the yards on the False Creek flats. The tracks were pulled up in the 1930s following the completion of the Dunsmuir Tunnel, now the SkyTrain route into downtown Vancouver, but the corridor has survived and will become a greenway.

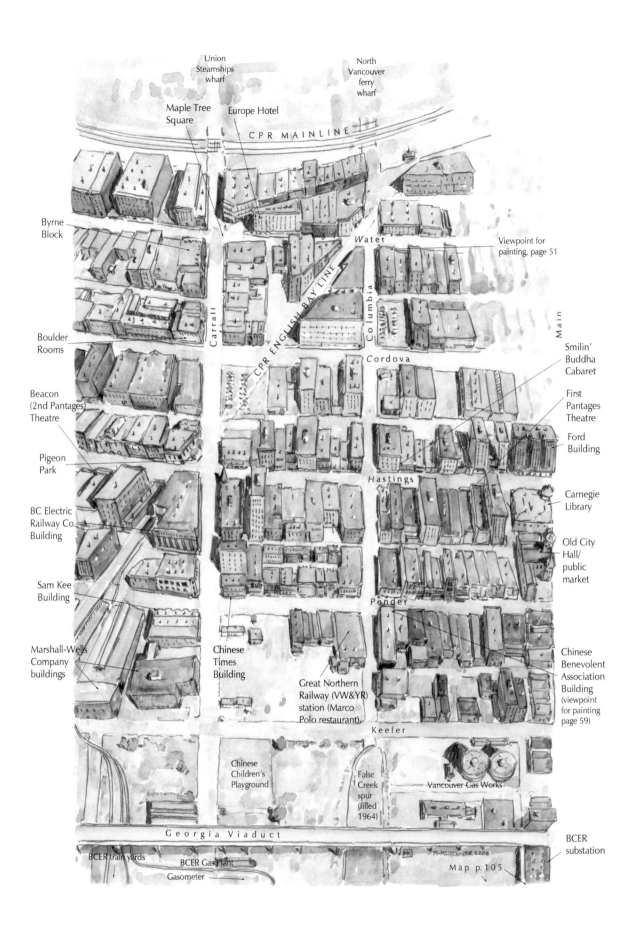

Union
Steamships
wharf

North
Vancouver
ferry
wharf

Maple Tree
Square

Europe Hotel

CPR MAINLINE

Byrne
Block

Water

Viewpoint for
painting, page 51

CPR ENGLISH BAY LINE

Columbia

Main

Boulder
Rooms

Smilin'
Buddha
Cabaret

Cordova

Beacon
(2nd Pantages)
Theatre

First
Pantages
Theatre

Ford
Building

Carrall

Pigeon
Park

Hastings

Carnegie
Library

BC Electric
Railway Co.
Building

Old City
Hall/
public
market

Sam Kee
Building

Pender

Marshall-Wells
Company
buildings

Chinese
Times
Building

Chinese
Benevolent
Association
Building
(viewpoint
for painting
page 59)

Great Northern
Railway (VW&YR)
station (Marco
Polo restaurant)

Keefer

Chinese
Children's
Playground

False
Creek
spur
(filled
1964)

Vancouver Gas Works

Georgia Viaduct

BCER
substation

BCER train yards

BCER Gas Plant

Gasometer

MK M. KLUCKNER 2006

Map p. 105

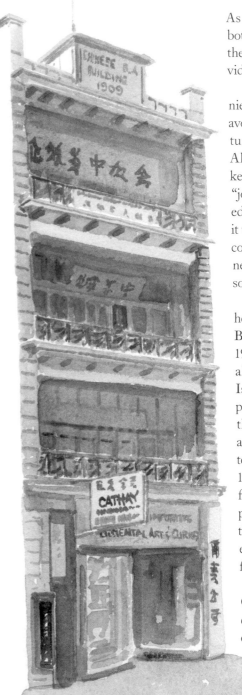

As shown on the Mountain View Cemetery map on page 223, these societies, both white and Chinese, often looked after members' burials; in addition, the Chinese societies repatriated human remains to China. They also provided Chinese-language education for the children in the neighbourhood.

A distinctive Chinese style of architecture, with deeply recessed balconies, "cheater" stories (inserted between floors like mezzanines as a way of avoiding taxes) and Ming hats and spires, developed. Opium was manufactured openly for the first decade of the 20th century, primarily in Market Alley between Hastings and Pender, and carried through the streets in baskets. Newspaper stories commented on the pungent odours, the peddlers "jog-trotting" with baskets balanced on the ends of a bamboo pole supported on the shoulder, the pigtails and the buttonless coats (they used knots); it was said there were underground gambling dens with secret passageways controlled by sentries, and opium dens full of old ruined men. The alleged network of tunnels took on the quality of urban legend: everyone knew somebody who had a friend who'd been there, it seemed.

The reality was probably more prosaic. The province had chosen a head tax as the means to keep the quantity of "Celestials" under control. Beginning in 1885 at $50, it rose to $100 in 1900 and a colossal $500 from 1903 to 1923, at which point the Chinese Immigration Act put an end to all arrivals. It allowed major capitalists like the Dunsmuirs on Vancouver Island to obtain a supply of cheap labour while effectively stopping the importation of wives whose children would colonize the province and demand the rights of citizenship. The upshot was that Chinatown was increasingly a neighbourhood of old, lonely men, unable to make enough money either to reunite their families or return home. For example, between 1915 and 1930 the Chinese population in Canada (almost completely in BC) declined five percent to about 27,000, while the Japanese population jumped 65 percent. However, a number of ambitious immigrants did manage to pay the tax and establish themselves, most notably Hok Yat Louie, who started working on a market garden on the Fraser River flats and went on to found one of the province's largest wholesale grocery firms.[1]

It was in market gardening and wholesaling foodstuffs that Chinese Canadians first developed a real economic influence. In the 1930s, at the crack of dawn each day – according to newspaper accounts – hundreds of trucks made their way from market gardens in the southern part of the city and Lulu Island to a rendezvous on vacant land opposite the CNR station on Main Street, where other local trucks picked up the produce to distribute it around the city. The Chinese wholesalers were said to control 75 percent of the green vegetable market in the province, and neither the efforts of the big Gastown

1 His son's biography, *Tong: The Story of Tong Louie, Vancouver's Quiet Titan* by Ernest Perrault (Harbour, 2003) vividly describes life in Chinese Vancouver in the early years of the 20th century.

ABOVE *The Chinese Benevolent Association Building at 108 East Pender was built in 1909. Its recessed balconies and decorative pediment are typical elements of Chinatown's historic buildings, most of which were erected by family societies.*

NEXT PAGE *On a fine February afternoon, I climbed up the CBA building's fire escape onto its roof, then crossed over onto the roof of the Sun Ah Hotel at Pender and Columbia to paint the view looking west along Pender toward the towers of "white" Vancouver.*

CHINATOWN

Cabins on Gore Avenue in the 1980s, with the wall of the Kuomintang Building behind. The Kuomintang provided support for Dr. Sun Yat-Sen's successful rebellion against the Qing dynasty, then shored up the anti-Communist cause in the 1950s and 1960s until, in 1970, Canada formally recognized the People's Republic of China.

firms – Kelly Douglas and Malkin's – nor of the vegetable marketing board could stem the tide. The 84 stores of the Chinese Fruit and Vegetable Retail Merchants Association took out a newspaper ad on December 2, 1937, stressing the service they gave to the community. In addition, there were more than 150 licensed Chinese peddlers in the city, delivering vegetables door to door.[1]

Organized labour remained virulently anti-Chinese until after the Second World War. Article Nine from the Trades and Labour Congress's principles stated that an "Asiatic" was "a member of a race which cannot be properly assimilated into the national life of Canada." Certainly much of their fervour was due to wage competition. But even average Vancouverites had a slightly different view, at least when it came to their own homes, as many of them had come to depend on the efficient and inexpensive help from Chinese cooks and houseboys.

The diaries of Mary Isabella Rogers, the wife of the owner of the BC Sugar Refinery on the Vancouver waterfront, provide a description of household and staff relations in the West End a century ago. Typically they were paid $25 to $30 a month and were given a few days off at Chinese New Year; they shaved their hairlines back, as it was fashionable to enhance the size of their foreheads, and braided their long pigtails, keeping them coiled around the tops of their heads when working, but letting them down and adding a coloured tassel on the end when they went out on the town. Accommodation was usually a room behind the kitchen; there, they ate rice and a little fish and, it was said, smoked opium in the evenings for relaxation. One of the houseboys at Gabriola on Davie Street was taught English by the family governess; later, he owned a grocery store in the West End, married and raised four children, of whom three were gold medalists at UBC. Mrs. Rogers employed a Chinese cook named Tim when she moved to 3637 Angus Drive in the mid-1930s.

For average Vancouverites who didn't have a personal stake in the labour and wages issues, the Chinese of Chinatown were no longer perceived as "immoral" or as a threat to them. Instead, in the 1930s there arose a kind of sympathetic curiosity, prompted by China's underdog status in its defensive battle against the expansionist Japanese army. Occasional newspaper stories followed the efforts of local men to find out what was happening in the war zones. In July 1937, following the Tientsin offensive in northern China, newspapers showed photographs of Chinese men crowded around the office of the Chinese *New Republic Daily* at East Pender and Carrall (until recently the Chinese Times Building) reading posted sheets covered in columns of news drawn in brush and ink characters.

However, the city and province were still rife with discriminatory laws. A provincial act banned white and Aboriginal women from working in Chinese-owned restaurants. In September 1937, the BC Royal Cafe at 61 East Pender,

1 One Chinese grocery peddler, Ho Leung, delivered produce in his truck through the Kerrisdale and Shaughnessy area into the 1970s.

the Hongkong Cafe at 126 and the Gee Kong at 168 were closed by the city for non-compliance. The three owners – Toy Chew, Harry Lee and Chinese Benevolent Association president Harry Ting – sued the city but lost, and in October were forced to fire the white women in their employ. No matter that 30 of the waitresses appeared as a delegation to city council to demand reinstatement. The status quo was supported by groups including the League of Women Voters and the chief of police, W.W. Foster, who stated in March 1939: "In view of the conditions under which the girls are expected to work, it is almost impossible for them to be so employed without falling victim to some sort of immoral life."

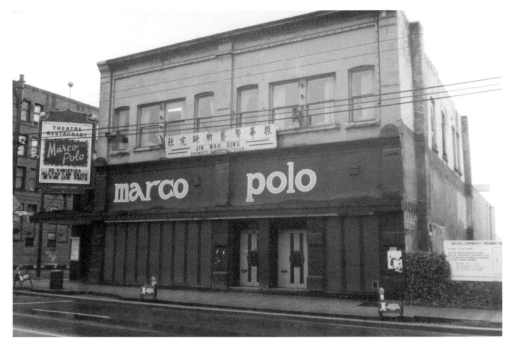

Postwar, everything changed. The racial under-pinnings of Canadian society, which were subtle compared with American Jim Crow laws but nevertheless real, were dismantled. Chinese Canadians received the right to vote in 1947 and registered in the spring of 1948 for their first federal election in the Vancouver Centre riding. Finally, wives and children could immigrate, and newspaper stories early in 1949 described the dozen or so Chinese men waiting at the airport each week "as CPA's giant 'Empress of Hong Kong' drones in from the Pacific . . . The Chinese step forward to greet the brides they left behind decades ago." By the following year, the city's Chinese population had risen by 350, including 100 wives and children who arrived on a single Great Northern train from San Francisco. The city's Chinese population of 15,350 was said to be the third largest in North America after San Francisco's and New York's.

The Communist victory in 1949 prompted further emigration. Foon Sien, president of the Chinese Benevolent Association, had described Chiang Kai-shek's vanquished regime as a "ruthless dictatorship," but noted in 1950 that there were "few Red sympathizers in Vancouver's Oriental population." The situation worsened as a flood of extortion letters arrived from China, de-manding that local Chinese pay heavy land taxes to save their families from harm. Foon Sien spoke of a new loyalty to Canada among Chinese, partly a result of new citizenship rights, partly due to antipathy for the Communists.

The former Great Northern Railway station, built in 1904 at the corner of Pender and Columbia, shortly before its demolition in the early 1980s. The GNR line into Canada (now the BNSF that comes north from White Rock) was technically the Vancouver, Westminster & Yukon Railway – hence the sign on the building's sidewall.

LEFT *Kuo Seun Importers at Pender and Columbia was, according to this 1960s postcard, the largest Chinese department store in Canada.*

RIGHT *The Foo Hung Company at 129–31 East Pender had other rooms displaying curios, jewelry, chinaware and novelties. These shop interiors had been modernized to appeal to contemporary western tastes. (Photographers unknown)*

By 1955, more than 12,000 Chinese had arrived in Vancouver, leading all other nationalities. The few dozen blocks of housing east of Chinatown were dubbed China Valley by its residents.

In Chinatown itself, Pender Street was bathed in neon, the furniture and curio shops stayed open late, and it all seemed so much more interesting than the dreary, predictable shops of Granville Street. The entrepreneurial group in Chinatown that developed in the 1920s and 1930s transformed Chinatown in the postwar years into the first of the ethnic shopping streets in Vancouver. Before that time, the shops and cafes were somewhat impenetrable to outsiders, but by the 1950s the old storefronts had been converted with plate glass and retail displays to appeal more to westernized tastes. *Western Homes & Living* magazine's restaurant listings in 1956 included three Chinatown restaurants: the Ho Inn at 79 East Pender had "Chinese food in a western setting," Ming's at 147 East Pender had "a rich Oriental Modern setting," and the Bamboo Terrace at 155 East Pender was a "popular after-theatre spot offering a wide choice of Chinese dishes in a lively Oriental setting." The last two reviews carried the coded statement that "Beverages are served," which everyone knew to mean that they had liquor licenses. By the 1970s, the kind of westernized atmosphere epitomized by Ming's had become passé to some. More adventurous diners sought out more authentic cafes like the Orange Door and the Green Door in Market Alley between Pender and Hastings.

More substantially, there was real progress in terms of political empowerment, symbolized by the election of Douglas Jung as a member of parliament in 1957. Two years earlier, Margaret Jean Gee, a 25-year-old Vancouver-born lawyer, became the first Chinese woman to plead a court case when she acted as assistant defence counsel in the trial of a notorious bank robber, Daniel Haddon.

In 1960–61, just as the community was becoming settled, it found it had to organize against the city's slum clearance and freeway plans. Community

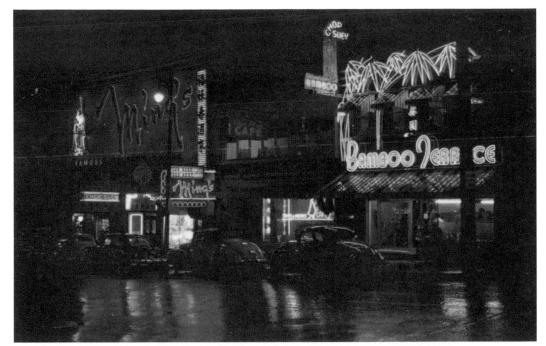

Pender Street after dark was fabulously awash in neon in the 1940s and 1950s, a colourful and exotic destination in the middle of a rather dull city. The postcard below looks west from Main Street. (Postcard above by an unknown photographer; below by Rolly Ford)

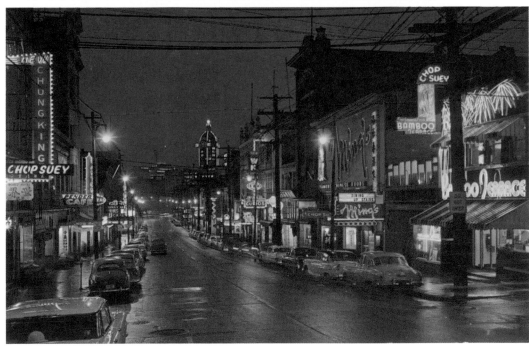

leaders argued that the city's plans would cause the collapse of Chinatown's social structure and the strangulation of Chinese commerce. Its 68 fraternal organizations and four schools would wither if the community were dispersed, a process that soon began with the building of the first housing projects in China Valley (page 112). In 1967, as the city's freeway juggernaut moved closer to reality, Foon Sien bitterly called it "the latest abuse in 81 years of racial injustice and discrimination against Vancouver's Chinese . . . The city officials cannot, or will not, understand that they are not dealing with just streets and buildings. They are dealing in human lives, in a unique ethnic community too

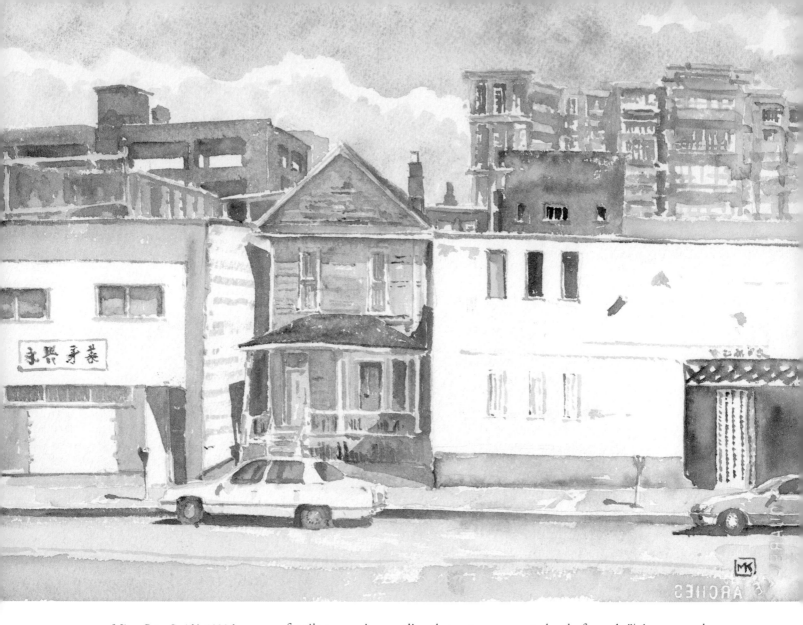

Miner Peter Smith's 1899 house at 227 East Pender survives incongruously amidst the small factories of a more recent Chinatown. Before WW II, the city's black population lived on these blocks near Hogan's Alley (map, page 105). Rosa Pryor's Chicken Inn on Keefer, which ran for 42 years, was the first southern fried chicken house in the city; on this block, Mother's Tamale and Chili Parlour was owned by another black woman, Mrs. Alexander.

1 Tony Eberts, "Freeway: Concrete knife in the heart of Chinatown?", *Province,* December 2, 1967.

fragile to survive a policy that puts pavement ahead of people."[1] As summed up on pages 32–33, the freeway and urban renewal plans were shelved in the early 1970s.

Having survived demolition, the historic Chinatown along Pender Street nevertheless lost its pre-eminence in the 1980s when the more posh suburban Chinatown developed along Number Three Road in Richmond. The Chinese community had by that time dispersed around the region and put its stamp on retail streets from East Vancouver to Kerrisdale. Concurrently, changes to the city's signage policies rendered much of old Chinatown's neon obsolete – that is, not replaceable once it wore out – and the streets darkened. The sense of it being slightly unsafe grew, not surprisingly, from its proximity to the decidedly unsafe East Hastings strip a mere block away.

A sign of the area's slow rebirth was the development of the Dr. Sun Yat-Sen classical garden and an adjoining public garden and community centre, on the block bounded by Carrall, Pender, Columbia and Keefer. Many community activities now focus on the huge Floata Restaurant in a new building at Main and Keefer. It is light-years away from the Chinatown of a century ago.

Victory Square

Victory Square, with the Dominion Building in the background, in the late 1970s during a civic workers and garbage strike. With the onset of the recession of 1982, men and women began to sleep in the bushes and underneath bridges and viaducts. Homelessness became visible for the first time since the Great Depression of a half-century earlier.

Hastings Street takes a jog at Cambie, the CPR's street pattern fitting itself around the Old Granville Townsite. This happy circumstance created one of the few anomalies in Vancouver's relentless downtown grid: the pie-shaped park called Victory Square, a space beautifully enclosed by century-old oak trees, the Dominion Building on the north and the old Province Building on the east. The former's beaux-arts roof, red brick and yellow terra cotta add colour and texture to the downtown, as does the mix of materials on many of the surrounding buildings. It is that visual richness, so different from the flat, smooth, glassy surfaces of the new downtown, that makes the old skyscrapers unique in the city.

In the modern city, the name Victory Square refers to the area south of Gastown, west of Chinatown and east of "Downtown," a.k.a. the Central Business District. South of it, beginning on high ground at about Robson, is the new/old Yaletown neighbourhood, largely redeveloped with highrise condominiums in the past 20 years. By comparison, Victory Square's stock of buildings has changed comparatively little in the past half-century, as they never received the kind of speculative pressure and rezoning that turned the rest of the downtown and the West End into a developer's blank canvas. Hastings Street was the dominant shopping area until the 1960s, anchored by Woodward's on the east and the Eaton's/Spencer's store on the west; since the opening of Pacific Centre in the 1970s, the failure of Sears Harbour Centre and the collapse of Woodward's, large-scale retail has concentrated on Granville Street. Hastings Street is now coming to be dominated by institutions, with Simon Fraser University in Harbour Centre and, coming soon, the SFU School of Contemporary Arts on the redeveloped Woodward's site.

The original occupant of Victory Square itself was the provincial courthouse, a fine, domed structure erected in 1888 and the first major building outside of Gastown. Within a year, there were more brick buildings on Hastings: the Bank of British Columbia at 490 West Hastings and the red brick Innes-Thompson Block, demolished as part of the redevelopment that turned the old bank next door into the Morris Wosk Centre for Dialogue. The courthouse only lasted 20 years; its new, larger replacement on CPR land – Georgia Street between Howe and Hornby – is now the Vancouver Art Gallery. But during its brief heyday at the end of the 19th century, citizens used it as the public square and made their rendezvous at the Arcade across the street

TOP *Alvo von Alvensleben's offices at 405 West Hastings Street, about 1912. See also the map of his west-side land dealings on page 23.*

MIDDLE *Von Alvensleben's legacy is the Wigwam Inn on Indian Arm, designed for him and Benjamin Dickens by Sholto Smith in 1910; it was allegedly financed by Kaiser Wilhelm and intended as a hunting retreat. It is now owned by the Royal Vancouver Yacht Club.[1] (Photographer unknown)*

NEXT PAGE *The view northeast from a seventh-floor window of the 402 West Pender Building across the rooftops of the Victory Square area in the late winter of 2006. The Dominion Building and the Woodward's "W" punctuate the skyline. The empty space to the right of the foreground building is the site of the Pender Auditorium (page 180).*

1 The photograph of his office is from *British Columbia* magazine, July, 1911. A brief biography of him appears in *Vanishing British Columbia*, p. 196. See also Donald Luxton's *Building the West*, p. 354, for references to the Wigwam Inn.

– a covered mall with 13 shops that ran diagonally across the corner – rather the way later generations met at the Birks Clock when it stood at Granville and Georgia.

Although the area lost the courthouse, it still managed to attract the city's best buildings. The Dominion Building (completed by the Dominion Trust Company on the Arcade site) and the Province Building, both erected in 1909, were two; the other was the skyscraper that became known as the Sun Tower a stone's throw to the southeast at Pender and Beatty. Another commercial building, also associated with the Dominion Trust Company, stood a few blocks to the west at Pender and Homer. Only the Birks Building and the second Hotel Vancouver "uptown" were of similar quality (page 79).

Real-estate speculation and foreign investment figured largely in the tawdry history of the Dominion Trust Company. It had a subscribed capital of more than $2 million during the last years of the great Edwardian boom but, unbeknownst to its depositors and the majority of its directors, managing director W.R. Arnold (page 192) had made "heavy and unauthorized loans" to – among others – a German developer-realtor named Alvo von Alvensleben. When the market suddenly tumbled in 1913, Arnold's house of cards trembled; then, with war declared in August 1914, von Alvensleben took up residence in Seattle in the neutral United States, leaving his companies owing more than a million dollars. Arnold committed suicide on October 12 and his company went into liquidation two weeks later. The scandal rocked the Conservative provincial government of Sir Richard McBride, already in office for nearly a dozen years, and contributed to its rout in the 1916 elections.

Victory Square itself got its name and cenotaph in 1925 due to a donation by Frederick Southam, who bought the *Province* newspaper from its long-time owner, Walter C. Nichol; he published from what had been initially the *News-Advertiser* building of Conservative supporter and politician Francis Carter-Cotton. The printing building across the back lane has been restored with the main floor used as offices of the Architectural Institute of BC.

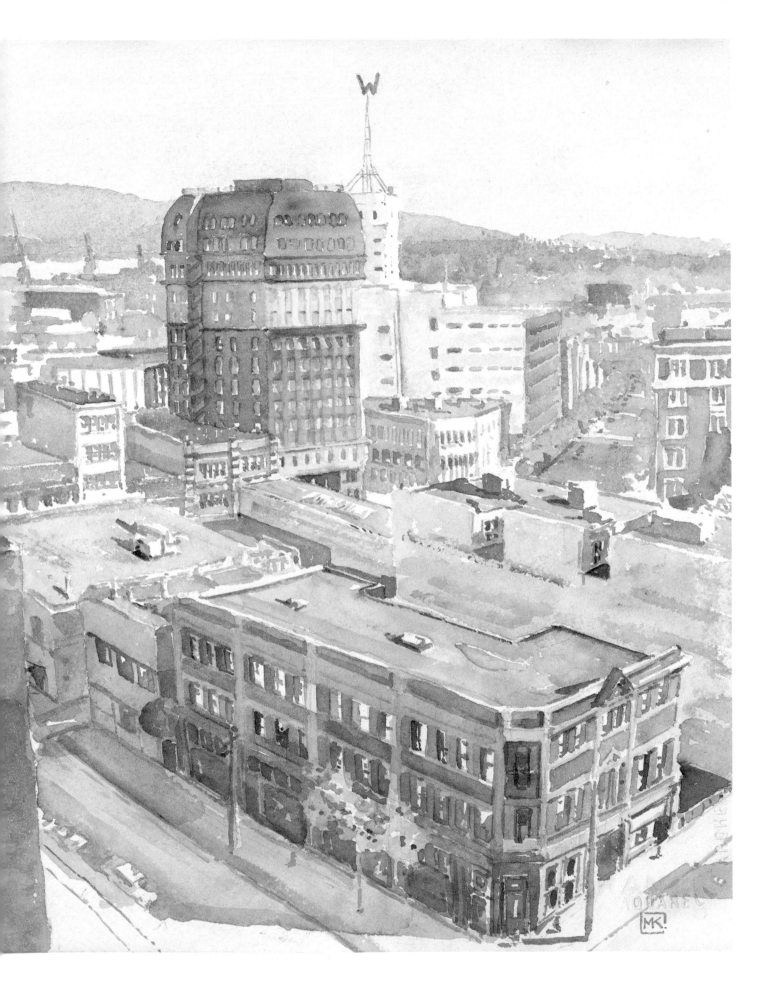

VICTORY SQUARE

Donald Cromie became publisher of the Vancouver Sun *following the death of his father, Robert, in 1936. Although his career was not as dramatic as that of his father, who was a bellhop in a Winnipeg hotel when he met his future employer and mentor J.W. Stewart, he made some stunning business decisions. One was to hire Len Norris: according to legend, Norris had been trying to draw "standard" political cartoons, the kind with labels and caricatures, and was so frustrated he was about to quit. When he finally did one his own way, Cromie "personally helped him unpack his bags." Cromie's brother, Samuel, an NPA alderman at 28 and assistant publisher, drowned in a boating accident off the Sunshine Coast. Donald Cromie died in Vancouver in 1993.*

WHO'S WHO IN CANADA, 1958 EDITION, P. 116

1 See *LD: Louis D. Taylor and the Rise of Vancouver* by Daniel Francis, Arsenal-Pulp, 2004.

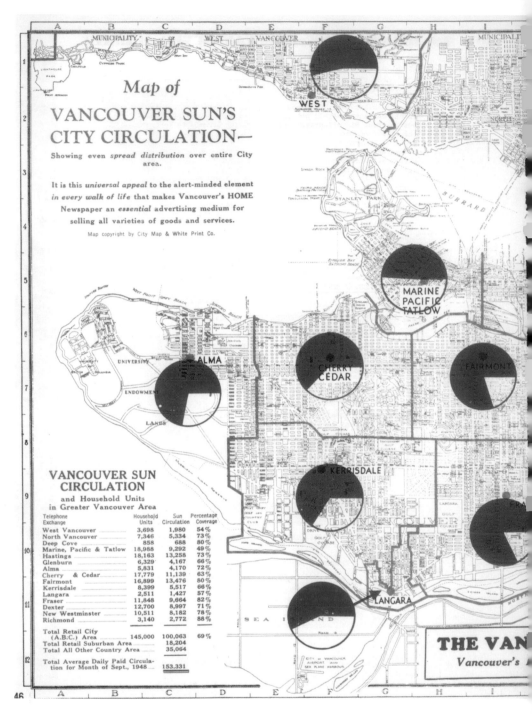

Vancouver's legendary newspaper era of hard-drinkin', cigar-chompin', typewriter-poundin' newshounds and sportswriters will always be associated with the Province Building, the Sun Tower and the streets around Victory Square. The money that built the Sun Tower came from Louis D. Taylor's *World* newspaper, the mouthpiece for his political aspirations.[1] The *Sun* shone under the direction of Robert Cromie, originally an accountant working for the major shareholder, Major General John W. Stewart. An early arrival in Vancouver, Stewart created with his business partners (who were also his brothers-in-law) one of the largest independent construction firms

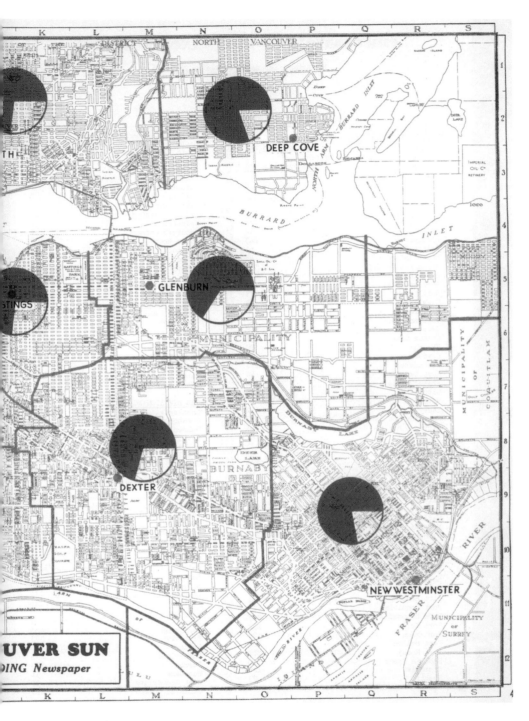

The Sun's-*eye view of the Lower Mainland in 1948, showing the old telephone exchanges that continued until automatic dialling was introduced a decade later and the telephone prefixes changed to* MUtual *(68),* REgent *(73),* TRinity *(87),* AMherst *(26) and so on. In that not so distant time, you could be certain what part of the city someone lived in by his telephone number. The map is reproduced from a* Sun *publication:* Industrial British Columbia 1948–49.

of the era: Foley Stewart & Welch. His abilities greatly aided the Allied war effort on the Western Front; an indication of his reputation is the fact that, during the Prince of Wales's 1919 visit, he stayed at Stewart's home, Ardvar at 1675 Angus Drive. Stewart wanted the newspaper to promote the Liberal party and his interests in the Pacific Great Eastern Railway (now BC Rail/CNR). Cromie eventually bought him out and ran the *Sun* until his sudden death in 1936; his sons then took over, one of whom, Donald, took control and published the paper until selling it to the Sifton family in 1963.

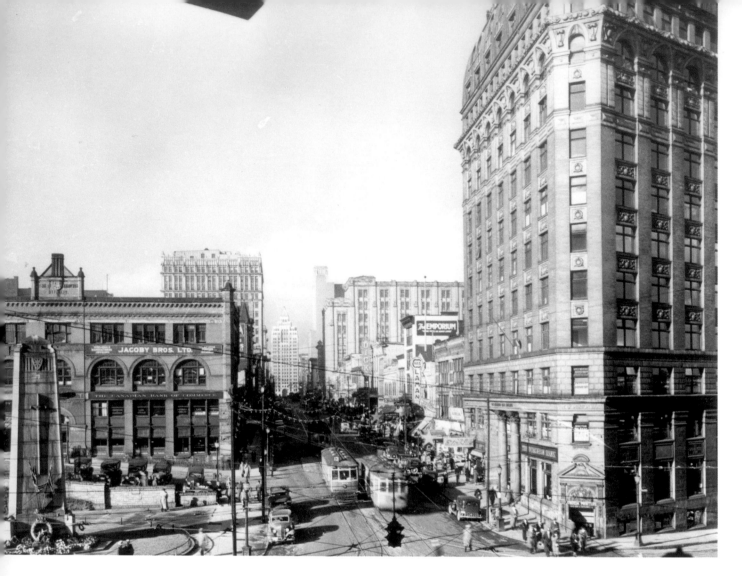

Hastings Street looking west from the Province Building at Cambie Street in the 1930s. The Cenotaph on Victory Square is on the left, the Dominion Building on the right, Spencer's Department Store (now SFU Harbour Centre) in the middle distance on the right and the Marine Building framed in the distance. One of the few changes to the street today is the loss of Inns of Court Building in the left foreground, which provided chambers for many of the lawyers working in the courthouse that occupied Victory Square until about 1910. (Photographer unknown)
VPL 6439

1 A good overview of the press is Douglas Sagi's essay in the *Greater Vancouver Book*, pp. 420–21.

Under the Cromies and, later, Stuart Keate, the *Sun* overtook the *Province*, which was never able completely to recover from a 41-month printing-trades strike in the late 1940s. The *Sun*, publishing from its signature tower between 1937 and 1965, attracted columnists and writers, including Alan Fotheringham, Paul St. Pierre, Jack Wasserman and Denny Boyd, and cartoonists Len Norris and Roy Peterson; in the twilight of the print era, before evening television news dominated, the *Sun*'s afternoon delivery heralded a quiet evening of reading (and perhaps knitting) in front of the fire. Many families took both papers, laughing over Eric Nichol's humour and Hymie Koshevoy's puns in the *Province* at the breakfast table. The two newspapers amalgamated their sales and production facilities in 1964 and moved to the new Pacific Press building at Seventh and Granville, since demolished.[1]

Nostalgic Vancouver shoppers generally reminisce about Woodward's, the home-grown department store chain that began on Main Street at East Georgia in 1892. Charles Woodward was nearly 40 when he opened his first store with the intent of capturing a share of the booming young province's mail-order business. Like his main competitor, David Spencer in Victoria, he did not believe in credit. "We keep no books, have no accountants, thereby saving thousands of dollars to those who patronize the store," Woodward wrote in the 1902 catalogue. Until about 1950 and the end of the coastal

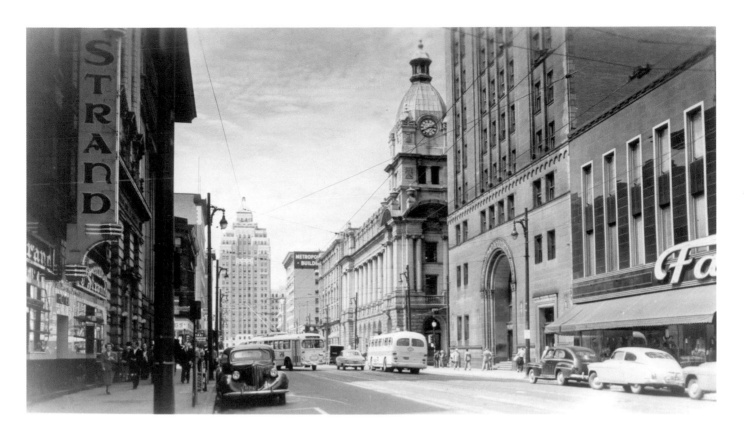

steamship era, Woodward's was a critical connection to the outside world for remote settlers. Its food department was essential, shipping orders by rail using the BC Electric interurban system to the Fraser Valley, and by the Pacific Great Eastern northward into the province's interior.

Woodward moved his business to Hastings Street at Abbott in 1903 and over the ensuing decades expanded the store so that it occupied most of the block, with a parking garage adjoining it on Cordova.[1] It was a practical place to shop, with sensible clothes, a good hardware section, a pharmacy and a superb food floor in the basement – really the only place in Vancouver in the 1960s and early 1970s for a variety of imported and ethnic foodstuffs. A Saturday afternoon in Vancouver often included a trip to the food floor, ending at the cash register with the request, "deliver it, please" and a later wander through Gastown. And on cold, wet December nights families made the trip to Hastings Street to see the decorated window displays with marvellous tableaux of mechanical elves making toys. During the 1940s and early 1950s under Charles's sons "Willy" and "Puggy," the company expanded slowly, becoming the anchor department store tenant in the landmark Park Royal mall in 1950 (page 29) and the Oakridge mall in 1959. But under the direction of the grandson, "Chunky," the company over-expanded to 26 stores, lost the ownership of the land they stood on and had to seek protection from creditors in 1992. "Chunky" Woodward had died two years earlier, having pursued his love of cattle ranching at the Douglas Lake Cattle Company for many years.

The Hudson's Bay Company bought out Woodward's in 1993 and closed the flagship store. Over the ensuing decade, the boarded-up hulk loomed

West Hastings between Seymour and Granville in the 1950s. The Strand Hotel on the left was home to a famous dining room and bar known as "Vancouver's Lloyd's," due to the amount of shipping and insurance business transacted there. Its facade was modernized in a 1939 renovation, although the original hotel dated from 1889. It was demolished and re-placed by a bank building. (Photo probably by J.C. Walker.)

1 The derelict garage had a starring role in Jackie Chan's film, *Rumble in the Bronx.*

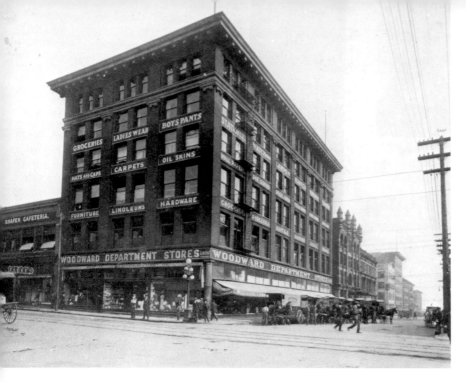

The original part of Woodward's at Hastings and Abbott, as it appeared about 1910. This is the section that will be retained and restored as part of the redevelopment of the site. Delivery wagons and all other traffic travelled on the left-hand side of the road until 1922.

WOODWARD'S COLLECTION 1984

above the decaying streets of the Downtown Eastside, a stark symbol of the failure of that part of the city. The province bought the building in the 1990s, then sold it to the city in 2003; after an exhaustive and controversial public process, during which time the building was occupied by squatters and surrounded by a tent city of the homeless, the city finalized a development plan that was a compromise between subsidized housing, educational and public uses, and market housing and commercial space. Only the original 1903 building, and the signature revolving "W" on the roof, will be retained intact, although brick facades along Hastings and Abbott will recall the old department store. Nevertheless, the building is the key to the revival of that part of Hastings and a triumph for activist politician Jim Green, who spearheaded the campaign for more than a decade.

The other Hastings Street department store of the postwar era was Eaton's, occupying a 1920s collection of buildings assembled and erected by David Spencer Ltd. Starting in Victoria in 1862 during the Cariboo gold rush, David Spencer built a solid regional store specializing in imports from England. Like his distant competitor Timothy Eaton in Toronto, Spencer was a particularly orthodox Methodist; also like Eaton's, the store developed a reputation for high-end drygoods, a level above Charles Woodward's wares.

David Spencer entered the Vancouver market in 1906, taking over a smart drygoods shop named Drysdale & Stevenson. His well-liked son Chris, known to the employees as "Mr. Chris," moved to Vancouver to take over the operation and built himself a fine house at 49th and West Boulevard in Kerrisdale, later Athlone School for Boys. Another son, Victor, was a more dashing character and something of a playboy in his youth; he owned Aberthau, the large house near Locarno Beach now used as a community centre. The store prospered until the family sold out to Eaton's in 1948. The latter, which had maintained a small retail and catalogue operation at 526 Granville for a number of years, established itself in the old Spencer's but also bought the Hotel Vancouver at Granville and Georgia, demolishing it in 1949. Even though a 1963 city study and review selected the blocks bounded by Seymour, Dunsmuir, Hamilton and Hastings for redevelopment, Eaton's persuaded the city to change its mind and promptly announced it would build its new store at Georgia and Granville. Several years later, a new Eaton's arose as the anchor tenant of the Pacific Centre (page 81).[1]

In the 1970s, Sears became involved with the Harbour Centre project as the occupant of the 1928, nine-storey part of the old Spencer's store. Its failure there both indicated the decline of Hastings as a retail street and pointed to the future difficulties department stores would have in competing with new kinds of retailers such as London Drugs. Regardless, Sears ended up buying the

1 See Donald Gutstein, *Vancouver Ltd.*, pp. 70–71.

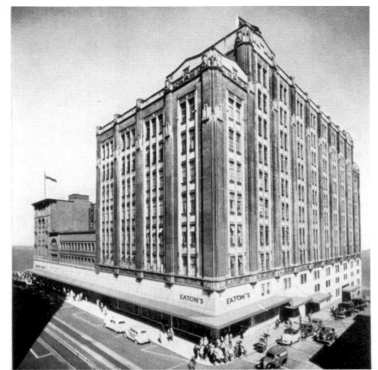

View of
T. EATON Cᵒ
THE BRITISH COLUMBIA LIMITED
Store, Vancouver, Canada.
Located on Hastings Street,
between Seymour and
Richards Streets.

ABOVE *The T. Eaton Company bought out* BC *department store chain Spencer's in 1948 and took over its landmark site on Hastings between Seymour and Richards. The modern awning links the 1928 store with a low retail block and, in the distance, the former Molson's Bank building of 1897. All but the 1928 store were demolished in 1973 to make way for the Harbour Centre tower with its robot-like revolving observation deck.*

BELOW *Shoppers at Eaton's in the 1950s and 1960s could relax over lunch in the Marine Room and take in a view enjoyed today by students at the SFU Harbour Centre campus. Eaton's vacated the store in the early 1970s when Pacific Centre opened at Georgia and Granville.*

(Photographers unknown)

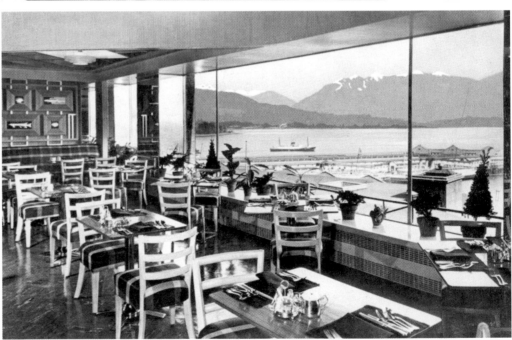

failed Eaton's store in Pacific Centre in the 1990s. In the final, happy chapter, Simon Fraser University took over the Spencer's/Eaton's/Sears store and renovated it as a satellite campus that opened in 1989; in one of those serendipitous chains of events in the city's history, it put courses for mid-career students, seminars and public lectures onto Hastings Street just at the point when the blocks to the east were declining. With the old CPR station/Waterfront Station a block away providing transit connections throughout the region, the downtown campus is a wonderful use of an old Vancouver landmark that has stabilized a historic commercial street.

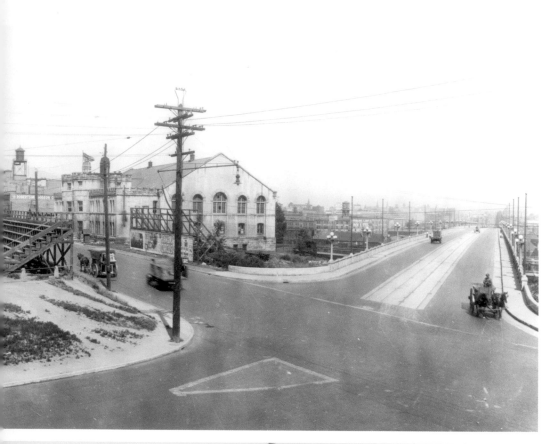

ABOVE *The Georgia Viaduct at Georgia and Beatty around the time of its opening in 1916, looking east toward Strathcona. The bleachers of Larwill Park are visible on the left, as is the Beatty Street Drill Hall. The Viaduct was taken down in the early 1970s; a new, freeway-like connector just for eastbound traffic was then built on that corridor. The land drops away quite steeply behind the Drill Hall to what used to be the False Creek flats, the current site of a Costco outlet and General Motors Place. (Photographer unknown)* VPL 6578

BELOW *Eddie's Grocery at Robson and Hamilton, about 1970. The buildings in the right background occupy the site of today's Library Square. Dilapidated buildings like this were the last remnants of a large working-class neighbourhood that for nearly a century occupied the part of the downtown peninsula from Victory Square all the way to False Creek. (Ken Terriss photograph)*

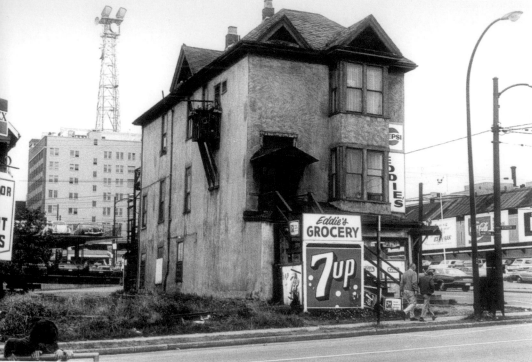

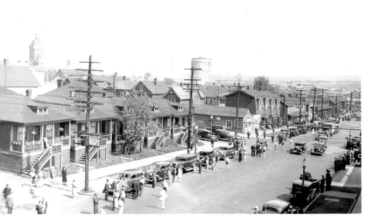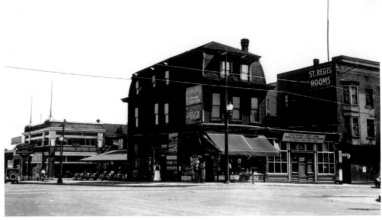

S ome great schemes never got off the drawing board, such as the plan for a multi-block civic centre bounded by Homer, Beatty, Pender and Robson south of Victory Square.[1] However, there is a half-century's worth of institutional buildings that took root on those blocks, giving the impression of an idea that would never die. Rather like the amorphous, centreless University of BC campus, the civic centre's plans from the boom years before the First World War were never realized in the ensuing decades of war and depression.

The area had been home to civic institutions from the city's beginnings. Directly south of Victory Square was the Central School which, together with the East End School (now Strathcona), the West End school (at Barclay and Burrard, now demolished) and the Mount Pleasant School (at Kingsway and Broadway, now demolished) formed the city's public educational system. That site is now occupied by the old Vancouver Vocational Institute building, a Sharp & Thompson, Berwick, Pratt design that introduced modern Bauhaus architecture to the city's downtown in 1949 and was truly a harbinger of the future.

The original city hospital occupied the block to the east between Cambie and Beatty, now a multi-storey parking garage. A neat set of gabled, two-storey red brick buildings with open wooden verandahs and fine flower beds and lawns "kept in perfect order by the chain gang," the hospital served Vancouver from 1888 until Vancouver General opened in Fairview in 1905 (page 160). Reused first as the western outpost of McGill University before the founding of UBC, the buildings then became the city's social service department. In the Great Depression, long lines of family men seeking relief (the hapless man had to lug home a hunk of meat and a hundred-pound sack of potatoes) formed on the grounds, and the men idled their days away on the grass of Victory Square.

South of these buildings between Georgia and Dunsmuir is Block 48, originally called the Cambie Street Grounds, a playground cleared by the CPR in 1887 to try to lure development south and west from the Gastown area. With the construction of the Beatty Street Drill Hall for the Duke of Connaught's Own Rifles at the turn of the 20th century, the playground became a useful parade ground.[2] The city's long-term intention was to develop it as parkland, and it was duly named Larwill Park in 1906 after the founder of the Vancouver Athletic Club. But the area around it was occupied by an increasingly scattered community of working families with little political influence, so nothing much was done with it for the next 40 years. As a "temporary

Two photographs from the 1930s by George Fukuhara. The left one, of a foot race along Georgia Street, shows the intact neighbourhood of that period, a mixture of houses, tenements and small apartment buildings with shops on their main floor. In the left distance is the Sun Tower; in the middle, the BC Electric's gasometer rises above the False Creek flats. The photograph on the right shows the Richards Grocery at Georgia and Richards streets. It was owned by Fukuhara's older brother, Jenichiro, who is posing in his white apron. George and Fumiko Fukuhara bought a grocery store at 44th and Main late in the '30s, then lost it when they were interned at the outbreak of the Pacific war.[3]

KATHY UPTON

1 Two architects' visions from the 1914 competition appear in Donald Luxton's *Building the West*, pp. 320 and 416.

2 The B.C. Regiment (Duke of Connaught's Own) celebrated its centenary in the Drill Hall in 2001.

3 Their story is told in *Vanishing British Columbia*, pp. 38–39.

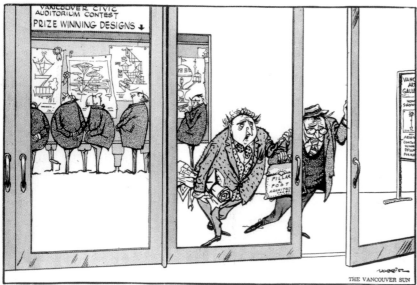

" . . . it wasn't the Dishonorable Mention so much as the critics saying our design looked like nothing but a big auditorium . . . "

ABOVE *The General Post Office on West Georgia in the late 1950s. (Photographer unknown, Coast Publishing Company)*

BELOW *Len Norris's comment on the architectural competition for the Queen Elizabeth Theatre.*
USED WITH PERMISSION

measure" once the old bus depot at Dunsmuir and Seymour had outgrown its space, a new bus depot took over the park, remaining there until Pacific Central Station, itself incorporating a bus depot, opened in the old CNR station on Main Street in the early 1990s.[1]

Three more institutions were added to the old civic centre site in the 1950s. First was the Vancouver School of Art in 1952 on Hamilton north of Dunsmuir. Then in 1958 and 1959 respectively, the huge Post Office and the Queen Elizabeth Theatre opened on Georgia Street in the two blocks between Homer and Cambie. The post office continued the modernist style pioneered a decade earlier in the vocational institutes a few blocks north, while the Queen Elizabeth Theatre is a design chosen after an open 1954 competition won by a firm from Montreal.

All this activity took place in what had been a working-class neighbourhood of frame houses on narrow lots south of the Central School. Like the Yaletown area to the south, planners in the 1920s envisaged it being redeveloped with commercial and warehouse buildings, but instead parking lots, autobody shops and small factories eroded its sense of community. "In fact," geographer Walter Hardwick noted, "a better economic return was possible for land as parking than land with a house on it."[2] The last of the old houses have disappeared in the past 20 years.

Further evidence of the persistence of the civic centre idea occupies the blocks south of Georgia between Homer and Cambie. The CBC building on Hamilton Street, built in the 1970s, looks like a fortress erected against a hostile world – an apt metaphor for the liberal public broadcaster, perhaps. And in the early 1990s the splendid Library Square, hated by architecture critics but enjoyed by the public, helped to re-animate the southern edge of the old civic centre site.

1 A good overview is Brian Kelly's history of bus lines in the *Greater Vancouver Book*. pp. 464–65.

2 Hardwick, *Vancouver*, p. 85.

Downtown

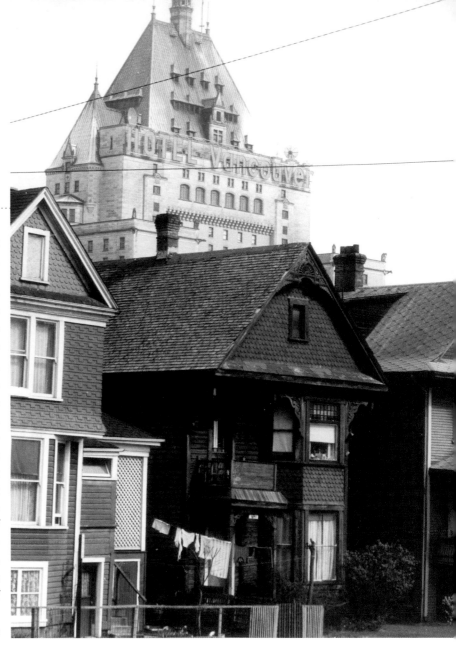

Backroom real-estate and development deals blighted part of downtown Vancouver for much of the past half-century. Although the city got off relatively lightly compared with, say, Montreal, the wheeling and dealing around the old Hotel Vancouver site at Georgia and Granville robbed the city of its best crossroads. Railway hotels have a symbolic importance in all of Canada's large cities. Anyone who can remember the late 1940s will likely recall the demolition of the old hotel as a wanton act of vandalism; people of my generation who can remember the 1950s and 1960s recall the ugly parking lot at Georgia and Granville and the shock we felt when the stark white Eaton's department store sprawled across the block. The demolition of the Birks Building in 1972 for the Vancouver Centre development dealt the *coup de grâce* to the corner. But a new day dawned, with the reform of city politics beginning at the end of that year.

The CPR's "second" Hotel Vancouver was only 25 years old when the railway closed it in 1939. Concurrently, its presumed competitor, the CNR, opened its hotel at Georgia and Burrard and took the Hotel Vancouver name. The city had required the CNR to build a large downtown hotel in return for trackage rights-of-way and other concessions; included in the deal between the two railway companies and unbeknownst to the public was the proviso that the Georgia-Granville site could not be used for a hotel again. The CNR's project had begun in the late 1920s, sat abandoned during much of the Depression and then was hurriedly finished for the 1939 tour of the Commonwealth by George VI and Queen Elizabeth, intended to rally patriotism on the eve of the anticipated European war.

With the country embroiled in war, the old hotel became a militia headquarters and then was occupied by about 1,200 returned servicemen and their families in 1946 to 1947. The Eaton department store family purchased the site in March 1948, at the same time that it bought out and shut down a potential rival, Spencer's, on Hastings Street (page 73). Ignoring pleas from the board of trade, the tourist association and the Architectural Institute of BC, Eaton's demolished the hotel in 1949 but did nothing with the land for 20 years.

A rich man-poor man image of Vancouver about 1970. In the foreground, downtown houses dating from the 1890s; in the background the Hotel Vancouver at Burrard and Georgia, a few blocks away. The streets nearby these houses looked more like the top postcard on page 87. (Photo by Ken Terriss)

The children of WW II veterans playing on the former roof terrace of the old Hotel Vancouver at Georgia and Granville in 1948. The child in the pram is Barbara Lawrie who shared "one room, sixth floor, two years" with her older brother, mother and father during the severe housing crisis that greeted returning veterans in 1946. The Lawries' story is told on page 230. In the background, the new Hotel Vancouver and the Medical-Dental Building dominate the skyline.
BARBARA BURWOOD

By the late 1960s, the CPR and its real-estate division, Marathon Realty, were long gone from the Georgia and Granville area, although evidence of their efforts lingered. In the push and pull of the city's early development, the CPR used all its might to drag the key city institutions into its bailiwick next to its hotel, connected by Granville Street with its docks and the railway station on the waterfront. However, the area became the city centre more in the entertainment and tourist sense than in a commercial or governmental one. Only the provincial courthouse moved from the older Victory Square area (see page 65) to Georgia Street. Other government buildings ended up blocks to the east on the Civic Centre site, financial organizations clustered around the bottom of Howe Street, and retail still concentrated along Hastings Street, with the exception of the Hudson's Bay Company kitty-corner from the CPR's hotel.

The new Hotel Vancouver became the city's premier destination, hosting legendary performers like Dal Richards and his orchestra at its Panorama Roof. Three other Georgia Street hotels, the Georgia at Howe, the Devonshire at Hornby (demolished) and the Ritz just west of Burrard (demolished), provided a second tier of accommodation. The Georgia[1] was especially popular with visiting entertainers performing at nearby clubs such as Isy's on West Georgia (demolished) and the Cave on Hornby (demolished). The Modernestyle Vancouver Art Gallery opened in 1931 on Georgia west of Thurlow. Its original facade by Sharp & Thompson was altered to an International-style one by Ross Lort 20 years later; it was demolished after the art gallery moved into the former courthouse in 1983.[2]

"Theatre Row," the blocks of Granville Street between Robson and Nelson, attracted people from all over the region on Friday and Saturday nights. They lined up on the neon-washed sidewalks or met friends and drank coffee in the Chanticleer or Scott's or Sid Beech's Vancouver Tamale Parlour. Others came to the area to dance at the Commodore on Granville, the Alexandra Ballroom on Robson or the Palomar Ballroom across Burrard from the Hotel Vancouver. The prime cinemas were the Orpheum, which narrowly escaped chopping up for a multiplex and was restored as a civic theatre in the 1980s; the Strand at Georgia and Seymour, demolished in the early 1970s for the regrettable Vancouver Centre and Scotia Bank tower; the Art Moderne Vogue, built as an Odeon cinema by liquor money in 1940 and revitalized in the 1990s; and the Lyric on Granville Street north of Robson, demolished for the Pacific Centre development.

The Lyric, originally known as the Vancouver Opera House, was as important a link to the city's early days as was the CPR's old hotel. The railway company promised to construct it as an inducement to settlers and property buyers in its part of town, and actually had to be chivvied along after delaying its start. CPR land commissioner J.M. Browning headed the project and built his own house at the northwest corner of Burrard and Georgia; initially, he was only able to attract to the area other CPR employees, including engineering director Henry Cambie, who built at the southeast corner of Georgia and Thurlow. (Another CPR director, Henry Abbott, built further west at Jervis a few years

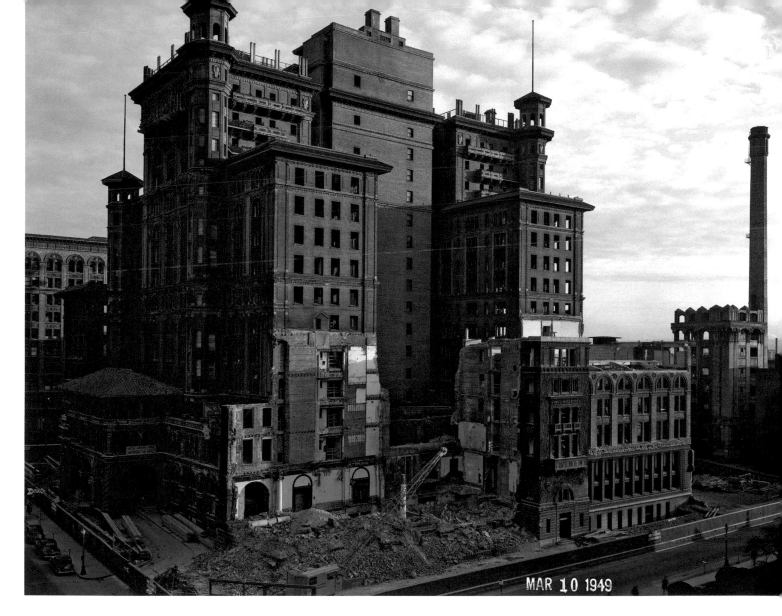

MAR 10 1949

later; his house, now restored as part of an office complex, is the last survivor of the "Blueblood Alley" mansions of the 19th century.) After his death and until its demolition in the 1930s, Browning's house became a residential hotel known as Glencoe Lodge, home to one of the city's few literary and musical salons of the era.

The opera house opened on February 8, 1891, with performances of excerpts from *Carmen* and *Lohengrin*. As a none-too-subtle advertisement, it had as a drop screen a painting done in New York of the Three Sisters, a mountain near the CPR's Banff Springs Hotel. With the railway's transportation connections, the opera house was soon a stop on the circuit of touring performers. Actors and musicians of world renown, such as Sarah Bernhardt and Mischa Elman, played in Vancouver, even though the city was home to fewer than 25,000 people in the late 19th century. Advertisements in suburban papers such as the *Point Grey Gazette,* published in Eburne-Marpole for the semi-rural residents, always noted that the last runs of the BC Electric's streetcar and interurban service were timed to coincide with the end of the performance. But by 1910 the CPR believed that the opera house had done its duty and sold it to private interests who painted over the drop screen with advertisements and re-opened it as a vaudeville palace called the New Orpheum. It lived out its days

The demolition of the old Hotel Vancouver at Georgia and Granville in the spring of 1949. The porte-cochère on the left faced onto Georgia Street; the Birks Building is visible in the background. The land is now occupied by the Toronto Dominion Bank tower and the former Eaton's department store – since the latter's bankruptcy, a Sears outlet. (Photo by Otto Fernand Landauer)
JEWISH HISTORICAL SOCIETY
28497

1 See Sean Rossiter's *The Hotel Georgia: A Vancouver Tradition,* Douglas & McIntyre, 1998.

2 See *Vancouver Art and Artists: 1931–1983,* published by the Vancouver Art Gallery, 1983.

as a cinema, its interior a smaller but equally ornate version of the 1927 Orpheum Theatre on Granville. In the 1930s and 1940s, visiting musicians such as Sergei Rachmaninoff or Jan Paderewski played at the Orpheum or, sometimes, at the Vancouver Arena on Coal Harbour (see advertisement, page 135).

The urban gathering place of the era was the square in front of the courthouse, across the street from the Devonshire and Georgia hotels in a space framed by the the old and new hotels Vancouver. It became the logical place to have a riot. The Georgia Hotel attracted a sit-in of the unemployed in 1938, and VE and VJ day celebrants filled the street in 1945, but the real action occurred when

TOP LEFT *The demolition of the Lyric Theatre and adjoining buildings in 1969.*

BOTTOM LEFT *The hoarding around the construction site for the Pacific Centre, as seen from Granville and Robson. (Photos by Richard Stace-Smith)*

ABOVE RIGHT *Mayor Tom "Terrific" Campbell riding the wrecking ball at the commencement of demolition of the Lyric Theatre. (Photographer unknown; reproduced from the cover of James Lorimer's* A Citizen's Guide to City Politics, *1972)*

Vancouver hosted the Grey Cup game in 1955, 1963 and 1966. Football fans staying at the Hotel Georgia tossed glasses and bottles onto the violent crowd below and hundreds were arrested, including a man who scaled the Devonshire Hotel to rip down its flags. About 60,000 people, many drunk, thronged the blocks of Georgia between Howe and Burrard. In 1964 when the Beatles came to town, everyone presumed they would stay at the Georgia and filled the street out front; in fact, they stayed under tight security at the Biltmore at 12th and Kingsway!

"Elegant Vancouver" still shopped around the Georgia and Granville district in the 1950s and 1960s, keeping the downtown core alive. Vancouver did not have the problems of depressed, antiquated industries and a large minority underclass that caused the flight to the suburbs in 1950s American cities, and although manufacturing and wholesaling decentralized to the suburbs, new managerial and service jobs opened up – prompting the high-density redevelopment of the West End. Nevertheless, doctrinaire planning philosophy urged the city to attract the newly mobile suburbanites and the city government responded with proposals for a radial freeway system, a publicly subsidized downtown parking corporation and public help with land assembly for new projects. Much of the planning and the granting of profitable zoning

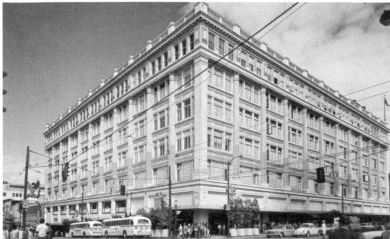

variances to "insiders" took place behind closed doors, led by the city's all-powerful board of administration.[1] As the 1960s proceeded, citizens became increasingly angry. The austerity of the black towers and blank white walls of Pacific Centre, like a porcelain urinal along a block of the city's main drag, were a particular sore point. However, the redevelopment of Burrard Street with office complexes including the Bentall Centre aroused little concern. Later outrages, especially the proposal by eastern developers to build 12 high-rise towers at the Coal Harbour entry to Stanley Park, cemented the fate of the Non Partisan Association civic government.

The man most identified with that period of Vancouver when developers seemed to have a choke-hold on civic affairs actually came on the scene when projects like Pacific Centre were already approved and in the works. Nevertheless, Tom Campbell believed heartily that business and property owners had an absolute mandate to reshape the city to their own vision of the future. Beginning his stint in public life as a pro-development alderman in the 1960s during the tenure of Bill Rathie, he went on to become mayor just at the time when everything he stood for was being questioned by an aggressive anti-establishment – "the hippies," as he usually described them.

His father was a city policeman in the mounted squad in Stanley Park. Seeking a challenge after the war, he got himself promoted to detective and spent his time "chasing bootleggers and other crooks around the downtown." Campbell recalled that his father was happier just riding his horse.

In his spare time he built apartments. Young Tom, then 12 years old, helped him build the first one in 1939 in the 1900-block of Nelson Street – 10 units that cost $2,700 per suite to build and rented for $27 a month. Over the next decade, the elder Campbell built 15 or 20 small apartment buildings in the West End. Although they would have been profitable to keep, the elder Campbell was a bit of a horse trader, selling the buildings when the price had gone up a little. If he had kept them, his son recalled, he would have done better in the long term, but "he liked to deal." In 1951, when Tom Campbell was in law school, his father became a test case on capital gains taxation. Although he claimed he was only trying to raise his family, he eventually had to pay the government $40,000.

Tom Campbell practised law for three or four years in an era when a "single practitioner could do it." Although he was prospering, he realized he was "only

ABOVE LEFT *The Granville Street facade of Eaton's Department Store, anchor tenant of the Pacific Centre, in the early 1970s: a rude introduction for many Vancouverites to Miesian architecture. (Photo by Dave Pryor)*

ABOVE RIGHT *The venerable Hudson's Bay Company department store at Georgia and Granville, built in stages between 1913 and 1926. It was the principal retailer on Granville before Eaton's arrived. (Photo by George Weinhaupl)*

BELOW *Buskers on Granville at Robson about 1979.*

1 See John Punter's *The Vancouver Achievement,* p. 18, for a detailed explanation of the system.

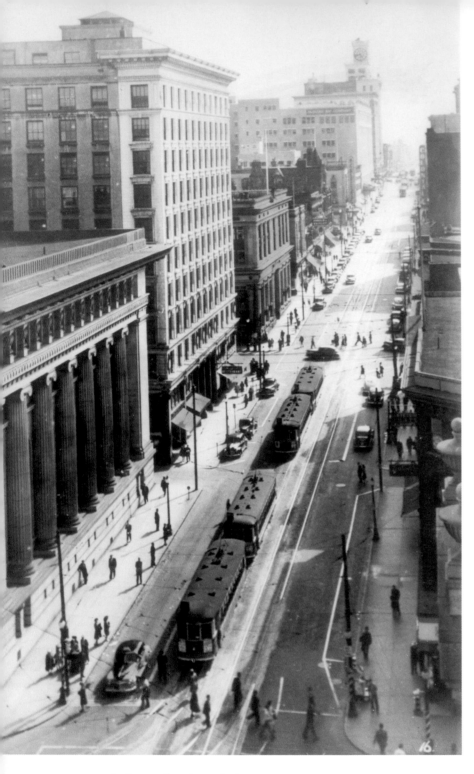

Looking south on Granville from the post office clock tower at Hastings Street in the 1940s. On the near left are the Bank of Commerce (now Birks) and the Rogers Building. The streetcar dominance of downtown Vancouver continued until the mid-1950s. (Gowen-Sutton postcard)

1 Kalman, *Exploring Vancouver* (1978 edition), p. 140.

selling time, so instead of selling time I'll rent space." Although his colleagues thought he was crazy to abandon the law, he went into business and started developing little buildings around town. "Nothing is for sale – once I buy it I keep it," he said. "I didn't like the idea that when I went on holiday I wasn't making any money."

The first apartment he built was at 3rd and Cypress, a frame walk-up with 10 suites. Financing was easy to get and the market was good, so he went on and built five or six more in the Kitsilano area. In 1956 he got the chance to buy almost two acres at the south end of the Burrard Bridge for $150,000. The city decided a week later that it wanted it for a park but Campbell wouldn't sell. The land was zoned for three-storey apartments but he argued that, because the Burrard Street roadway there is elevated, the building would have been down in a hole with the tenants looking at roadway underpinnings and everyone else seeing its roof. Although there was resistance to him building higher, he got his way, arguing that he would not get any more suites than the 234 he could have built as a low-rise. He claims never to have liked the design, by architect Peter Kaffka. "Nobody liked the building," he recalled. But in the long run, it confirmed the use of that part of Kitsilano as residential, rather than the industrial uses exemplified by the Sicks'-Molson's Brewery on the other side of Burrard (see page 151).

His next big project was the 30-storey Imperial Tower, also designed by Peter Kaffka, at English Bay Beach. He built it with day labour, using available financing in a fast-changing market. The building was one of the few large slab-sided towers erected in the city, its 266 small suites contributing "to the assault on family living that has characterized new apartments in the West End."[1]

By the time he was applying for the permit for Imperial Tower, Campbell had become interested in politics and ran against Tom Alsbury for mayor in 1961, although he knew he couldn't win. At the next election, he squeaked in as an alderman and gained in popularity during five years on council. In 1966, with Bill Rathie's retirement, he ran for mayor and won. An enthusiastic

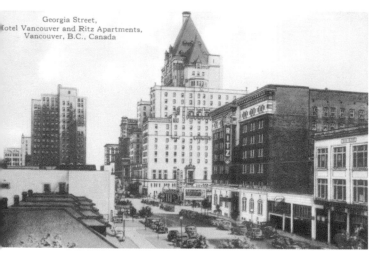

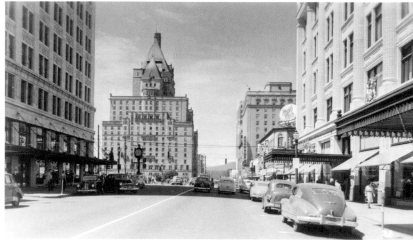

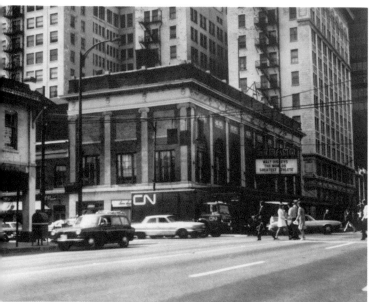

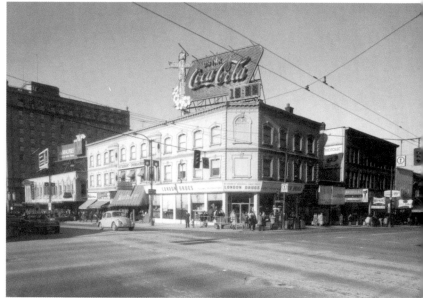

ABOVE LEFT *Georgia Street looking east from about Thurlow in the 1940s. The Ritz Hotel started life as a YMCA Building; its beer parlour was as beloved as the Devonshire's, and both were sadly missed when the hotels were demolished in the 1980s. Visible between the Ritz and the Hotel Vancouver is the Palomar Ballroom, a dine and dance palace that survived until the construction of the Burrard Building in the 1950s. Car dealers shared much of Georgia west of Burrard with places like the Ritz and the Palomar. (Coast Publishing postcard)*

ABOVE RIGHT *Georgia Street in the 1950s, looking west along the Hudson's Bay Company south wall toward Granville Street. The image captures the downtown when it was the high-end place to shop. Birks, visible on the left, was the most prestigious jewellery, silverware and china store in the city, and people met at the Birks Clock, visible on the corner in front of the store. The Hotel Vancouver and Hotel Georgia frame the street in the distance. (J.C. Walker postcard)*

BELOW LEFT *A 1970 view of the Strand Theatre at the southwest corner of Seymour and Georgia streets. Built in 1919 as part of the Allen Theatre chain, it became a Famous Players cinema, which it remained until it was demolished in 1974 to make way for the Scotia Bank tower and Vancouver Centre underground mall. (Photo by Walter E. Frost)*
CVA 447-391

BELOW RIGHT *Now the site of the 18-storey IBM Tower, the second of the two "black towers" of the Pacific Centre development, the cheerful Johnston and Howe Block, home of the original London Drugs store, stood at the northwest corner of Georgia and Granville. Even in the 1960s, this little emporium was pointing the way to the superstores of the future with its range of cameras and housewares. (Photo by H.W. Roozeboom)*
VPL 8628

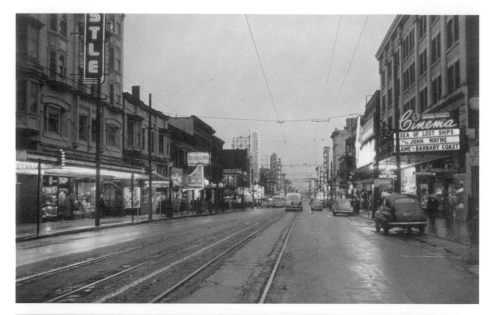

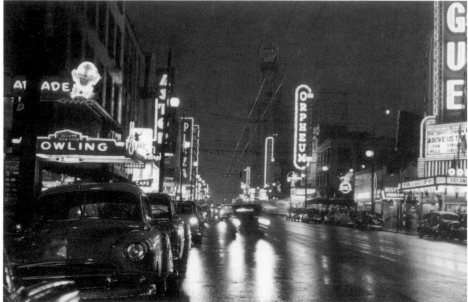

LEFT *The Granville Street Theatre Row in the 1950s, its most glorious period of vibrant street life and neon reflections on the rain-washed pavement. The top photograph shows it in the brief period in the mid 1950s when trolley buses had taken over from the trams but the tracks were still on the street. Theatre Row began to develop in the 1920s and kept adding attractions, everything from tacky pinball arcades, bowling alleys, pool halls in dingy basements to high-end dance halls like the Commodore Ballroom next to the Orpheum Theatre. The parked cars provided a buffer between the cruising traffic and the pedestrians crowded onto the narrow sidewalks. (Photos from top to bottom by J.C. Walker, unknown and Hasso Ebert)*

BELOW *The Chanticleer at 776 Granville was one of the smart cafes on Granville that catered to a tea and luncheon set. (Advertisement from a 1930s symphony program, collection of Cherniavsky family)*

NEXT PAGE *Sid Beech's Vancouver Tamale Parlour stayed open late for the after-theatre crowd and was a favourite hangout for musicians from the nearby clubs. Located in the Orillia, a modified row house on Robson at Seymour, it was an attraction as much because of the personality of Beech, a soldier, billiards player and sometime boxing promoter in the 1930s and 1940s. He died in 1954 at the age of 63. The Orillia itself was home to a diverse range of businesses including a taxi company, used clothing stores and a pool hall. It was demolished in 1985 and replaced by a nondescript office building. (Photographer unknown; obituary published in* Province, *July 2, 1954, including drawing by an unknown artist)*
KELLY BERG

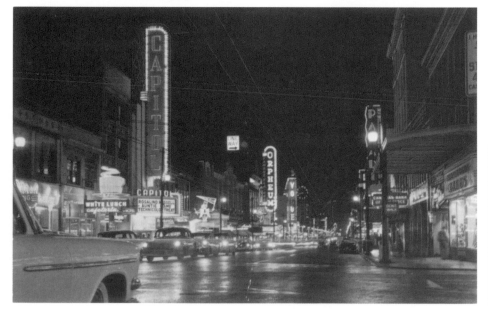

NOODLES CHILI AND
SPAGHETTI ENCHILADAS

Open till 2 a.m.

SID BEECH, Proprietor

Vancouver
TAMALE PARLOUR

Take Some Home

Opposite Government Liquor Store

605 ROBSON STREET

SEY. 6776

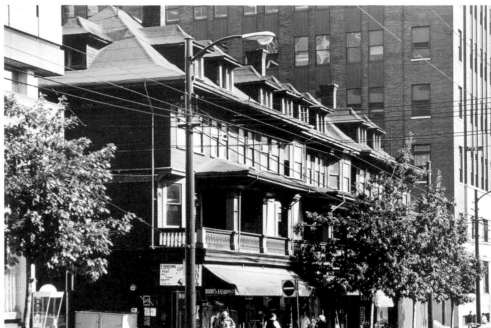

supporter of downtown redevelopment and the freeway system, he scoffs to this day at Gastown preservation advocates and the complexities of the city's modern development process. The only regret he expressed to me was that Pacific Centre "looks in on itself." He tried, he said, to get more windows along the street frontages of Eaton's.[1]

Tom Campbell became mayor just as the city's counterculture was blooming. Many city hippies lived in Fairview Slopes or Kitsilano but congregated downtown during the day. While the Court House fountain was under construction as a centennial project in 1967, the plywood hoarding surrounding it became the city's first "paint-in" – an explosion of good-natured, colourful creativity. Campbell soon found himself publicly criticizing the hippies, especially performance artists like Joachim Foikis who, armed with a $3,500 Canada Council grant and a wagon pulled by donkeys Peter and Pan, became the self-appointed town fool and a regular on the Court House steps and on city streets. The corner of the Hudson's Bay Company at Georgia and Granville, sheltered by the marquee, became the hangout for a large flock of chanting, dancing Hare Krishna devotees until the store started washing the windows and sidewalk continuously. Campbell's provocative stand against the *Georgia Straight* newspaper gained him more publicity and notoriety and, of course, helped his adversaries.[2] He and his hippies were as mutually dependent as rhinos and the birds that groom them. His relationship with the city's radical youth reached a nadir during the police action in Gastown on August 7, 1971 (page 50).

The climax of that era, in my memory, came on January 9, 1972, a cold grey Sunday, when a motorcade of shiny cars full of politicians from all governments marshalled itself at the east end of the Georgia Viaduct. They were preparing to drive across the viaduct to celebrate its opening. At the downtown end stood a placard-wielding throng of protesters and street people, many with long hair and beards, who were convinced that the viaduct, the first phase of a freeway

1 The above quotes are from an interview I had with Campbell in 2001. I found him lively, engaged, and still very free with his opinions. He told me that once he left politics in 1972 he had never given an interview or made a public comment about civic affairs for any newspaper or magazine. He maintained that he had stuck by his rule of never selling anything that he built, so he must be one of the city's largest landlords.

2 See *The Georgia Straight: What the Hell Happened?*, pp. 67–73, for a chronology of the paper's woes.

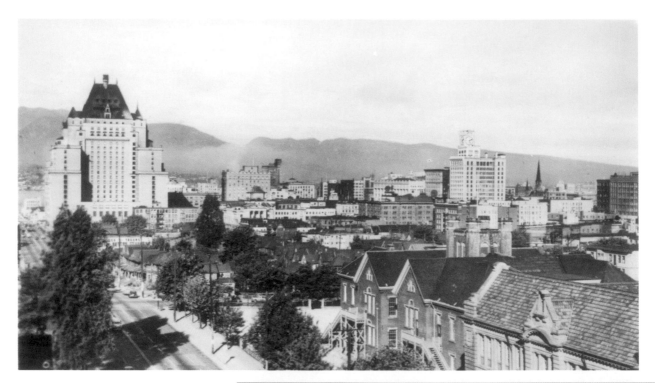

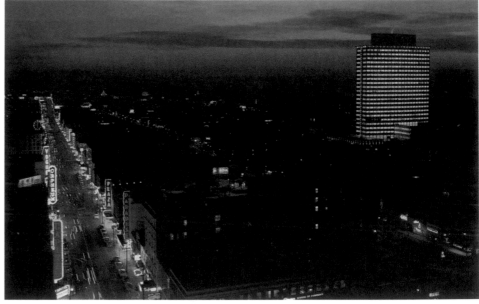

ABOVE *A postcard view from the early 1950s looking northeast from St. Paul's Hospital and showing the transitional area between the downtown business district and the working class residential area to the south. Dawson School is on the right, the site of the BC Electric Building in the middle centre, and the Hotel Vancouver on the left. (Gowen-Sutton postcard)*

BELOW *"Vancouver's Great White Way," about 1960, in a view from the Vancouver Block on Granville near Georgia. The BC Electric Building rises like a beacon above the ramshackle houses and shops of the Nelson and Burrard area. (Photo by Rolly Ford)*

1 An engineer, fisherman and lawyer, Gordon was a long-time cycling advocate. I worked as a deckhand on his troller off Ucluelet in the summer of 1972. He died prematurely in 1997, and is memorialized on the Vancouver Bicycle Club website.

system, was the thin edge of the wedge. A group of us from the UBC militant cyclists club – it had no official name – formed a chain across the viaduct directly in the path of the motorcade.

Leading the dignitaries was a Vancouver police force motorcycle phalanx, which stopped briefly in front of our chain before pushing directly into it at the bicycle behind mine – my girlfriend's, who probably wished she was somewhere else. She moved, but a cyclist named Gordon Bisaro[1] moved into their path and had to be hauled away. Although his example was followed by others, eventually the motorcade made it through. That night all the newscasts decried the protest as the work of thugs, agitators and troublemakers.

The following day the mayor wrote a number of letters, carbon copies of which survive in the city archives. One, to the superintendent of the police

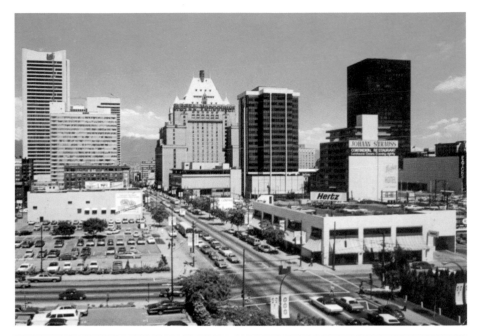

ABOVE *A view looking north from the roof of the YMCA Building at Barclay and Burrard about 1972. Only the first "black tower" – of the Toronto-Dominion Bank – has been erected, as has the Royal Bank Tower at Georgia Street on the extreme left. The library huddles at the foot of the Hotel Vancouver. But the overwhelming impression is of transitional buildings and parking lots – the look of downtown Vancouver until about 1990. The parking lot in the foreground occupied the playing field of the Aberdeen School – the original West End school of Vancouver's infancy – which was still standing when this picture was taken. In the Mayfair Hotel on Hornby Street, the Johann Strauss restaurant provided an eastern outpost of the German-flavoured Robsonstrasse west of Burrard Street. (Photo by Merle Somerville)*

BELOW *Vancouver's public library between 1957 and 1995 was one of the best modern buildings in the city. As the years went by, it was a low-rise oasis in the middle of the downtown jungle. In the mid-1960s, its wide sidewalk was a gathering place for the city's burgeoning hippie culture. After a lengthy campaign in the 1990s to save the building, during which many people said it would never again be a desirable address, it was renovated and reopened with a hip TV station, restaurant and music store appealing to a new young generation. (Photographer unknown)*

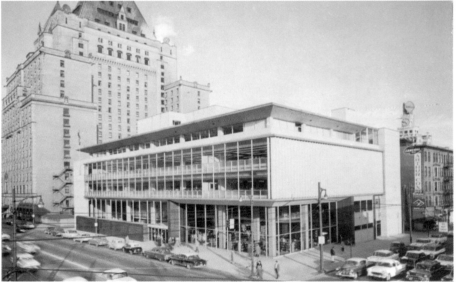

traffic division, stated: "Just a note from myself and Mrs. Campbell to express our appreciation for the excellent manner in which the motorcycle officers handled the disturbance at the opening of the viaduct." Another, to the Most Reverend James Carney, who was riding in the convertible with the Campbells, said: "I would apologize for the disrespect shown yourself and your office by some of the citizens of Vancouver. I am certain that you are aware that this is only the opinion of a very, very small minority."

On the last point the mayor soon realized he was wrong. Opposition grew and on February 9, when it was clear that he had lost the support of some of the surrounding municipalities, the senior levels of government and even some influential members of the business community, he lashed out at the "Maoists, communists, pinkos, left-wingers and hamburgers" who were standing in the

way of progress (he defined a hamburger as someone without a university education). Not long afterwards rumours began to circulate that he would not seek re-election.

A cautionary tale is provided by Birks, a Canadian legend where any engaged couple of any status at all registered a silver and china pattern for the convenience of wedding-gift buyers. Based originally in Montreal, Henry Birks & Sons expanded across the country, usually taking over established local jewellers. In Vancouver the company bought Trorey's, which operated from a two-storey brick building at the northeast corner of Granville and Hastings. In 1913, at the height of an economic boom, Birks moved to its exquisite, curved-front tower across the street from the Hotel Vancouver and the Hudson's Bay Company – Vancouver's premier corner – taking with it Trorey's old clock.

By the late 1960s, Birks had expanded into shopping malls and had lost its way. Seeing its flagship store as yet another mall site, it and its banker partners tore down its building and the Strand Theatre to the east on Georgia and built an unprepossessing, low building clad in cold brown marble and set on the diagonal to its corner. Neither it nor the attached Vancouver Centre mall enjoyed the anticipated success. Over the years, the company's fortunes foundered, and only the Vancouver habit – if indeed it remained more than just an expression – of "meeting at the Birks Clock" continued. When an Italian company purchased Birks in the 1990s, it quickly rejected the Vancouver Centre as a site from which it could sell prestigious jewellery. So down Granville Street went Birks again, settling into the restored Bank of Commerce Building at the corner of Hastings and Granville, just across the street from the site of Trorey's. The clock, of course, moved too.

The former Birks store then went through a few incarnations indicating its inability to attract high-rent clients. First was a bookstore called Bollum's, trying to capitalize on the success of big-box stores in the east and the USA.

CPR steamers at piers D (left) and C in the 1930s. Pier C shared a double wharf with B, and had a Spanish Colonial entrance hallway that survived until 1985 and the creation of the Canada Place cruise ship terminal on the old wharf. Pier D, built in 1920, burned in an enormous fire on July 27, 1938 and was never rebuilt; eight years later, during the Second World War, the SS Greenhill Park *blew up at Pier B while loading cargo, shattering windows throughout the downtown area, including in the Marine Building. (Coast Publishing)*

Marine Building from the Waterfront, Vancouver, B.C. Canada.

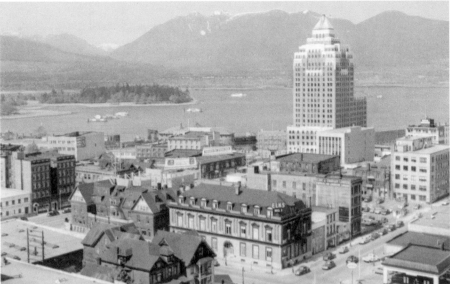

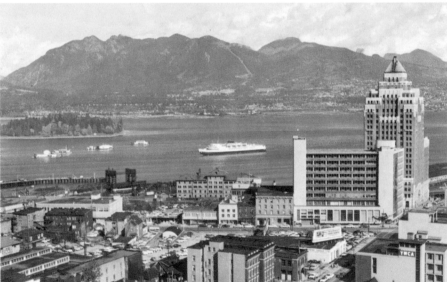

LEFT *The old Park Plaza Hotel at 1140 West Pender Street was a good building erected in the wrong part of downtown. It opened on April Fool's Day, 1911, as the Elysium, at a time when the 19th-century Blueblood Alley mansions of the early city had been converted into rooming houses, their large lots infilled with low commercial buildings and garages. However, the area remained like that for more than 50 years, the hotel district consolidating itself along Georgia Street and new office buildings locating blocks to the east. It was a returned soldiers club after WW I, then reopened as the New Elysium before being converted into suites by architect C.B.K. Van Norman in 1943; as the Park Plaza, it lasted from 1945 until its demolition in the 1970s. (Photo by Richard Stace-Smith, c.1970)*

RIGHT *Two views of the Marine Building, the top one in the 1940s, the other in the 1950s, showing how it stood in splendid isolation for decades before the city's economy caught up with it. Construction began in March 1929, at what turned out to be the end of the Roaring Twenties; its builder, the Stimson Company of Toronto, was bankrupted by the time it opened in the deepening economic depression. It was touted briefly as a city hall, then purchased in 1932 by British Pacific Properties Ltd., the company that later used Guinness brewing money to erect the Lions Gate Bridge and develop exclusive housing in West Vancouver. In the 1950s image, the new Customs Building (demolished in the 1990s) put a modern face onto the brick and terracotta of the old city; the long brown building on the waterfront directly beneath the incoming ship is the old Immigration Building, built in 1915 and segregated into "White" and "Chinese" sections. Although designated by the city as a heritage building, it was demolished in 1976 when the CPR lobbied for more space for truck parking for its island ferry service. (1940s: photographer unknown; 1950s: Coast Publishing)*

When it foundered, Celia Duthie, owner of the legendary independent book chain, jumped into the breach. She soon also had to retrench. Finally it became a London Drugs, an irony as the chain had its roots on the site of the IBM Tower kitty-corner across the street in the era when the Pacific Centre was just a dream.

There were other fine office buildings in the old downtown. The Rogers Building at Granville and Pender is a contemporary of the Birks Building and, like it, is finely clothed in white terracotta; its namesake, Jonathan Rogers, was a businessman and community pillar whose other civic legacy is the park system (see page 168). The Winch Building, named for a pioneer of the fish-canning industry, is a part of the Sinclair Centre development at Hastings and Howe (see page 121). The homeliest of the set – the 1912 Vancouver Block on Granville just south of Georgia – also survives. The Medical-Dental Building at Georgia and Hornby was demolished in 1989 following a prolonged controversy. Its magnificent sister, the Marine Building at Burrard and Hastings, is still a landmark on the city's waterfront, a reminder of the role the Panama Canal played in the development of the port. The Marine Building was home to the Grain Exchange, grain being a major export once the canal opened, and to the Guinness Company, which bought the building and went on to develop the Lions Gate Bridge and the British Properties in West Vancouver.

In the years since the Pacific Centre–Vancouver Centre debacle, two experiments also deteriorated the downtown's character. Granville Mall, the only significant planning failure of the 1972 to 1976 TEAM council, stripped the excitement of cruising cars and constant activity from the street, although it arguably made Granville a much more effective transit corridor. The street and its businesses had been hard hit by Pacific Centre, which drained street activity away into the underground and left the surface blocks enough of a void to encourage even more drug dealers and prostitutes onto the widened sidewalks. It always had an edge to it, but by the 1980s, with the rise of homelessness and more serious substance abuse in the city, it began to feel downright dangerous.

The Robson Square–Law Courts complex of the 1970s was more of a mixed blessing, as it created a visually stunning two-block mix of fine architecture and public spaces while removing pedestrian activity from the sidewalks. The amount of public use envisaged by architect Arthur Erickson has simply never happened; in the related project of converting the old courthouse into the Vancouver Art Gallery, the front doors on Georgia Street were closed off and the building reoriented to the rear. The back steps to the old courthouse have become a hangout and the sidewalk a curious place isolated from the purposeful surrounding streets. But compared with the idea it replaced – an austere 55-storey provincial government office tower – it is an unqualified success.

A new generation of offices arrived in the 1960s to keep the Marine Building company, most notably the Guinness Tower at 1055 West Hastings. The photograph shows the Daon Building under construction in 1980 across Burrard Street from the Marine Building, an interesting juxtaposition as the new one reflects and refracts the older. Pier B-C, the abandoned steamship terminal from the 1920s, is visible behind the Daon Building; a few years later, it began its remarkable transformation into Vancouver's signature "sails" – Canada Place. (Photograph by Richard Stace-Smith)

Two watercolour sketches of the Marine Building's entranceway in 2001 for an aborted project for its owners. The building is an architectural tour de force, rewarding both the distant view and minute examination. A much grander and more elaborate version of the demolished Medical-Dental Building on Georgia Street, it shared some of the whimsy of the latter's trademark nurses (in the hoary old joke, the Rhea sisters Pia, Dia and Gonna).

Its terra cotta decoration provides a mini-history of the planet, depicting everything from amoebae and gargoyles to dirigibles, biplanes, locomotives and ocean liners. The building itself was described in a news story as "some great crag rising from the sea, clinging with sea flora and fauna, tinted in sea-green, touched with gold." The art deco sunburst over its brass entry doors and the flood of light into its darkened foyer caught my eye.

Yaletown & False Creek

The Yale of Vancouver's Yaletown is the hamlet in the Fraser Canyon above Hope. It was significant to the Canadian Pacific Railway in the early 1880s because it was the limit of river navigation and thus the supply point for the construction of the tortuous canyon section built largely by Chinese labour. With the completion of the railway through to the coast in 1886, Yale was largely abandoned, but many of its small houses were dismantled or loaded in sections onto flatcars and brought to the newly founded Vancouver. The workers, both Chinese and white, moved too.

The CPR's general manager, William Van Horne, favoured building ocean docks at Kitsilano Point rather than in Burrard Inlet due to the force of the tides running through First Narrows; in fact, it had been company policy since the 1870s when the area was first considered for a railway terminus. Railway yards and a roundhouse were planned for the land just west of the Indian Reserve and the village of Sun'ahk (page 146), and in preparation the

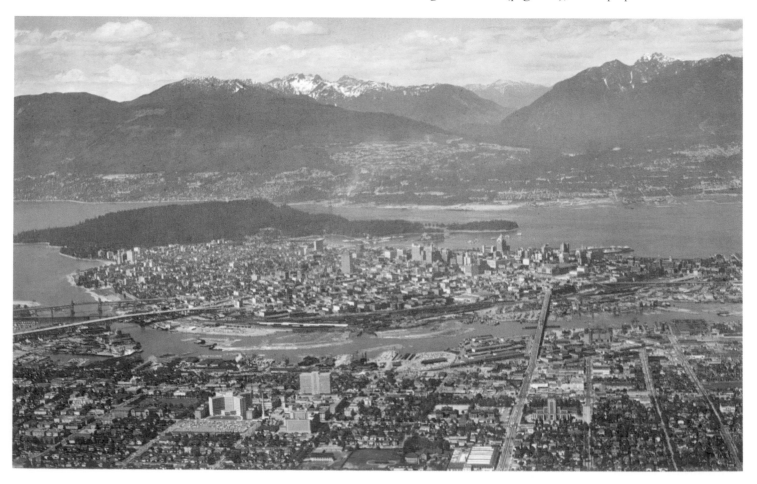

railway ran a fixed trestle across False Creek near its mouth to the Kitsilano shoreline. This effectively closed False Creek to commerce and caused an outcry of city businessmen and the council.

The city responded with a carrot, offering the CPR tax-exempt status for 30 years if the company located its roundhouse, shops and yards on the north shore of the Creek. The CPR agreed, but used the issue of the unopenable Kitsilano trestle to wring further concessions for its Burrard Inlet port facilities. Eventually, in 1902, a new bridge with a steel draw was completed for the use of the predecessor of the BC Electric Railway Company's interurban service – the Kitsilano trestle that survived until the 1980s.[1]

The CPR's English Bay Line, as it was called, reached the roundhouse and yards on False Creek via a switch on its main line just east of Columbia Street in Gastown (see map, page 57). The line ran diagonally across the city grid, crossing busy Hastings Street just west of Carrall and skirting the western edge of Chinatown. The traffic congestion this line created prompted the company in the 1930s to dig a tunnel from False Creek along Dunsmuir Street that looped around to a portal on the Burrard Inlet waterfront near the Marine Building; a half-century later, the tunnel was taken over by the SkyTrain rapid transit system.

The hard-drinking workers of Yale transferred their recreational habits with them to Yaletown, which quickly developed a reputation for rowdiness. Centred around the False Creek end of Granville Street, these men and their families lived closer to the railyards while Yaletown's more respectable residents congregated on the blocks of Howe, Hornby and Burrard. The Yale Hotel at Granville and Drake, originally known as the Colonial, is the last surviving commercial building from those days, having been built in 1890 when Vancouver was just four years old. It was the first hotel reached by travellers using Granville Street to get from Eburne and the Lulu Island farms to downtown Vancouver and sometimes served as an overnight stop. The blocks of Granville Street between Nelson and the bridge, with their single-room occupancy hotels and rough beer parlours, are in the tradition of the original Yaletown.

Granville Street from Drake, looking south along the bridge deck in 2005. The third building along was the Continental Hotel, a hostel in recent times. The venerable Yale Hotel has become a centre of Vancouver's jazz and blues scene. Thirty years ago it had more of a reputation as a bikers' bar, while the beloved Cecil Hotel was the watering hole of choice for intellectual students and Kitsilano hippies. Chess games, earnest discussions and feminist graffiti in the washrooms indicated a certain refined quality only achieved elsewhere at the Ritz and the Devonshire on Georgia Street. Alas, the Cecil may be demolished as part of a comprehensive redevelopment that would retain the Yale, a building with a heritage pedigree more profound than just blues and jazz.

1 The complete reference is Robert K. Burkinshaw's *False Creek,* published by the Vancouver Archives in 1984.

ABOVE *The north end of Burrard Bridge about 1970, showing the once-familiar view of ratty frame houses that occupied the block from Pacific to Drake. The majority of them were built in 1904–06 by small-time carpenter-developers and were occupied by salesmen, machinists, engineers and mill-wrights, some of whom worked nearby on False Creek. Adrienne Cameron operated a modelling school from the nearest house at 1386 Burrard. (Photo by H.W. Roozeboom)*
VPL 8621

NEXT PAGE *The house at 819 Pacific Street, just west of the Howe Street ramp of the Granville Bridge, was built in 1904 for fireman J.W. Campbell and raised in 1927 so that a confectionery could be inserted below. In the 1950s it became the Bridge Cafe and evolved in the 1970s and 1980s into a bistro called L'Escargot and, later, La Cuisine. The building in the fore-ground, a converted Jaguar repair garage, was in those years an espe-cially good Greek restaurant called Kozmas, its interior like a small village square and its tables home to high-stakes backgammon games; it is now Tony Roma's, "Famous for Ribs." In the middle distance, the midrise Anchor Point condo development from the 1970s oc-cupies the site of the houses in the photo above.*

1 See "The House That Leslie Built" by Betty Funke in *Heritage West,* September 1981. An article by Lois Light, "Yellow House Cared For," appeared in the *Sun* on September 11, 1970. Thanks to Diane Switzer, Vancouver Heritage Foundation, for locating the clippings.

The George Leslie house at 1380 Hornby Street, known since 1973 as Umberto's Restaurant, is the oldest house left from the Yaletown era. Leslie was from Cape Breton, a plasterer who came west looking for opportunity and perhaps worked on the original Hotel Vancouver before starting work on his own place, probably in 1888. Fifteen years later he built a second, smaller house on the back lane for his growing family. His daughter and son lived in the main house until 1947, when Wilhelmina Meilicke bought it and opened an interior design business there. She renovated it, making some changes to fa-cilitate the moving of furniture in and out, and operated it until 1966 as Leslie House Ltd. The next owners, Olive and Mano Herendy, were dress design-ers, their Mano Designs a favourite of fashionable brides in the late 1960s. The Herendys changed the house colour from blue to the chrome yellow still there today and lived in the lane house at the back of the property.[1]

As Umberto Menghi's restaurant enclave expanded, the lane house became an encumbrance. He donated it to the Vancouver Heritage Foundation, which moved it in 2004 to a thin vacant lot on the Mole Hill block (page 122) and rehabilitated it. Although no longer really a lane house, as it sits at the back of a long garden, it is a really charming addition to that historic precinct. The only true lane house left in the West End sits behind the Sands Hotel near English Bay (page 131).

The last of the true Yaletown houses – that is, the ones moved by flatcar from Yale – sat behind the Cecil Hotel and was pulled down to make way for the Seymour Street off-ramp for the new Granville Street bridge in the early 1950s. It was, as you would expect, a simple little cottage with a stoop and a centred bay window on a single-storey gabled front wall. The Cecil and its neighbour to the south, once known as the Continental Hotel, were marooned below the street when the new bridge descended past them and touched down at street level near Drake Street in front of the Yale Hotel (the earlier bridge touched down at Pacific Street). The scene there of ramps, cloverleafs and over-passes is reminiscent of freeway-laced American cities, a hint at Vancouver's potential future 50 years ago.

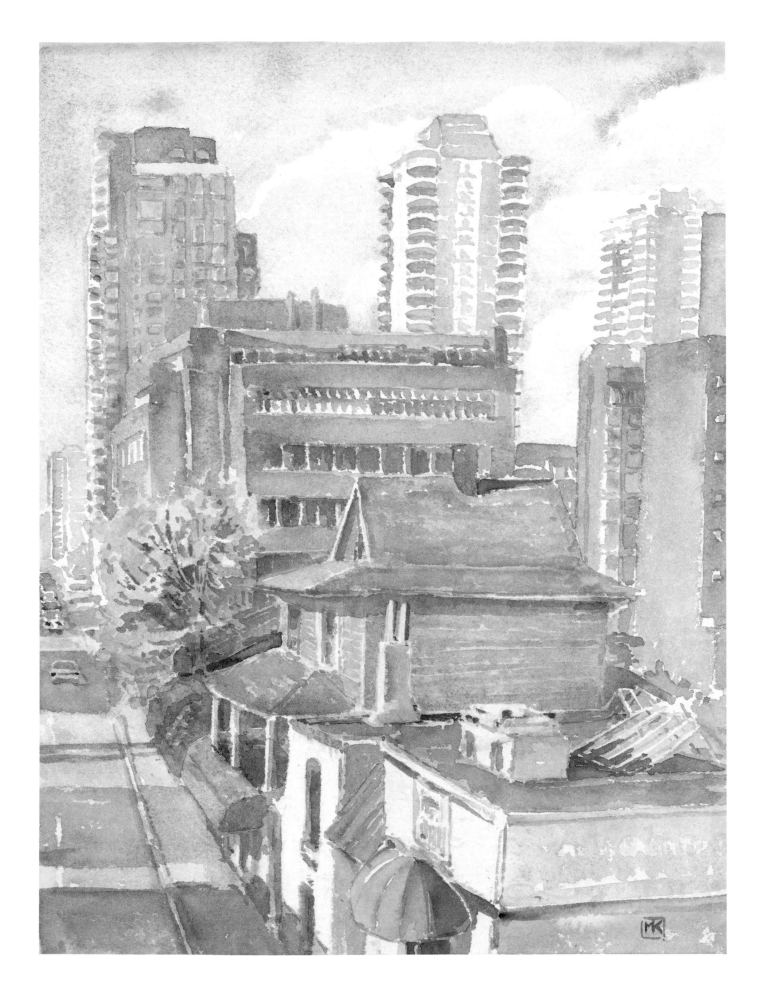

YALETOWN & FALSE CREEK

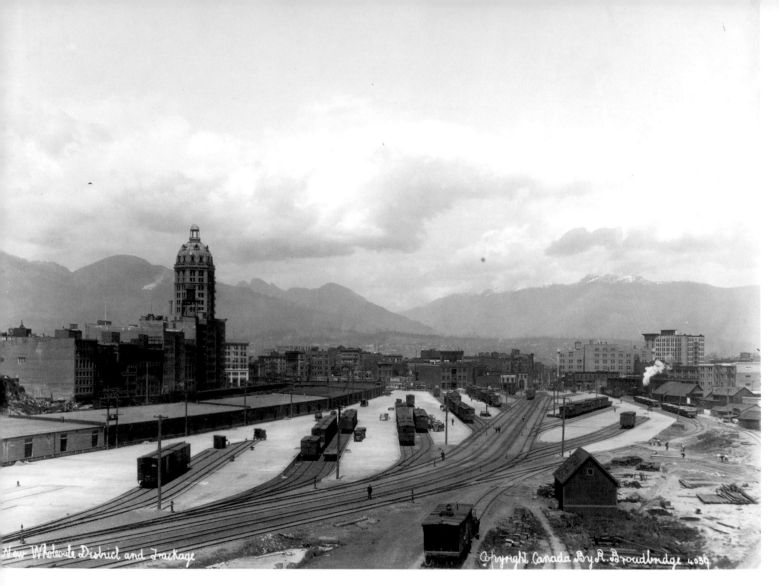

The CPR railyards in 1912, with the incomplete World Building, more recently known as the Sun Tower, on the left. The set of four tracks is aligned with Carrall Street, looking north through Chinatown into Gastown, with remnants of the North Vancouver forest visible in the distance. (Photo by Richard Broadbridge)

JIM WOLF

The name Yaletown is now firmly attached to several square blocks of rehabilitated warehouses on the edge of the Concord Pacific neighbourhood, previously known as the site of Expo '86 and originally the CPR's railyards. At first blush its looming brick structures look like Gastown's, especially when seen from Homer Street, but the loading bays along Hamilton and Mainland show exactly how they once worked. Even in the early 1980s, boxcars still used the railway tracks that ran along the streets and were loaded with cargo there, the workers using the protective rain awnings projecting over the concrete bays. When the city began to look at rehabilitating the area, it recognized the awnings and bays as a defining feature and insisted they be retained; in an incongruous and silly gesture, some of the new condo towers nearby have faux awnings, sometimes 25 storeys up in the air!

The streetscapes have changed comparatively little since the first brick warehouses were built more than a century ago. Early occupants included Sherwin Williams Paint at 1128 and Empire Brass at 1038 Homer; Piggly Wiggly Foods, an early competitor of Safeway's in the self-serve supermarket business, was at 1000 Hamilton; Murchie's Tea and Coffee, the local source of good coffee in pre-Starbucks Vancouver, had a fine warehouse designed by architect Thomas Hooper at 1200 Homer. Another Hooper warehouse at 1038–40 Hamilton was converted into offices in the 1980s as part of the Yaletown renaissance.

VANCOUVER REMEMBERED

Three photographs of Yaletown from 1982:

ABOVE LEFT *Hamilton Street looking south from Nelson, a boxcar sharing the street with delivery vans and cars. The loading docks and awnings of this characteristic warehousing scene have been preserved in the modern Yaletown fix-up, which includes the conversion of one warehouse into a very popular brew pub.*

ABOVE RIGHT *Mainland Street, on the left, looking north from Drake, with the CPR railyards on the right.*

RIGHT *Nelson Street looking west from Hamilton.*

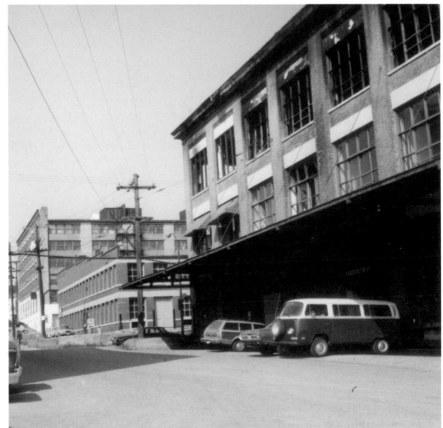

LEFT *The front of the Penthouse Cabaret on the west side of Seymour Street south of Nelson, about 1990. It is one of the few low-rise buildings left in that part of Downtown South.*

RIGHT *Seymour Billiards at the northwest corner of Seymour and Nelson was a cut above most other downtown pool halls, as it had full-sized tables and was well-lit and comparatively airy. The individual balls on its neon sign flashed in sequence. Photographed about 1990.*

Changes began in the 1970s when designers, commercial photographers and architects seeking flexible working spaces discovered the warehouse interiors and their cheap rents. Some retail operations followed, but never anything of the scale of the boutiquing of Gastown in the early 1970s. As well, Yaletown was never "beautified" with pavement and lamp treatments, that experiment having worked adequately in the touristy atmosphere of Gastown but considered inappropriate here. Nevertheless, the area has been "aesthetisized," to use a term favoured by academics, taking it from an authentic working place to a district of consumption and pleasure – allegedly the essence of the post-modern city. "Yaletown" is a brand, as sexy as Gastown was in its brief heyday 35 years ago.

An indication of the "nowhere" status of the adjoining streets is the area's name: Downtown South. It was the southward and westward extension of the working-class neighbourhood that thrived on the downtown peninsula until the 1950s. In the Victory Square chapter of this book, the northern part of the community is mentioned – the catchment area for the old Central School. In what is now called Downtown South, children once walked over to Burrard Street to go to school, at Aberdeen at Barclay Street or later at Dawson, the site of the Wall Centre south of Nelson.

Zoning changes endorsed by the Bartholomew city plan of the late 1920s ripped the guts out of Downtown South. It very quickly lost its cohesion as a neighbourhood, so that by the 1950s and 1960s there were only scattered houses and small apartment buildings, usually poorly maintained and rented out to poor people. A few of the houses achieved a kind of status, such as the one on the east side of Seymour between Helmcken and Nelson, across from the Penthouse Cabaret, that housed the Casa Capri restaurant – which every-one knew simply by the owners' name, Iaci's.

The Penthouse was and is a venerable beacon on Seymour Street, known even to prudish suburban Vancouverites who streak past it on their purposeful way downtown. An island in the midst of a constantly shifting landscape of pool halls, small garages, factories, warehouses, and second-tier nightclubs and discos, the Penthouse attracted the showgirls and callgirls, the touts, the small-time hoods and gamblers, the University boys out for a wild time or taking an engaged friend on a stag night. Sometimes big names in town looked for some Las Vegas–style action of a hotter class than what was available at Isy's on Georgia. Sammy Davis Jr. and George Burns were two of the American stars who performed there.

Until the 1950s and the tentative liberalization of provincial liquor laws, all such places (and restaurants) were bottle clubs. In the Vancouver legend of that generation, clubs and restaurants had specially made tables with a compartment, usually a shallow shelf that would hold a couple of mickeys (that is, half bottles of liquor), covered by the edge of the tablecloth. If the police raided the club, the customer and owner could, of course, deny all knowledge of the illegal booze. Very few people drank wine; many took a bottle with them on a date and then "killed it" rather than bringing it home, a culture of binge drinking, followed by driving, that took a generation to overcome.

Opened in 1945 by Sicilian-born businessman Joe Philliponi, the Penthouse Cabaret represented an evolution of the "restricted areas," or red-light districts, where prostitutes were tolerated generations earlier (page 54). Philliponi came to Vancouver in the early 1930s, when he was about 20, and started Eagle Time Delivery Systems, a business allegedly tied in with the bootleggers who operated mainly in the Strathcona neighbourhood. Later it became a taxi company, its colourful neon sign still hanging from the cabaret building.

In one of the city's periodic crackdowns on vice, police shut the club down at the end of 1975 and Philliponi, together with a group of associates dubbed the Penthouse Six, were charged with living off the avails of prostitution. Although he was never convicted, his business license remained under threat.

LEFT *The Arts Club Theatre at 1181 Seymour was a former Gospel Hall and parts warehouse. In 1972, the modern era of Vancouver professional theatre opened there with the production of* Jacques Brel is Alive and Well and Living in Paris.[1] *The Vancouver Film Centre, a cultural bonus in a modern condominium development, now occupies the site. (Photo by Peter Vaisbord, 1991)*

RIGHT *A tin-sided shack at Richards and Helmcken about 1985, an extreme example of the dilapidated streetscapes of Downtown South before redevelopment began.*

1 See "Musicals and Reviews" by Mark Leiren-Young in the *Greater Vancouver Book*, p. 690.

He kept the club open until he was murdered in his office there in 1983, the year he turned 70 years old. His funeral attracted a cross-section of Vancouver society, ranging from businessmen to exotic dancers. The club continued in operation managed by his nephew, Danny Filippone.

By the time of Philliponi's murder, street prostitution had become an issue far more annoying than the behind-closed-doors world of a few downtown clubs or the discreet brothels of women like Wendy King, whose rolodex contained a who's who of Vancouver men, including a judge, when it was seized in an arrest in 1979. Seymour and Richards streets developed a sidewalk cruising scene that by the standards of the time was outrageous. For a time, prostitutes also worked the streets farther west until the Concerned Residents of the West End, supported by local MP, now Senator, Pat Carney, pressured them to move on. The Mount Pleasant industrial area north of Broadway then became the place to go until a "Shame the Johns" campaign and police pressure scattered them. But by the 1990s there was no longer any semblance of a "restricted area," as hundreds of women and men used prostitution as the only way to support drug habits. The Penthouse of a generation ago seems quaint beside the predatory, violent, desperate conditions of the Downtown Eastside today.

RIGHT *The Doric Howe at 1060 Howe Street (now Bosman's Hotel) opened in 1960 as part of a chain of 15 west coast hotels that provided an alternative to Kingsway-style motels and auto courts for visitors to Vancouver. Designed by Allen C. Smith & Associates, it featured push-button sunlamps, heating and air-conditioning controls in all the rooms.*

BELOW LEFT *The southeast corner of Davie and Howe about 1988. Strips of single-storey shops with varied tenants, such as the excellent Tupper antiquarian bookseller, added character to low-rent parts of Vancouver such as this.*

BELOW RIGHT *Houses awaiting demolition on Howe Street just north of Davie, about 1988.*

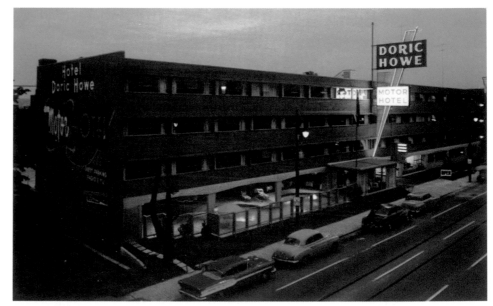

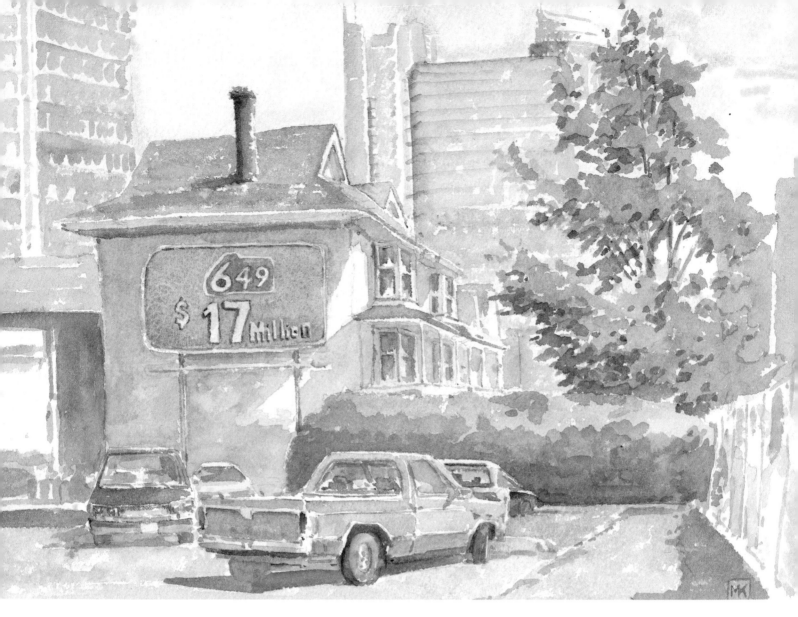

The few surviving old buildings around False Creek, including the handful of frame houses and single-storey shops, evoke the days when the banks of the Creek were the city's industrial backwater – both a decaying, polluted basin and a source of jobs for working people living nearby. Long gone are the shanties and houseboats of squatters who eked out an existence on the edge of the industrial lands.

The economic boom of the Second World War bought some time for the "filthy ditch," but by the early 1950s politicians began to consider a final solution. Planning orthodoxy suggested retaining a deep shipping channel but reclaiming more land for industry. The water area had, in fact, shrunk significantly from its 1885 shoreline. Mayoral candidates in 1950 argued for the complete reclamation of the Creek, noting that a major arterial roadway could be built down the middle of it to benefit the entire city. Planning for the new Granville Bridge was too far advanced to stop, however, but the successful candidate, Fred Hume, still argued that reclaiming the entire Creek would eliminate the need for further bridges and would provide more land for downtown parking and good industrial employment. But that solution was dashed in a 1955 report by E.L. Cousins of the city engineering department, which demonstrated that filling it would cost more than double the value of the reclaimed land.

(text continues on page 104)

Two well-maintained houses at 1251 and 1243 Hornby Street north of Davie in 2005, surrounded by the highrises of the shiny new city; I liked the visual inference, "win the lottery and be able to buy the houses." They are typical of the builders' designs of a century ago: wooden boxes with off-centre bay windows on both floors and a semi-hipped roof. The house at 819 Pacific (page 95) is simpler, lacking the upstairs bays.

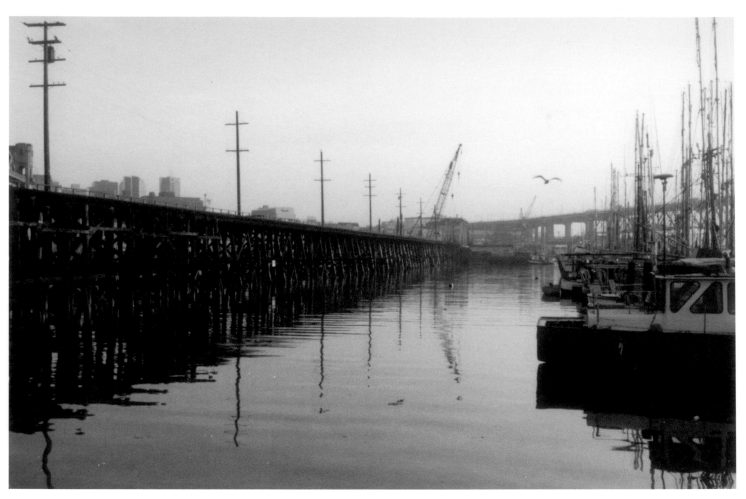

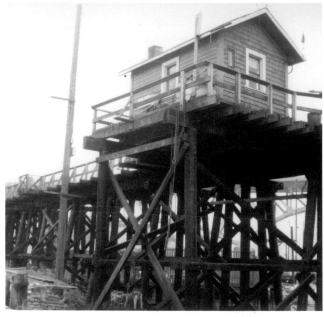

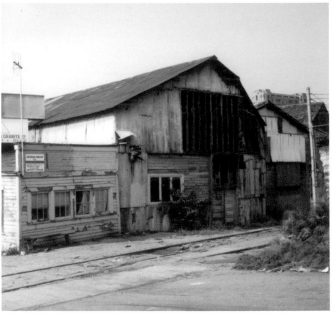

Photographs from 1982 of the Kitsilano Trestle, looking south across False Creek to the Burrard Bridge. The bridgekeeper worked in a small shack on stilts near the downtown end and controlled its swing span, a narrow gap at the best of times. (I was deckhand on a salmon troller in 1972 that got stuck in the gap trying to get out of False Creek!) Just south of the swing span was a fixed steel section; during the Second World War when Victory ships built at the yards farther up False Creek (page 164) were launched, a Gulf of Georgia Towing Company barge stacked with timbers would be positioned under the span at low tide, then moved away at high tide, taking the span with it. (The late Ray Bicknell, owner of the barge company, described the method to me in 1983.) The third photo shows the former Vancouver Granite Company buildings at the foot of Howe Street with the BCER track passing in the foreground.

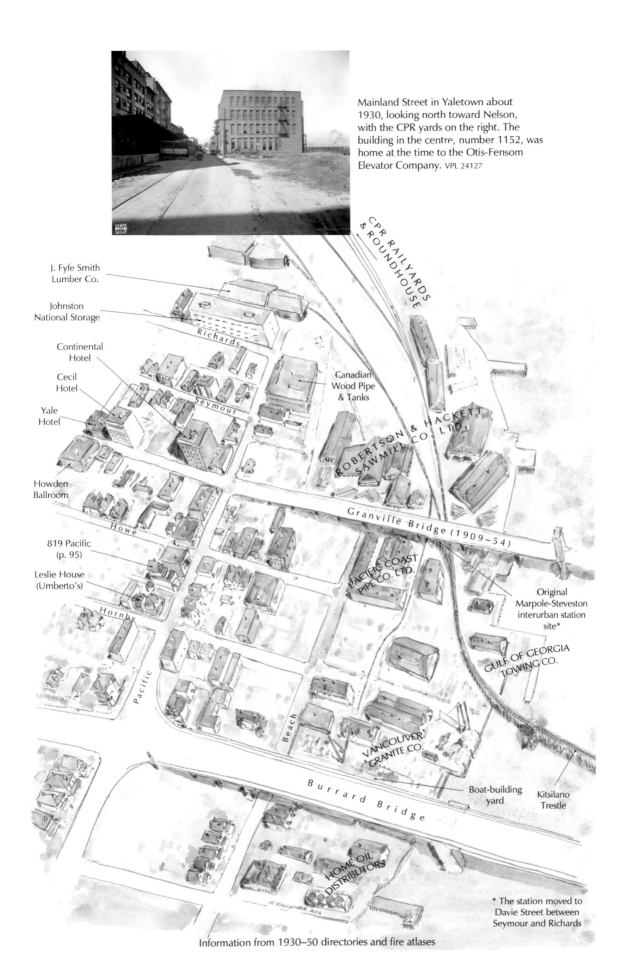

Mainland Street in Yaletown about 1930, looking north toward Nelson, with the CPR yards on the right. The building in the centre, number 1152, was home at the time to the Otis-Fensom Elevator Company. VPL 24127

CPR RAILYARDS & ROUNDHOUSE

J. Fyfe Smith Lumber Co.

Johnston National Storage

Richards

Continental Hotel

Cecil Hotel

Yale Hotel

Seymour

Canadian Wood Pipe & Tanks

ROBERTSON & HACKETT SAWMILL CO. LTD.

Howden Ballroom

Howe

Granville Bridge (1909–54)

819 Pacific (p. 95)

Leslie House (Umberto's)

Hornby

PACIFIC COAST PIPE CO. LTD.

Original Marpole-Steveston interurban station site*

Pacific

GULF OF GEORGIA TOWING CO.

Beach

VANCOUVER GRANITE CO.

Burrard Bridge

Boat-building yard

Kitsilano Trestle

M. KWICKNER 2006

HOME OIL DISTRIBUTORS

* The station moved to Davie Street between Seymour and Richards

Information from 1930–50 directories and fire atlases

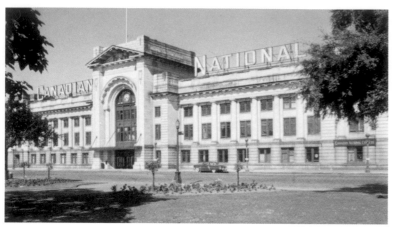

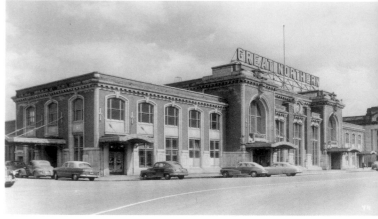

THIS PAGE *The station of the Canadian National Railway, so named after the Canadian Northern and Grand Trunk railways were nationalized due to their bankruptcies after the First World War. After years of little use, the CNR station was converted in the early 1990s into a multimodal facility for both Via Rail and buses; tied in with the nearby SkyTrain station, it is a very modern use for what was once seen as a white elephant. However, long-time Vancouverites (especially me) still grit their teeth at the station's new name: Pacific Central, erected along the roofline in the same lettering as the old and implying the existence of an imaginary railway company. The Great Northern station immediately to the north was a beautifully designed building; sadly, it was demolished when the American passenger rail connection ended in the 1960s. Once the service resumed, Amtrak trains used the CNR station. The Rocky Mountaineer recently built its own station nearby. (CNR: photographer unknown; GNR: photo probably by J.C. Walker)*

NEXT PAGE *A bird's-eye view of Main Street at the eastern end of False Creek as it was about 1950.*

The new residential and recreational vision that gradually evolved for False Creek had to contend with the complexities of land ownership and the huge economic value of the businesses lining its shores. About 4,000 scow and barge loads of everything from sawdust to cement entered and left False Creek annually in the 1950s, and the payroll of businesses was an estimated $17 million. On the north shore, the Canadian Pacific Railway dominated, and in 1967 exchanged land with the province in order to consolidate its ownership of the foreshore land between the Cambie and Granville bridges; the province, in return, obtained control of the riparian rights on the south shore (the fate of the industries on the south shore is discussed in the Fairview-Mount Pleasant section beginning on page 145).

Nearly a decade after the transformation of the south shore began, the north shore began to be cleared of its railyards and industrial facilities. The provincial government effected the deal in 1980 with a $60 million cash and land-transfer agreement with the CPR's Marathon Realty. An arterial-style roadway called Pacific Boulevard was extended eastward from Pacific Street's end at Richards across the old flats just north of the Roundhouse. The huge BC Place stadium opened in 1983, providing a dramatically different view from the corner of Robson and Beatty – once the north end of the 1912 Connaught a.k.a. Cambie Bridge. In the latter's shadow were a sawmill and the Sweeney Cooperage, situated on a grimy piece of foreshore at the foot of Smithe and one of False Creek's oldest and most picturesque businesses. When it shut down it held a sort of close-out sale; hundreds of Vancouverites had a look around and bought the old barrels (I recall squeezing one into the back of a Volkswagen Beetle; it ended up planted with strawberries in our Kitsilano backyard).

Then came the city's centennial and Expo '86, the summer-long party that drew international – especially Asian – attention to Vancouver at the critical juncture when Hong Kong's British rule was rumoured to be coming to an end. The subsequent, controversial sale of the Expo lands by the Bill Vander Zalm government to developer Li Ka-shing triggered an enormous transformation by the latter's Concord Pacific Developments. The frog got kissed and became a prince.

During the past half-century there has been comparatively little change to the former False Creek flats east of Main Street. In the early days of Vancouver, False Creek extended nearly all the way east to Clark Drive, with swampy

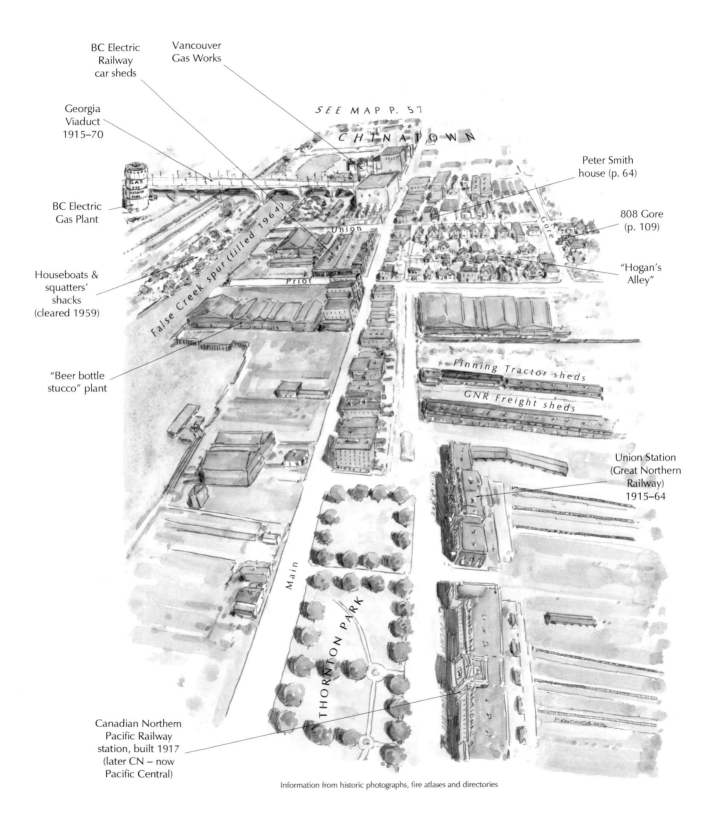

BC Electric
Railway
car sheds

Vancouver
Gas Works

Georgia
Viaduct
1915–70

BC Electric
Gas Plant

Houseboats &
squatters'
shacks
(cleared 1959)

"Beer bottle
stucco" plant

SEE MAP P. 57

CHINATOWN

False Creek spur (filled 1964)

Union

Prior

Peter Smith
house (p. 64)

Gore

808 Gore
(p. 109)

"Hogan's
Alley"

Finning Tractor sheds

GNR Freight sheds

Union Station
(Great Northern
Railway)
1915–64

Main

THORNTON PARK

Canadian Northern
Pacific Railway
station, built 1917
(later CN – now
Pacific Central)

Information from historic photographs, fire atlases and directories

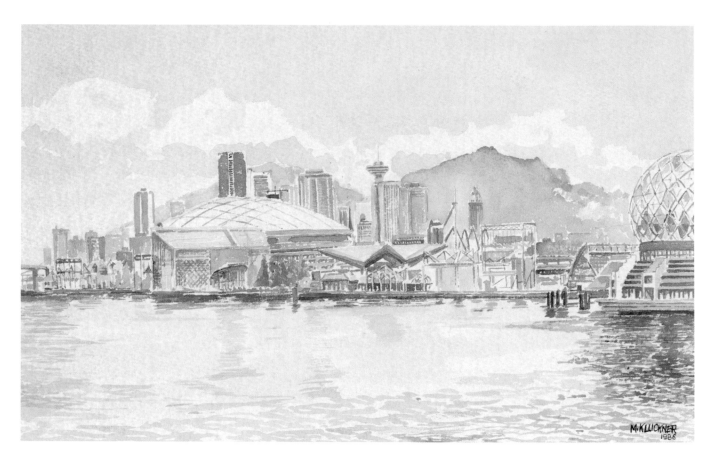

The Expo site, a transitory piece of the Vancouver landscape in January 1986, a few months before the fair opened. The Science World Omnimax Theatre on the right and the green-tinted Plaza of Nations were the only structures built to endure. The definitive record of the fair is The Expo Celebration, *published by Whitecap Books in 1986.*

bays extending northward at high tide into the area around Heatley and Prior, the site of a garbage dump and, at the beginning of the Great Depression, a "Bennettville" shantytown. The city's engineering office drew a plan in 1905 for False Creek docks, proposing a bascule span bridge at Main Street, much dredging of the flats, and a ship channel running northward to Burrard Inlet along the "canoe route" slough just west of Clark Drive.

However, with the chartering of the Canadian Northern Pacific Railway and the need of the American-based Great Northern Railway for more land than it had on the edge of Chinatown (page 61), the shipping news became a train agreement. The Great Northern Railway agreed to build a large terminus and exclude Asiatics from its labour force, among other terms. A few years later, in 1913, the city turned over the final 160 acres of the flats to the CNPR in return for the agreement to build the station, deep-water wharves at the foot of Main Street, and the Hotel Vancouver (page 77). Two out of the three were completed during the First World War.

Residential Vancouver

Strathcona

S trathcona is the last survivor of the 19th-century neighbourhoods that developed before there was any distance-busting streetcar system. Settlement even in the West End barely got started before the streetcar loop of Granville, Davie, Denman and Robson began to operate in 1895. As discussed in previous chapters, the other pre-streetcar neighbourhoods were the working-class area south and west of Victory Square and the Yaletown community, which was more or less self-contained and focused on False Creek and the CPR railyards.

Strathcona's survival is a tribute to the citizen activism of the 1960s and demonstrated how even poor people and ethnic minorities could shift the policy of senior levels of government. There are few other examples in Canada – Toronto's Cabbagetown is one – and fewer in the United States where citizens stopped the urban renewal and freeway juggernaut. By comparison, the 1960s rebellion in Kitsilano was more hedonistic, at least at the beginning; in the 1970s, when the community there came together around highrise and housing issues, the "enemy" was private developers with individual projects rather than governments pushing a utopian Trojan horse.

Writer and Strathcona resident John Atkin described the area as Vancouver's first neighbourhood and the "home of the working man."[1] It was also called the East End, originally an expression of pure geography to distinguish its school from the West End and Central ones; later, as it became the first port of call for non–Anglo Saxon immigrants, it was a derogatory one. East Enders were tough kids, JDs (for juvenile delinquents likely to end up in "Juvie Hall" on Yale Street in Hastings Sunrise). As the city evolved, the East End has become the East Side, this neighbourhood itself has become known as Strathcona after the official name for its school, the China Valley nickname from the 1950s has disappeared, and the skid road streets to the north have been rebranded as the Downtown Eastside.

It was also called a slum, especially in the 1950s when politicians and planners believed they had a social obligation to improve people's lives by uprooting them, bulldozing their homes and relocating them in modern-style buildings whose design evolved from architectural ideas proposed in Europe early in that century. Urban renewal was practised with devastating effect on American and eastern Canadian cities in the 1950s and 1960s. In the United States, "federal urban renewal and highway funding had laid waste vast areas of inner cities and downtown cores, spreading 'aggressive urban design and an impoverished version of modern architecture' across the urban landscape."[2] By 1967, American urban renewal and highway programs had displaced almost three-quarters of a million *households*; the riots in Detroit and the Watts district of Los Angeles, the garrison quality of "Fort Apache, the Bronx," and the flight of the middle class and its offices to the suburbs were the inevitable results.

PREVIOUS PAGE *Georgia Street looking east to Vernon Drive on a sunny autumn day. The retaining wall on the left levels the playground of Seymour School. A century ago, the local streetcar travelled this way, turned left at the corner in front of the store, then continued north to Frances.*

1 His definitive history is *Strathcona, Vancouver's First Neighbourhood,* Whitecap Books, 1994.

2 John Punter, *The Vancouver Achievement,* p. xvii.

Vancouver had a particular advantage even over other Canadian cities such as Toronto, in that the federal boodle was slow to arrive. By the time it did, everyone could see what had happened to inner-city neighbourhoods, even just three hours away by car in Seattle. Issues of social justice found common cause with environmental and cultural questions for the first (perhaps the only) time.

The collection of houses, shops and streets that community members set out to protect was the most diverse ever seen in Vancouver. Sometimes several houses were shoehorned onto single lots. There were rowhouses, small apartment buildings, bakeries, auto-repair garages and small factories. An example of unfettered capitalism in an age with few regulations on private property, Strathcona started out with one big owner – the Vancouver Improvement Company – and hundreds of small entrepreneurs and builders. The result, seen from the perspective of the 1950s and the orderly west-side neighbourhoods in which most city politicians and planners lived, was an irrational mess certain to support lawlessness, poverty and disease.

Houses at Gore and Union with, in the right background, one of the towers of the 1963 MacLean Park urban renewal project peeking through. In the foreground, the 1900 cottage at 808 Gore was already in bad repair when I painted it in 2005, and by 2006 was burnt out and boarded up. In the city's plan, an eight-lane freeway was to run across this land and join up with the Georgia Viaduct one block to the west (left).

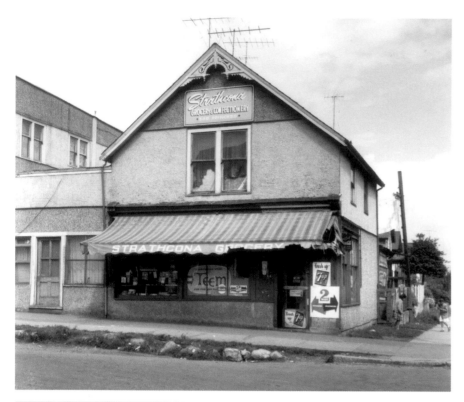

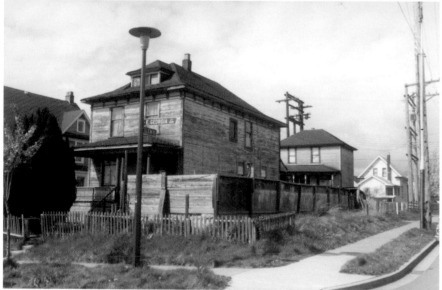

ABOVE *Old Strathcona – a grocery store at Princess and Keefer next to the school about 1960. (Photographer unknown)* JOHN ATKIN

BELOW *An unrestored house in the 1980s at East Georgia and Glen in the Kiwassa neighbourhood, the enclave east of the Raymur Housing project.*

The Vancouver Improvement Company, controlled by a group of businessmen headed by wholesaler and future politician David Oppenheimer, offered lots for sale in 1886 at an average price of $350. To complement the Hastings Mill at the foot of Gore Avenue, they set out systematically to attract industry to the eastern waterfront. Oppenheimer, for example, donated land to B.T. Rogers for his new sugar refinery at the foot of Glen Drive[1] and, sitting in the mayor's chair, negotiated tax and water concessions for it. Another Oppenheimer investment was the Vancouver Electric Railway and Light Company, whose first piece of track connected the refinery's part of the waterfront with downtown in 1890. Such was the way cities were built a century ago. In ensuing years, streetcar tracks extended east from Main along Georgia Street to Vernon, then went north and east again along Frances Street to Victoria Drive; the granite blocks that ballasted the tracks still exist on Frances from Vernon to Commercial Drive.

The local school opened in 1887 at Jackson and Cordova but soon moved to grand new buildings two blocks south at Pender; in 1900 it was named for Lord Strathcona – the CPR's rags-to-riches president Donald Smith – no doubt an inspiration for the locals. The students were as diverse a set as the neighbourhood's buildings. In the 1920s, about half the enrolment was Japanese due to the proximity of the Powell Street community (page 55), plus Chinese from Chinatown to the west, Italians who mostly settled along Union, Scandinavians who attended the Lutheran church (now a Chinese Catholic one) on Pender at Princess, Ukrainians who settled farther east on Pender around Hawks, and Jews whose synagogue stood on Pender at Heatley. Not surprisingly, the school was nicknamed the League of Nations.

There was a small black population, too, in houses east of Main on Union, Prior and Keefer, including Jimi Hendrix's grandmother, who had arrived from Tennessee in 1911. Unfortunately, two of the most notorious killings of the era involved black men, fanning the undercurrent of prejudice and con-

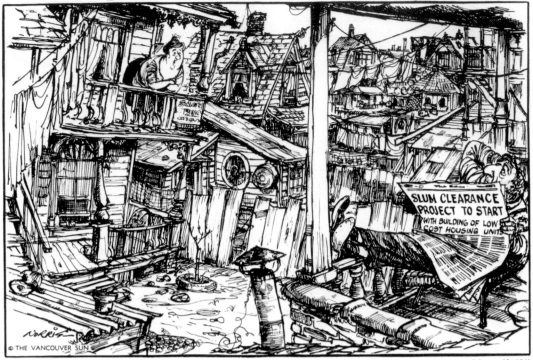

February 13, 1960

"D'you s'pose they'll move us into some characterless row of rabbit hutches they're talking about?"

tributing to the brief rise of the Ku Klux Klan in the 1920s. In the first one, a black drug addict from Detroit who was holed up with a white prostitute in rooms above a store at 522 East Georgia Street killed a local boy and the chief of police before taking his own life; in the other, a man from Florida killed a police officer and Victoria Cross winner in a gunfight on Granville Street near the Austin Hotel. When Vancouverites thought of crime in the 1920s and 1930s, they usually thought of Hogan's Alley (see map, page 105). It was said to be a hotbed of bootlegging, loansharking, and illicit boozing, occasionally visited by "frat-rats" from UBC intent on stirring up even more trouble. It was erased from the map by the new Georgia Viaduct in the 1970s.

Industrial jobs were the first to go in the Depression and Strathcona was hit harder than anywhere in the city other than the Yaletown/Downtown South neighbourhood. Transients and hobos riding the rails ended up in tent and shack camps on the edge of the False Creek railyards, and soup kitchens organized at the First United Church at Gore and Hastings by the firebrand Reverend Andrew Roddan concentrated the homeless within walking distance. Most of the rallies of the unemployed took place nearby in Oppenheimer Park, and Strathcona School was actually invaded by protesters in 1935. During the Second World War, there was further disruption when the Japanese community was removed en masse from the coast and residents of Italian descent were put under surveillance by the RCMP.

Throughout those years, local businesses like Benny's Market at Union and Princess somehow survived, extending credit when they could. Alfonso Benedetti started in Vancouver in 1909 with an ice cream parlour and opened his Strathcona store in 1917. With his wife, Violet Teti, their son, Ramon, and daughter-in-law, Irma, they kept changing and expanding the business to keep it afloat, becoming major importers of Spanish and Portuguese products, as well as their Italian staples, and supplying Italian stores and work crews all the

Sun cartoonist Len Norris, who lived in West Vancouver, had a colourful imagination when it came to city neighbourhoods. His earlier "Peace on Earth" cartoon (page 31) shows a mix of buildings not unlike Strathcona except for the curving street. It is harder to read his feelings in this 1960 fantasy of the Strathcona "slum." Did he have a live-and-let-live attitude to the poor people and their deteriorating housing? Given his constant lampooning of the denizens of "Amblesnide" and "Tiddlycove," who could never see the folly of their own actions, he was probably laughing at what he thought was people's blindness to their own circumstances. But who in Vancouver in 1960 actually knew what housing project life would be like?

USED WITH PERMISSION

1 See *The Refiners: A Century of B.C. Sugar* by John Schreiner, Douglas & McIntyre, 1989.

way up the coast to Prince Rupert. Other families near the False Creek flats made ends meet by keeping cows in small back-alley barns and grazing them around the railyards.

As if the poverty and upheaval of the 1940s were not enough, Strathcona had to deal with academics in search of blighted areas. UBC professor Leonard Marsh and his students examined Strathcona and found a large percentage of houses that were, in their opinion, in poor condition. In 1958 the city came to the same conclusion, again focusing on a few blocks that did not reflect the majority of streets or the wishes of the occupants. With the arrival in the 1950s of a large number of Chinese immigrants who helped form the Chinatown Property Owners Association and dubbed the area China Valley, Strathcona began to have a cohesion that it perhaps had lacked in the past. Nevertheless, the city started to renew the area, first by building a cluster of modern highrises on MacLean Park (bounded by Jackson, Dunlevy, Union and East Georgia) in 1963 and then demolishing all the buildings on a block further east bounded by Hawks, Heatley, Georgia and Keefer. A second project got underway just east of the Great Northern Railway tracks a few years later, creating the Raymur housing project.

City officials proceeded to buy up and clear houses by stealth, keeping as quiet as possible about city plans for a freeway running down the Union-Prior axis to downtown. When the plans were announced in 1968, the outraged residents found common cause with Chinatown merchants to the west and the entrepreneurs who had just started refurbishing old Gastown buildings (page 45). A loose coalition, including the Community Arts Council and a new generation of activist students and professors from UBC, quickly emerged to fight the freeway. In 1968 about 600 people attended the founding meeting of the Strathcona Property Owners and Tenants Association (SPOTA). Homeowner Mary Lee Chan, whose grandfather had come to Canada from Kwangtung in 1879, worked with her daughter, Shirley, to lead the fight. Their challenge included building bridges across the cultures and enlisting local people who were reticent and effectively powerless in the broader society.[1] They were assisted by, among others, lawyer, future mayor and premier Mike Harcourt and future councillor and provincial cabinet minister Darlene Marzari.

And the tide was running against the modernists and renewers. In 1969, the federal government decided to review its policies and froze all funds for further "improvements" to the area. The policies that emerged were much more incremental and sensitive to Strathcona. Most important from a community-wide perspective was the Neighbourhood

The Schara Tzedeck congregation worshipped in this building at Heatley and Pender from 1917 until 1948, by which time the Jewish community had largely decamped for the Oak Street area. The first purpose-built synagogue in the city, it replaced a converted house nearby at 514 Heatley. Subsequently it became the Gibbs Boys Club, named for sportsman Rufus Gibbs who donated it for the use of local boys; such clubs were once common in the poorer neighbourhoods of the city. In the 1980s, housing activist and developer Jacques Khouri converted it into condominiums. Khouri, a Kitsilano resident who was involved in affordable housing campaigns in the 1970s, went on to found the Inner City Housing Society, which incorporated 30 co-ops and built 1,200 units of housing in the city. He is currently president and CEO of Vancity credit union. The photo was taken about 1982.

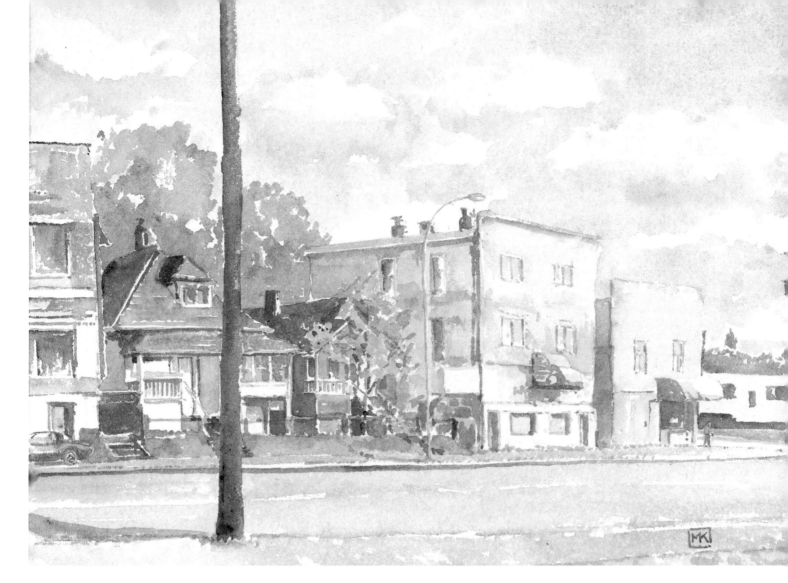

Improvement Program, while individual homeowners benefited from the Residential Rehabilitation Assistance Program. With Strathcona as the impetus, other older areas in the city eventually benefited, too. Kitsilano, for example, took nearly one-third of the RRAP grants (I received one in 1976 to fix the foundation of a duplex at 5th and Stephens that was sinking into a poorly filled creek bed). As for SPOTA, it went on to develop non-profit housing in the area.

By the late 1970s, the trickle of artists and renovators moving in became a stream. What had been seen merely as usable housing stock by the first generation of SPOTA members began to be appreciated as heritage buildings by a new group of inner-city enthusiasts and restorers. In the last two dozen years, a huge amount of private investment has revived houses that were merely propped up by the RRAP grants of a generation ago. With the maturing of the neighbourhood, the backyard vegetable gardens of Chinese families are now harder to find, whereas flower gardens are now practically everywhere. The gentrification of Strathcona has pushed back against the malaise of drug dealing and prostitution spilling over from the Downtown Eastside streets. It is still home to more artists' studios than practically anywhere else in the city and with the adjoining Kiwassa neighbourhood and the old warehouses around Venables and Clark Drive is the centre of the annual Eastside Culture Crawl.

Two of the last houses left on the north end of Clark Drive, at Napier, sharing the street with small false-fronted shops that have apartments above. All four buildings were erected in 1906–07. Both apartment buildings – the near one to a car alarm shop, the one on the corner to the Truck Stop Café – have had their original board siding covered with beer-bottle stucco and their windows replaced with cheap aluminum sliders, leaving them looking tawdry and forlorn. No wonder so many people see little value in keeping such buildings.

1 A detailed examination of the saga is "To Build a Better City: Women and Culturally Hybrid Grassroots Resistance to Slum Clearance in Vancouver" by Jo-Anne Lee and Mike Bruce at www.cpsa-acsp.ca/papers-2004/Bruce-Lee.pdf.

The West End & Stanley Park

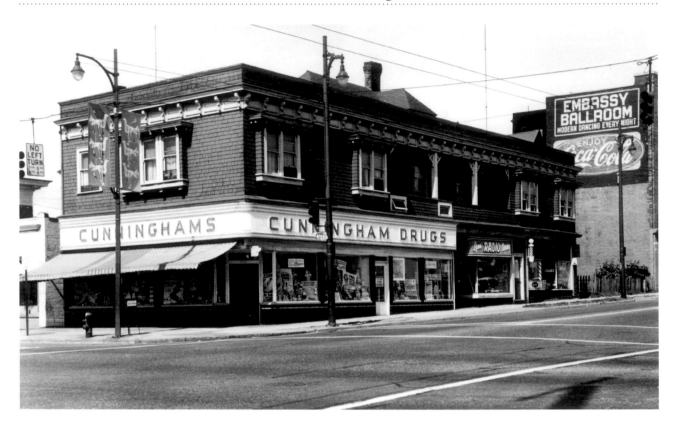

Davie Street at Burrard looking west in the 1950s. The Embassy Ballroom in the distance achieved even greater fame in the 1960s as the Retinal Circus (page 180). Cunningham's was a local chain of 35 drugstores started by George T. Cunningham (1889–1985). Born in a North Dakota oxcart, he moved to New Westminster at age two. His first drugstore opened in 1939 at the corner of Denman and Nelson. (Photo by A.L. Yates)
CVA BU P. 508-17

1 See Jean Barman's *Stanley Park's Secret* (Harbour, 2005), for details on the families and the land-title history of the park itself.

The peculiar geography of the downtown peninsula and a series of historical events created two of the city's greatest assets: the West End and Stanley Park. You will travel a long way before finding anything like the combination of quiet side streets, animated main ones, century-old wooden houses next to concrete highrises, wide views and intimate spaces, all in a square mile set between a modern business district and a huge, picturesque park. All city visitors somehow get to Stanley Park and are duly impressed; the few who wander in the West End are usually astonished.

Burrard Inlet before the railway's arrival in 1887 had a few scattered settlements. Stanley Park was an Aboriginal place, with the settlements of Chaythoos and Khwaykhway occupying shoreline between First Narrows and Brockton Point; in a fishermen's village of small frame cabins between Brockton Point and Deadman's Island lived a group of families including intermarried Aboriginal people and settlers. Near the foot of Denman Street on Coal Harbour, another group of families lived in the so-called Kanaka Rancherie.[1] Most significantly, because of the undisputed legality of their pre-emption, was the Brickmakers' Claim (District Lot 185 – the modern West End), owned since 1862 by the "Three Greenhorns," John Morton, Samuel Brighouse and William Hailstone; Morton occupied a cabin on the northeast

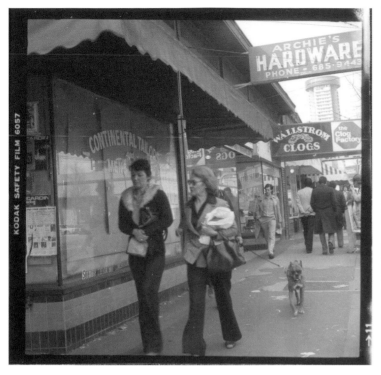

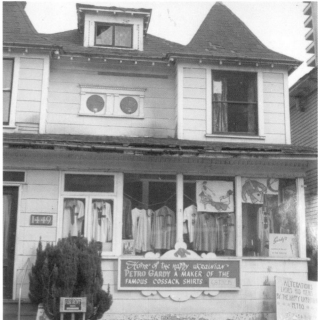

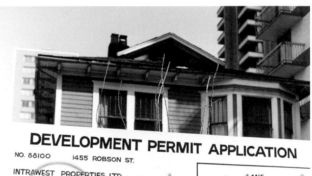

corner of their tract just west of modern Burrard Street. To the east of their land was a government reserve and, after 1870, the Old Granville Townsite; to the west was a military reserve established in 1860 both for strategic control over the First Narrows and, in theory, to provide a source of ships' masts. After some selective logging in the 1860s and 1870s by such legendary characters as Jonathan Miller, later the first constable in Gastown, it became Stanley Park in the 1880s.

The "Three Greenhorns" were so named because, according to the New Westminster Establishment, they had spent their money on a remote, useless block of land. Their plan of making bricks in the midst of the best building timber in the world came to naught, as the coal and clay deposits along Coal Harbour were not as extensive as they had hoped. The three argued and ended up dividing their land. Morton took the western part; the other two engaged partners, most notably the ubiquitous, wealthy merchant David Oppenheimer, and subdivided in 1882. Using the appealing name City of Liverpool, they attempted to market it but were too far ahead of the wave. Even before the Canadian Pacific Railway arrived, they agreed to donate one-third of their lots into the land grant given to the CPR as part of the gratuity brokered by provincial premier William Smithe.

Over the next 20 years, the West End streets completely filled with houses, smaller ones nearer the city, grand homes above Sunset Beach and near Stanley Park. Davie, Denman and Robson became the shopping areas, connected by streetcar with downtown. In the years just before the First World

Robson Street shops about 1980, showing the combination of "neighbourhood" and "funky" before the arrival of the plate-glass blandness of the modern fashion strip. Some residents were enthusiastic about redevelopment.

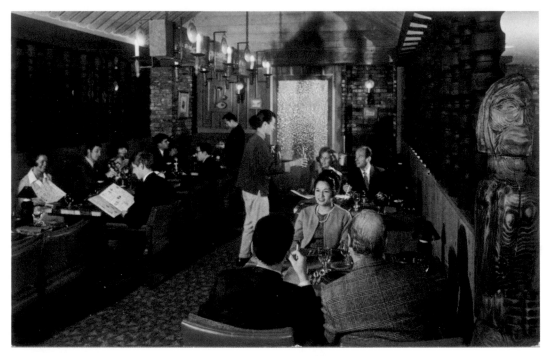

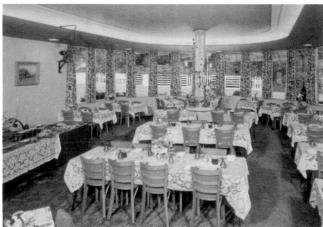

DINING ROOM
CAPILANO GARDENS RESTAURANT
657 Marine Drive, West Vancouver, B.C., Canada

Vancouver restaurants in the 1960s:

ABOVE *The Three Greenhorns opened in the lower level of Denman Place, a 32-storey hotel complex completed in 1969, just at the point when people were looking for new types of restaurants. Rather than providing anything really new in the way of food, it was "themed" like the Keg and Cleaver, the Old Spaghetti Factory or Victoria Station (locations of which always had a train car incorporated into the restaurant). The postcard shows one of the rooms, Morton's Shack, "decorated with old reclaimed bricks which may well have been manufactured by Potter Morton more than 100 years ago." Another postcard featured "The Ship Room . . . steeped in tradition with portraits of our early discoverers, old ship models and charts. It is dedicated to the* HMS *'Plumper' and Captain Richards."*

LEFT *More typical of Vancouver restaurants in the fifties and sixties was Capilano Gardens at Park Royal, featuring "Smorgasbord of Canadian Foods and Steak and Roast Beef Dinners. Banquet and wedding receptions." (Photographers unknown)*

War, apartment buildings replaced some houses, and most of the remaining family homes were converted into rooming houses or flats by the time of the Second World War. Poverty in the 1930s and housing and *matériel* shortages during the booming wartime economy ensured the retention, yet slow deterioration, of the West End's buildings.

It was this mix of affordable places on the edge of downtown that provided a milieu for the culturally diverse, cosmopolitan residents of the city. One example was the house at 1216 Robson, home and gallery of the nationally famous photographer-artist John Vanderpant. Robson became the city's first ethnic shopping street, dubbed Robsonstrasse for the German/European flavour of many of its shops. There were the European News, Mozart Konditorei and Schnitzel House, for example, but equally there were Galloway's and Vincent's for specialty foods and cheeses, Murchie's for coffee and a range of such neighbourhood shops as greengrocers and hardware stores. It was a far more diverse and interesting street, both commercially and architecturally, than the international fashion mall it has become in recent years.

On Robson Street and in Gastown, the Vancouver culture of dining in hole-in-the-wall restaurants developed in the 1960s. Before then, most evenings out involved steaks (Hy's Encore at 637 Hornby, for example), fried chicken, ribs or smorgasbords, with many popular Chinese ones being "all you can eat." A really sophisticated meal started with a shrimp cocktail, and in a good place the salad came with a choice of dressings. Many people combined a pleasant drive in the family car with a meal: the White Spot (page 211) and Delmar's fashionable Flamingo Room at 8615 Granville gave the option of car service. In Burnaby, the Gai Paree (page 229) and the Rob Roy at 1381 Edmonds were regional destinations; Dolphins, near Totem Park at UBC, was another favorite. Oscar's at 1023 West Georgia was a "popular spot with the entertainment world."[1] Otherwise, people went to supper clubs like the Cave on Hornby or to hotel dining rooms: the Hotel Vancouver, the Sylvia, the Grosvenor, or the Astor on Kingsway.

As food writer James Barber recalled, "The Italian Village on Robson Street was developing a sophisticated technique with the wine that patrons brought with them in brown paper bags: they would take it from you at the door, rapidly set a cup and saucer for everybody at the table, and – the wine still in the paper bag – pour a little into the teacup of the host for his approval."[2] Barber, and later Jurgen Gothe, wrote about food and restaurants with an amusing touch that encouraged people to try new places and types of food, while the *Sun*'s Alex McGillivray ate several courses and focused on his personal friendships with the owners.

Maurice Richez was one of a small group of French restaurateurs who changed Vancouverites' palates a generation ago. Born in Paris in 1928, he joined the French army as a young man and became a paratrooper, decorated for his service in the Korean War. After a tour of duty in French Indochina, he became fed up with both the army and his homeland and immigrated to Canada. He started in Burnaby at the Astor Hotel in the 1950s and worked

Maurice Richez was a personage on the Vancouver restaurant scene in the 1970s and early 1980s, often seen around town in his Excalibur exoticar with PARIS *license plates. I drew caricatures in 1982 of him and his chef, Patrice Suhner, for the menus at Au Café du Paris, his bistro on Denman near Alberni.*

1 Reviews in *Western Homes & Living Magazine,* May, 1956, p. 63.

2 From the *Georgia Straight*'s 30th anniversary issue, May 8, 1997.

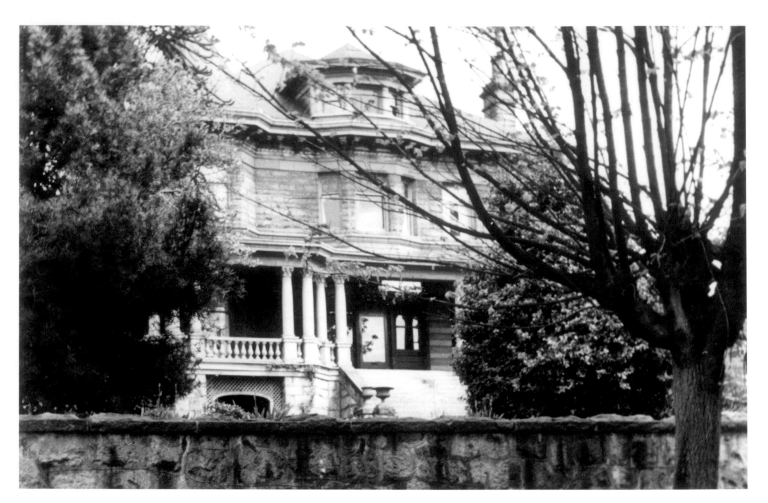

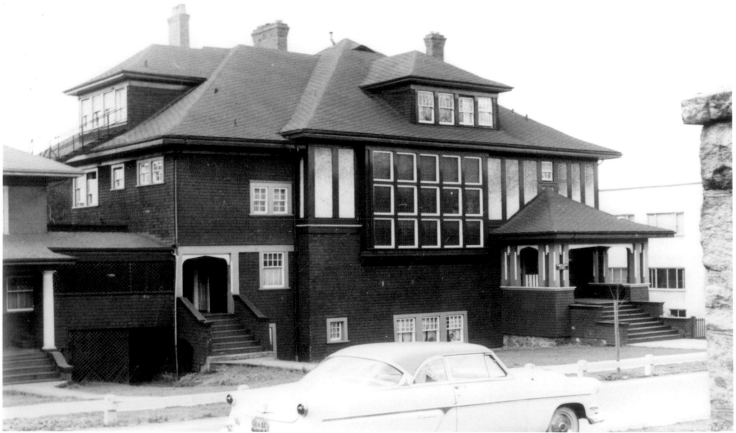

for years for other people, then in 1968 opened the first real French restaurant in the city: La Côte d'Azur, in John Vanderpant's old house at 1216 Robson. Within a few years, Enrico Pietrobruno opened Lili la Puce nearby on Alberni Street, and Le Petit Montmartre and La Crêperie opened in Gastown. A decade later, "Monsieur Maurice" moved down Robson to Denman and opened "Au Café de Paris," still one of the most appealing bistros in Vancouver. Like his compatriots, Richez loved dogs and hunting; he retired to a rural property in the mountains east of Princeton in 1985, taking with him his collection of guns and vintage wines and cars. He died in 1999.

In the 1950s and 1960s, a neighbourhood of beautiful old houses made way for apartments on the blocks above Sunset Beach. The old houses reflected Victorian-English values, filtered through the lens of the well-established Ontario town. The photographs by A.L. Yates reproduced on these pages show mature landscaping, stone walls, and rambling, picturesque wooden buildings, a far cry from the rather austere streetscapes dotted with nondescript buildings that have taken their place. Many of the worst rooming houses burned before they could be demolished, some no doubt by arson, others from bad wiring, short circuits, cheap hot plates or bedtime smokers. I had a 15th-floor apartment on Harwood in 1975 and recall the throngs of curious onlookers walking from all directions to witness the spectacles. Fortunately for our sense of our past, this old West End aesthetic survives in Shaughnessy Heights.

A century ago, the south slope of the West End peninsula above Sunset Beach and English Bay was the most fashionable address in the city. The wealthy in Vancouver were astonishingly restless, as only 10 years earlier they had built grand houses on "Blueblood Alley," the north slope of the peninsula west of the CPR waterfront and the compact downtown. But no sooner had they reestablished themselves and their gardens than the rush began for Shaughnessy Heights, led by West End resident A.D. McRae. One of the families that hung on the longest was the Rogerses, who stayed in Gabriola at 1531 Davie Street until 1925, albeit due to the impossibility of finishing their huge Shannon estate (page 208) during wartime and the sudden death of B.T. Rogers at the age of 53 in 1917.

Gabriola was completed in 1901; it was among the earliest of the grand houses and is the only survivor. B.T. Rogers had made his fortune with his sugar refinery in the decade before he built this house. His across-the-street neighbour, wholesale grocer Robert Kelly, had also prospered selling to Klondike gold seekers and new migrants to the province. They and their neighbours were young, nouveau riche, hard-driving businessmen, barely in their 30s when they became successful. Rogers, for example, was 36 when he moved into Gabriola. Kelly and his fellow grocery magnate W.H. Malkin were almost exact contemporaries. Other Establishment figures, such as Henry O. Bell-Irving and Sir Charles Hibbert Tupper (who had a grand home near Stanley Park), were about 10 years older. The photographs that survive in public collections of these men were

ABOVE LEFT *The home of contractor Alexander Morrison at 1185 Harwood in the mid-1950s, when it was the Margaret Private Hospital. (Photo by A.L. Yates)*
CVA BU. 508.27

BELOW LEFT *The 1907 home of Henry O. Bell-Irving at 1210 Harwood in the 1950s. It was converted into 19 suites by the Bell-Irving Insurance Agency in 1931. (Photo by A.L. Yates)*
CVA BU. 508.69

BELOW *B.T. Rogers, West End resident and owner of the B.C. Sugar Refinery, drinking cocktails with two friends on his steam yacht* Aquilo *about 1912.*
JANEY GUDEWILL

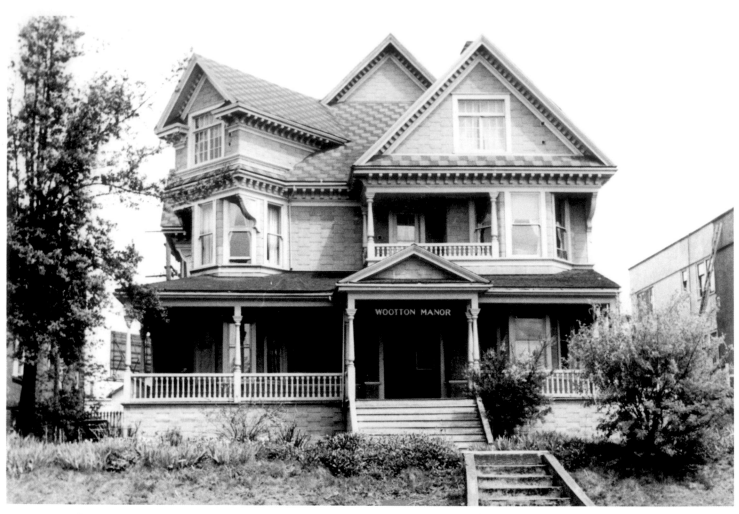

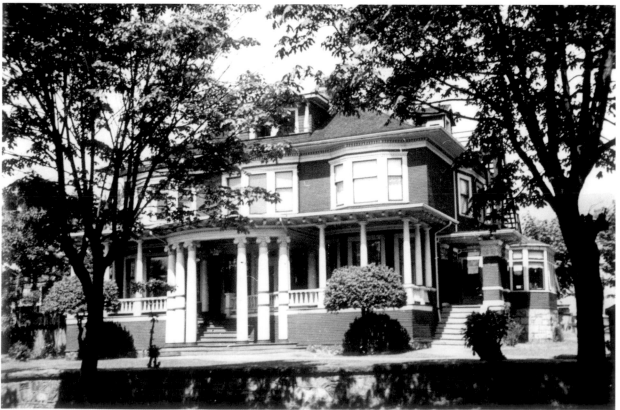

usually taken in their mustachioed, portly middle age and do not reflect the young person's town that Vancouver was; the youth of their wives was similarly disguised by the formal clothes and poses of portraiture.

Richard V. Winch, whose name survives on the building at the Hastings and Howe corner of the Sinclair Centre, was 32 and flush with a fortune from salmon canning when he built his mansion at 1255 Comox in 1894. The newspaper descriptions of it at the time of its demolition in 1955, three years after his death there, described adjoining billiard and ballrooms each more than 40 feet long, solid oak billiard tables, a mahogany staircase and a bathroom with a 600-pound marble tub. The converted coach house once held a pair of Rolls Royces. Lumberman John Hendry built a similar house at 1281 Burnaby in 1903, but moved only a decade later to 3802 Angus Drive; Helen Gregory MacGill, the first woman judge in BC, occupied a flat in the house in the 1940s. CPR official William F. Salsbury, the civic-minded treasurer of the railway's Pacific Division, built a large home at 1340 Burnaby but followed the crowd to Shaughnessy Heights soon after. Some of the "who's who" turned developer: W.L. Tait, for example, demolished three houses across the lane from his Thurlow Street home, built a 54-suite apartment block, then moved to his behemoth Glenbrae, now Canuck Place, in Shaughnessy Heights.[1] Always there were greener pastures for the wealthy, who left in their wake the picturesque, decaying rooming-house landscape preserved in the photographs on these pages. Never again was there the formality and proximity of Vancouver's high society[2] – more recently, bohemians and gays have created the kind of tightly knit community that the elite once had in the West End.

ABOVE LEFT *George Coleman's 1901 house at 1221 Burnaby, in 1956, when it was divided into rooms on a portion of its original 132-foot-square lot. (Photo by A.L. Yates)*
CVA BU. P. 508.64

BELOW LEFT *Cannery-owner Duncan Rowan's 1912 house at 1201 Pendrell, photographed in 1956 when it was "The Pillars," a 12-suite apartment building. (Photo by A.L. Yates)*
CVA BU. P. 508.82

BELOW *The Buttimer house at Pendrell and Bute being demolished in 1956. George Buttimer was a pioneer salmon canner and partner in Dawson and Buttimer. (Photo by A.L. Yates)*
CVA BU. P. 508.71

1 Wynn and Oke, eds., *Vancouver and Its Region*, p. 133.
2 The diaries of Mrs. B.T. Rogers describe the West End's rituals in great detail: see *M.I. Rogers 1869–1965*.

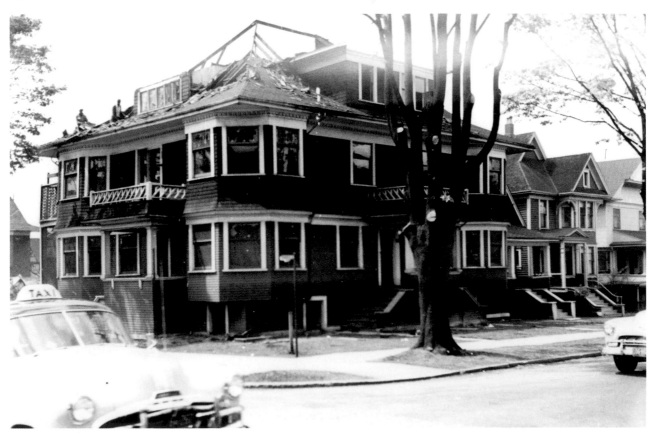

A postcard photograph from about 1915 showing the Comox Street side of Mole Hill as it originally was. The block of housing on the left was demolished in the 1970s for parkland, a fate that seemed certain for the other side of the street until citizen action in the 1980s and 1990s convinced city council to rehabilitate its houses. In the left distance, the 1912 seven-storey Caroline Court at 1058 Nelson pointed the way to the West End's high-density future. (Photographer unknown, John Valentine & Sons postcard)

1 Obituary and article published in the *Sun*, September 13, 1999.

2 See *More than a House: The Story of Roedde House and Barclay Heritage Square,* by Janet Bingham, 1996.

Ironically, modest West End housing fared better than the mansions, which were easily picked off as apartment sites. A few isolated houses on single lots have been well maintained by their owners, though most groups that could be consolidated were demolished for apartment development. An exception was the houses on the 1300-block of Comox Street, bought by speculator Alex DiCimbriani in the 1960s, painted black and white and rented out as the Elizabeth and Erkindale Apartments. DiCimbriani, who dubbed himself "the proud mayor of a city within a city," shunned the public spotlight after convictions on gross indecency charges and a $550,000 settlement to a group of bilked investors, including former premier Bill Vander Zalm.[1]

Two other blocks of modest houses survived into the 21st century. Both had been assembled by the city with the intention of clearing them and developing standard-design parks. The first, bounded by Haro, Broughton, Barclay and Nicola, contained several architecturally and historically significant houses, most notably the turreted 1893 home, said to have been designed by a young F.M. Rattenbury, of the Roedde family of printers and bookbinders. After a protracted preservation campaign led by the Community Arts Council and supported nationally by the Heritage Canada Foundation and writer-historian Pierre Berton, the Park Board caved in and allowed nine of the houses, occupying one-third of the block, to remain. Roedde House is now a museum and the other buildings have public or non-market housing uses.[2]

The double block from Nelson to Pendrell west of Thurlow was also slated to become parkland. The northernmost half was cleared in the 1970s and landscaped into an undistinguished sward that, as the years went by, seemed best at attracting drug dealers, prostitutes and the homeless. Meanwhile, the tenants on the block bounded by Comox, Pendrell, Bute and Thurlow began to organize to try to preserve their homes. For a time in the late 1980s, it looked like the Park Board would create a little petting zoo by moving a handful of the houses to Pendrell Street while clearing off the rest of the site, but the persistent tenants, led by Blair Petrie, eventually convinced city council to rehabilitate the entire block using provincial government low-income housing money. Now known as Mole Hill, after the nearby home of resident Henry Mole (whose pioneer farm is now Point Grey Golf Course), it is a showpiece of early Vancouver painted in original "true colours" using the Vancouver Heritage Foundation's authentic local colour palette, with gardens in the back lane and small landscaped walkways threading though the middle of the block.

The block includes market housing, subsidized family housing, a daycare centre and the Dr. Peter AIDS centre, reflecting

(text continues on page 126)

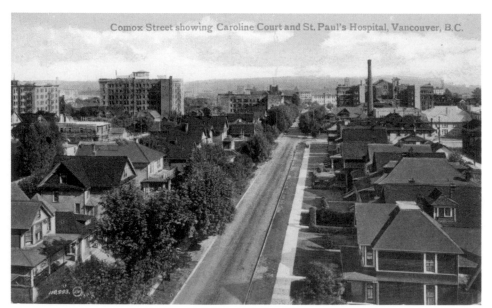

Comox Street showing Caroline Court and St. Paul's Hospital, Vancouver, B.C.

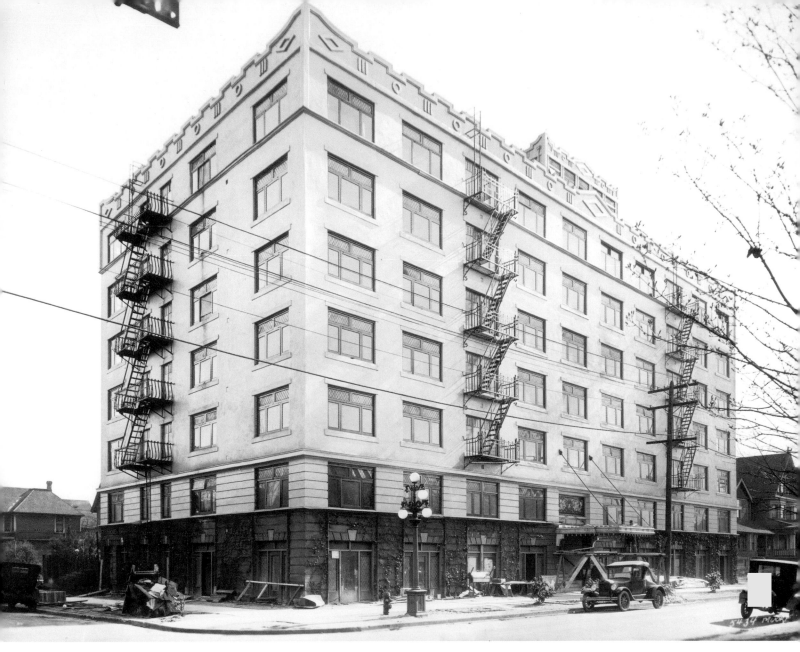

ABOVE *Strathmore apartments at Comox and Bute, built in 1909. At the time of the photograph in 1927, it was being repaired after the city's worst-ever loss-of-life fire, when eight people died after a painter's varnishes caught fire on a hot July day. The photograph was included in a city planning report arguing that buildings such as it were too dense and recommending a low-rise, garden apartment style like Tudor Manor on Beach Avenue. (Photo by W.J. Moore)*
JOHN ATKIN

RIGHT *The Central Presbyterian Church at the northeast corner of Thurlow and Pendrell, photographed in the 1970s by John Clarke. It was demolished for expansion of St. Paul's Hospital. Clarke (1945–2003) was a well-known mountaineer, making over 600 first ascents in the province.*

ABOVE *The 1898 Queen Anne–style home of dentist C.B. Mansell at the northwest corner of Nicola and Barclay, photographed in the fall of 1982. It had been a rooming house since the early 1930s.*

BELOW *Another, more substantial Queen Anne with granite foundations awaiting demolition at the northeast corner of Broughton and Barclay in the fall of 1982. Medical doctor F.T. Underhill built it in 1897; by 1920 it was known as Broughton Lodge, "a large residence now used as apartment house," according to city water-department records.*

RIGHT *The block between these two houses was owned by the Park Board and slated for demolition to provide open space for the apartment dwellers of the neighbourhood. In an innovative decision following years of citizen pressure, nine buildings were kept on their original sites with open space crafted around them to provide an oasis in the middle of the concrete desert. In recent years, every shelter on the open spaces, such as the gazebo at Broughton and Barclay, has been occupied nightly by the homeless. I painted the watercolour from the bar in the Empire Landmark on Robson Street.*

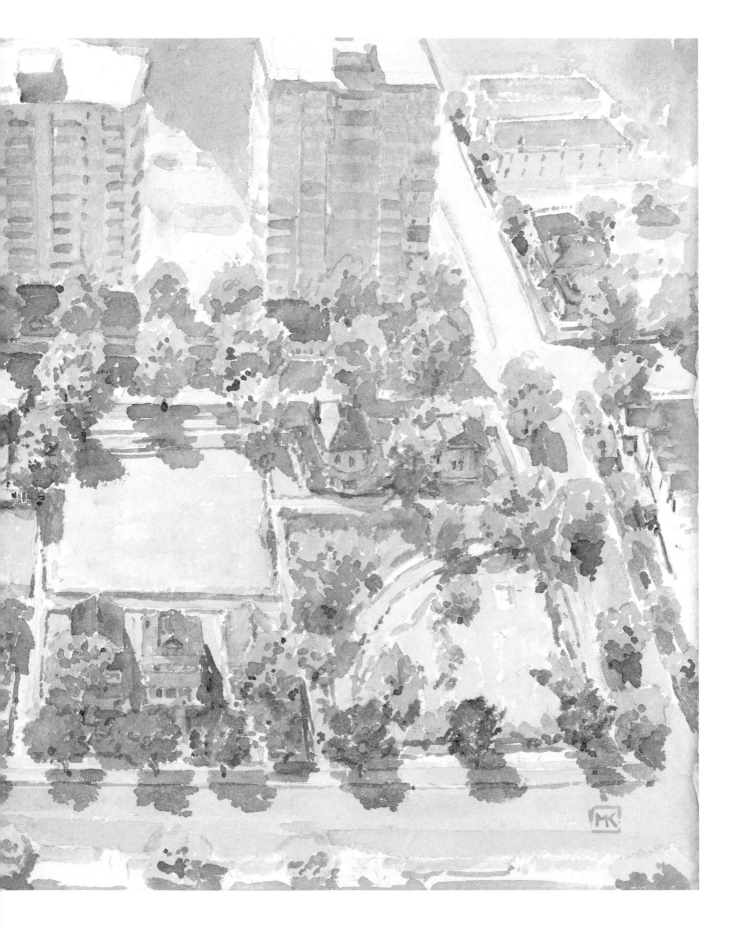

August 11, 1959

". . . at that stage the stonemasons went out . . . then the steel men . . . fortunately at the very end there happened to be a thatcher in town."

ABOVE *The only thing that stood in developers' way in the West End was the notoriously bad union-management relations of the 1950s.*

USED WITH PERMISSION

NEXT PAGE *The West End from above Lost Lagoon in 1965; the red roof of the old William McNeil estate at 1945 Barclay is a visible survivor of the mansions that once bordered Stanley Park. (Photo by Herbert L. McDonald)*

the work of AIDS diarist Dr. Peter Jepson-Young (1957–1992), on a formerly vacant lot at 1110 Comox. The lane house behind Umberto's Restaurant now occupies a narrow lot on Pendrell Street (page 94). The Strathmore apartment building at the corner of Comox and Bute is privately owned.

By 1915 there were about 50 apartment blocks west of Burrard Street, most of them small walk-ups. A handful, including the 1909 Strathmore, the 1909 Beaconsfield at 884 Bute, the 1910 Holly Lodge at 1210 Jervis, the 1912 Kensington Place at Nicola and Beach and the 1912 Sylvia Court at Gilford and Beach, were substantial, multi-storey masonry structures that could have sneaked in from a large eastern city. The inference in these early buildings was that one could maintain a refined lifestyle there, with some suites even featuring a small maid's room off the kitchen — they were not for itinerant salesmen or other rootless tenants.

The West End landmark from the early years is still English Bay's beloved rendezvous — the Sylvia Hotel, which started life as an apartment block. In 1912, in the middle of the city's greatest building boom, developer Arthur Goldstein engaged architect W.P. White to construct a seven-storey landmark that *was* the West End skyline until the 1950s and named it after his 12-year-old daughter Sylvia. It is interesting to imagine the West End if Goldstein's "brownstone" style had caught on. Instead, there was almost no construction along the seashore for more than 20 years, and when new apartments began to emerge along Beach Avenue and on the adjoining streets they were typically stripped down Moderne walk-ups, stucco-clad, with windows set in horizontal bands on the plain facades.

The big change began in 1956, when the city permitted the construction of the 18-storey Ocean Towers on Morton Street. It was soon followed by the Imperial Apartments on Bidwell across from Alexandra Park, erected in 1963 by developer and future mayor Tom Campbell (page 81). Its 266 small apartments were ideal for the singles with downtown office jobs whose lifestyles changed the formerly demure standards on the beach and supported the myriad restaurants that began to line streets such as Denman and Robson. In 1964, when the city again changed its regulations and omitted balconies from its floor-space calculations, outdoor space grew and new buildings were designed with more articulated, less slab-like facades. In this new West End, instead of looking over back-lane picket fences to see the neighbour's junk, one had only to look up at the balconies, which became convenient storage places for bicycles and other gear!

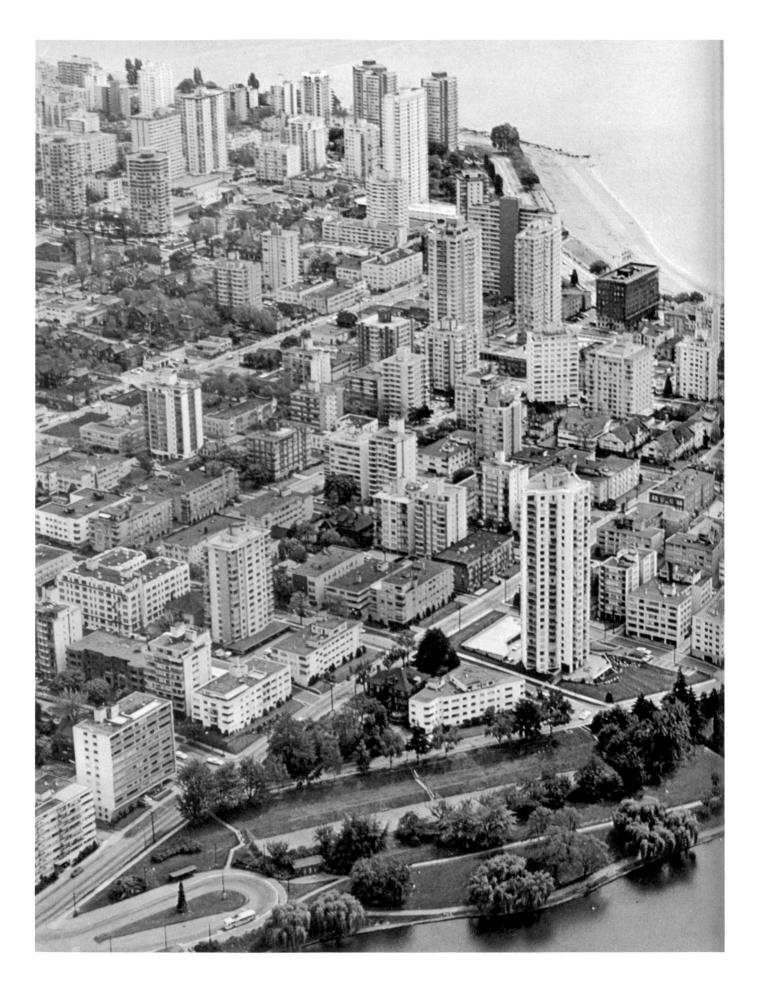

THE WEST END & STANLEY PARK

The 26-suite Chatsworth Apartments at 1950 Robson provided affordable rental accommodation; in the housing shortages of the sixties and seventies, suites were passed from friend to friend by word of mouth, with few ever coming onto the rental market. It was demolished not long after I took this photograph in 1982 and replaced by a low-rise condo containing 48 small suites.

1 See the comments about affordability in the preface on page 13.

2 See Kalman, *A History of Canadian Architecture,* vol. 2, p. 805.

3 Wynn and Oke, eds. *Vancouver and Its Region,* pp. 240–42, provides an interesting micro-geography lesson.

Statistics show that between 1941 and 1981 the population of the West End doubled; during the middle part of the period the number of dwelling units quadrupled, reflecting reductions in household size as individuals were able to live alone, for better or worse, in the modern new apartments. Even an unrequited nostalgist for the rooming-house era, like me, recognizes that the living conditions in those cheap old places were often appalling.[1] It was an interesting juxtaposition of events: in the late 1940s, the Vancouver engineering firm Read Jones Christofferson developed a "flat-plate" construction technique[2] that, together with the small lot assemblies in the West End, allowed developers to erect quite narrow and relatively elegant high-rise apartment buildings, different from the monolithic slab-sided towers that were wrecking, for example, Toronto neighbourhoods. These buildings fitted in to the Edwardian streets (where the typical mansion had occupied four 33-foot lots), concealed to a degree by the boulevard trees and other landscaping. Heated, uncovered year-round outdoor swimming pools – in an age of ultra-cheap natural gas – occupied low podiums beside the towers and gave a view of trees and sky. Meanwhile, all of the novelties of the age, from birth-control pills to low unemployment to affordable higher education, caused young people to search for optional ways of living. Although Vancouver had always been a home-owning culture, it took to the apartment-living, restaurant-dining, hanging-out style of the West End with aplomb. Later, in the 1970s when the gay culture began to flourish, this new West End provided the perfect template for the growth of that community along the Davie Street "strip."[3]

Home living and decorating magazines quickly picked up the trend. In its May 1956 issue, *Western Homes & Living* featured two single-family homes, one apartment designed for family living (see page 204) and two apartments implicitly decorated for childless couples. One was a garden apartment in Capilano Highlands, while the other was a standard West End apartment of three rooms, "architecturally quite conventional." The young couple, identified as Michael and Barbara Ryan, were newlyweds "whose tastes in music, art and decorating are definitely Contemporary [sic] . . . Because this was their first home, they were fortunately able to furnish it 'from scratch' according to their own tastes. Several of the pieces were well-chosen wedding gifts. Others were selected for design, utility and the usually modest budget of young homemakers."

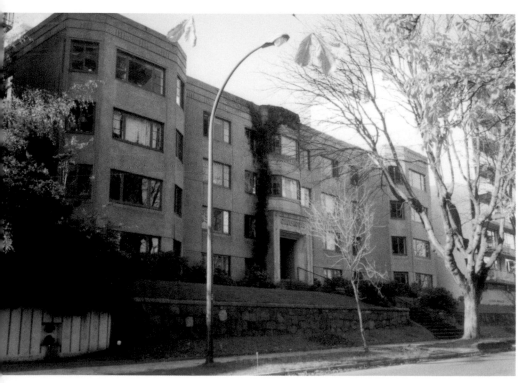

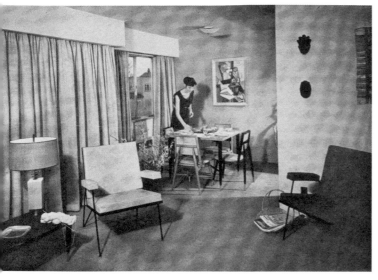

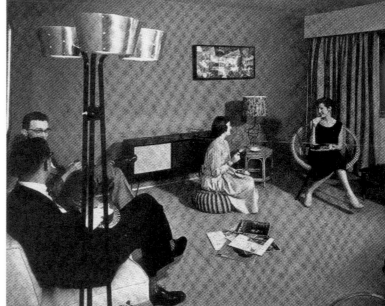

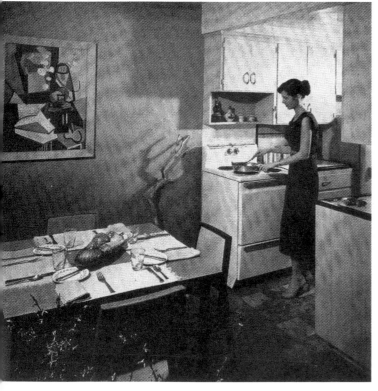

A set of photographs by Selwyn Pullan for Western Homes & Living magazine showed the possibilities of living and entertaining in a one-bedroom apartment somewhere in the West End in 1956. The kitchen-dining room pictures on the left show it to be a standard L-shaped living area. The walls are turquoise and bamboo colours, the drapes unbacked burlap, and the natural-coloured sisal carpet is laid wall to wall. The mahogany dining room suite in black and natural finish was designed by Raymond Loewy. Artwork includes contemporary abstracts by Jack Shadbolt and Donald Carter,

African tribal masks, a tappa cloth map from Samoa and Mexican gourds as a table centrepiece. The floor lamp in the living room photo has a wrought iron stand and perforated brass reflector, while the table lamp was copied from a Calder mobile. The foam rubber settee has a built-in end table. The article noted that the "Hi Fi set" in its cabinet formed the social focal point of the living room, a substitute for the conventional fireplace. Television had just been introduced into Vancouver three years earlier. (This suite would be the height of fashion again in 2006, it seems.)

The tallest and broadest West End highrises are the oldest. The earlier of them arguably had negative impacts on the community, such as the slab front of Ocean Towers, attractive enough on the beach side but flaunting its backside (just hallways) and parking lot to its northern neighbours. City planners gradually got better at using their discretionary zoning power to insist upon, for example, underground parking. So successful was the new bylaw, and so profitable for developers, that as early as 1963 planners were suggesting that the West End was becoming too dense. The business-oriented city council, mindful of the hand that fed it, refused to slow the pace. Regular design review and a downzoning happened more than 20 years after the boom began. A perhaps unintended consequence of the downzoning is the incentive to maintain the old highrises, which are taller and more dense than any replacement building could be. Thus, the West End seems to be avoiding the cycle of deterioration, demolition and replacement that uprooted people more than a generation ago and creates the constant flux in other cities' neighbourhoods.

The blocks of the West End around the corner of Davie and Denman have, since the 1890s, developed as a kind of beach resort, evolving gradually from wooden cottages and a log-strewn bathing beach into an apartment and condominium area of multimillion-dollar view suites. It is the most public of the promenading spots in Vancouver – a mixture of homeless people with shopping carts, vendors with hotdog carts, sunbathers and wandering lovers of every gender and style. In spite of the anomie of the modern city, it is still cherished as a public place; thus, the poisoning of several street trees by condo owner June Matheson in the spring of 2004, ostensibly to regain the view she had lost during 20 years of living there, was taken as an "assassination." "Vancouver news media treated the case of the Beach Avenue tree killing as a major crime,

THIS PAGE The view from the back of the Sylvia Hotel in the 1920s, with trams passing on Denman Street. The transition from wooden houses on narrow lots to apartment buildings is underway, but the evolution of Denman into a commercial street is still in the future. Many of the houses that had been built for families had already been converted into suites or rooming houses in the wake of the flight of families from the West End to suburbs like Kitsilano and Kerrisdale. (John Valentine & Sons postcard)

NEXT PAGE The house in the alley behind the Sands Hotel is the last of its kind in the West End, a granny house or lane house for the larger home at 1754 Pendrell. Built in 1904 by Adorinam J. Paterson, the chief clerk of the CPR steamship department, the two buildings were typical of the way early Vancouverites defined their property rights: they built what they wanted. City records show it was home to two families and five roomers in 1938. Others chose to add stores onto their front yards. In the middle distance, the English Bay Hotel is a 1940s relic; the sweep of Beach Avenue and the trees of Stanley Park form the backdrop.

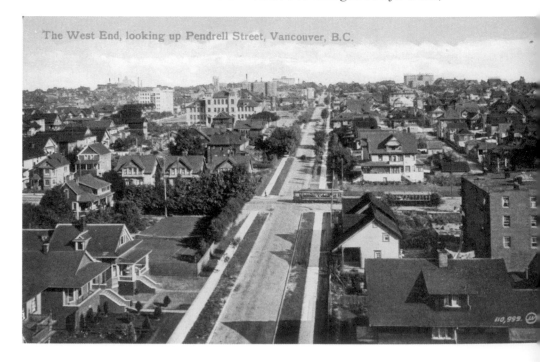

The West End, looking up Pendrell Street, Vancouver, B.C.

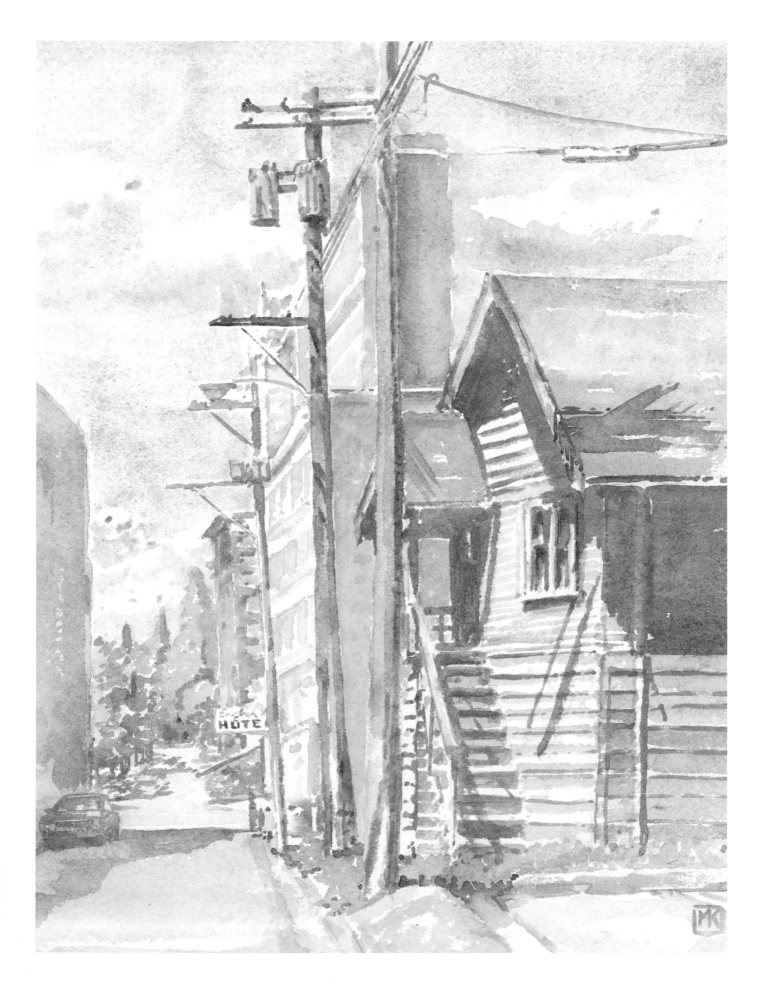

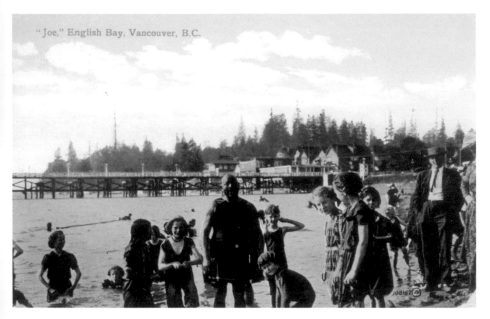

"Joe," English Bay, Vancouver, B.C.

Seraphim "Joe" Fortes became so famous that the John Valentine & Sons branch in Toronto published a postcard of him for the local market. In the scene, c. 1910, the beloved lifeguard is surrounded by the local children he taught to swim. The trees in the background are in Stanley Park; the pier at the foot of Gilford Street was modelled on those in English seaside resorts; that tradition of promenading survives in the Lower Mainland today only in White Rock.

and Ms. Matheson became the target of hate mail, death threats, and taunts," wrote Mark Hume.[1]

The original wooden bathing pavilion at the foot of Denman, built for $6,000, was soon replaced by a concrete one. In 1909, at the foot of Gilford, the city built a bathing pier that extended about 100 yards into the water; on its end was a glassed-in dining and dancing pavilion known as the Prom. On the triangular park bounded by Morton, Davie and Beach, the Imperial Roller Rink was another attraction until it burned down in the 1920s. Later, an aquarium established itself in the bathhouse before moving to Stanley Park in 1956.

The ghost of Joe Fortes, the lifeguard, continues to inhabit the English Bay beachfront. A fine sculpted memorial by Charles Marega adorns pretty Alexandra Park at Bidwell. The library branch on Denman Street is named for him, as is the posh Joe Fortes restaurant on Thurlow. The latter is an odd appropriation of his name, for he was a black man from Barbados who lived simply in a cottage at the foot of Gilford Street during the first two decades of the 20th century. But irrespective of any prejudice the society as a whole had for non-Caucasians, Fortes became a beloved and respected local character (no doubt because there were so few people of African descent in Vancouver that no one could perceive them as a threat).

In the gentle West End of a century ago, parents sent their children off to English Bay with lunch and the admonition to "stay close to Joe." Twenty years ago there were still people alive there who remembered him fondly. Beatrice Wood, for example, wrote to me in 1985 that she was "one of the West End kids he taught to swim. I was also a nurse on the Workmen's Compensation ward at VGH in 1922 when he was brought in dying of pneumonia. When I told him he had taught me to swim, his comment was, 'I won't teach no one no more, Missy.'"[2] His funeral in downtown Vancouver later that year was one of the largest ever held in the city.

1 *Globe and Mail,* January 6, 2006.

2 Beatrice Wood was the daughter of BC Sugar Refinery vice-president J.W. Fordham-Johnson, who later became lieutenant-governor. She married Frederic G.C. Wood, the first BC-born educator at UBC when it opened in 1915, the founder of the University Players' Club and namesake of the theatre there. She lived out her long, active life in a fine apartment overlooking Stanley Park and died in 1992.

The West End's northern face looks onto Coal Harbour, which has changed more than any other place in Vancouver other than False Creek. Since 1960, it has done a complete Cinderella turn, shedding boatyards for yachts and houseboats for luxurious condominiums and hotels. The English Bay side may still have some apartments for the fiscally challenged, but the only affordability on Coal Harbour is in the few enclaves of subsidized housing mandated in the city's redevelopment plan. Coal Harbour feels corporate, sleek and planned, while English Bay is democratic.

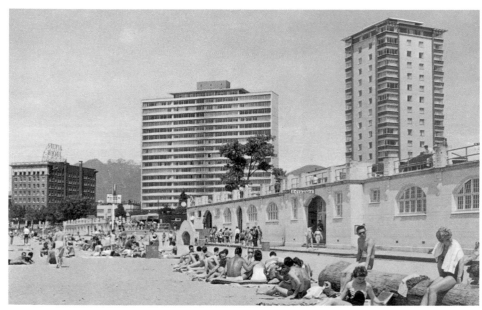

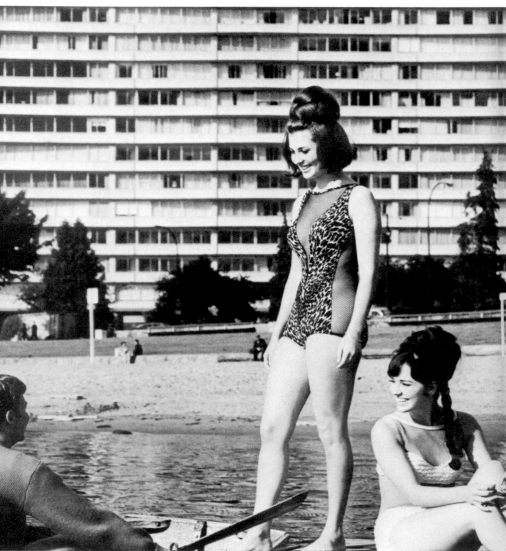

ABOVE *English Bay beach in the mid-1960s, with the Sylvia Hotel on the left. The hotel's namesake, Sylvia Goldstein Ablowitz, was an early female graduate, in 1921 with a degree in French, from the old* UBC *campus in the Fairview shacks south of Vancouver General Hospital. Her family moved to Los Angeles in the 1920s, at least in part due to the larger Jewish community there. Sylvia, however, married and stayed in Vancouver, establishing a successful insurance business. She lived out her long life at Crofton Manor in Kerrisdale, dying there in April 2002 at the age of 102. (Photo by Rolly Ford)*

BELOW *Beach fashions about 1965, with the facade of Ocean Towers in the background. (Photo by Herbert L. McDonald)*

The evolution of a Vancouver house. G.M. Blackman's Queen-Anne cottage at 1968 West Georgia Street stood next door to the Stuart Building, the eccentric turreted apartment building at Chilco that was demolished in 1982.

LEFT *The house in its sylvan setting shortly after its construction in 1899, before the huge Horse Show Building was erected a few doors to the east (left) and the apartment went up next door. (Photograper unknown)*

RIGHT *In 1927, the house was raised one storey to take advantage of its industrial-commercial neighbourhood. In the 1940s, the downstairs space was the Parkview Cafe; in the 1950s, when this photo was taken, it was a machinists' supply company. (Photo by A.L. Yates)*
CVA BU P. 508-2

John Morton of the "Three Greenhorns" has his name commemorated in the one-block street that runs from Denman to Beach in the heart of English Bay, and he lived out his declining years before his death in 1912 in a cottage at 1947 Pendrell. But his historic cabin – the second dwelling in "Vancouver" after Peter Smith's at Brockton Point – stood on the bluff immediately to the east of the portal of the SkyTrain tunnel on the downtown waterfront. That bluff, around 50 feet high, extended westward to about Jervis Street – the historic shoreline before filling created land for railyards and later condominiums. High tide came almost to Georgia Street between Cardero and Denman; midway between Gilford and Chilco, the last block before the park, the shoreline crossed Georgia Street and ended at about Chilco and Alberni.

What we now know as Lost Lagoon was a tidal extension of Coal Harbour, with a slough continuing south to English Bay that effectively made Stanley Park an island at high tide (which is how it appeared on early maps, including Captain Vancouver's). Georgia Street crossed to the park on a trestle, which served the double purpose of carrying the city's main water line, installed in 1889, from the Capilano reservoir on the north shore, under Burrard Inlet and via Pipeline Road through the park to the edge of the city. Like all coastal cities, Vancouver has added land to its shore to create more valuable real estate; the reason why the CPR established its docks and first station at the foot of Howe Street was the water depth, about 40 feet at low tide in 1885. To improve navigation, Coal Harbour was repeatedly dredged, the spoil being used to stabilize the shoreline, fill in the gap at the mouth of Lost Lagoon and create the causeway in the early 1920s.

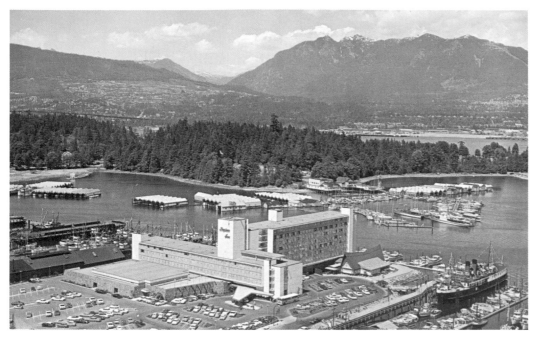

Programme of
RECITAL
by
Ignace. Jan. Paderewski

VANCOUVER ARENA

on Wed. Evening, April 13, 1932

Management for
MR. PADEREWSKI,
George Engels, New York
Northwestern Directors:
Steers and Coman, Portland

Local Management:
LILY J. LAVEROCK

As it became more established, the railway extended its tracks and yards along Coal Harbour as far as Cardero. The Union Oil Company had a tank storage facility at the foot of Bute; to the west were small wharves of tugboat companies, shipbuilders and the Bidwell Street Cannery. The Pacific Coast Lumber Company's sawmill, dry kiln and yards occupied most of the shoreline between Broughton and Cardero.

The Vancouver Arena, sometimes called the Denman Street Auditorium, erected in 1911 by the Patrick Brothers for the Stanley Cup–winning Vancouver Millionaires, occupied the northwest corner of Georgia and Denman. In the 1930s it was the (rather inappropriate) venue for classical music concerts: on a visit to Vancouver, my father attended a Paderewski piano recital there and recalled how the pianissimo portions were more or less drowned out by the sound of a thunderous downpour on the roof! It was also the site of boxing matches and political rallies before it burned to the ground in a spectacular fire in 1936.

The other large building near the park stood across Georgia just to the west of the arena. Originally the Horse Show Building, it later saw service as the drill hall for the Irish Fusiliers regiment before it, too, burned in a huge conflagration in March, 1960. For the next 45 years the land sat vacant, dotted with dandelions and scrubby alder, its foundations stilll marking the site, while the owners bided their time; it was redeveloped with condominiums in 2006. Until the 1970s, the north side of Georgia Street was a line of small wooden structures belonging to boat-building and marine servicing companies, behind which were additional sheds, wharves and marine railways. For the last few years before they were cleared away, craftspeople and small hippie boutiques occupied some of them.

W.R. Menchions and Company, founded in 1898, were the most re-nowned boat builders on Coal Harbour. Their wharf stood about 50 yards east of the foot of Cardero, and over the years they produced about 300 boats

LEFT The Bayshore Inn in the 1960s, the first major hotel in the city that did not relate to the port or the railway but rather to a clientele who came by car or private plane (it had a seaplane dock). It glowed in the international spotlight in 1972 when reclusive billionaire Howard Hughes was allegedly in residence. Note the Trader Vic's restaurant, part of the Polynesian craze spawned by the movie South Pacific; *it was closed in 1996 and barged to Vancouver Island, leaving only the 1954 Tiki Lounge at the Waldorf Hotel on East Hastings as an outpost of tiki culture. The posh Princess Louise II restaurant occupied a deck of the berthed* Lady Alexandra *at right. (Coast Publishing Co.)*

RIGHT Everything from classical music to wrestling played at the arena at Denman and Georgia between 1911 and its immolation in 1936. Suffragette and news reporter Lily Laverock was the city's leading impresario in the 1920s and 1930s.
CHERNIAVSKY FAMILY COLLECTION

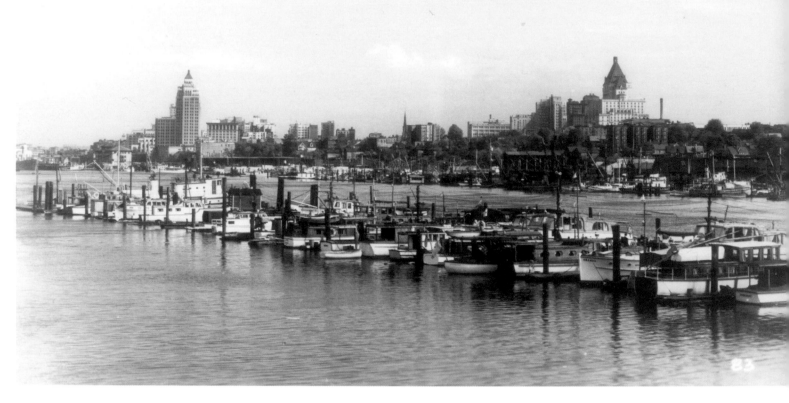

Coal Harbour in the 1940s showing the "mosquito fleet" of working harbour boats and the shoreline with its boatyards and small jetties. In the distance, the Marine Building and the Hotel Vancouver define the skyline. (Photo by J.C. Walker)

in their yards. Jimmy and Henry Hoffar also built boats as well as becoming involved in the early history of aviation in the city.

A daredevil named W.M. Stark piloted a pontoon-fitted biplane from Coal Harbour on the first seaplane flight in Western Canada on June 14, 1914. In the fall of 1916, the Hoffar brothers enlarged their boatworks and over several months of trial and error constructed a two-seater biplane. It had a single pontoon beneath the fuselage and outrigger pontoons at the tips of the wings. Jimmy Hoffar taught himself to fly it and had a summer of successful flights until he hit a log while taxiing at high speed and sunk. They fished it out but could not repair it; in their ignorance, they had not thought to cross-brace the wings and it had collapsed like a house of cards. They next built a flying boat, and were demonstrating it to the Forestry Department of BC on September 4, 1918, when it lost power at about 1,500 feet and crashed into the roof of the home of Dr. Farish at the corner of Bute and Alberni. The pilot, Lieutenant Victor Bishop, was tossed out of the wreckage into the bathtub, but survived.

Perhaps wisely, the Hoffars then became involved with the legendary William Boeing of Seattle. The organizers of a display of war trophies at the Horse Show Building thought that the presence of an airplane would attract crowds, and Boeing was enticed to fly up from Seattle on February 28, 1919 – the first international flight into Vancouver. When he left from the Royal Vancouver Yacht Club dock on Coal Harbour on March 3, he took with him a mailbag for Seattle – the first airmail. The Hoffars became Boeing's BC representatives, establishing a manufacturing plant to build airplane wings at the foot of Denman just north of the Arena. It was a significant part of the region's military effort during the Second World War.

Like False Creek and much of Burrard Inlet, Coal Harbour was home to "a heterogeneous mass of floats and small craft that clutter up the shoreline,"

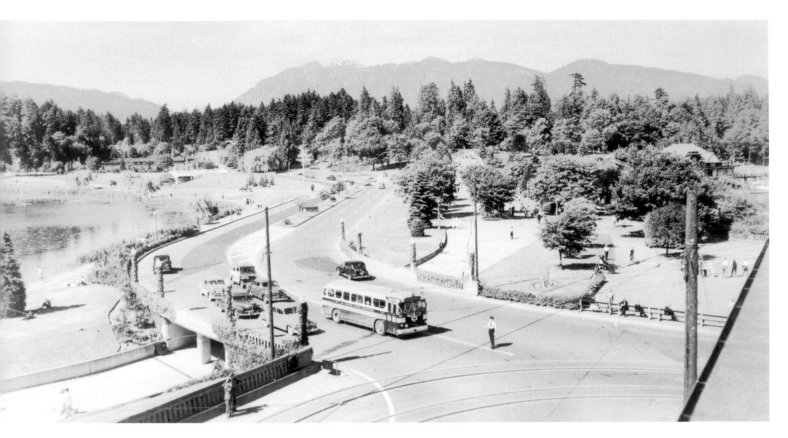

in the words of a Park Board planner in the 1930s. As part of the ongoing, never-realized schemes to "formalize" Lost Lagoon and turn Georgia Street into a Champs Elysées grand boulevard from Stanley Park to the Civic Centre (page 75), the Town Planning Commission began to discuss creating a park to the west of Nicola Street and cleaning out the houseboats and other riff-raff from Coal Harbour. To create a more pristine, natural view of the park, it was suggested that the tugboat "mosquito fleet" should go to False Creek or else further east in the main harbour, and the yacht club's moorings should be moved to their main headquarters at the foot of Alma. The fire chief added his voice to the call, signalling out the houseboaters for concern.

The houseboaters were a tidy community, presided over by their "mayor," Thomas Marshall, a pioneer whose floathouse was referred to as city hall. They gained a reprieve with the coming of the war, dodging a 1944 eviction order when it was determined that 90 percent of the 200 people living on the 45 houseboats at the foot of Denman were engaged in war work. By 1949, the colony had grown to 700.

The industrial use of the area seemed about to continue when Pacific Mills bought land west of Cardero for a paper converting plant to manufacture "Milady Products" such as grocery bags, fruit wrap, gum tape, bread wrap and paper towels. A proposed dock would give unloading facilities for barges from its mill at Ocean Falls. The Park Board and Town Planning Commission objected vociferously.

There was enough of a delay in permits and plans, and further delay when Pacific Mills amalgamated with other sawmills to form Crown Zellerbach Canada Ltd. in 1954, that the proposed use for the property was abandoned. In May 1956, a group of investors including Leonard Boultbee, Norman Whittall and Peter Cromie bought the property west of Cardero and proposed a $25 million development of offices, shops, hotels and office

The placid entrance to Stanley Park in the 1940s, photographed from the turret of the Stuart Building. Chilco Street meets Georgia on the bottom left of the picture. (Photo by J.C. Walker)

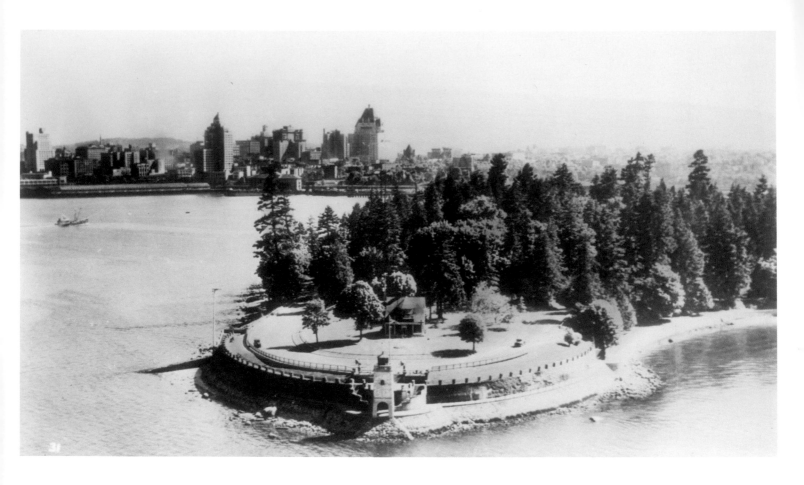

Brockton Point and the light-keeper's home in the 1940s. Letter from Eric V. Jones, 1985: "As a small boy, I was probably around six years of age, we used to visit with Captain Jones in his home at Brockton Point. I clearly remember sitting in his living room where he had a real old gramaphone, one with a large horn amplifier. He was also proud of his climbing roses. He had them all around his house. Apart from tending the Brockton light he also serviced the nine o'clock gun. He was living on the point up until the time the light was automated . . . When he was obliged to move, it broke the old man's heart and he didn't live long after." (Photo by Gowen-Sutton)

1 A more detailed, politically charged telling of the tale is Donald Gutstein's, in *Vancouver Ltd.*, pp. 78–83.

buildings, touting it as "the Wilshire Boulevard of Vancouver." What eventuated was the Bayshore Inn, a "garden court hotel" built by Marwell Construction and designed by modernist architect Douglas Simpson. Construction began in 1959; the management group was headed by the co-owner of the New York Yankees, Del Webb.

The Bayshore Inn represents one of those "tipping points" in history, like Tom Campbell's Parkview Towers in Kitsilano – it tipped the balance from industry toward a quasi-public, residential or recreational use and fuelled Vancouver's drive to become a post-industrial, postmodern city. There was one problem with the Coal Harbour proposal, though: it seemed to be the harbinger of a future where only wealthy people would have access to the waterfront at the entrance to Vancouver's jewel, Stanley Park. The poor people's houseboats and jobs had been forced out, leaving only the yachts of the RVYC. As a further stake in the heart of the parkland concept, Webb & Knapp proposed in 1962 a $70 million apartment and marina project on both sides of Georgia at the entrance to Stanley Park. As it evolved over the next nine years, it gained a new, American developer – William Zeckendorf, who had designed the mammoth Place Ville Marie in Montreal. Fifteen towers were approved for the site, plus a Four Seasons hotel. In June 1971, and continuing through the summer, the site was occupied by protestors who called it "All Seasons Park" in the style of the "people's park" in Berkeley, California. Finally, in August 1972, the federal cabinet refused to grant a lease on a critical piece of waterfrontage and the project died. Four Seasons Hotels ended up building in Pacific Centre.[1] It was a narrow escape.

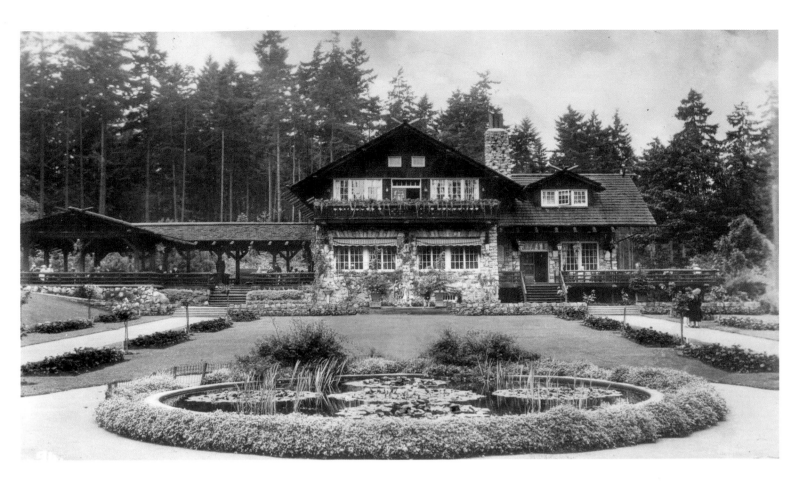

Stanley Park

Stanley Park itself has a much less controversial history. Like all expropriations and changes of use, when it was declared parkland in the 1880s it had its victims – the half-dozen families at Brockton Point who under a more sympathetic legal system would have been able to claim title by squatters' rights and would at least have been directly compensated. But when one thinks of evictions, images of heavy-handed police or midnight vigilantes come to mind. In fact most of the families in question were given tax-sale houses elsewhere in the city, and Tim Cummings was allowed to stay on in his home, located on the Burrard Inlet side of the totem pole attraction, until he died in 1958 at the age of 77.[1]

Nearly 120 years after the park was dedicated by Lord Stanley "for the use and enjoyment of peoples of all colours, creeds and customs for all time" – admirable sentiments notwithstanding the invocation of a head tax on Chinese immigrants four years earlier – the park has a settled, tranquil feeling. Only the razzle-dazzle of the aquarium seems out of character with the contemplative quality of the lawns, trails and forests. Its seawall links the downtown waterfront with English Bay, False Creek and Kitsilano, a remarkable achievement compared with other coastal cities such as San Francisco or Sydney. Close to the high-rises of the West End and Coal Harbour, the park is a cultural landscape of non-native trees, but quickly becomes a natural rainforest. It was never logged in the sense of being clear-cut, but evidence of some logging exists; even from the roadway, especially on the hill climbing up toward Prospect Point, there are still stumps from 130 years ago with notches in them, where planks called springboards were inserted, on which the loggers stood while

The Stanley Park Pavilion, probably in the 1920s. The building is much the same, although its terraces have been infilled to provide more indoor seating. The real change is in the garden plantings; the English-style standard roses and carpet bedding of small annuals has been changed in recent years to a profusion of more exotic species and colours. (Photo by Gowen-Sutton)

1 Richard M. Steele, *The Stanley Park Explorer*, pp. 45–46.

Even Prospect Point had its own totem pole in the 1950s! A cairn there commemorates the Hudson's Bay Company sidewheeler Beaver, *which dashed itself on the rocks below in 1888. When the United States and Britain settled on the 49th parallel as the international boundary in 1846, the HBC lost the use of its Fort Vancouver and other "Oregon Territory" posts, but found it could trade quite profitably using a steam-powered ship. Together with Fort Langley, the* Beaver *was the last connection in the Lower Mainland with the fur-trade era. (Photo by Gowen-Sutton)*

sawing the trees down. The park's fallen trees became nurse logs for new generations of growth, the stumps sporting a toupée of salal and a lacy western hemlock like a feather on a cap, thriving in the shade of the long-lived cedars and Douglas firs.

The totem poles at Brockton Point are probably the most visited site in the city, with typically a half-dozen tour buses parked nearby, confirming the tourist-friendly marketing strategy of a century ago. The site began to be developed early in the 20th century, adding an attraction to a province that also marketed its scenery and Britishness to visiting Americans. The local Aboriginal people, especially those living in frame buildings and holding industrial jobs, were not seen as sufficiently picturesque, so the site was developed as a kind of a theme park with a focus on the dramatic totem poles of First Nations farther up the coast and the nostalgic message that First Nations culture had effectively vanished.

A less-visited site, which greatly amuses American visitors who stumble upon it, is the monument to Warren G. Harding, a president who is usually ranked as one of the worst one or two in US history. It is, I believe, the only memorial to an American public figure in British Columbia. Harding visited Vancouver for only 10 hours in July 1923, on his return to the lower 48 from Alaska, and managed to squeeze in nine holes of golf at Shaughnessy, a ticker-tape parade on Granville Street and a speech in Stanley Park in which he likened Canadians to the sort of good neighbours "from whom one could borrow an egg." High praise indeed. When he died a week later in San Francisco – either from heart disease, shellfish poisoning or, as it was rumoured, poisoning by either his wife or his mistress – Vancouverites were saddened. The Kiwanis Club raised funds for the elaborate memorial by

Harding Memorial,
Stanley Park,
Vancouver, B. C.

Copyright

ABOVE *The Harding Memorial, erected to honour the dead US president by his fellow Kiwanians in the 1920s. (Coast Publishing Co.)*

BELOW *The Lumbermen's Arch camping area as it was during the First World War years, an image I confected from several old photographs in 1983 for* Vancouver The Way It Was.

sculptor Charles Marega, showing two androgynous females representing the youth of the two countries clasping an olive branch above a bas-relief of the fallen president.

The Harding Memorial rests on the edge of the clearing in the park's most developed quadrant, where Harding spoke at the bandstand. The lawn nearby provides seating for the Malkin Memorial Bowl, erected in 1934 as a replacement for the bandstand by bereaved Mayor William Harold Malkin in memory of his wife, Marion. Generations of Vancouverites have passed warm summer evenings on their picnic blankets watching Theatre Under The Stars musicals. TUTS began a fundraising campaign early this century to replace Malkin Bowl with a new structure that will, they hope, be less vulnerable to vandalism, arson and squatters; meanwhile a preservation campaign has been mounted by Heritage Vancouver.

Not far away is the statue of Lord Stanley, an impressive work by Sydney March unveiled in 1960 and displaying the dedication statement quoted above. Sir Frederick Arthur Stanley, first Baron Stanley of Preston and 16th Earl of

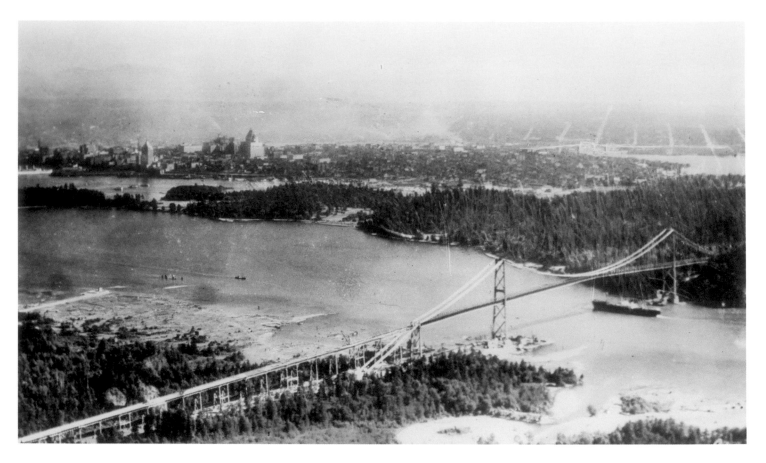

The First Narrows and Stanley Park in the 1940s. Opened in 1938, the Lions Gate Bridge was a necessary investment by the Guinness Company to connect its extensive land developments in West Vancouver with the city. For its first decade it truly connected "nowhere with nowhere," but after the end of the war and gas and tire rationing it came into its own. When Park Royal Shopping Centre opened in 1950, Vancouverites got their first clear picture of what the future would look like (see page 29). (Photo by Gowen-Sutton)

Derby, was one of the generations of minor English aristocracy who did their public service in the far-flung British Empire. Other than his donation of the hockey trophy, he is remembered for having confirmed the non-partisan nature of the governor general's office when he refused to disallow a pro–Catholic Church motion of the Quebec legislature. Another evocative monument in that part of the park is the Japanese War Memorial, a column topped by a pagoda rising from a lily pad inscribed with the names of the battles fought by Japanese Canadians in the First World War; it is, of course, melancholic due to the seizure of their property, their evacuation from the coast during the Second World War and the number of years that had to pass before they were given full rights of citizenship in 1948–9.

Stanley Park belongs in the tradition of 19th-century English and eastern North American public landscapes, including cemeteries. As with almost everything in the city, Vancouverites are lucky there was never enough money to impose a single grand design on it. Thus, the lawn areas are modest and enclosed by forest and the few formal gardens are counterbalanced by riots of rhododendrons planted beneath native trees. The evolution of Lost Lagoon is an interesting example: it went from a natural place beloved of the poet Pauline Johnson (who hated the name Coal Harbour and wrote a poem of "the lost lagoon"), with Aboriginal dwellings on the north shore and a brewery at the foot of Alberni Street, to a formally conceived water feature. It is now on its way to being turned back to natural habitat, especially on its north shore; the goose manure–stained concrete edging on the south shore and a shabby fountain are all that is left of its formal period.

Nearly a century ago there was considerable public debate about the lagoon's future. The Mawson Plan, named after the English landscape architect hired to present options to the Park Board, suggested either filling it to provide

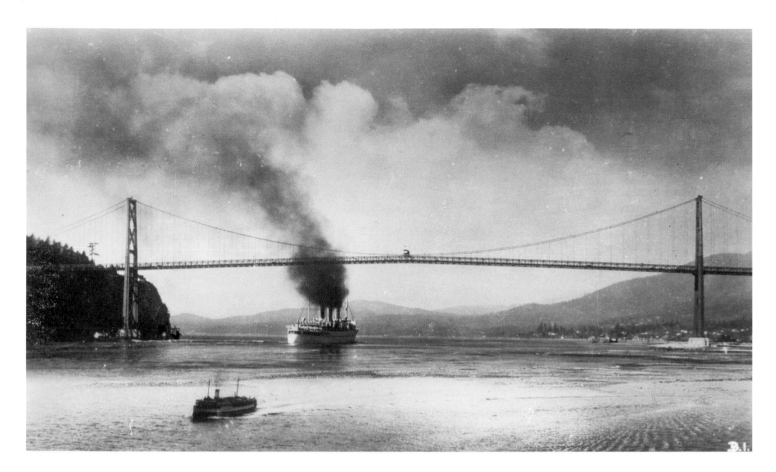

Romantic Vancouver at the end of the steamship era – an ocean liner passing under Lions Gate Bridge in the 1940s. (Photo by Gowen-Sutton)

a sports field (the preferred option of the Vancouver Trades and Labour Council) or constructing a museum and stadium on its shores and linking it into a larger "City Beautiful" vision of the city. A Park Board engineer, A.S. Wooton, reflected that "Fortunately, they never got beyond the plan stage. The design might have been suitable for a Peace Palace or a European Capitol but would have resulted in substituting for the present beautiful natural lagoon a purely artificial treatment at a very high cost."[1] Once again, lack of money saved Vancouver from the visionaries.

Gifts of sculpture have in the main been fairly discreetly placed or else prone to rotting and removal, such as the original Lumbermen's Arch in the illustration on page 141. Constructed like a Doric temple, it began life in 1912 as a triumphal arch erected on a downtown street through which the carriage of the Duke of Connaught, the then governor general, passed. To celebrate the first site of Stamp's Mill (page 38), the Park Board re-erected it in the park, plunking it onto the exact site of the largest lodge of the Khwaykhway First Nation's village! Its replacement in the 1950s by the current arch – little more than a large felled tree – removed the cultural insult.

Old photographs show a variety of rustic structures throughout the park, conforming to the park founders' ideas of suitable architecture for a romantically imagined wilderness. One of the few survivors is the Stanley Park Pavilion near the Malkin Bowl, a Craftsman-style chalet built before the First World War. The other structures from earlier eras include the Sports Pavilion, pictured overleaf, and the Vancouver Rowing Club on Coal Harbour. The latter is a 1911 replacement for a floathouse which itself replaced a building that began life as the clubhouse at the foot of Thurlow and eventually became the city's smallpox quarantine facility on Deadman's Island. It was suggested by the planning commission in the 1930s that the rowing club, along with

1 Quoted in Steele, *The Stanley Park Explorer*, p. 166.

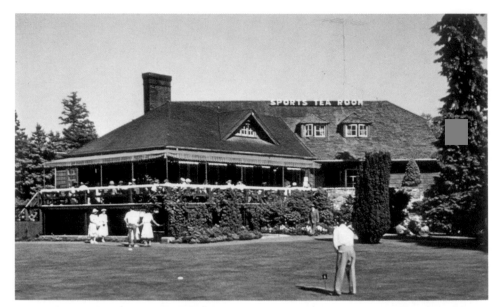

Two postcards of Stanley Park in the 1950s:

ABOVE *The Sports Pavilion opened in May 1930, near the Beach Avenue entrance to the park in the area that is effectively the backyard of the nearby apartment buildings; it is currently the Fish House restaurant. The lawn bowling facility nearby dates from 1919, when it replaced an elk paddock that had been one of the park's attractions. The 18-hole pitch-and-putt golf course was created two years after the pavilion and today borders the huge rhododendron collection that brightens the coastal forest palette every spring. (Photographer unknown; Natural Colour Productions)*

BELOW *The Ferguson Point tea house was an officers' mess built in the late 1930s as part of the fortification of Vancouver harbour. Artillery was placed at the point during the First World War due to fears of a raid by German cruisers. (Premier Sir Richard McBride purchased two used submarines in Seattle to bolster the coast's defences and requisitioned B.T. Rogers's yacht to act as support for them.) Other structures, including an observation tower like the one at Tower Beach (page 189) survived well into the 1950s. The tea house evolved into a posh restaurant in the 1980s. (Coast Publishing)*

the yacht club's moorage, be removed as part of the Coal Harbour cleanup, but its influential members were able to keep their building and access to the tranquil waterway. Its half-timbered Tudor design, like the Sports Pavilion's, was almost as popular a choice as the rustic Craftsman style for picturesque places and was used for caretakers' houses throughout city parks in the first half of the 20th century. Later additions, like the pavilions at Brockton and Prospect points and the Park Board's headquarters itself, are much more modern in design, but their low profiles and use of wood and stone make them fit just as well into the evolving landscape.

Fairview, Mt. Pleasant & False Creek

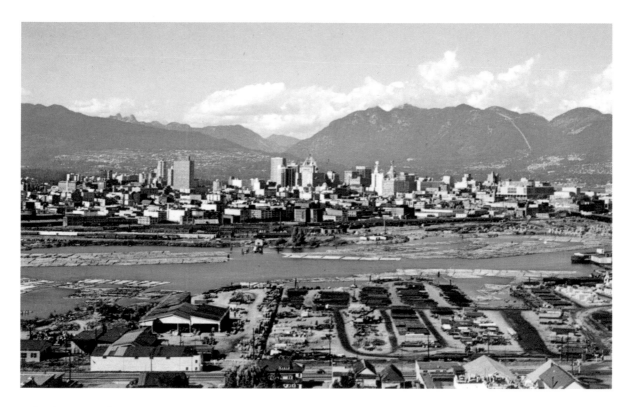

A short list of important incidents in Vancouver's history would include the heritage designation of Gastown and Chinatown (page 49) and the transformations of Coal Harbour (page 138) and False Creek. Tourists seek out Gastown, Chinatown and Granville Island and can't miss Coal Harbour on their way to the totem poles in Stanley Park. But the richness of the communities that border False Creek usually eludes them in their headlong rush to shop and point and click.

Fairview and Mount Pleasant are two of the more historic communities in Vancouver; together with what became the south shore industrial area on False Creek, they were linked with the five-year-old city in 1891 by the Fairview Belt-Line streetcar, which used Broadway and bridges at Granville and Main to traverse the communities. In 1904, a trestle bridge crossed False Creek at Cambie; it was replaced by the swing-span Connaught Bridge, which lasted from 1912 until 1985, when the current Cambie Bridge opened just in time for Expo '86. A third bridge crossed False Creek near its mouth, linking downtown's Burrard Street with Cedar Street on the Fairview-Kitsilano border in 1932 (the latter was renamed Burrard in 1938).

The construction of the Burrard Bridge climaxed a period when businessmen and politicians collaborated to rid Kitsilano Point of its Indian Reserve. Aboriginals had traditionally lived at Sun'ahk, a word meaning "inside, at

The scene looking north across False Creek in the 1960s. Demolished industrial works had largely been replaced by storage facilities, although the sawmilling industry obviously still dominated the waterway. CPR railyards and shops occupied the north shore until the early 1980s, when they were cleared away in preparation for Expo '86. (Photographer unknown; Natural Colour Productions)

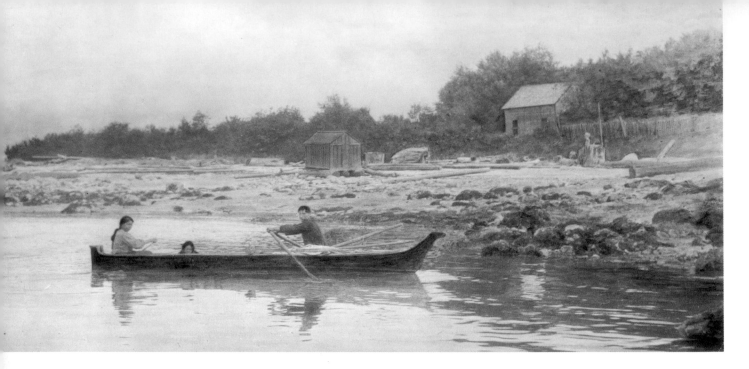

August Jack Khahtsalano, grandson of Kitsilano's namesake, and his wife, Swanamia, a.k.a. Mary Ann, and daughter in their canoe near his birthplace, Sun'ahk, on the Kitsilano Indian Reserve about 1910. August Jack (1867–1967) was the son of Supple Jack of Chaythoos, a village just east of First Narrows in Stanley Park, and worked in a sawmill. In the 1930s, he became Major Matthews's great informant on Aboriginal life in the Lower Mainland, material that became an essential part of the Vancouver City Archives. (Photographer unknown)
CVA IN. P.35

the head," a village on the shore just east of where the bridge crosses. Nearby, at what became the back channel of Granville Island, they successfully used a tidal pool as a fish trap. Their 72-acre reserve, established in the 1870s, had boundaries roughly of First Avenue, Chestnut and the water – land today occupied by Seaforth Armoury, Molson Brewery, the Vancouver Museum and Planetarium, a coast guard base and Vanier Park, home of the Children's Festival and Bard on the Beach.

The Canadian Pacific Railway made no secret of its desire to build its ocean port on Kitsilano Point, and had obtained through government expropriation about 10 acres of land for rail operations. However, it leased its land to the BC Electric Railway in 1905 for the latter's interurban rail system and focused its attention on its Burrard Inlet port facilities. Regardless, the provincial government was determined to get the reserve "by fair means or foul," as the Indian agent noted. About a century ago, the First Nation exhumed its dead from the cemetery and began moving to Squamish and North Vancouver. The reserve was effectively vacant in 1913 when the provincial government began negotiating directly with heads of families rather than the First Nation's legal representatives. After a scandalous, protracted process, these Aboriginals sold the reserve for just over $200,000, with the government agent, H.O. Alexander, receiving $80,000 of it as a fee! The federal government refused to endorse the deal; the First Nation was further swindled in negotiations over land for the bridge approaches in 1930.[1]

Attempts to establish industry on the reserve failed. Squatters and the homeless used it in the Depression; homeless people camp near the bridge today. Until the 1960s, air force storage buildings occupied much of the site. The tangled mess of the sale of the reserve will probably be finally resolved under a settlement announced in 2000 between Canada and the Squamish Nation for $92.5 million in compensation, partly related to this property. A further piece of restitution was the award to them of 10 acres of former CPR property beneath the Burrard Bridge by the B.C. Court of Appeal in 2002.

The Burrard Bridge was one of the recommendations of the 1927 Harland Bartholomew plan, formulated in anticipation of Vancouver's amalgamation with Point Grey and South Vancouver. Cornwall and Cedar would be

1 See *Vancouver The Way It Was*, p. 99.

M-KLUCKNER
2004

upgraded to funnel automobile traffic through to Kitsilano, the university and
Kerrisdale. In January 1929, a year before the Great Depression began to bite,
a plan came forward for a double-deck bridge, the lower intended to carry
the traffic using the Kitsilano Trestle (page 102). As finally designed with
an art deco superstructure, it became a ceremonial bridge rather than just a
functional one.

Like the Lion's Gate, the Burrard Bridge is one of the city's icons. Plans
to widen its sidewalks with outriggers became an election promise in 2005 and
are being fought in 2006 on heritage conservation and economic grounds. At
the same time, the city is once again negotiating with the Squamish Nation,
now empowered, for easements related to the proposed work.

*The Burrard Bridge, as it was in
2004.*

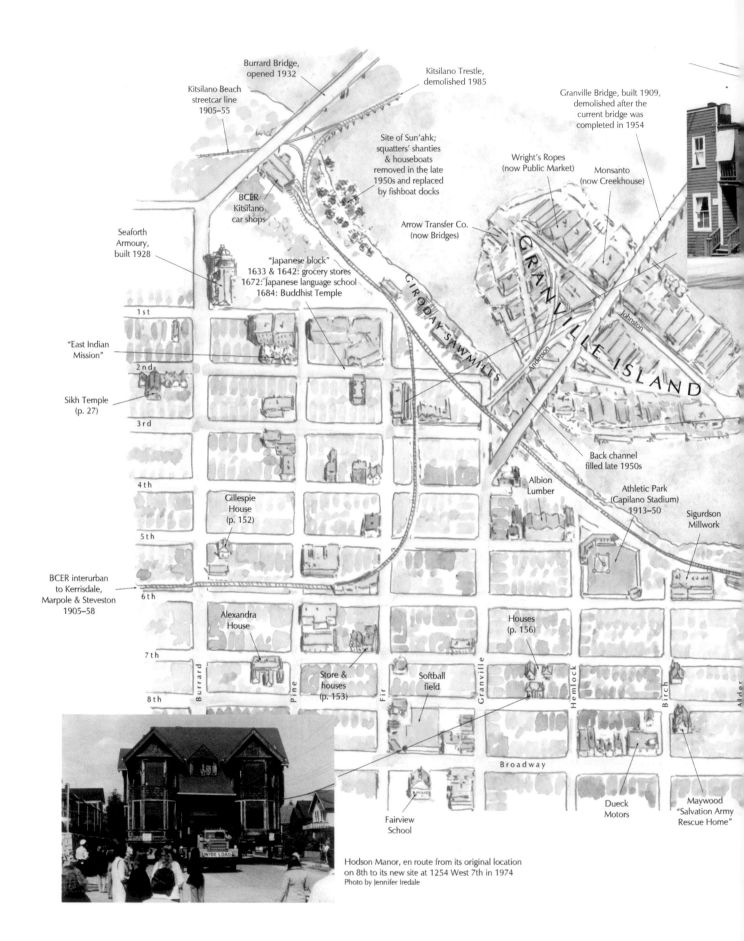

Burrard Bridge, opened 1932

Kitsilano Trestle, demolished 1985

Kitsilano Beach streetcar line 1905–55

Granville Bridge, built 1909, demolished after the current bridge was completed in 1954

Site of Sun'ahk; squatters' shanties & houseboats removed in the late 1950s and replaced by fishboat docks

Wright's Ropes (now Public Market)

Monsanto (now Creekhouse)

BCER Kitsilano car shops

Arrow Transfer Co. (now Bridges)

Seaforth Armoury, built 1928

GRANVILLE ISLAND

GIRODAY SAWMILLS

"Japanese block" 1633 & 1642: grocery stores 1672: Japanese language school 1684: Buddhist Temple

Johnston

1st

Anderson

"East Indian Mission"

2nd

Sikh Temple (p. 27)

3rd

Back channel filled late 1950s

4th

Albion Lumber

Athletic Park (Capilano Stadium) 1913–50

Sigurdson Millwork

Gillespie House (p. 152)

5th

BCER interurban to Kerrisdale, Marpole & Steveston 1905–58

6th

Alexandra House

Houses (p. 156)

7th

Store & houses (p. 153)

Softball field

Dueck Motors

Maywood "Salvation Army Rescue Home"

Burrard

Pine

Fir

Granville

Hemlock

Birch

Alder

8th

Broadway

Fairview School

Hodson Manor, en route from its original location on 8th to its new site at 1254 West 7th in 1974
Photo by Jennifer Iredale

Fairview & Granville Island
1930s–1950s
(Information from fire atlases & directories of the period)

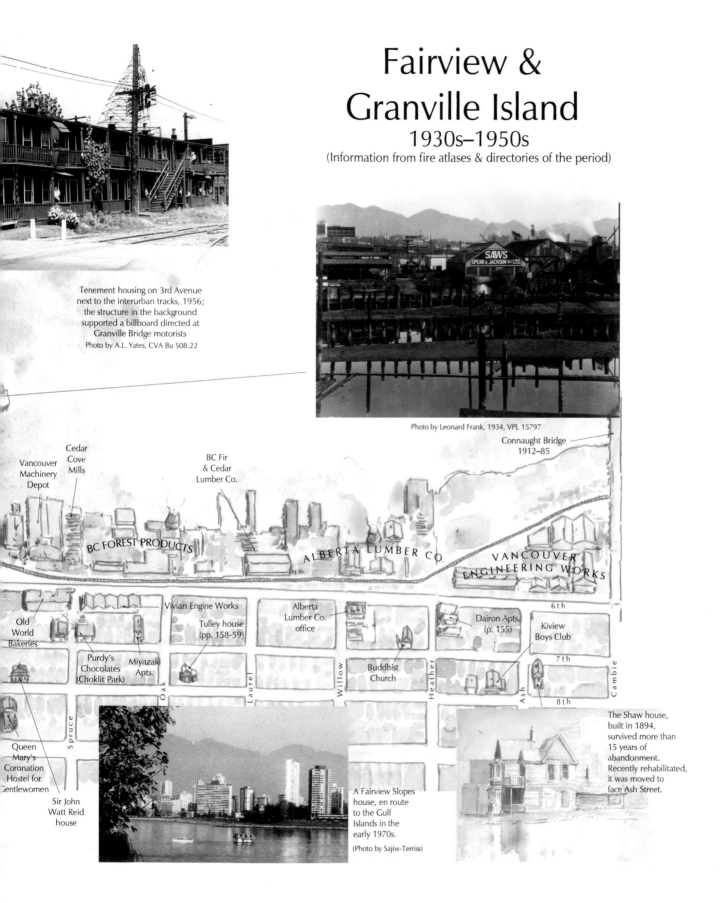

Tenement housing on 3rd Avenue next to the interurban tracks, 1956; the structure in the background supported a billboard directed at Granville Bridge motorists
Photo by A.L. Yates, CVA Bu 508.22

Photo by Leonard Frank, 1934, VPL 15797

Connaught Bridge 1912–85

Vancouver Machinery Depot

Cedar Cove Mills

BC Fir & Cedar Lumber Co.

BC FOREST PRODUCTS

ALBERTA LUMBER CO.

VANCOUVER ENGINEERING WORKS

Old World Bakeries

Purdy's Chocolates (Choklit Park)

Miyazaki Apts.

Vivian Engine Works

Tulley house (pp. 158-59)

Alberta Lumber Co. office

Buddhist Church

Dairon Apts. (p. 155)

Kiview Boys Club

Oak

Laurel

Willow

Heather

Ash

Cambie

Spruce

6th

7th

8th

Queen Mary's Coronation Hostel for Gentlewomen

Sir John Watt Reid house

A Fairview Slopes house, en route to the Gulf Islands in the early 1970s.
(Photo by Sajiw-Terriss)

The Shaw house, built in 1894, survived more than 15 years of abandonment. Recently rehabilitated, it was moved to face Ash Street.

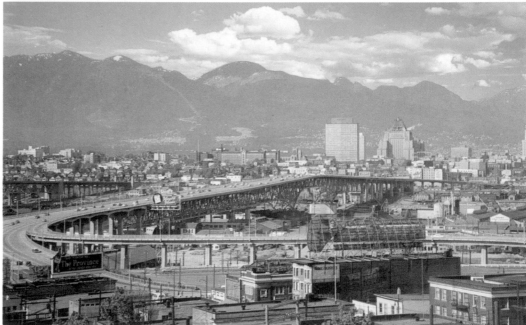

ABOVE *The view from the penthouse of Douglas Lodge at 12th and Granville in the early 1940s. The haze in the distance is very likely smoke from the sawmills around False Creek. The newly completed Hotel Vancouver dominates the downtown peninsula. (Photo probably by Jan Cherniavsky)*
JANEY GUDEWILL

BELOW *The new Granville Bridge, finished in time for the British Empire & Commonwealth Games in 1954 (page 232). The first (1889) bridge spanned from 3rd to Beach, the second (1909) from 4th to Pacific, and this one from 6th to Drake. According to a story I was told more than 20 years ago by a talk-show caller to radio*

station CJOR, Mayor Gerry McGeer stage-managed monumental traffic jams by getting scows to block open the swing spans of the Kitsilano Trestle and the Granville and Cambie bridges during rush hour when he was trying to sway public opinion in 1947 toward building the $12 million bridge. In the 1950 election campaign, successful mayoral candidate Fred Hume wanted to stop the bridge but too much work had already been done. (Photo by Rolly Ford)

LEFT *Mayor Gerry McGeer, builder of Vancouver City Hall, born on a farm at Kingsway and Fraser, labour leader, married to a member of the wealthy Spencer family,* MLA, MP *and senator (page 161).*

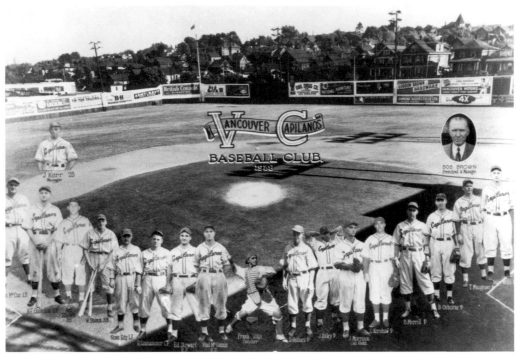

Breweries and sports teams go together like bears and garbage. The Sick family of Lethbridge, Alberta, established the Capilano Brewery at 1445 Powell in the 1930s and purchased a franchise from the Western International League in 1939. Their Vancouver Capilanos team took over Athletic Park at Fifth and Hemlock, a stadium built in 1913 for the Vancouver Beavers of the Northwestern League; it was christened Capilano Stadium in 1942, but had a short life as the city decided it needed the land for the cloverleaf approaches to the new Granville Bridge. After a protracted debate in the Riley Park neighbourhood, the brewery built a new Capilano Stadium just east of Little Mountain, where the first game was played on June 15, 1951. The team folded along with the league in 1954, a victim of television. Pro ball returned a few years later with the Vancouver

Mounties of the Pacific Coast League, owned by a syndicate that included White Spot founder Nat Bailey (page 211). The stadium is now named for him.

ABOVE *The picture, by an unknown photographer, looks south from the grandstand to Sixth Avenue just east of Hemlock.*
VPL 11759

BELOW *In 1950, Sicks' built a new brewery at the south end of the Burrard Bridge as "The Home of Old Style Beer." A tower on the rooftop held a large "6" which changed colour according to the weather forecast. Molson's bought it in 1958 and retained the Old Style brand and label for more than 25 years. The current Vancouver baseball team – the Canadians – is sponsored by Molson's.*

The Andrew Gillespie house at 1752 West Fifth, built in 1904 and torn down in 2005. It was a fine, solid family home that Gillespie (a labourer according to city directories) erected on the western edge of Fairview. A later occupant, Samuel North, was the city's chief of police. By the time I painted the watercolour in 2001, the house had been abandoned for a year or so and the collection of junked cars and a rusted-out school bus had been cleaned off the property. Over the years its neighbours had changed from small factories and houses to the trendy Fifth Avenue Cinemas.

1 See Henry Ewert's *The Story of the B.C. Electric Railway Company*, p. 57.

At the millennium, the transformation of Fairview Slopes was almost complete. New building complexes occupied the sites of frame houses and small factories, people walked to Granville Island to shop where once they would have walked to work. Condominiums set on the edge of artificial lakes looked onto a shoreline that half a century earlier was lined with houseboats and squatters' shacks.

It is still possible to read the landscape, though. A hint of the area's former industrial flavour still hangs around the railway track that snakes up the hill from the foot of the Burrard Bridge. In 1902, the CPR laid the Vancouver & Lulu Island Railway tracks from False Creek all the way to the booming Steveston canneries; its "Sockeye Limited" freight service on this line lasted only three years, as the railway company entered into an agreement to lease it to the BC Electric Railway Company. The BCER also took over the two-mile-long south shore industrial line that ran from Lulu Island Junction (the south end of the Kitsilano Trestle) along False Creek almost to Main Street. The junction was so named because the BCER's new Kitsilano beach streetcar line branched off there. The passenger station for the new service was established at the west side of the Granville Bridge on the north shore of False Creek.[1] Last used for passenger rail in 1958, it continued in use as a freight line until 1999, when the few remaining customers in the upper Fairview-Kitsilano area closed out (page 175). The CPR then turned its attention to obtaining a rezoning for residential or commercial use of the right-of-way, known by then as the Arbutus Corridor; a decision by the Supreme Court of Canada in February 2006 sided with the City of Vancouver, which had zoned it as a permanent transportation route.

The watercolours on these pages show two of the few remaining sites that hark back to the Fairview of an earlier generation. In recent memory, places like the store above have been home to cafes and emporia of the enduring, ever-changing counterculture, but for their first 60 or so years of existence they were ordinary corner stores in a stable working-class neighbourhood.

One of the first buildings in the area was a donation by David Oppenheimer: the Alexandra Orphanage at Seventh and Pine, a rambling, picturesque building with many gables and dormers that dated from the early 1890s. Inside, in the winter, it could be "as cold as charity." It was a Women's Christian Temperance Union orphanage in its early years, and West End families supported it as part of their Christian duty. Mary Isabella Rogers's diary noted a visit to it with her children, bearing popcorn and toys, on Boxing Day, 1901 – the year they moved into Gabriola (page 119). On another occasion she and

Old store and houses at Seventh and Fir – the last enclave in Fairview that looks like the hippie Vancouver of a generation ago. A man named S.G. Purkis built the store and adjoining houses in 1906–07. For half a century they've been shadowed by the Fir Street offramp from the Granville Bridge, where I stood to sketch out the watercolour in 2004.

False Creek on July 4, 1960: log booms, barges and blazing saw-mills on the south side, a symbolic end to the industrial era there. In the left distance, City Hall stands on the Mount Pleasant hillside; in the middle in the smoke, Fairmont Medical Building; on the right, the turreted King Edward School at 12th and Oak. (Photographer unknown)
VPL 2871

1 See "Neighbourhood Houses" by Dave Adair in the *Greater Vancouver Book*, p. 407.

her friend Harriet Murray drove over in her carriage to choose an orphan each to support financially. In 1938 it became the city's first Neighbourhood House (Gordon House on Broughton in the West End, the second, opened in 1942). Neighbourhood Houses provided social services, helped with home-making and finding low-cost housing, and provided a non-church alternative of "fresh-air camps" for city children – notably Camp Alexandra at Crescent Beach.[1] Alexandra House was also the scene of community dances: I vividly remember one on a soaking autumn night in 1973, with a jug band playing and the local hippie community in overalls, peasant skirts and hiking boots practi-cally shaking the walls. Soon thereafter, the building mysteriously caught fire and burned to the ground. Alexandra Lodge is now the name of a townhouse complex at Arbutus and Valley Drive.

The entire neighbourhood had been changing since the 1950s when the city rezoned the area for light industry and set out to replace the former Japanese and Indo-Canadian area northwest of Fourth and Granville. City planner Gerald Sutton-Brown, drawing on British experience, believed that small industrial sites were the key to creating vibrant employment opportuni-ties and, eventually, large sustainable industries. The same thing happened

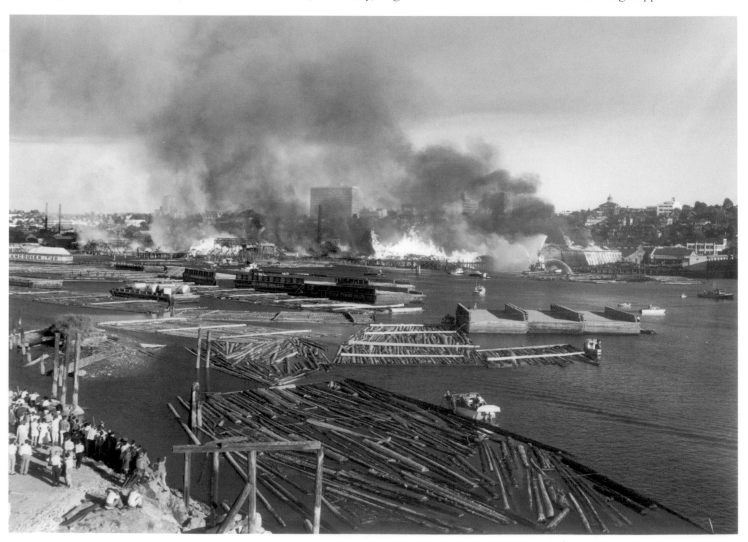

in Mount Pleasant north of Broadway during that period, but only Purdy's Chocolates and a handful of other businesses located in Fairview Slopes due to the steeper hills.[1]

Throughout the 1950s, landowners and the city supported the industrial use of the False Creek shoreline. Plans called for partial reclamation to create more industrial land, a process that would have filled the entire area east of the Cambie Bridge. Instead, only the back channel on the east side of Granville Island was filled, using dredge spoil from the development of the fishermen's marina at the eastern end of First Avenue.[2]

The fire on the south shore on July 4, 1960, had a symbolic effect far beyond the destruction of property and jobs. A short circuit in a planer shed caused a fire that rapidly became a conflagration, destroying the False Creek spruce division of B.C. Forest Products and damaging the extensive Alberta Lumber Company yards. In the heat of that clear summer day, the fire took off through the piles of lumber and dried-out buildings, leaping 50 feet at a time, shattering windows and twisting railway tracks. Pleasure craft and sightseers hampered the Fire Department, whose entire force of 450 and its fireboat fought for four hours before getting it under control. There were 250 jobs lost. The companies never rebuilt, realizing the insecurity of their tenure and the emergence of conflicting visions for the area. By 1963 there were only three

The Dairon Apartments at 2200 Heather is one of the few remaining buildings in Fairview Slopes built to house working families from the nearby False Creek industries. Erected in 1911, it was an investment by J. Dairon & Company, which sold "mantels, grates, tile floors and wall coverings" from a showroom next door at 690 West Sixth.

1 See Hardwick, *Vancouver,* p. 93.
2 See Burkinshaw, *False Creek,* p. 48.

sawmills left operating and much of the south shore was used for open storage, mostly of automobiles.

Land exchanges between governments and the CPR set the stage for False Creek's rebirth. In 1967 the provincial government was able to consolidate its hold on the south shore and the CPR's on the north shore (page 104). The following year, the provincial government sold its land to the city for $400,000 and an unused cemetery site on Burnaby Mountain that it required for the expansion of Simon Fraser University. The first plans to change the area to residential and parkland emerged in 1967 from geographer Walter Hardwick and architect Wolfgang Gerson and their UBC students, along with park commissioner J.E. Malkin. As the Roberts Bank port development was already underway, even die-hard industrial enthusiasts could see that it was time for False Creek to change.[1]

The city decided to lease its new land rather than selling it outright (which happened 20 years later when the provincial government sold the Expo site to Li Ka-shing). With the aid of consultants it drew up a plan that mixed public amenities, such as the seawall and parks, with a range of housing schemes, some for co-operatives, some subsidized and others market. Inspired by the academics who philosophically dominated The Electors Action Movement (TEAM), the governing civic party, the plan proposed an almost utopian mixing of types of people and income levels in the small residential enclaves. In the spirit of the times, Kitsilano residents who had formed food co-ops and been month-to-month tenants in shared houses – buildings usually held for speculation by absentee landlords – eagerly sought out the new False Creek housing, all the while maintaining that they weren't interested in accruing personal capital by owning fee-simple land in the normal housing market. It all worked surprisingly well for most, and continues to today. "It was a classic demonstration of cluster development maximizing public space and waterfront access while creating intimate courtyards and play and sitting areas within housing enclaves to serve local residents," wrote urbanist John Punter.[2]

The False Creek development was well underway when the federal government, urged on by its powerful local cabinet minister, Ron Basford, decided

Two houses on Seventh Avenue west of Hemlock consolidated as a development site in 1982. The combination of wrecked cars, mud, trash and weeds were a sure sign of impecunious tenants and speculator-landlords. Between about 1975 and 1990, the Fairview Slopes were almost completely redeveloped.

1 There is more detail in Burkinshaw, *False Creek*, pp. 53–57.
2 *The Vancouver Achievement*, p. 39.

to convert Granville Island into a "festival shopping" area. Basford was doubtless inspired by the Gastown example, including Larry Killam's proposal for a fishermen's wharf there, and by the idealism and positive attitude of the organizers of the Habitat Forum, the Jericho Beach complement to the United Nations housing conference held in Vancouver in 1976. The plan by Norman Hotson Architects ensured the reuse of as many of the old industrial buildings as possible; the management by a board of directors has kept a balance of artists and artisans, the food market, a few blatant tourist attractions such as a model railway museum, boating outfitters and the industrial and educational facilities, including the Ocean Cement plant, Granville Island Brewery, the Arts Club Theatre and the Emily Carr College of Art and Design. American visitors are usually astonished that there are no chain stores such as Starbucks, and admire the audacity of the vision. Unlike, say, Ghirardelli Square or Fishermen's Wharf in San Francisco, it authentically mixes the gritty industrial past with the sybaritic pleasures of modern urban life, and as long as it doesn't sink beneath the weight of tour buses and shopping bags it will continue to thrive into the future.[1]

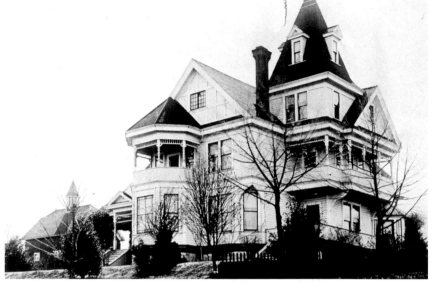

Jonathan Miller's home at the southeast corner of Eighth and Birch originally occupied much of the block with its barn, carriage house, paddocks and gardens. Miller bought it unfinished in 1895 from H.R. Morse, a sawmill owner. He arrived in the area in the 1860s, tried logging, then became the tax collector and constable for Granville, a.k.a. Gastown. In 1886, he became the city's first postmaster, but like some early residents he became wealthy through land-dealing. He died in 1913 at the age of 79. His house later became the Maywood School for Girls, an unwed mother's hostel with eight dorms and 25 beds run by the Salvation Army and affiliated with Grace Hospital. (Photographer unknown)

Fairview Slopes was a dank, deteriorated sort of place for much of its existence. It originally attracted some wealthy people who built grand homes with spectacular views, but as False Creek became the city's smoking industrial heartland it rapidly lost its lustre and its view. By the 1900s the writing was clearly on the wall, although a few people continued to believe it was a desirable area. James England, for example, in 1910 built the Queen Anne house at Seventh and Birch, a block below Jonathan Miller's mansion illustrated above. Miller had evidently moved there because his friend Charles Gardiner Johnson lived a block east at 1190 West Eighth, a large home called Bandra House that became Queen Mary's Coronation Hostel for Gentlewomen; Gardiner Johnson later moved to Oakhurst (page 210). Other nearby families of that rank included Walter C. Nichol, publisher of the *Province* and later lieutenant-governor, at 1151 West Eighth – the earliest Fairview house, built c. 1889 by Sir John and Lady Reid and now renovated as architects' offices. West of Hemlock, at 1417 West Eighth, lived the Hodson family; Jennifer Iredale and Nickel Brothers moved it a few blocks in 1974 to 1254 West Seventh, where it became headquarters for Early Music Vancouver.[2]

By 1910 Fairview Slopes was also home to a very different group of people. The Takehara Apartments at 1017 West Seventh was a tenement for Japanese sawmill workers; a Buddhist church stood a few blocks to the east. Middle-class houses occupied most of the lots, but by the 1920s they were

1 See *Island in the Creek: the Granville Island Story* by Catherine Gourley (Harbour, 1988).

2 In "Moving the Gingerbread House" (*Heritage West* magazine, Fall 1983), Jennifer Iredale told the story of Hodson Manor (the photo on p. 148 is from it) and a "pretty gingerbread cottage" she moved from 1301 West Seventh to Mayne Island. Ann Terriss noted one house floating away and photographed it, p. 149.

Carpenter Charles J. Tilly built himself this charming Queen Anne cottage at 975 West Eighth in 1905. The lot drops away sharply, allowing both room for a basement containing a furnace and fuel storage and a rare (for Vancouver) ground-level entrance.

beginning to be converted into rooming houses. As the industry along False Creek disappeared, students, drifters and hippies took them over. It was a dying, almost spooky place by 1970, with a few party houses here and there, lots of poverty, uncut grass, wrecked cars and houses desperately needing maintenance. Broadway was a commercial strip garishly illuminated by the neon of car dealerships such as Dueck and Bow-Mac, whose huge sign is now draped by the logo of a big-box toy store. The tenant community on the slopes, operating under the splendid acronym FRACAS (Fairview Residents Association and Community Action Society), fought against the rezoning of the slopes and argued equally unsuccessfully in 1972 against the high-rise Holiday Inn on Broadway at Heather. Insult was added to injury when a picket-shaped, concrete medical-dental tower sprang up a block to the west. Lot by lot the houses were boarded up, then demolished. A handful of the old frame houses were floated away to the Gulf Islands and recycled.

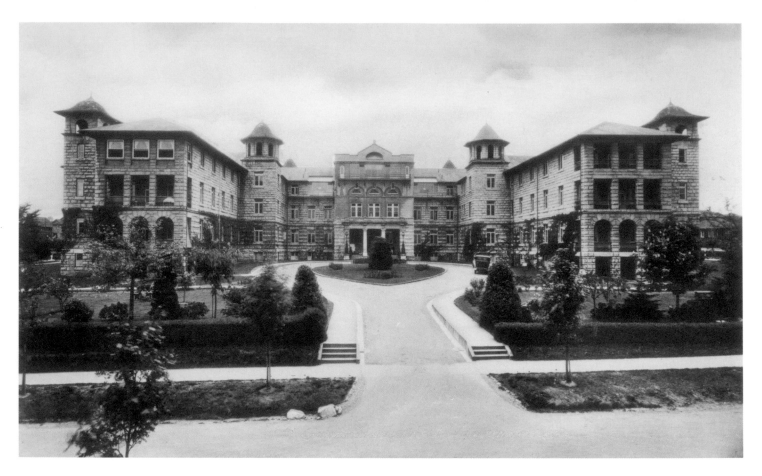

Vancouver General Hospital, the building we now know as Heather Pavilion, in the 1920s, seen from 10th Avenue. In a less hurried era, its fine gardens were objects of public pride. Returned to its original look, it will be the centrepiece of public open space in the evolving hospital precinct, with some kind of non-hospital use yet to be determined. (Photo by J. Fred Spalding)

Redevelopment of Fairview Slopes came very rapidly in the 1970s and 1980s – not the high-rises that many developers wanted, but a sort of San Francisco set of terraced townhouses that will probably be declared a heritage asset in another 20 years or so. It took a century of change before this settled community finally emerged.

The early landmarks on the Fairview flatlands above the slopes were the Vancouver General Hospital and King Edward School, both built in 1904–05. The former was an extraordinary act of public investment in a 15-year-old city, replacing the already cramped City Hospital at Pender and Beatty near Victory Square (page 75). Under the banner of the Vancouver Medical Association, citizens petitioned the provincial government for a hospital that would be free of profit motive or religious affiliation. A fine structure of brick and stone rose on the barren hillside and in January 1906, 47 patients made the trip in horse-drawn ambulances across the old Cambie skid bridge and up the hill. That building, engulfed in additions and renovations, became known as the Heather Pavilion and by 1960 was one of the almost anonymous wards where one would search for sick friends in the shadow of the 12-storey, cruciform-plan Centennial Pavilion. The original building remains almost intact in the midst of the sprawling hospital precinct, and its adaptive reuse as the focus of open space in the "Heritage Common" seems ensured after a campaign of at least 15 years led by the Heather Heritage Society, championed by former city councillor Marguerite Ford.

King Edward High School did not fare so well, but it was a fire that erased it from the landscape. Its gymnasium survived and became the nucleus of the King Edward Campus of Vancouver Community College. A new campus was developed in the early 1980s on the site of the old China Creek cycle track

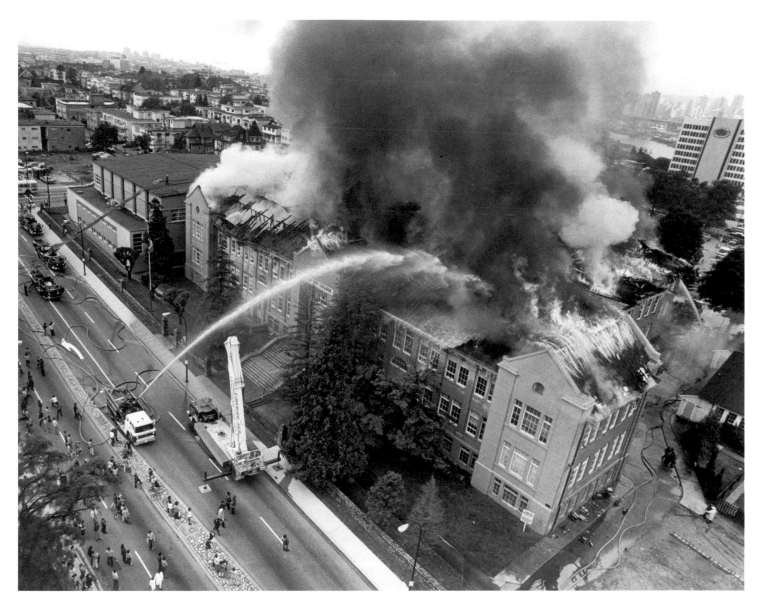

at East Broadway and Glen Drive, and hospital buildings expanded onto the school grounds. The entire precinct is now dominated by the Jim Pattison Pavilion, formerly known as the Laurel Pavilion, the largest and tallest building outside the downtown area.

The third landmark on the hillside south of False Creek is City Hall, the brainchild of Mayor Gerry McGeer. A headstrong, volatile, larger-than-life figure, he concurrently held elected office provincially, then federally, while he was mayor in the 1930s. He was always able to fire up the voters with allegations of official corruption, especially in the police force. He was a senator during his final time as mayor in the 1940s, during which he died suddenly of a heart attack. McGeer was independently wealthy due to an advantageous marriage. The location of City Hall away from the downtown was his gesture to the newly amalgamated municipalities of South Vancouver and Point Grey; its construction in the depths of the Depression was a feat of financial hubris perhaps unequalled in provincial history.

A Sun news photo by George Dyak of the fire in June, 1973, that destroyed King Edward School at 12th and Oak. The newly completed BC Automobile Association building stands in the right distance at the corner of Broadway and Oak. Remnants of the school's stone wall have been retained around the modern hospital buildings that now occupy the site.

ount Pleasant was already an established community, situated on the high ground south of False Creek on the New Westminster Road, by the time streetcar service reached it in the 1890s. It owed its existence to the foresight of Henry Valentine Edmonds, the clerk of New Westminster, who in 1869 became convinced that a railway would eventually have to terminate at Burrard Inlet. He bought a plot of land corresponding with the slope north of Broadway on both sides of Main Street, District Lot 200A, later adding another tract to the southeast. His land was bisected by the New Westminster Road, just to the east of the huge timber lease controlled by the Hastings Mill. The road had its origins in a military trail cut by Colonel Moody in 1860 to give early warning to the colonial capital, New Westminster, of any American attack, and evolved in the 20th century into Kingsway (page 228).

Until expanding Vancouver engulfed it, Mount Pleasant was a distinct separate town centred on the junction of Westminster Avenue, New Westminster Road and Ninth Avenue. The names changed between 1909 and 1913 to Main, Kingsway and Broadway, respectively, in anticipation of the rising of a great metropolis there! With a school, industries, shops, churches and hundreds of houses, it was Vancouver's first suburb. To the west lay the Fairview Slopes, surveyed by the CPR's Lauchlan Hamilton in 1885, with the "tree" streets beginning at Ash west of Cambie and continuing all the way to Larch in Kitsilano. Along the False Creek shoreline, logging camps came and went and a few shingle mills were established to process the rich harvest of cedar from the rainy hillside above. Mount Pleasant cyclists, wagons and streetcars crossed the False Creek narrows on a trestle bridge on Westminster Avenue to reach the downtown; at Granville Street, another trestle carried the streetcars across the sandbar that became Granville Island in 1916.

Mount Pleasant was relentlessly middle class on the high ground and working class on the gentle slope down to False Creek. It never attracted wealthy residents except in the blocks around Strathcona Park, which became the City Hall site in the 1930s. The preservation and continued use of the grand houses, most now divided into suites, is a tribute to the adaptable zoning system

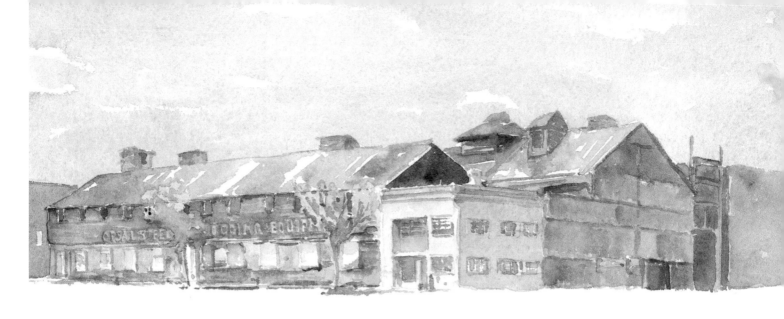

adopted there by the city in the 1980s. The inspiration was the Davis family, who a decade earlier began buying and restoring a block of derelict houses on 10th Avenue between Columbia and Alberta.[1] It was on the route of every tour bus company in the city until local residents tired of the invasion; now its "traffic-calmed" roundabout intersections are an extension of the beautifully gardened private yards.

Below Broadway, blocks of houses came down after the city's rezoning of the area in the 1950s for light industry. These austere, flat-roofed buildings usually housed "clean" businesses, a contrast with the smokestack industries closer to False Creek. Just east of the Cambie Bridge stood (and still stands) the city works yard on West First Avenue where the short streets named Wylie, Crowe and Cook descend from Second Avenue, the arterial. The docks and works of West Coast Shipbuilders dominated the shoreline to the east in the war years, a set of huge sheds with travelling cranes later used by Western Bridge and Steel Fabricating and the Canron Shipyards. Between Manitoba and Ontario were two mills: Sauder Lumber Company and the Allan Butler & McDougall shingle plant. A paper plant and some stone and concrete suppliers occupied the end of False Creek – the waterfront for the Olympic athletes

"Good jobs close to home," the mantra of politicians in the sustainability era, had a parallel in Mount Pleasant a generation ago. Whether there were good homes close to the jobs is a moot point.

PREVIOUS PAGE *An apartment building like a modified rowhouse that stood on Yukon at Sixth until the early 1980s.*

ABOVE *The huge Opsal Steel buildings at Second and Quebec, designed by T.H. Bamforth and built by Dominion Construction in 1918 for the Columbia Block and Tool Company. The Moderne corner office was added much later. Its prominent* LOGGING EQUIPMENT *sign is reminiscent of the foundries and machine shops of False Creek and Granville Island, which manufactured specialized equipment for the lumber and towboat industries on the muscular working harbour of generations ago. After decades of deterioration, they have miraculously avoided destruction and will evidently be rehabilitated and adaptively reused.*

BELOW *The McLean & Powell Iron Works foundry on Second at Yukon, shortly after the fire in 1982 that ended its existence.*

1 See *Vanishing Vancouver*, pp. 94–96 and *Vancouver Walks*, p. 79.

village for 2010. This was as heavy as heavy industry got in Vancouver. All that remained of it at the millennium was the Vancouver Salt Company building at the foot of Manitoba, a fine piece of industrial architecture that will be incorporated into the new residential community.

Along Second Avenue between Cambie and Main and on the adjoining blocks to the south was a diverse collection of primary industries. The Bissinger Company hide-processing plant at Second and Wylie was a classic: a large frame building with narrow horizontal board siding and rows of large, multi-paned wooden windows below a low-pitched roof, it had an ingrained smell about it that, it was said, precluded any adaptive reuse. Across the street was the W. Holt & Son glass manufacturing factory. On the triangular lot where Fourth and Yukon meet Second, the McLean & Powell Iron Works puffed smoke into the neighbourhood until a fire took it out in 1982. Everywhere there were foundries and machine shops, none bigger than the Opsal Steel Company that still dominates the block between Ontario and Quebec. Directories in the 1950s listed a legion of vanished businesses: Elco Manufacturing Company, Viking Automatic Sprinkler, Perfex Bleaching

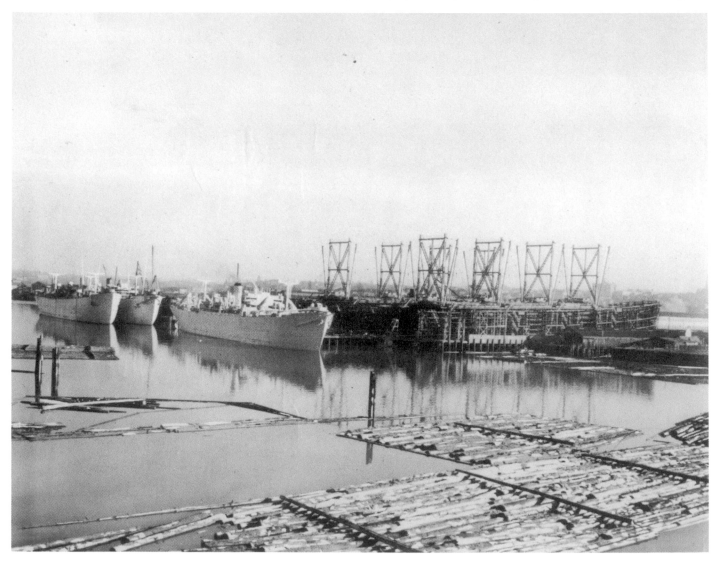

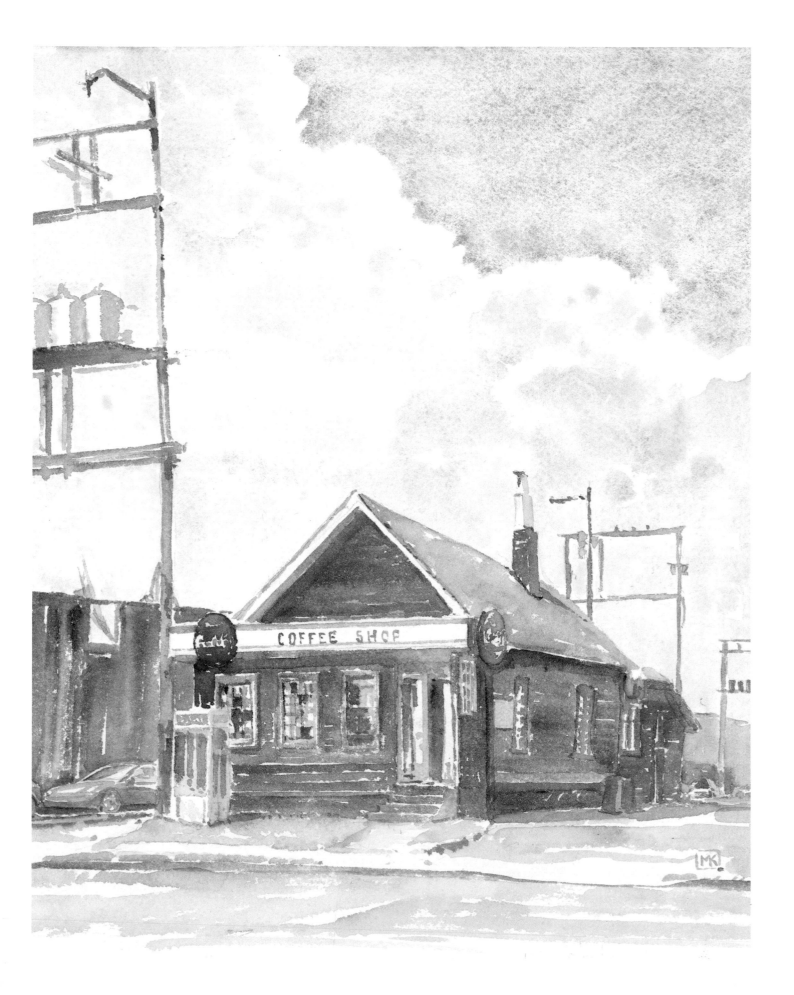

COFFEE SHOP

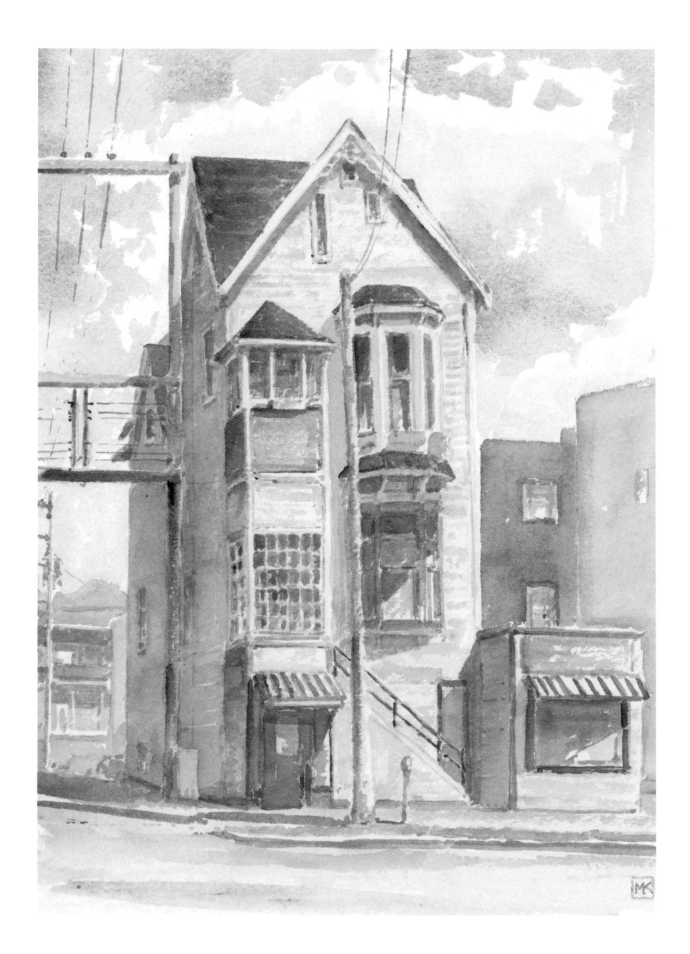

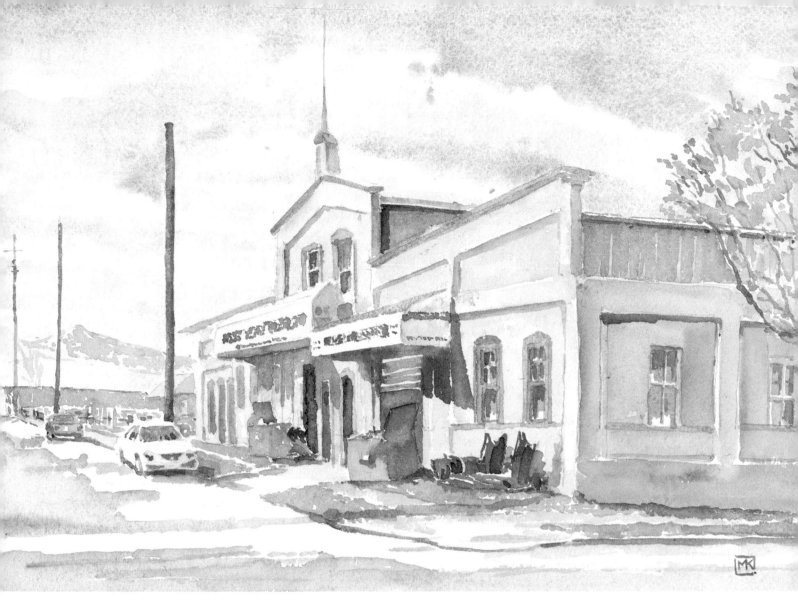

Company, Wilkinson & Company Steel and Wire Warehouse (the site of Citytv at Columbia), Black & White Auto Painters, Gibbs Tool & Stamping Works, Pacific Leather Company, Defiance Lumber, Spotless Cleaners and International Junk.

The old Mount Pleasant crossroads at Broadway and Main attracted some fine commercial buildings in the first years of the 20th century, which will be part of the rebirth in the 21st. In the past several years, the ubiquitous swarm of condos has settled on the area, reusing the former lots of car dealers such as Johnston Motors at Kingsway and Seventh. A block to the east at Sixth Avenue, a renovated stone building, part of the old Reifel brewery complex, heralded the arrival of "artists' lofts" in the area. Now there are several on the blocks to the north, catering to hip artists and wannabes with decent cash flow.

Scotia Street more or less follows the line of Brewery Creek, which rises on the slope of Mountain View Cemetery (page 222) and flows northwest into an area around 14th Avenue once known as the Tea Swamp (for the Labrador tea plant that grew there) – one of the few breaks in the forest on the New Westminster Road of colonial times. In the days before it was confined to a pipe, the stream spilled out of the swamp, crossed Broadway beneath a wooden bridge just east of Main, and tumbled down a gully into False Creek. It was Captain Stamp's first (though unsuccessful) water source for his

PREVIOUS PAGE *A rare early survivor from the Mount Pleasant of 115 years ago: 151 East Eighth is a tall Victorian building, probably built c. 1891 as a rooming house by a man named Pencier. The decor on the house and shop reflected their use by Bains Chocolates, which for years occupied the flatiron building at Kingsway and Main.*

ABOVE *Now used as an autobody shop, the old Boiler and Engine Room for Vancouver Breweries at 263 East Seventh is an interesting industrial relic with a clerestory to illuminate the central shop floor. Its water connection permit was signed in 1913 by Henry Reifel, the legendary brewer (page 174).*

sawmill (page 38). In 1880s and '90s Vancouver, before the city water supply reached the area, Brewery Creek's banks were lined with bottling companies: the San Francisco brewery of the Reifel brothers, the Vancouver Breweries of Charles Doering and a soda-water works that produced ginger beer and beverages named Kola Champagne, Iron Brew and Sarsparilla. At the mouth of the creek stood two slaughterhouses and a tannery. In addition to the above-mentioned brewery building, the 1913 boiler and engine room for the brewery stands at Seventh Avenue, illustrated on the previous page. The commemoration of Brewery Creek in handsome cairns along Scotia Street was the work of a group including historian Bruce Macdonald and neighbourhood activist Charles Christopherson.

Working-class areas are typically "park deficient," in planner's jargon, and Mount Pleasant was no exception. When Strathcona Park became the City Hall site, pioneer and philanthropist Jonathan Rogers willed $100,000 to replace it. The namesake of the Rogers Building at Pender and Granville, Rogers was a contractor and developer who turned his interests increasingly to the city's park system. He sat on or chaired the Park Board from 1908 to 1943, spearheading the creation of the ribbon park that follows the city foreshore all the way from the West End to Spanish Banks and beyond. His wife, Elisabeth, was similarly public-minded. Following his death in 1945, the city created Jonathan Rogers Park on the block bounded by Columbia, Main, Seventh and Eighth. Regrettably, the families for whom the park was intended moved away due to the rezoning that raised their taxes and attracted industry, leaving the park a rather forelorn, treeless, rainswept place for a generation or more. It will take the march of the condos to put park users into that part of Mount Pleasant again.

The Ledingham House at 8th and Brunswick as it appeared in 1982 before the grievous alteration that left little more than its corner turret standing. Built about 1895, three years after the Mount Pleasant School opened a block away, the house was occupied for a half-century by contractor George Ledingham and family. LEDINGHAM-stamped sidewalks are still common, especially on the west side of the city, and the family name remains associated with the construction business. The school – eight rooms with a brick tower and a slate roof (identical to Dawson School, page 86) – opened in 1892 at Kingsway and Broadway. When it was demolished in 1972, the house's tenants rescued the granite sign and kept it on their lawn.

Kitsilano & Jericho

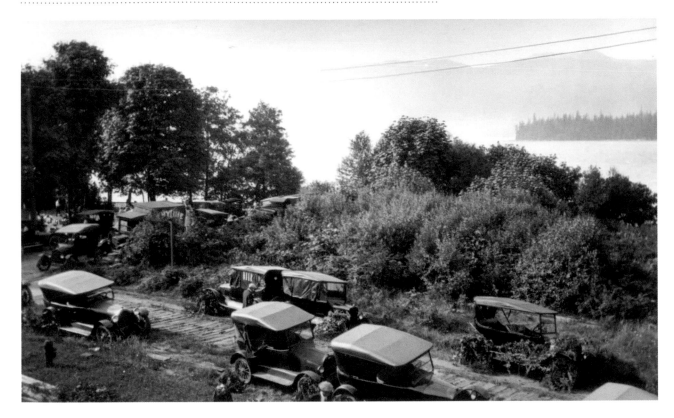

Kitsilano and its foreshore have been inseparably linked in the Vancouver consciousness since campers arrived in rowboats in the 1880s and spent idyllic summers in their tents. Logging camps came and went, the most permanent being Jerry Rogers's at "Jerry's Cove" – Jericho – a natural clearing that had been used as a seasonal fishing camp by Aboriginal people for millennia. A trail along the bluff west of Kitsilano beach, approximating the route of Point Grey Road, allowed campers and a few early settlers, such as the Quiney family who built in the woods at 4th and Dunbar in 1907, to pack groceries in from Yaletown stores.

The campers were unharried as long as they didn't attempt to build anything permanent on the shore. Witness Sam Greer, who arrived in 1882, two years before the CPR received its land grant, and claimed he had pre-empted property bounded roughly by Arbutus, Trafalgar and Sixth Avenue – the northwest corner of the railway's huge District Lot 526. He built a cabin on the beach near the site of the modern pavilion, planted a garden and an orchard and set his cow to graze among the stumps on swampy Kitsilano Point. But his idyll with his wife and daughter, Jessie, was short-lived. Lacking political connections, he had been unable to register his claim, and he kept changing his story on significant details such as whom he had bought it from. The CPR had

Cars of picnickers on Ogden Street, Kitsilano Point, about 1918. The tires are covered with brush to stop them from cracking in the hot summer sunshine. Following a bequest by pioneer jeweller Harvey Haddon in 1931, the park took his name. The treed profile of Stanley Park encloses English Bay in the distance.
ANNE AND KEN TERRISS

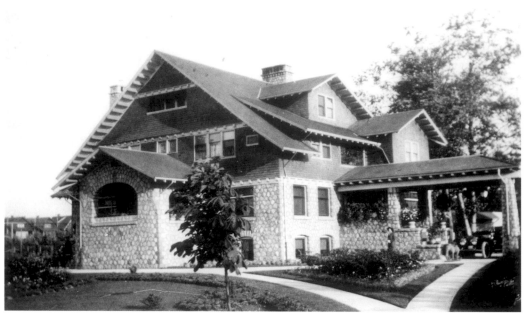

ENGLISH BAY

Point Grey Road

KILLARNEY

Bayswater

TATLOW PARK

TATLOW COURT

LEFT *The Tatlow Park area, as it was until the mid-1950s.*

ABOVE *Killarney, the home of John and Jessie Hall, lasted from 1908 until 1956. A few comparable buildings survive on First Avenue west of Larch and on Point Grey Road.* CVA BU. P. 113

ABOVE RIGHT *Robert Garnet Tatlow, tragically killed in 1910, was the Conservative minister of finance in the provincial government and a friend of the Halls. The pretty park next to Killarney took his name. (Drawing by Leslie Ward, a.k.a. Spy)* CVA PORT. P. 724

BELOW *Tatlow Court, the purest example of a bungalow court left in Vancouver. As built in 1928, it comprised 12 one-bedroom units in steep-roofed Tudor cottages on three sides of a garden court. (Photo by Leonard Frank, 1933)* VPL 5299

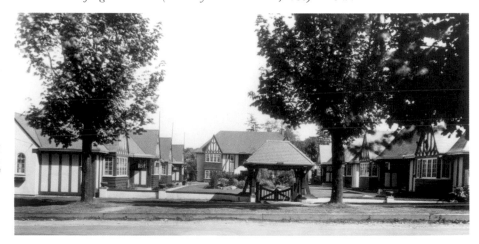

NEXT PAGE *The undeveloped part of Kitsilano Beach as seen from the foot of Dunbar. It is still a place of solitary walkers, discreet sunbathers and the occasional smelt fisherman. In its untrammelled state, it survived a "glamour parkway" scheme, promoted by an engineer named Neville Beaton in 1956 and touted by Mayor Bill*

Rathie as a suitable centennial project for the city. His successor, Tom Campbell, also supported it, arguing that it would shield Point Grey Road homeowners from traffic and noise. In the final plan, Kitsilano would have gained 25 acres of grassed parkland on the bank above and a half-mile of groomed sandy beach.

other plans and issued Greer with an eviction notice, following it up with a civil suit. Finally, in 1890, Sheriff Armstrong and two deputies were dispatched to evict him, but Greer holed up in his cabin, refused to come out, then opened fire and shot the sheriff (but he did not shoot the deputy). Denounced as a liar and convicted of common assault, Greer was sentenced to imprisonment at the BC Penitentiary, where he was seen by many as a political prisoner and hero for standing up to the CPR.

Sam Greer thus holds the distinction of being the first Kitsilano flouter of authority; a one-block street between Cypress and Chestnut on Kitsilano Point preserves his name. But in the democratic, egalitarian west, the sins of the father were not visited on the daughter, who became one of the pillars of Vancouver society. Jessie Greer, born at Jack o' Clubs Creek in 1872 and purportedly the first white birth in the Cariboo, married John Hall, a notary public who parlayed his early arrival in Vancouver into a substantial fortune. From Killarney, her fine home on Point Grey Road at Bayswater, she directed charitable events, held Conservative political meetings and hosted parties in the downstairs ballroom with its sprung floor. She died in 1949; her era ended symbolically several years later when the Killarney Apartments rose on the site of her demolished mansion. By that time, Kitsilano was under the influence of a new generation of land developers who met in city hall backrooms and in downtown office buildings.

Other adventurous settlers of means also chose land west of the CPR boundary at Trafalgar. The first arrival in 1903, four years before the Halls, was a realtor named Thomas Calland, who built a grand home called Edgewood on the bluff between Stephens and Trafalgar. For his first few years there, he walked or rode his bicycle to Granville Street, where he could catch a tram downtown. Then, following the 1905 deal with the CPR that gave birth to the Vancouver-Steveston interurban system, the BC Electric Railway Company ran a streetcar line from the end of the Kitsilano trestle west to Greer's Beach, as it was popularly called. Suburban development began immediately, as did a flood of sunbathers and campers during fine weather. A few years later, when the tents were lined three deep along the beach, the city was forced to ban camping for sanitary reasons. It built a bathhouse and pavilion, cleared the rocks off the shore and brought in sand from dredging operations in False Creek. Kits Beach, the all-seasons pleasure ground, was born.

The CPR went looking for a new name for its suburb in 1905 and consulted with local authorities,

Edgewood, the Thomas Calland house on Point Grey Road west of Trafalgar, considered to be the "Finest Home West of Granville Street" in 1904, as it appeared in the 1940s shortly before its demolition. Fragments of its wall survive in front of smaller houses that now occupy the site. (Dominion Photo Company)
VPL 26502

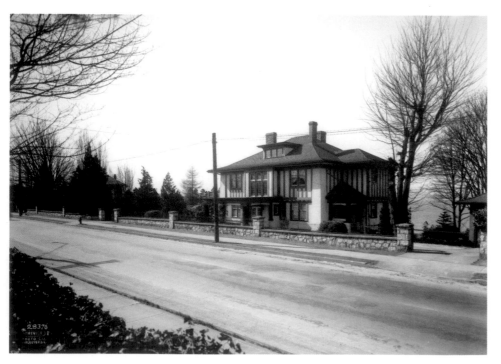

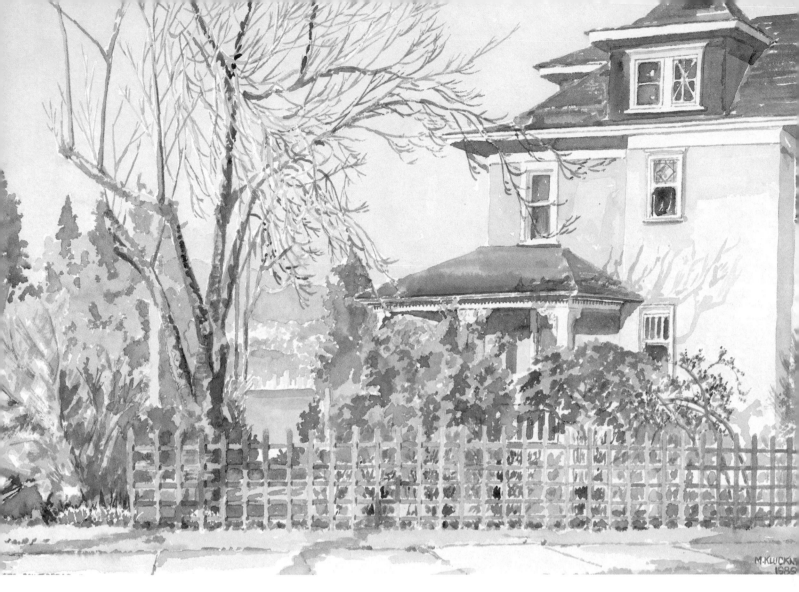

including an ethnologist, Charles Hill-Tout, who suggested calling it after a Squamish chief: Khahtsalano, the father of Supple Jack of Chaythoos and Sun'ahk and grandfather of August Jack Khahtsalano of Sun'ahk (page 146). The CPR agreed and Kitsilano was born. But the anticipated boom did not immediately materialize, no doubt because there was equally attractive, more convenient land available in the West End and Fairview, and west of the CPR's land, where there were no restrictions on lot sizes or types of dwellings. Two harbingers of the future were planted just on the west side of Trafalgar Street: the Panama Apartments and Annex at Fifth, in 1911, and the brick-faced Wellington Apartments at York, built in 1926.

The CPR eventually launched its community by building five large Craftsman houses on Kitsilano Point in 1909; the first one, sold to William Evans who drove the first locomotive into Port Moody in 1886, straddled two lots at 2030 Whyte Avenue. In the early 1990s, its owners – musician Bill Henderson and his wife – tried to preserve it with a heritage agreement that would have constructed an infill house, but after protracted protests from neighbours about excessive density the house took a barge trip to Bowen Island and the lots were redeveloped with two very large new houses, which also annoyed the neighbours. *Sic transit* Kitsilano Point heritage.

I painted the Ells House, at Stephens and Point Grey Road across the street from the Edgewood site, in 1989 when it looked like it would be demolished. Instead, it was moved to the edge of its lot, destroying a fine garden but making room for a townhouse grouping. Built in 1908 for a man who appears to have been a grocery clerk at a Hastings Street emporium (but who must have dabbled in real estate), the house is one of a handful of survivors from the period when Kitsilano west of Larch Street was an option for well-off Vancouverites leaving the West End for greener pastures.

One part of today's Kitsilano neighbourhood that has all but disappeared is the industrial area south of Broadway centred on the Arbutus Corridor railway tracks. At the same time that the CPR named Kitsilano, it was extending water mains into what was then called West Fairview and selling lots and blocks for industrial operations. The BCER's freight division installed spur lines from the Steveston interurban line to service the new plants. A shingle company, a tile and brick works, a commercial bakery, a dairy and a prefabricated-house plant were among the businesses that located within a quick shunt of the rail line. The biggest was Vancouver Breweries Ltd., which in August 1909 bought Block 383 – bounded by 11th, 12th, Yew and Vine streets. Its brick tower, straddling the spur line that brought grain in and took beer out, became the neighbourhood landmark. A number of the 80 or so workers employed at the plant made their homes in the small frame houses on nearby streets. The brewmaster himself lived on 11th.

Henry Reifel (1869–1945) started in the brewery business in Nanaimo but soon moved his operations to Vancouver, settling first along Brewery Creek (page 167). One of his early brands was Cascade – "the beer without a peer" brewed from the "pure waters of the Capilano" (that is, city tap water), which in 1911 cost $2 for a dozen quarts. Working with his son George, Henry Reifel dominated the beer and liquor business in BC until the 1930s.

During British Columbia's experiment with Prohibition from 1916 to 1920 the brewery kept operating by making "temperance beer," sometimes called "beaver piss," which nevertheless was said to contain four percent alcohol. After Prohibition ended in 1920 following a myriad of corruption scandals, the Reifels engineered a distribution policy in which "a few breweries operating by agreement among themselves divided the business by friendly arrangement." The brewers made the deal with Liberal Attorney General J.W. deB. Farris,

An Al Beaton cartoon from 1956 accurately depicting both the look of a standard government liquor store and the policy reflected there-in: drinking was not supposed to be fun! *The small selection of merchandise was intended to minimize administrative difficulties while maximizing government profit. Beaton (1923–1967) drew cartoons for the* Province *from 1953 to 1961, then moved to the Toronto* Telegram. *A graduate of the Vancouver School of Art, he travelled extensively and served overseas with the r c af during the Second World War.*

"Say, let's US have an office party . . ."

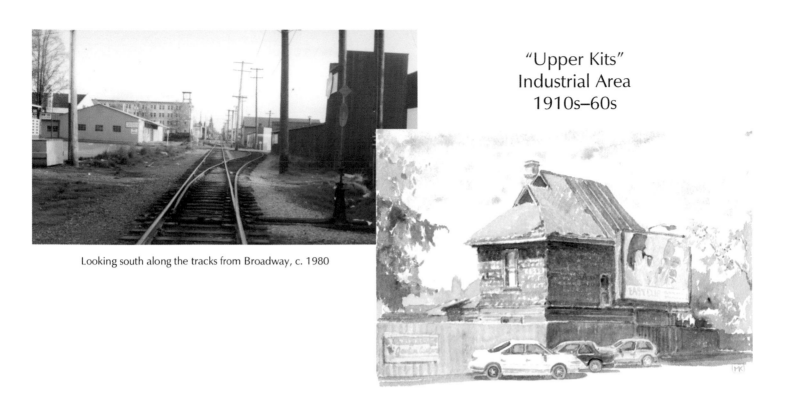

"Upper Kits" Industrial Area 1910s–60s

Looking south along the tracks from Broadway, c. 1980

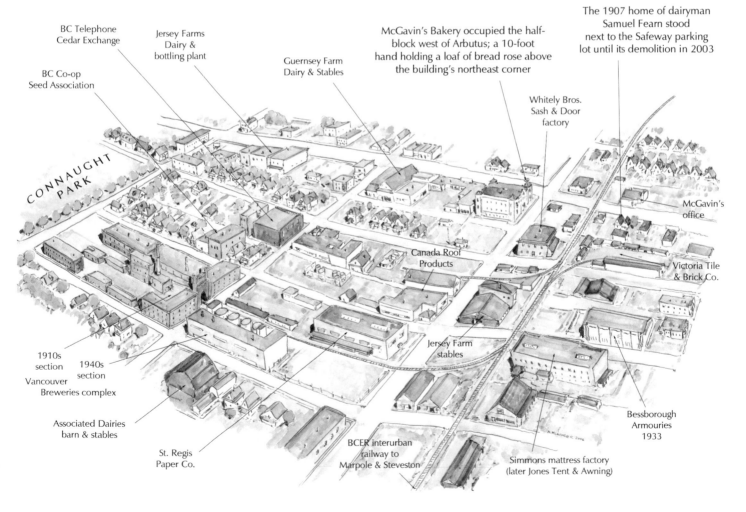

BC Telephone
Cedar Exchange

Jersey Farms
Dairy &
bottling plant

BC Co-op
Seed Association

Guernsey Farm
Dairy & Stables

McGavin's Bakery occupied the half-
block west of Arbutus; a 10-foot
hand holding a loaf of bread rose above
the building's northeast corner

The 1907 home of dairyman
Samuel Fearn stood
next to the Safeway parking
lot until its demolition in 2003

Whitely Bros.
Sash & Door
factory

CONNAUGHT PARK

McGavin's
office

Canada Roof
Products

Victoria Tile
& Brick Co.

1910s
section

1940s
section

Vancouver
Breweries complex

Jersey Farm
stables

Associated Dairies
barn & stables

Bessborough
Armouries
1933

St. Regis
Paper Co.

BCER interurban
railway to
Marpole & Steveston

Simmons mattress factory
(later Jones Tent & Awning)

who subsequently retired from politics and became the Reifels' lawyer before his appointment to the Canadian Senate in 1936.

Liquor policy in the wake of Prohibition and continuing for a half-century thereafter was embodied in the name of the provincial agency: the Liquor *Control* Board. "Pay government taxes and support the big brewers and distillers by buying alcohol but don't drink it in public and don't, whatever you do, appear to be having any fun" – in a nutshell, that was government policy. Liquor licenses were tied to hotels: one result was dark taverns reeking of smoke, stale beer and besotted old men, and separate entrances for "ladies with escorts"; cocktail lounges only began to appear in the 1950s, wine in restaurants in the 1960s and neighbourhood pubs in the 1970s. There were only *government* liquor stores, all with a clinical atmosphere: before the 1970s you chose from a list, paid a cashier and then were handed your selection in a brown paper bag. Liquor-equals-sin persisted in BC until Expo '86.

Distilled liquor was profitable enough with just the local market, but a huge business opportunity opened up when the United States went dry from 1920 to 1933 following the passage of the Volstead Act. Colourful stories of high-speed motor launches loaded with liquor eluding the Coast Guard and threading their way to midnight rendezvous in the San Juan Islands became part of the Vancouver legend.[1] The Reifel name was attached to most of them. In the public record, Henry Reifel purchased the BC Distillery in New Westminster in 1924, then went on to buy and establish others. He remained president of the Brewers and Distillers Corporation until his sudden resignation on July 26, 1934. On August 1, Henry and George were indicted by the United States District Court in Seattle on charges that they had violated American customs and tariff regulations by smuggling more than 2,000 cases of assorted liquors by shortwave radio-equipped speedboat into the USA. The Reifels agreed the following July to settle out of court for $700,000.

The Reifel sons, George and Harry, built the two great "Hollywood Spanish" mansions of the period: Casa Mia and Rio Vista on South West Marine Drive. George built the Commodore Ballroom and the Vogue Theatre on Granville Street. Harry was a more retiring character, raising Jersey cows in Langley. The family "weekender" and hunting property evolved into the Reifel Migratory Bird Sanctuary on Westham Island, opened in 1965.

The Yew Street Vancouver Breweries plant expanded in the 1940s with the purchase of the half block fronting 12th Avenue between Yew and Arbutus and the construction of the large industrial plant that was familiar until the millennium. Carling's bought out Vancouver Breweries in the 1950s; a subsequent merger made it the Carling O'Keefe Brewery. In 1989 Molson's merged with Carling O'Keefe, and over the next decade consolidated the brewing operations in the old Sicks' Capilano brewery on Burrard (page 151), leaving the Yew Street plant vacant and ripe for redevelopment.

The conversion of underused industrial land for residential purposes has been a significant element of the city's planning for "densification," while bringing minimal change to the surrounding family neighbourhoods. The brewery's distinctive tower was replicated as part of a condominium development. Of the other buildings in the area, only the old Jones Tent and Awning plant on 11th has survived, although it, too, was converted into suites in the 1990s.

1 See the memoir *Slow Boat on Rum Row* by Fraser Miles (Harbour, 1992).

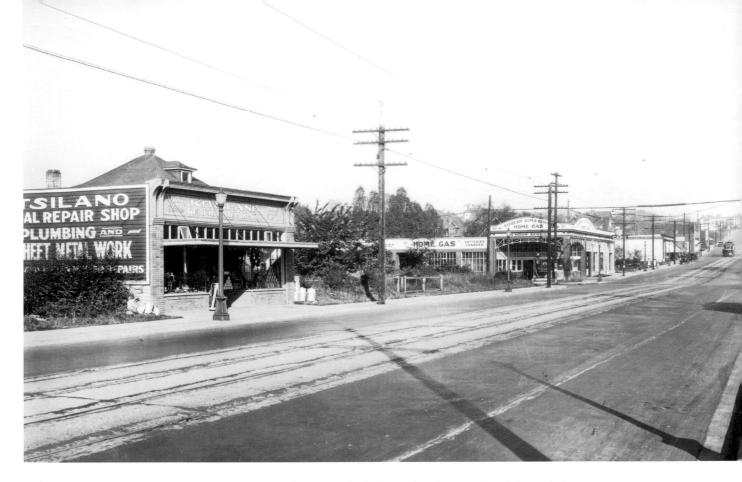

The beach community was just one aspect of residential Kitsilano. Another distinctive precinct is a child of the 1909 Fourth Avenue streetcar line, which reinforced the commercial area that had developed at the top of the hill around Yew and Vine streets in the previous few years and opened up acres of virgin land to the speculative builders of the boom years just before the First World War.

The blocks around Macdonald between Point Grey Road and Broadway are the most intact streetcar suburb of the era. On each narrow 33-foot lot, carpenters fitted in more square footage of house than anywhere else in the city. The gutters on the big Craftsman homes on Macdonald between Fifth and Seventh, for example, touch or even overlap. Only fashion and the persistent dream of detached family homes kept early Kitsilano from becoming a suburb of row houses. When building resumed after the First World War, buyers demanded smaller homes and usually got a California bungalow such as the ones in the long row on Fifth west of Bayswater; by the 1930s and 1940s, buyers were offered even more modest boxes, usually stucco with a hipped roof. More often than not these "starter homes" fitted into vacant lots between the bigger houses of the previous generation.

With the advent of the Depression in the 1930s, followed by the wartime housing shortages of the 1940s, many older homes were easily converted into rooms and suites. In the 1950s, students from booming postwar UBC found affordable accommodation in them; by the 1960s, with the blooming of the counterculture, Kitsilano was ready-made to become the Haight-Ashbury of Canada.

Fourth Avenue looking east toward Macdonald Street about 1925. The gas station on the corner opened in the early 1920s as a Studebaker agency called Ever-Ready Garage and Service Co., and became Tremblay Motors in 1934. A venerable family of mechanics, the Tremblays ran a Chevron station that was a neighbourhood institution until they made way for a gas bar and minimart. (Photo by W.J. Moore)
JOHN ATKIN

Kitsilano
in the hippie era
(advertisements & businesses from c. 1968–74)

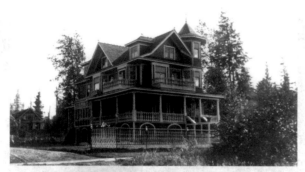

R.D. Rorison's 1908 home at 3148 Point Grey, built with the timbers of the old English Bay Cannery at the foot of Bayswater, was known as the "Peace House" in the 1960s, a famous crash pad for visiting bands and cultural icons, including Timothy Leary, Baba Ram Dass and Allen Ginsberg.

(Photo by James Quiney c. 1912, CVA 7-88)

CPR Engine 374, which pulled the first train into Vancouver, stood at Kits Beach from 1947 until it was moved in 1985 to the Roundhouse Community Centre on False Creek.

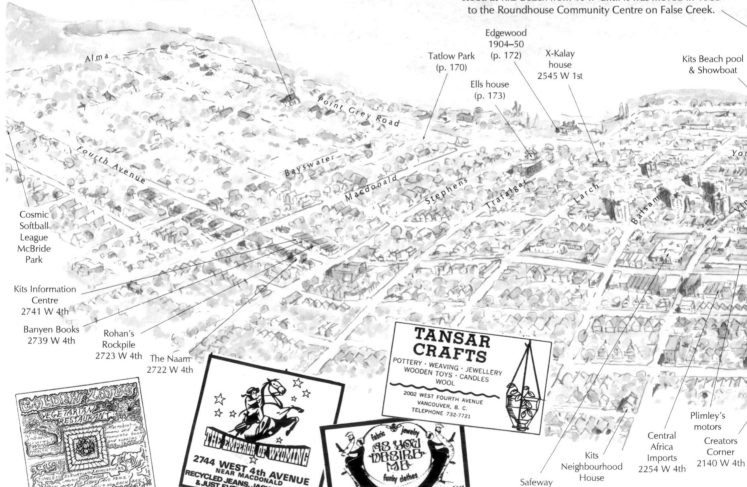

Alma

Point Grey Road

Fourth Avenue

Bayswater

Macdonald

Stephens

Trafalgar

Larch

Balsam

Vine

York

Tatlow Park
(p. 170)

Edgewood
1904–50
(p. 172)

Ells house
(p. 173)

X-Kalay
house
2545 W 1st

Kits Beach pool
& Showboat

Cosmic
Softball
League
McBride
Park

Kits Information
Centre
2741 W 4th

Banyen Books
2739 W 4th

Rohan's
Rockpile
2723 W 4th

The Naam
2722 W 4th

Kits
Neighbourhood
House

Safeway

Central
Africa
Imports
2254 W 4th

Plimley's
motors

Creators
Corner
2140 W 4th

GOLDEN LOTUS
VEGETARIAN RESTAURANT
733-2920

THE EMPEROR OF WYOMING
2744 WEST 4th AVENUE
NEAR MACDONALD
RECYCLED JEANS, JACKETS, SKIRTS
& JUST EVERYTHING $4 & UP

TANSAR CRAFTS
POTTERY · WEAVING · JEWELLERY
WOODEN TOYS · CANDLES
WOOL
2002 WEST FOURTH AVENUE
VANCOUVER, B. C.
TELEPHONE 732-7721

AS YOU DESIRE ME
fabric jewelry
funky clothes
738-4616
2175 W.4th Avenue, Vancouver.

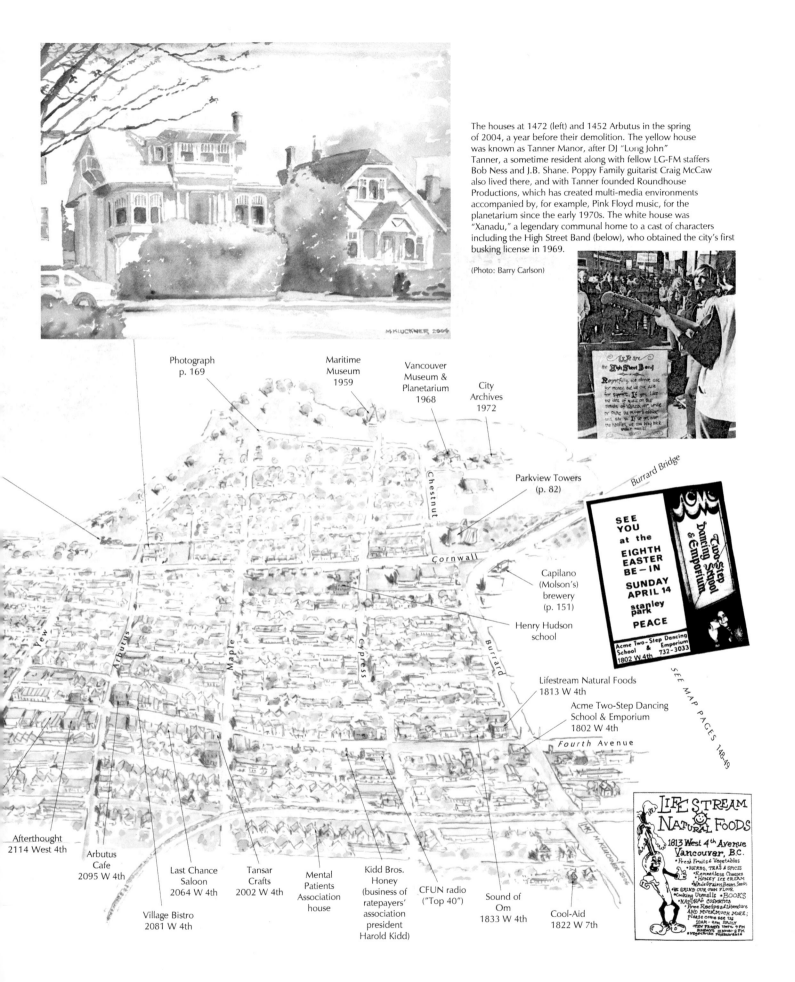

The houses at 1472 (left) and 1452 Arbutus in the spring of 2004, a year before their demolition. The yellow house was known as Tanner Manor, after DJ "Long John" Tanner, a sometime resident along with fellow LG-FM staffers Bob Ness and J.B. Shane. Poppy Family guitarist Craig McCaw also lived there, and with Tanner founded Roundhouse Productions, which has created multi-media environments accompanied by, for example, Pink Floyd music, for the planetarium since the early 1970s. The white house was "Xanadu," a legendary communal home to a cast of characters including the High Street Band (below), who obtained the city's first busking license in 1969.

(Photo: Barry Carlson)

M.KLUCKNER 2004

Photograph
p. 169

Maritime
Museum
1959

Vancouver
Museum &
Planetarium
1968

City
Archives
1972

Parkview Towers
(p. 82)

Burrard Bridge

Chestnut

Cornwall

Capilano
(Molson's)
brewery
(p. 151)

Henry Hudson
school

Yew

Arbutus

Maple

Cypress

Burrard

SEE
YOU
at the
EIGHTH
EASTER
BE – IN
SUNDAY
APRIL 14
stanley
park
PEACE

Acme Two-Step Dancing
School & Emporium
1802 W.4th 732-3033

Two-Step
Dancing School
& Emporium

SEE MAP PAGES 148-49

Lifestream Natural Foods
1813 W 4th

Acme Two-Step Dancing
School & Emporium
1802 W 4th

Fourth Avenue

M.KLUCKNER 2004

Afterthought
2114 West 4th

Arbutus
Cafe
2095 W 4th

Last Chance
Saloon
2064 W 4th

Tansar
Crafts
2002 W 4th

Mental
Patients
Association
house

Kidd Bros.
Honey
(business of
ratepayers'
association
president
Harold Kidd)

CFUN radio
("Top 40")

Sound of
Om
1833 W 4th

Cool-Aid
1822 W 7th

Village Bistro
2081 W 4th

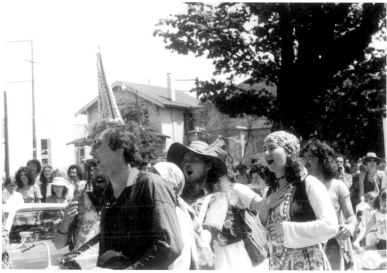

Hippie Kitsilano: a moon festival on the beach near the Maritime Museum about 1970, and a street parade probably a few years later. These nonconformist public displays rattled the old Vancouver standards, where people spoke in hushed tones, looked away from direct gazes and dressed in dour uniforms of suits and frocks. (Photos by Sajiw-Terriss)

1 The early Harold Hedd cartoons by Rand Holmes (1943–2002) in the *Georgia Straight* perfectly caught the laid-back mood.

Hippie Kitsilano got going around 1965 to 1967 in an atmosphere of poetry, music and hedonism and after a few carefree years morphed into a hotbed of social activism.[1] The Fourth Avenue strip of small, affordable stores provided the perfect venue for "head shops" and poster galleries – a one-stop shopping centre for hippie gear to take home, put up in the communal houses and cheap apartments that were so easy to rent nearby, or wear in the coffee houses where poetry was earnestly recited and protest songs sung. Since the re-zonings of the mid-1950s, many absentee landlords had been letting their places slide, doing only the minimal maintenance, and a half dozen or more young people could easily come up with the few hundred dollars of monthly rent and electricity to keep a house going. Margaret Laurence's Morag Gunn in *The Diviners* described their faded colour as "the light sea-bleached grey of driftwood, silver without silver's sheen."

The old Kitsilano Theatre on Fourth just west of Arbutus, abandoned due to the dominance of TV, provided one of the first coffee-house venues. Named the Afterthought by teenage impresario Jerry Kruz, it featured the Tom Northcott Trio and other local folkies. At the Village Bistro at 2081, comedians shared the stage with groups like the Poppy Family. Psychedelic bands, such as the United Empire Loyalists, Papa Bear's Medicine Show, Mother Tucker's Yellow Duck, My Indole Ring and the Collectors, emerged and were booked by Kruz into the Pender Auditorium[2] and the Be-Ins each springtime in Stanley Park. Roger Schiffer opened the Retinal Circus in the old Dante's Inferno/Embassy Ballroom building on Davie (page 114). Psychedelic poster artwork by Frank Lewis and Bob Masse, pasted onto blank walls around town, brought every "head" from miles around to hear the Steve Miller Band, Big Brother and the Holding Company, Country Joe and the Fish and the Grateful Dead.[3] Later clubs included the Daisy, a conversion of a Legion building at Fifth and Fir – home of the Lazy Gourmet in recent years. Visiting bands often crashed at the turreted "Peace House," once the Rorison home on Point Grey Road, or in motels out on Kingsway – these were not rich rock 'n' rollers travelling with private jets and entourages.

The psychedelic bands, complete with their light shows, also played at dances organized in church basements and even at dances in high school gyms. Extraordinary scenes remain in my memory, such as a priest at Immaculata school on West 10th trying to pick his way through swaying dancers in the pulsing strobe and swirling lights of the Ecto Plasmic Assault light show.

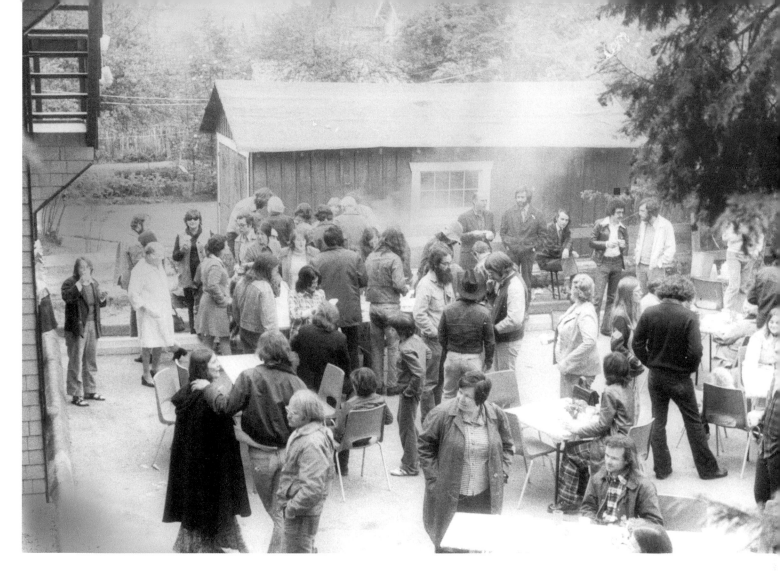

Elsewhere, rhythm and blues bands, such as Jason Hoover and the Epics or Kentish Steele and the Shantelles, remained popular and played for "young people's dances" at Establishment places like the Royal Vancouver Yacht Club – you only needed to know someone who was a member and could sell you a ticket. A weekend could start in a blazer and tie there and end in bell-bottom jeans and a tie-dyed T-shirt, writhing to Jefferson Airplane at the PNE Gardens or the Yardbirds at Kerrisdale Arena. At Kitsilano Beach near the tennis courts, bands plugged in and played looping, endless jams in the equally endless purple-haze twilight of Vancouver's summer evenings.

Rock 'n' roll had been perceived as "the ultimate in musical depravity" ever since Bill Hailey and the Comets played at Kerrisdale Arena in 1956, but at least it took place behind closed doors. By contrast, the outdoor, rebellious, pot-smoking side of hippie Kitsilano was a provocation. Otherwise harmless poets, such as Stan Persky, George Bowering and Dan McLeod, became ogres in the eyes of Harold Kidd, the ultra-intolerant president of the Kitsilano Ratepayers Association, and the city's shoot-from-the-lip mayor, Tom Campbell (pages 49 and 81). McLeod started the *Georgia Straight* newspaper after four hippies who were hanging out on the vacant lot behind the bus stop at Fourth and Arbutus were arrested for vagrancy and the Arbutus Cafe (ironically now Sophie's Cosmic Cafe) across the street posted a sign that read, "we do not serve hippies or beatniks." In the subsequent David and Goliath battle, Campbell threw every police and regulatory resource he could at hippies and their fledgling

The Kitsilano activist community at a barbeque at Kits House in May, 1974. Originally the Greek Orthodox Church in Vancouver, Kits House at Seventh and Vine became a neighbourhood house when the new church was built in Arbutus Flats in the 1960s; it was a centre of social activism, focusing on childcare, welfare assistance and housing. The man marked by the red dot, Nathan Karmel, was principal organizer of the West Broadway Citizens Committee. (Photo by Sajiw-Terriss)

2 In the Victory Block, 339 West Pender, destroyed by fire in 2003. A google search of "Pender Auditorium" brings up a lot of blogs and links about music and bands of that era.

3 The best overview I have read of that era's music scene is the interview of Jerry Kruz by Dave Watson, "The Be-In," in *Georgia Straight,* May 8–15, 1997. Poster artwork is on the web at www.richmcgrath.com/psychedelia.html and www.bmasse.com.

The corner of Yew and Cornwall about 1970. On the right, porches of cottages are visible; there were five of them (in fact, BC Mills Model J prefabs), three facing Yew Street and two on the lane, as well as the Blenheim Apartments, sharing a 100-foot-square lot! About five other cabins and a duplex shared the lane; today, only the duplex survives. One of the cottages facing Yew Street operated as a lending library, with a fee of 10 cents per book. The current corner tenant of the apartment building is Starbucks. (Photo by Sajiw-Terriss)

Old men on a park bench at Kitsilano Beach in the spring of 1974. Because of the downzoning of the slope due to neighbourhood activism, most of the old walk-up apartment buildings along the beach still exist, although many converted from rentals to self-owned. (Photo by Sajiw-Terriss)

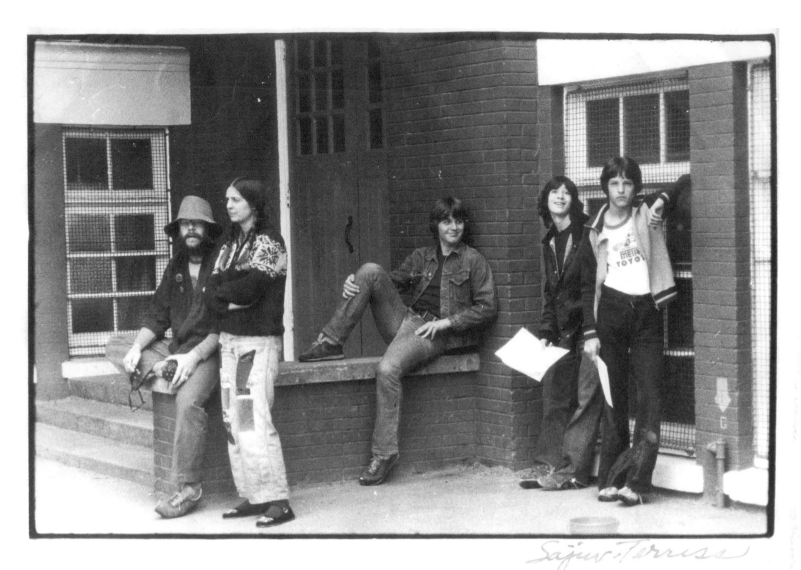

Sajiw-Terriss

businesses, egged on by Harold Kidd, whose dark pronouncements made Kitsilano seem intriguing to an impressionable teenager like me. In one newspaper account, Kidd explained,

> The boys are coming from parts of Canada, and they recruit the girl hippies, who are mostly school dropouts. They tell me they are looking for a hall to take in 11 and 12 year olds who are let out at night by their parents. They want to teach these children the hippie doctrine. I think they are Communists. At least they talk like Communists.[1]

Few social activists ever had such useful enemies, as few politicians ever had such an outrageous target to attract publicity and rally their supporters. According to Kidd, Campbell and others, the "hippie doctrine" included not just sexual depravity and opposition to the Vietnam War but abuse of welfare. In the popular imagination, which did reflect reality, many of the people living on the fringes of Vancouver at that time did seasonal work – for example, cutting grass for the Park Board in the summer – so they could move to Mexico for the winter and have their UI (unemployment insurance) cheques forwarded along; or they belonged to the "UI Ski Team" at Whistler, which was then very cheap, too.

Hippie Kitsilano: people at Henry Hudson school about 1973. (Photo by Sajiw-Terriss)

1 I quoted Kidd from a 1967 newspaper clipping in "Kitsilano History: Bringing it all back home," *Around Kitsilano,* August, 1974.

Many hippies – mere kids, perhaps fleeing small-town conformity or intolerant parents – had drifted to Vancouver with the blind faith that the Summer of Love would somehow get them through all adversity and were hanging around the Kitsilano streets penniless and ill. About 100 people who had been subsisting by peddling the *Georgia Straight* at 10 cents a copy desperately needed shelter in the rainy fall of 1967. Salvation arrived in the form of a 21-year-old boilermaker's apprentice named Ray Chouinard and a *Straight* staff member named Elmore Smalley, who found a vacant building at 344 East Hastings and managed to round up food for them. Calling his commune Cool-Aid, Chouinard moved in June 1968 to a house at 1822 West Seventh. There was food, counselling and a mattress to sleep on, and specialized medical services such as the VD clinic run by Dr. Shelley Wagner. Another "no hassle" medical option was the Pine Free Clinic opened a few blocks away by Dr. Murray Cathcart.[1] All attempts by the Kitsilano Ratepayers Association to remove Cool-Aid from the community failed, and it gradually came to be seen as a necessary part of the city's social welfare network. It closed in 1973, having to a certain degree outlived its time. Chouinard went on to become a lawyer, as did one of his early employees, future mayor and premier Mike Harcourt.[2]

Having finally secured a level of tolerance, the hippie community's activists and businessmen attempted to consolidate their position. Natural food stores like Lifestream at Fourth and Burrard became so successful that they were criticized for somehow not "keeping the faith." Today only the Naam at 2722 West Fourth remains of the original set of macrobiotic cafes, although there is a distant echo in specialty food stores like Capers. It was an era of hole-in-the-wall enterprises selling home crafts, leatherworking and macrame, rough silver jewellery and sandals; the map on pages 178–79 notes many of them. The head shops and original coffee houses are long gone, replaced by hair stylists and different coffee houses. In Kitsilano, there has been no second-generation hippie revival such as the one rejuvenating Haight-Ashbury since the late 1990s; if it still exists at all, it has moved to islands like Denman and Saltspring. Vancouver's youth culture has moved farther east, to Main Street around King Edward and to Commercial Drive, where the rents are cheaper.

The example of Strathcona's neighbourhood activists was taken up in Kitsilano early in the 1970s. As an antidote to the conservative, pro-development ratepayers association, young people who were putting down roots in the area formed the Kitsilano Area Resources Association. In the early 1970s it opened the Kitsilano Information Centre in a storefront at 2741 West Fourth, just down the block from Rohan's used-record store and live-music club, the "Rockpile." Using a federal government Local Initiatives Program grant, it hired

BELOW *A rooming house at Second and Dunbar in 1982, since restored as part of the house-by-house conversion of northwest Kitsilano back to its original role as a single-family neighbourhood. Some of the larger houses are in fact divided into suites and strata-titled.*

NEXT PAGE *A rooming house on Macdonald Street, as it was when I rented the attic in the early 1970s. For clarity, I have eliminated the collection of rope ladders and rotting staircases that served as fire escapes.*

1 "Media doctor" Art Hister moved to Vancouver from Montreal in 1971 and became the clinic's first full-time physician. The clinic still operates at 1985 West Fourth.

2 A thoughtful article on the period by SFU history professor Tina Loo is "Flower Children in Lotusland," *The Beaver*, Feb–Mar 1998, available on the web.

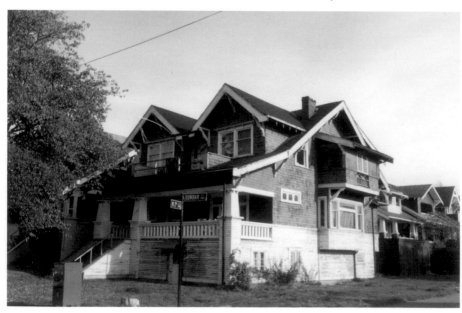

VANCOUVER REMEMBERED

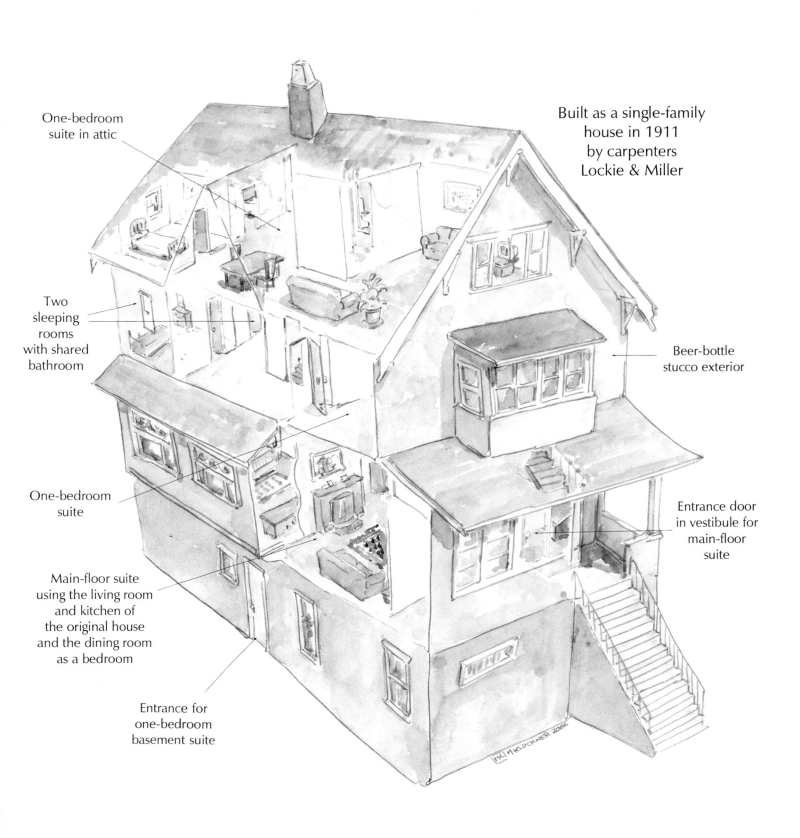

One-bedroom suite in attic

Two sleeping rooms with shared bathroom

One-bedroom suite

Main-floor suite using the living room and kitchen of the original house and the dining room as a bedroom

Entrance for one-bedroom basement suite

Built as a single-family house in 1911 by carpenters Lockie & Miller

Beer-bottle stucco exterior

Entrance door in vestibule for main-floor suite

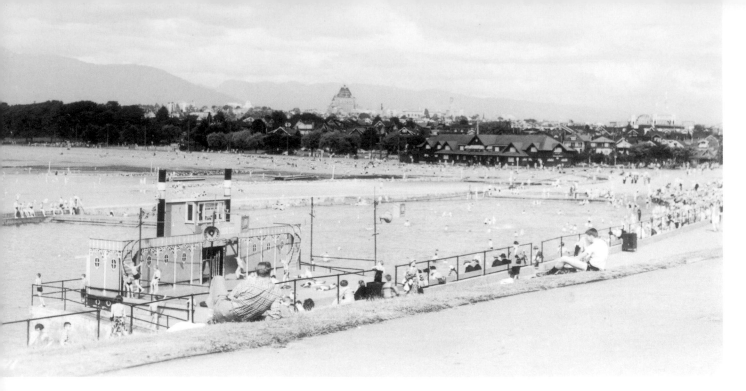

The Kitsilano tidal pool, opened in 1931, and the 1920s bathhouse at Kits Beach, in an early 1950s photograph (datable because only the new Hotel Vancouver is standing). The Kitsilano Showboat in the left foreground was the brainchild in 1936 of booster Bert Emery, a pharmacist who tirelessly promoted Kitsilano Beach to the wider city, initially as part of the Golden Jubilee. (Photo by Walker & Ward)

1 Donald Gutstein's *Vancouver Ltd.,* pp. 102–10, gives a spirited description of the main players.

coordinators, first Judy Alldritt, then Nancy Jennings (later director of the Carnegie Centre in the Downtown Eastside). The centre became a clearinghouse for rental and job information, published a monthly newspaper called *Around Kitsilano,* and hosted innumerable meetings of committees concerned with daycare, social services issues and community activism. A lot of effort went into trying to help mental patients living in the area due to the phasing out of the Riverview hospital complex in Coquitlam. In the period from 1972 to 1975 when the NDP held power provincially, there was a move to establish Neighbourhood Resources Boards, locally elected groups that would create and deliver social services programs; one board election was held in the summer of 1974 before the experiment was discarded when the Social Credit party returned to power the following year. Evening gatherings usually continued at the beer parlour of the Cecil Hotel or within walking distance at the King's Head Inn on Yew Street, where the tolerant waiters allowed an entire table of thirsty customers to order just a single plate of cheese rather than a separate meal for each drinker (liquor laws still being restrictive).

Meanwhile a more radical group had formed. Originally chaired by Jacques Khouri (page 112), the West Broadway Citizens Committee (WBCC) had a paid organizer, Nathan Karmel, and challenged developers while supporting tenants who were being evicted. It began by opposing the demolition of houses for parking and rumours of a mall-type shopping centre during the Broadway Beautification program. One of the first actions was a series of protests against a 13-storey high-rise intended for pensioners at 2229 Maple Street (the group favoured low-rise buildings). Another involved supporting a widow, Mrs. Helen Chester, who was evicted from her home to make way for a new condominium development. One high-rise project was blockaded: several days of choreographed picketing in March 1974 delayed the construction of Carriage House at Third and Balsam. Ninety tenants, including students, families with children, and low-income elderly people had been evicted from six well-kept houses to make way for a building containing small suites and a "no children" policy. Ultimately, an injunction from the BC Supreme Court against the WBCC allowed the developer to proceed.[1]

The city tried to respond to the protests that, to a greater or lesser extent, were common to the inner ring of Vancouver neighbourhoods struggling to maintain affordable housing and a sense of community. It established local area planning offices that invited neighbourhood involvement but then pulled back from devolving any real power to the citizen committees. Most of the activists quit in disgust. An analysis of the effect of the Kitsilano Neighbourhood Plan indicated only that the area *looked* better after community facilities, parks and streets had been improved.[2] In fact, many lower-income people were forced out. Although the flamboyance of the hippie era is fun to remember, it was the battles for affordable housing and neighbourhood control emerging from the community that made a significant mark on the city's history.

Some time around 1975 the sixties came to an end; as if a switch had been thrown, hair was cut, suits bought and the jobs promised by university educations obtained. (Saturday Night Fever–style white suits were *de rigueur* for the discos that sprang up in the 1970s on Granville Island and downtown.) The revenge of many Kitsilano activists who had put down roots in the community was to buy it back and restore the rooming houses they had once shared with their fellow travellers. But the restoration in most cases went full circle, back to the single-family era of 70 years earlier. Others made a chameleon change and became small-scale developers, converting the deteriorated houses into strata-titled suites, or bought into the luxurious townhouses and condominiums on the slope above the beach. What had been a casual, beach-front community with small lane houses between Yew and Arbutus became a chic retail enclave, mirroring the change taking place on Fourth Avenue where the old shops with their small display windows and inset wooden doorways made way for seamless plate-glass fronted facades. Like a mini Robson Street, Kitsilano became synonymous with conspicuous consumption, not conspicuous hanging-out.

The area that really went full circle was "north of Fourth," the blocks of houses between Blenheim and Alma. This was a subdivision owned by R.D. Rorison (whose home became the Peace House) and sold by pioneer-turned-realtor James Quiney for development in 1910–11. The great majority of the houses built there were good-quality Craftsman-style buildings, but those on Dunbar Street between Point Grey and Second Avenue are some of the most beautiful in the entire city. A middle-class version of Shaughnessy Heights, the area has a cousin in the Talton Place blocks north of 16th between Arbutus and Cypress.

All of the Dunbar houses were constructed in 1911 and 1912 by contractor Samuel W. Hopper, who built 1710 Dunbar for himself. They were large elaborate Craftsmans, some with subtle Japanese touches, all with fine granite

The H.R. MacMillan Space Centre, known as the Planetarium when it opened in 1969, was a gift from the lumberman and industrialist whose forestry company dominated the BC economy in the 1950s and 1960s. It is the centrepiece of the Vancouver Museum complex, one of the centennial projects that transformed the old Indian reserve (page 146) around 1970. The city archives nearby was a BC Centennial project completed in 1972. The space centre's roof recalls the conical hats worn by Coast Salish. (Photo by Jack H. Bain)

2 See Punter, *The Vancouver Achievement,* p. 49.

foundations and elaborate woodwork. No sooner had the neighbourhood become established than owners altered their homes to provide affordable housing for students and low-income families, a change encouraged by the city during the wartime housing crisis but resisted thereafter. Zoning changes in the 1950s encouraged demolitions and apartment construction further east on the slope above Kitsilano Beach but left this area intact. By the 1980s, prospering young families were beginning to move back and restore the old places. Today it is once again a stable neighbourhood of quiet streets, removed from the fray of redevelopment overtaking the rest of the city.

As a stable, middle-class area outside the transitional ring identified by planner Harland Bartholomew in the 1920s, Jericho missed the upheaval visited upon its eastern neighbour. It would fit more accurately into an examination of Vancouver's residential west-side communities, the subject of the following chapter, except for the interesting history of its extensive government reserve lands.

The Royal Navy survey of Burrard Inlet in 1859 identified two major military reserves, one the peninsula that became Stanley Park, the other a block of land between the Kitsilano bluff and the Point Grey headland. To the latter's west was the beach we know as Spanish Banks, recalling the meeting between Captain Vancouver's men in their longboats (his ships *Discovery* and *Chatham* were left anchored at Birch Bay) and two Spanish ships, part of the Galiano expedition also engaged in surveying the coastline. The beach became part of the city's park system in the 1920s, following the completion of the Marine Drive "scenic loop" around Point Grey. The Locarno Pact of 1925, an early effort of the League of Nations, gave the beach just west of the military reserve its name.

In the city's earliest days, the land adjoining Jericho Beach was a remote, rural area known as Langara, named for a Spanish admiral. The natural clearing provided a farm site for a man named J.M. Dalgleish. Another farmer named John Stewart ran a dairy farm on the logged-off headland, now part of the park north of Chancellor Boulevard, on what was known as the Plains of Abraham, between the first and second ravines west of Blanca Street; he shipped his milk using a funicular railway connecting the bluff with Marine

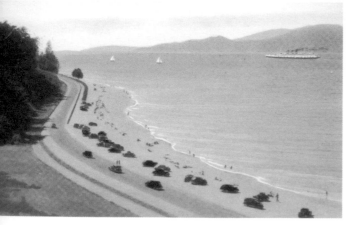

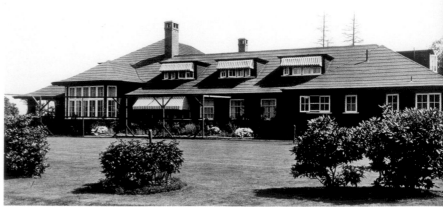

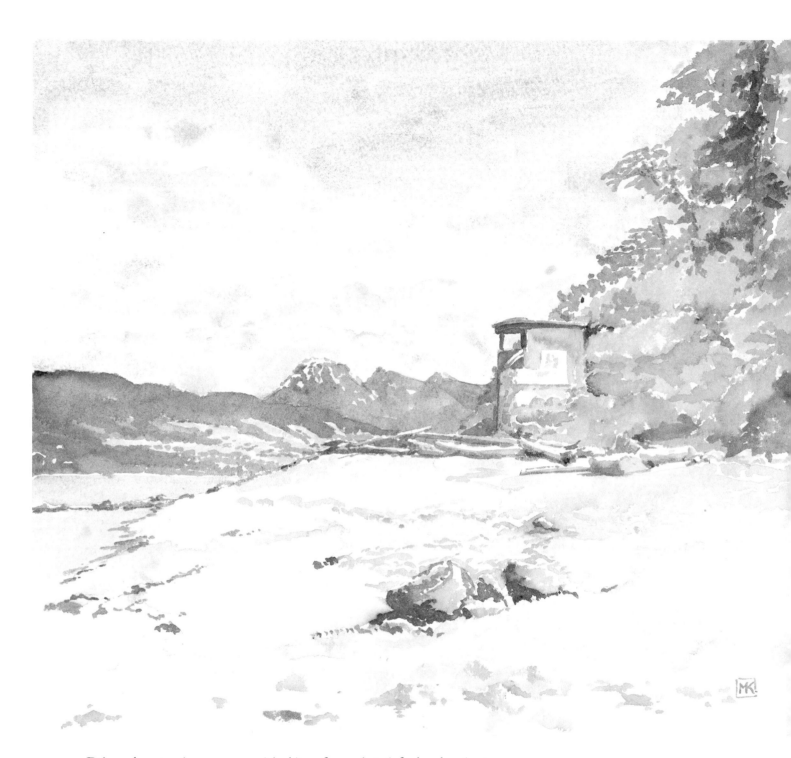

Drive, where trucks or wagons picked it up for market. A feed and grain store established in 1905 at the corner of Belmont and Sasamat evolved into the Langara post office and general store; 20 years ago it was still in use as a coffee house, but soon after it was demolished and replaced by a nondescript home.

Not surprisingly, given the area's natural beauty, it attracted a few wealthy Vancouverites looking to establish semi-rural estates. First was a man named James Rear, the general manager of the American Life Insurance Company, whose Arts and Crafts–style Aberthau is now the West Point Grey community

centre. The long-time home of Reginald Brock, namesake of Brock Hall at UBC, has been a seniors' centre for decades. There were also large houses on the bluff at UBC: the Graham house and the better-known Cecil Green Park. All were designed by the illustrious partnership of Maclure and Fox just before the First World War.

Part of the military reserve was leased as a golf course in the late 19th century; a "back nine" was created in 1924 on land south of Fourth Avenue leased from the provincial government. Like the other early golf courses of Vancouver (page 205), it lacked tenure and was abandoned when the Royal Canadian Air Force conscripted the land at the outbreak of the Second World War. The RCAF expanded its seaplane base on the shore, established in the 1920s, and created a substantial military presence on the Jericho lands that lasted until the 1960s. Just a few buildings survive now near the corner of Discovery Street and Marine Drive: one is a youth hostel, another an arts centre. The city worked from 1948 till 1973 assembling the land into a park, which became the site of the 1976 Habitat Forum and, two years later, the venue for the ongoing Jericho Folk Festival.

The Point Grey headland, like Ferguson Point in Stanley Park (page 144), was fortified with three six-inch guns, with the main gunnery position at today's Museum of Anthropology site (one of the gun emplacements is cleverly incorporated into the interior of the museum).[1] The crew quarters nearby, a set of shacks called Fort Camp, became a student residence after the war, notorious for its freezing rooms and hot parties. Down below on the beach were two searchlight towers, one of which survives today. In the 1950s, the Tower Beach "gun tower," as we called it, was a favorite family picnic spot, accessible as it is today by the steep trail descending from the corner of Marine Drive and Chancellor Boulevard; the concrete-block command post, hidden 50 yards back in the trees, survives as a graffiti-covered ruin.

As inconceivable as it seems today, Spanish Banks was a serious contender for a secondary airport in the 1950s. Light aircraft and seaplanes could avoid the "dangerous congestion" of Sea Island, argued the Vancouver Board of Trade. Small plane enthusiasts tried to enlist boaters' support from the yacht club, arguing that the breakwaters would improve the value of their site. *Western Homes & Living* magazine quoted an American airline official, who stated, "Vancouver would only regret such action once – the rest of its life." When the Massey tunnel and freeway opened a year later, it reduced the travelling time to the Boundary Bay airport and took the blades off the airport enthusiasts' props. Nevertheless, the proposal had a last gasp in 1962, but it failed to attract any support from city council.[2]

1 See "Military and Civil Defences, 1859–1948" by Peter Moogk in the *Greater Vancouver Book*, pp. 271–73, and Hayes, *Historical Atlas of Vancouver*, pp. 136–37.

2 Maps and brochures of the 1962 proposal are in Hayes, p. 162.

The West Side

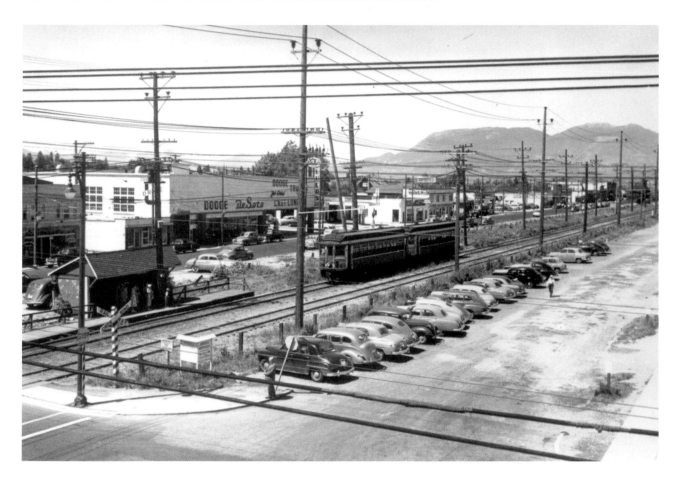

The heart of Vancouver's west side is Kerrisdale. It is the village created by the interurban railway system in 1905, the administrative centre of the old Municipality of Point Grey from 1908 to 1929, and the first community to add apartments around its main street in the 1950s and become a real town centre.

A century ago there was nothing but bush between Eburne on the Fraser River and Fairview. The former was a farmers' market centre on Sea Island with a hotel, a post office and a store run for years by the Grauer family. A narrow trestle built in 1889 at the foot of Hudson Street connected Eburne with the Vancouver side. Granville Street had just been cleared through the forest from False Creek, where a trestle crossed to Yaletown. In the winter of 1890, the Eburne bridge was badly damaged by ice but was soon rebuilt. Gradually businesses began to establish themselves on the Vancouver side, which came to be known as Eburne Station or, simply, Eburne.

The BC Electric Railway's interurban service stopped at two other dots of settlement on its first run on July 4, 1905. Magee Road – 49th Avenue – was the closest spot on the line to the Southlands farms, by then established for

An interurban train arrives from Vancouver at the Kerrisdale station at 41st Avenue on July 18, 1952, the last day of regular service between Steveston and Vancouver. (Photo by H.E. Addington)
CVA DIST P. 104

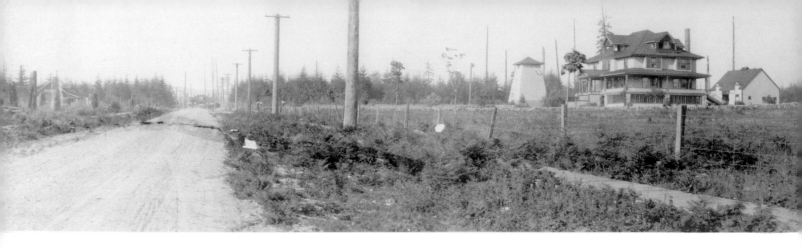

1 Elizabeth Bell-Irving, *Crofton House School: The First Ninety Years*, p. 131.

about 40 years. The core of the Fitzgerald and Samuel McCleery farms became, respectively, McCleery and Marine Drive golf courses. Henry Mole's farm became Point Grey Golf Course after he retired and moved to the West End near the Mole Hill block (page 122). Between these properties was the old Hugh Magee farm, which by the 1920s had evolved into a landscape of small orchards, nurseries and market gardens. Along the river near the foot of Blenheim Street, boat-building yards and fishing plants created their own small communities and, more importantly, had the wherewithal to pay for the extension of city water and telephone services that spurred settlement on the slope above. By 1908, there were several houses near the Magee Road stop, including the estates of W.R. Arnold (now Bannister Mews) and Chris Spencer of the department store family (later Athlone School) just west of the tracks; just south on the east side were the greenhouses of R.D. Rorison's Royal Nurseries, served by their own freight platform.

The other dot was Wilson Road – 41st Avenue – where the CPR had cleared land and established a market garden to provide vegetables for its passenger and hotel operations. The BCER's general manager, R.H. Sperling, asked one of the settlers, Helen MacKinnon, to name the interurban stop. With her husband, William, she had come to Vancouver from Scotland, where her Mackenzie ancestors owned Kerrysdale House, said to mean "the little throne." The MacKinnons built their own throne in 1903 on a double lot on 42nd Avenue west of Macdonald. On the first day of interurban service, the crossing was marked with the word KERRISDALE painted on an inverted coal oil can placed over a post by the tracks.

The MacKinnons were the second family in the district. During the previous year, a man named Richard Byron Johnson built a home on several acres east of Blenheim Street. It became well known for its subsequent occupants: Alvo von Alvensleben (page 66), Robert Cromie of the Vancouver *Sun* (page 68) and, since the 1940s, Crofton House School. As was the case in Kitsilano, the earliest settlement occurred on land west of the CPR boundary at Trafalgar Street, where property could be had in blocks large and small. The primary school located at Carnarvon Street, but the post office and stores were established several blocks east at the interurban stop. When the population exploded in the 1910 to 1913 period, the school board built Magee High School on 49th east of the tracks. Point Grey School at 37th Avenue was the last major project of the municipality, completed just before amalgamation with Vancouver in 1929; it used the former CPR market gardens as playing fields.

The demolitions and subdivisions of the past half-century have made it very difficult to read the west-side landscape and glean clues of its early history. The

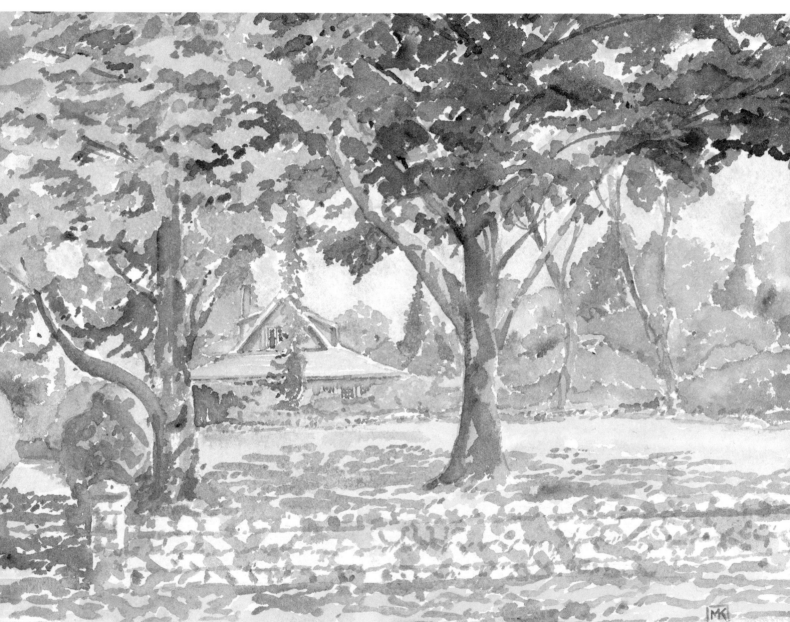

The Cunliffe house on West 49th Avenue in 1992. It was a very deep property, extending back more than 300 feet. A cul de sac called Balsam Place now enters the property and four houses occupy the grounds.

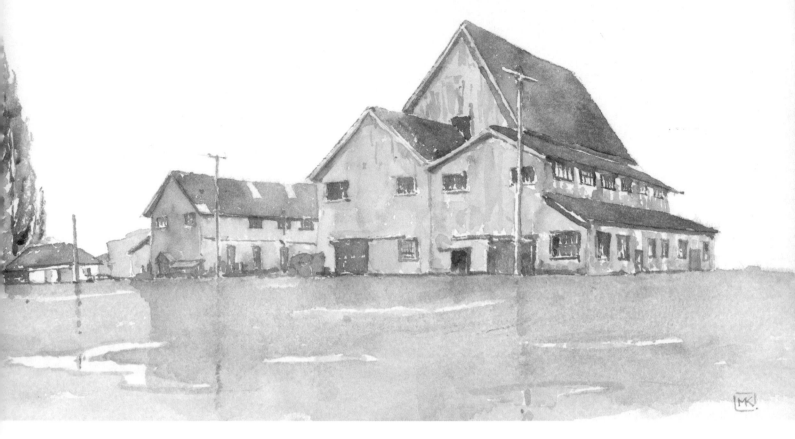

BELOW *A family gathering at Yoichi and Taru Minamimaye's home at 7225 Blenheim in 1935. They were fishermen who kept their boats in the slough near the Celtic shipyard.*
GEORGE MINAMIMAYE

Kerrisdale shopping area along West 41st has changed dramatically in the past 20 years, with only a handful of buildings dating back to its village beginnings. The brick Bowser block at the southwest corner of 41st and West Boulevard, now called the Boulevard Building, still exists, but Frank Bowser's estate on Macdonald (previous page) has vanished without a trace. Another large piece of property at 41st and Macdonald, once the Trinity House Preparatory School and the original Murray Nursery, has survived intact as a retirement home called Crofton Manor.

Another early place was the Cunliffe house at 2443 West 49th, which originally stood on five rural acres between Larch and Balsam. Although much of the property was sold off, the house retained a large estate lot until its demolition in 1993. The property was then crudely subdivided into four lots, on each of which a boxy mini-mansion sits. Part of its granite walls survives, as do portions of the walls that once surrounded the Arnold and Spencer estates. There is no trace of the Malkin estate, Southlands, that occupied the land between Balaclava and Blenheim north of Marine Drive from 1910 until the 1960s; however, cul-de-sacs that don't fit the city grid provide a clue to the history there.

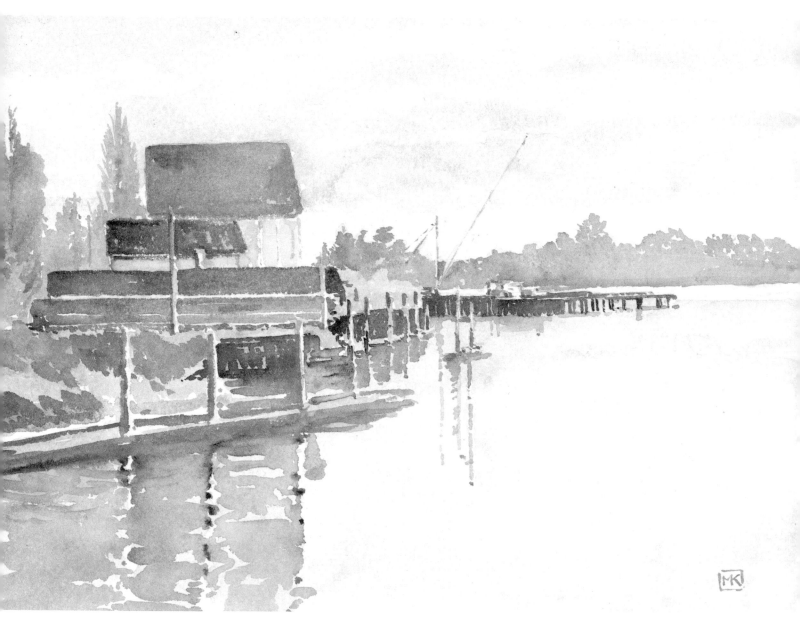

The intriguing relic on the Southlands flats is the Celtic Shipyard at the foot of Balaclava. Nearly a century old, the complex includes a high-roofed boatyard open to the river that can accommodate a fully-masted fishing boat, ancillary buildings and a wharf. On the edge of the slough at the foot of Blenheim, vestiges of a marine railway recall a Japanese fishing camp, although the caretaker's shack and donkey engine have long since disappeared. Until the 1942 evacuation, a large number of Japanese families docked their boats along the river there. The Minamimayes, for example, lived nearby on Blenheim Street, but their son and his family lived on the western edge of Sea Island.[1]

With the recent bulldozing of the 1940s-era BC Forest Service shipyard just upstream, the Celtic facility is the only working piece of foreshore left on the north arm. Southlands itself has become a piece of *faux* countryside, with ostentatious mansions replacing the small frame houses and horse-boarding facilities that had established themselves on the old Magee farm; the formerly natural Deering Island is a neatly groomed subdivision with speedboats docked beside some of the homes.

Two watercolours of the Celtic Shipyard on a calm winter day in 2005; the view above looks east from Deering Island along the Fraser River's North Arm to the distant bank of Sea Island, a scene that has changed little in a century.

1 Their wartime story is told in *Vanishing British Columbia*, pp. 135–38.

LEFT *The Kerrisdale Theatre, photographed in 1930, was part of a chain of neighbourhood cinemas that survived until the late 1950s, playing 15-cent matinees preceded by cartoons and newsreels, before succumbing beneath the jackboot of television. Stripped of its lobby, it became a post office, then a set of shops with a* trompe l'oeil *facade painted on the blank second-floor wall. (Photo by Leonard Frank)*
VPL 11043

MIDDLE *A 1938 advertisement from the* Point Grey News-Gazette.

BELOW LEFT *The Kerrisdale Legion stood at the northeast corner of 42nd and Yew. A high-rise condominium, parkade and new Legion building now occupy the property.*

BELOW RIGHT *Campbell's Grocery, at the southeast corner of 45th and Vine, was one of the myriad corner stores that could not compete with such chains as 7-Eleven and the "handy marts" attached to gas bars. I took the photograph about 1990.*

NEXT PAGE *Kerrisdale had several garages on West Boulevard and 41st Avenue, run by people like Watkin Mossman and, at the Esso dealership at 37th, a neighbourhood institution named Murray Virteau. Strathcona Garage stood at 39th and West Boulevard. All such garages have disappeared in the past 20 years. (Photo by Leonard Frank, 1945)*
VPL 15965

WHY GO DOWN TOWN? When You Can Get a Bigger Van

KERRISDALE TRANSFER

MOVING · SHIPPING · STORAGE

DAY OR NIGHT Phone KERR. 10

and a Better Job Right in Kerrisdale. Phone Kerr. 10 For Estimate

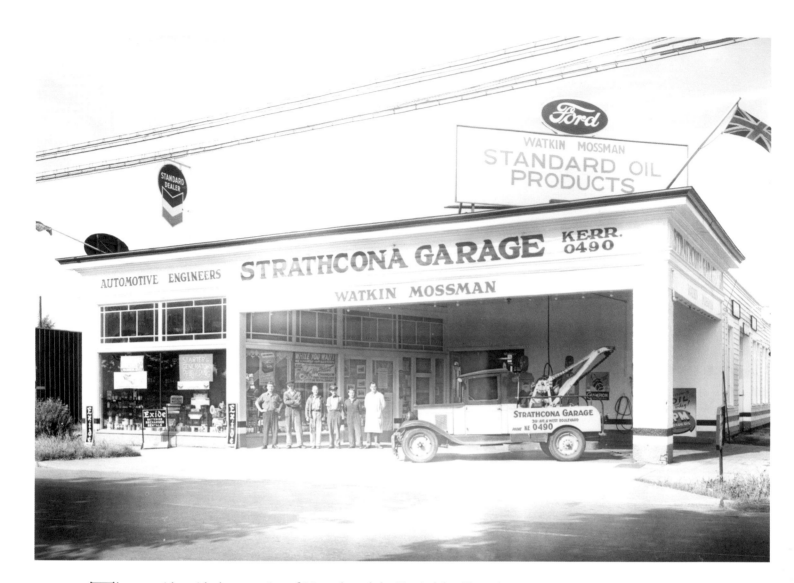

The west side, with the exception of Marpole and the Kerrisdale village, is the city's single-family heartland, a bastion defended vigorously against incursions by apartment developers, lot subdividers and basement-suite barons. Its geographic base is the CPR's 1884 land grant south of the original city boundary of 16th Avenue (page 22); its historic base stems from a distrust of the freewheeling land-use and management practices of the old Municipality of South Vancouver, which proved incapable of systematic tax collection, street paving, tree planting and park creation. Calling themselves the Municipality of Point Grey, the west-siders separated in 1908, establishing a more orderly fiefdom west of Cambie Street, building the Point Grey Municipal Hall in Kerrisdale at 42nd and West Boulevard (the community centre site) and enforcing strict zoning rules, the most noticeable of which is the uniform house setback from the streets.

There once was a pleasant sameness to the west side, its blocks dominated by 1920s and 1930s bungalows that were relatively small, fairly well built and set on lots large enough to provide space for a decent garden, or at the very least a mowed lawn. Most streets have a narrow boulevard planted with deciduous trees separating the road from the sidewalk; in many areas the trees are mature and beautiful, and compensate for the nondescript, low, unassuming quality of the houses. West Point Grey (south of 10th Avenue), Dunbar, Mackenzie

(text continues on page 202)

NEXT PAGE *"Old" or "First" Shaughnessy, between 16th and King Edward, is an area of huge Arts and Crafts/Tudor homes on expansive lots, with the occasional rambling Craftsman house like this one at Osler and King Edward. Most of them have been either beautifully restored or else replaced with modern interpretations of the traditional English architectural styles. This is one of the few remaining ramshackle places that recalls other names for Shaughnessy Heights – "Poverty Heights" and "Mortgage Hill" – from the 1930s and 1940s when many owners had to take in boarders to ward off foreclosure. Built about 1913 for Herbert Baker, a securities company president, it was converted into a rooming house in the late 1940s. The preference for the English idiom continued for the next two decades during the time that Shaughnessy grew southward to 41st Avenue.*

ABOVE *A 1931 home on Somerset Drive in "Third Shaughnessy" by the contractor S.W. Hopper, who built the splendid Craftsman houses in Talton Place and Kitsilano (page 187). A picturesque Tudor, it is simplified and stylized compared with the examples in First Shaughnessy. (Photo by Leonard Frank, 1937)* VPL 11354

BELOW *Architect Fred Townley's 1927 home, a shingle-covered English cottage at 1636 Avondale. Although Townley and Matheson are most often remembered for Vancouver's moderne City Hall, the firm worked in English historical styles in the 1920s: for example, Tudor Manor on Beach Avenue and the Gothic Point Grey School. (Photo by Leonard Frank)* VPL 5054

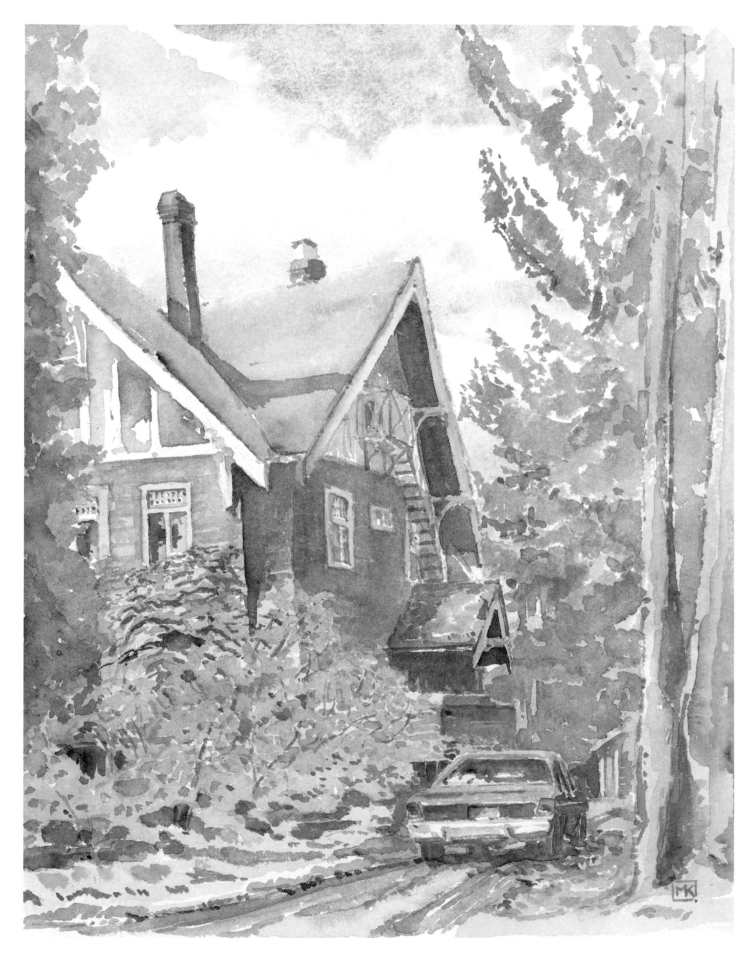

THE WEST SIDE

In the wake of the First World War, middle-class buyers demanded smaller, easier-to-maintain bungalows and sought romantic styles – whether Colonial, Spanish, English or Dutch – that would evoke an idealized antebellum world. Married couples had fewer children, couldn't afford or find servants and wanted to own the latest consumer goods, such as vacuum cleaners and cars. Convenience and mobility became the watchwords of the 1920s, as did thrift in the 1930s. The Pacific National Exhibition touted the small house beginning in 1934 with its "Ideal Bungalow" prize homes, featuring innovations such as venetian blinds and an electrical outlet on the mantelpiece for a clock – the successor of the grandfather clock of Victorian parlours. Usually they were around 1,000 square feet; as families grew, especially in the baby boom after the Second World War, carpenter dads filled in gloomy basement areas with jerry-built bedrooms. Never have more Vancouver children been raised in smaller homes than in the 1950s!

Vancouver's streets, both east- and west-side, were lined with bungalows such as these two, the Spanish one conjuring up an imagined Southern California, the English one "the old country." Both plans are from the pen of architect-designer Jens Pedersen of Saint Paul, Minnesota, published in 1927 by the Brown-Blodgett Company in a book called Practical Homes, which could be obtained with a local lumber yard's imprint on the cover. Speculative builders used such plan books, as they had before the First World War to build Craftsman cottages and California Bungalows, to fill in the city's vacant lots.

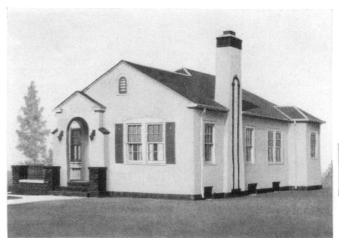

Design No. 112

Spanish Bungalow. This new Spanish Type bungalow is 28x38, of a very artistic and unusually pretty design, fills the wants of those who desire to deviate from the ordinary. It is very striking in exterior appearance. The interior arrangement is as perfect as can be made, and nothing has been overlooked for the comfort and convenience of the occupants. The cozy breakfast nook is an attractive feature. Basement fully equipped, with grade entry at rear.

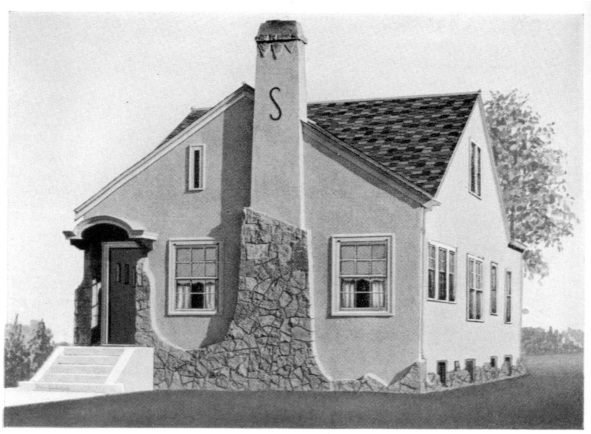

Design No. 52

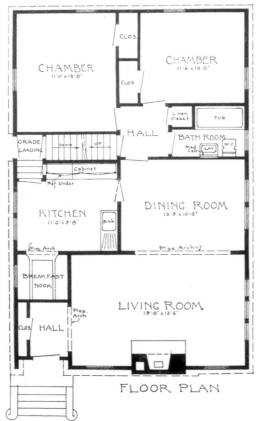

FLOOR PLAN

Aᴠᴇʀʏ unique bungalow, 26x40 in size. Most everyone, in deciding to build, wants a house which is different from the ordinary. This English type semi-bungalow gives an opportunity to deviate from the common to the elite, and secure a very artistic result. The craggy broken ashlar is limestone, blue and yellow, laid flatwise, with gray stucco and variegated asphalt shingles on the roof. The location of the chimney in front makes it an important element in the design, and gives the fireplace an unusual position in the living room.

The interior is well arranged and practical. Note the front hall with coat closet, large living room, 19'x12'6". Then there is a cheerful, fair sized dining room, and kitchen with breakfast nook. There is a refrigerator placed for icing from hallway, with grade entrance at side leading to kitchen and to basement. There is plenty of space for kitchen cabinet and a convenient position for the sink and stove; this kitchen arrangement is planned to save steps for the housewife. Two commodious chambers with closets are connected into the center hall, from which you can enter the bathroom. A stairway to the second floor leads up from this center hall; two rooms here may be finished off if desired, and still leave large space for storage purposes.

Oak, fir, or birch may be used for interior finish; and may be finished in any manner, as the specifications are drawn so as to give the owner his own choice.

Page 40

The block of King Edward Avenue west of Cambie would be a typical 1940s west-side streetscape were it not for the unusual replica Cotswold cottage at number 587, a 1941 piece of whimsy by builder Brenton Lea, allegedly with the help of architect Ross Lort. The other houses on the block are much more representative of that era in Vancouver's history: a few Gothic touches like the castle vestibule on the house on the left, rolled red duroid shingles over the eaves, white stucco, simple windows and trimmed laurel and privet hedges. At this point King Edward is a fine wide boulevard, yet the houses are too small and too separated to give the street any kind of grandeur. Four blocks to the east, where the CPR lands end, King Edward narrows into a standard roadway. Contrast this image of the 1940s west side with one five blocks east at Quebec Street showing the 1910s east side (page 215).

1 See Punter, *The Vancouver Achievement*, p. 143.

Heights, Kerrisdale and Marpole are pretty well indistinguishable: lots are typically at least one-third wider (50 feet) and 30 or more feet deeper than, for example, most Kitsilano lots. In the 1980s and 1990s, this extra space provided a money-making opportunity for small-time developers who despoiled the neighbourhoods with "monster houses" – larger versions of the Vancouver Special that is more common on the east side of the city. Neighbourhood character eroded not just because such new places were built, but because their white stucco and vinyl didn't mellow with time; old trees were ripped out and new gardens tended to be low-profile, low-maintenance and modest, featuring only a handful of shrubs like rhododendrons. The new places rarely melded with the established houses, trees and gardens; in the 1980s, Asian immigrants with different priorities were the often-criticized purchasers.

In response to widespread protests, the city changed its single-family zoning rules to reduce the maximum house sizes and try to improve the designs. The ever-popular Craftsman style, which fits into the west side's leafy self-image, has become the design of choice for new homes. Reflecting the high property values and the complexity of the new rules, many more west-side houses are designed by architects than previously was the case.[1]

Other than the Shaughnessy blocks, only two enclaves stand out for their historical consistency: Crown Crescent north of 10th Avenue in West Point Grey is a 1920s–30s showplace; Strathcona Heights, as it was originally called, the blocks of 36th and 37th Avenue near Point Grey School in Kerrisdale, has many fine "Swiss chalets" from before the First World War. Other areas are cheerful hodgepodges of bungalows, the blocks adjoining the Dunbar shopping area around 29th Avenue being a good example.

The erosion of neighbourhood character was first identified in the 1970s in Shaughnessy Heights, where it had more to do with regulations than values. After H.R. MacMillan's death in 1976, developer Larry Killam

bought Duart, MacMillan's home at 3741 Hudson, which stood on an acre of gardened grounds. He wanted to redesign the house's interior into three strata-titled residences with one or two detached coach houses, but the city zoning stipulated single-family, fee-simple lots. "I haven't the heart for a two-year fight," he said and demolished the house, dividing the lot into four.[2] Belatedly recognizing the problem, the city began to develop guidelines that would allow strata-titling and sympathetic infill. They were adopted in 1982, ushering in an era where design panels critiqued proposals for single-family houses and where developers could get a bigger building only if they played by the neighbourhood design rules. Nevertheless, for some neighbours, neighbourhood character meant "single family" and "low density" regardless of any other considerations. A recent dispute, in which the old Hamber mansion called Greencroft, at Cypress and Matthews, was restored and surrounded by small infill dwellings, showed how enduring those values were.

In the 1950s, families had few accommodation choices other than the single-family home. A few co-operatives in Kerrisdale and the West End offered people the chance to buy into a multi-family building, but the vast majority of such residents were tenants. A few innovative projects in the 1920s, such as Tatlow Court (page 170), pointed the way and, in the 1940s, a number of small rental bungalow courts were built along Fourth Avenue and Broadway for families; nearly all have since been demolished.

Dolphin Court at 2350 West 39th in Kerrisdale opened in 1956 and was planned expressly for families with children. The buildings, designed by architect Jocelyn Davidson, occupied only 40 percent of the site and surrounded a courtyard that landscape architect Desmond Muirhead planned as a protected play area for the children of the 41 families occupying the suites. "Every suite faces into the court, which has been divided by a variety of forms, surface materials and levels into a miniature play world that stimulates children's

2 *Province*, October 19, 1976, p. 40.

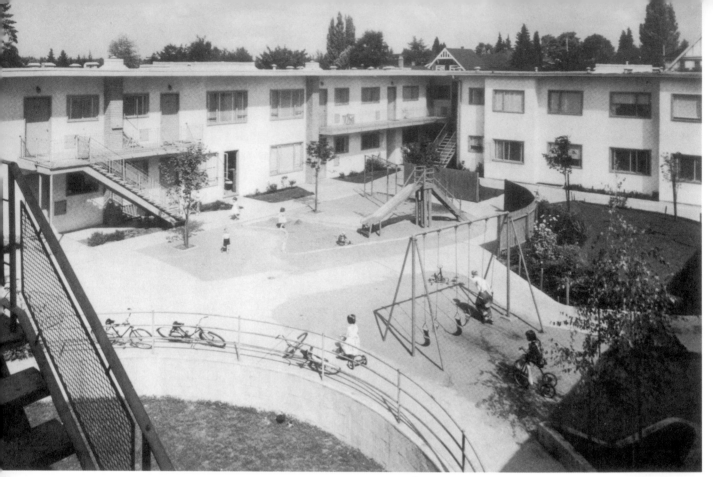

Two unusual buildings from 1950s Vancouver, both demolished:

ABOVE *Dolphin Court at 2350 West 39th Avenue in Kerrisdale, a 1956 apartment designed for family living. (Photo by Graham Warrington for* Western Homes & Living *magazine)*

BELOW *The front view of the butterfly-roofed house at 5889 Montgomery, designed by an unknown architect in 1950 for C.D. Hill, an employee of Confederation Life. I took the photograph about 1995.*

imagination and activities," noted *Western Homes & Living* magazine. The apartments, it suggested, had as much backyard as many private homes.[1] It was demolished a decade ago and replaced by a high-rise condominium.

The post-war post-and-beam "new" architecture was the fashionable style on the University Endowment Lands and in West Vancouver, but it barely got off the ground in west-side Vancouver. The houses tended to be quite small, and the isolated examples like the one on this page had no chance against the "more is more" juggernaut of recent years. Its butterfly roof reflected a house designed by Marcel Breuer in 1949 in the museum garden of MOMA in New York City – one of the first attempts at breaking away from the International Style.

1 May, 1956 issue, p. 17.

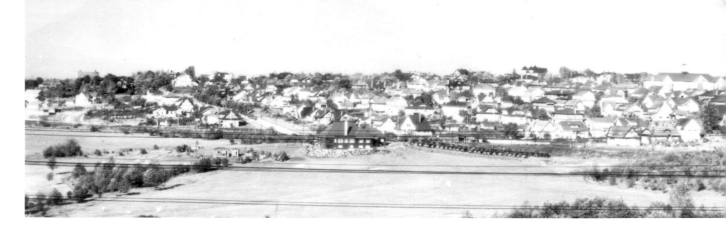

A combination of citizen action and happenstance preserved parts of the west side's early golf courses as parkland and gardens. In the case of the Jericho course, governments were the landlords (page 190). In the early 1990s, the politically influential local citizenry vigorously shouted down a provincial proposal to put housing onto the institutional lands south of Fourth Avenue (as they did 20 years earlier when subdivision and development of the University Endowment Lands, now Pacific Spirit Park, was suggested).

There were three golf courses on leased CPR land: Shaughnessy (1912–62), Quilchena (1925–55) and Langara (established in 1926, purchased by the city in 1974 and reworked to make room for the Langara campus of VCC). An earlier Shaughnessy course existed west of Granville between 33rd and 37th for several years at the beginning of the 20th century, but it clashed with the "big picture" subdivision plans and was abandoned.

The Quilchena Golf Club disappeared first. Unlike Shaughnessy on its high ground, Quilchena occupied a bowl of swampy land variously known as Asthma Flats, Consumption Hollow or Johnston's Farm (after a dairy farm operating in the 1920s). In 1925, two engineers named Ginnis Johnston and Harold Rindal laid out nine holes along the interurban tracks and built a clubhouse on the edge of the hill at 29th Avenue. The BCER interurban stopped at a small station nearby. A few years later, the course expanded into an 18-hole layout using land west of Arbutus Street. In the 1950s, when it became apparent that the CPR would not renew the lease, the club looked further afield and moved to Richmond.

The city paid the CPR $657,000 for school and park sites on the old golf course: Prince of Wales School opened in 1960 and Quilchena Park hugs the hillside along 33rd Avenue near the tracks, where it is still possible to see a hint of the old course layout. As for the rest of the property, the CPR's real estate division, Marathon Realty, stirred up a hornet's nest in 1964 with a proposal to build Arbutus Gardens – clusters of low-density garden apartments (since demolished and replaced with condominiums) that violated the

ABOVE *Quilchena golf course in the late 1920s, showing the view looking northeast with Glen Brae (now Canuck Place) in the right distance on the hillside. (Photo by Leonard Frank)*

BELOW *The course layout in the late 1930s.*

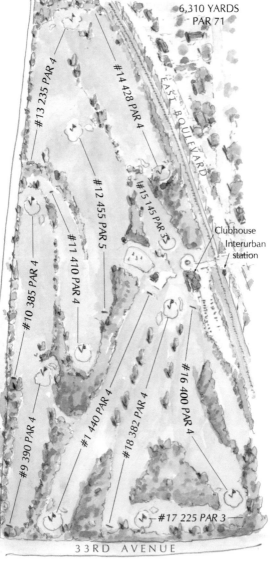

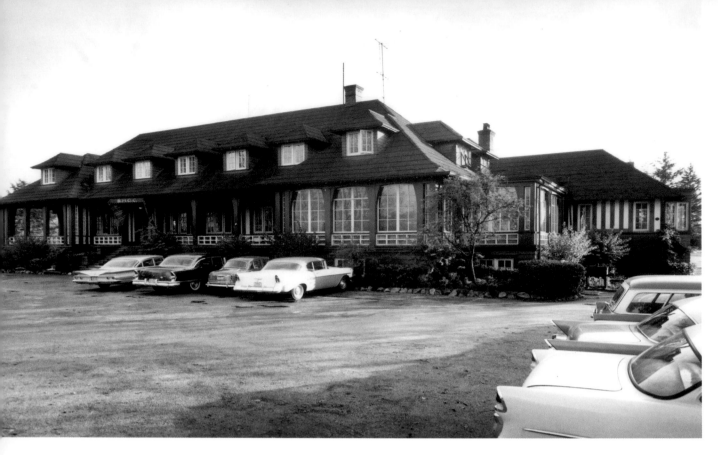

ABOVE *The Shaughnessy Golf Course clubhouse, at the end of a long driveway off 33rd Avenue, in November 1960 just before the course moved to South West Marine Drive. It was demolished in March, 1965. This was the second clubhouse, built after a fire destroyed the first one in 1916. Some of the trees and the fairways of the second, third and fourth holes survive as part of the "great lawn" of the Van Dusen Botanical Garden. (Photo by Williams Brothers)*

CVA BU 672.2

NEXT PAGE *The course in 1948, when it hosted the Canadian Open.*

1 See Don Harrison's essay on golfing in the *Greater Vancouver Book*, pp. 608–09.

2 On November 1, 1984, in Guerin et al. vs. Her Majesty the Queen, the Supreme Court of Canada awarded $10 million to the Musqueam First Nation for the improper lease of the reserve lands to the golf club.

3 *From Golf Course to Garden*, by Betty Stubbs, pp. 1–16 provides more detail.

unofficial single-family home-ownership dogma of the west side. A decade later it did it again, enraging the populace with a proposal for an Oakridge-sized shopping centre on a tract of bushland at Arbutus and King Edward; lawyer and future mayor Jack Volrich represented local residents, who were successful at getting the mall reduced in size.

Shaughnessy was a much more significant course for the tournaments and golfers it attracted, including celebrities like Clark Gable.[1] The golf club itself moved to the Musqueam lands late in 1960, having signed a lease with the government, acting on behalf of the band, that cost only $29,000 a year.[2] Much of the old course then lay fallow, although the 25-acre parcel east of Oak Street was promptly sold as the site of Eric Hamber School, and the panhandle from 37th to 41st became a housing and care-home site. A "Save Shaughnessy" committee arose "out of the ladies' locker room" to resist the CPR's subdivision juggernaut, but attempts to keep the land as a golf course or a park were defeated in civic capital plan votes in 1961 and 1962. However, by 1965 the Park Board had adopted the idea of making the 55 acres between 33rd and 37th west of Oak not just a garden but a *botanical* garden.

The provincial government became involved in 1968, and a committee of provincial and civic representatives, including Grace McCarthy, Tom Campbell, park board chairman George Puil and botanical gardens association member Dr. William Gibson, sat down to negotiate with Marathon Realty. It took two years to strike a deal: the province contributed a million; lumberman and Vancouver Foundation founder W.J. VanDusen contributed another (initially anonymously, although he later agreed to have the garden named for him); Marathon Realty dropped its price to $2 million in return for the right to build townhouses on 12 acres of the site; the city contributed the development costs. In 1971, the VanDusen Botanical Display Gardens began its evolution under the direction of Bill Livingstone.[3]

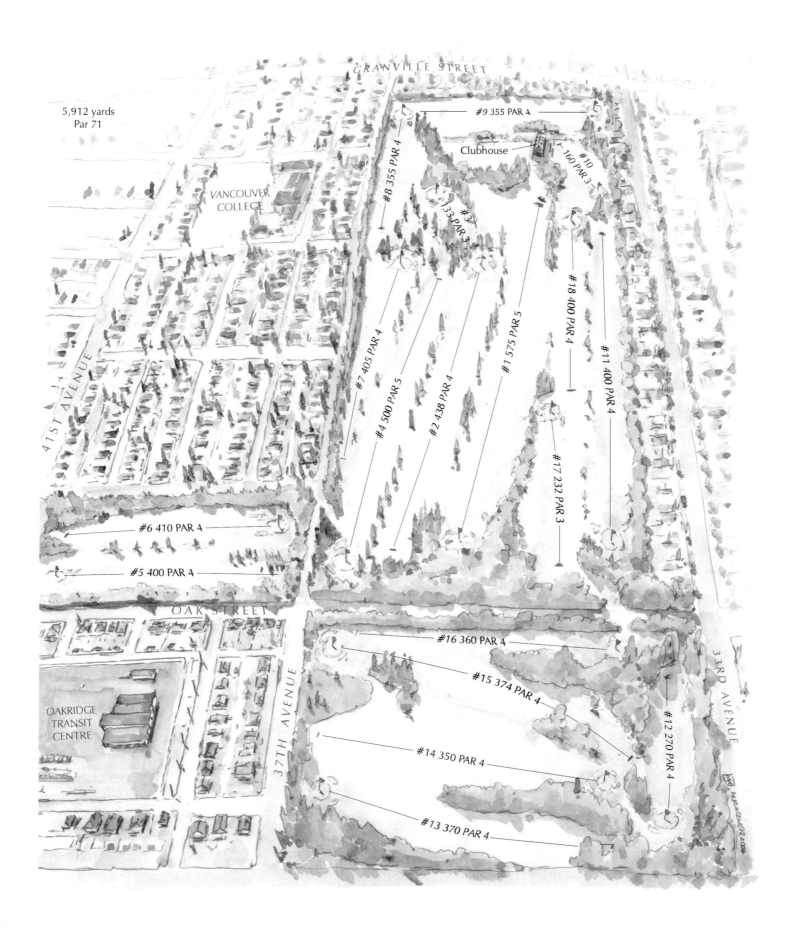

5,912 yards
Par 71

GRANVILLE STREET

#9 355 PAR 4

Clubhouse

#10

#8 355 PAR 4

#3 133 PAR 3

#160 PAR 3

VANCOUVER COLLEGE

#18 400 PAR 4

#7 405 PAR 4

#11 400 PAR 4

#1 575 PAR 5

#4 500 PAR 5

#2 438 PAR 4

41ST AVENUE

#17 232 PAR 3

#6 410 PAR 4

#5 400 PAR 4

OAK STREET

#16 360 PAR 4

33RD AVENUE

#15 374 PAR 4

OAKRIDGE TRANSIT CENTRE

37TH AVENUE

#12 270 PAR 4

#14 350 PAR 4

#13 370 PAR 4

The largest of Vancouver's early estates escaped obliteration not due to citizen action but because of the vision of a private developer, Peter Wall. Following industrialist Austin Taylor's death in 1965, the beautifully landscaped 10-acre Shannon estate at Granville and 57th was left empty for five years, deteriorating into an overgrown, looted, vandalized Gothic splendour heretofore unseen in Vancouver.

Taylor's millions came primarily from Bralorne gold and the Home Gas company, rather than from the real-estate trading that enriched earlier generations of Vancouver businessmen. He had a measure of international celebrity due to horse breeding and racing, the former at his A.C.T. stock farm in Milner (Langley), the latter at American spectacles including Santa Anita and the Kentucky Derby. His daughter Patricia married William F. Buckley Jr., the conservative American political commentator. He, likewise, was a staunch conservative, a no-nonsense, gruff man whose curriculum vitae included the chairmanship of the B.C. Security Commission, which removed Japanese Canadians from the coast during World War II, as well as philanthropy and public administration such as the Victory Loan Committee and relief work for flooded-out Fraser Valley farmers in 1948. Before his death he had publicly mused on a redevelopment of his estate with apartments.

Shannon was the dream of B.T. Rogers (page 119), who died before it was completed. His widow finished it and moved in with her children and a staff of about eight in 1925, having sold Gabriola on Davie Street to Charles Bentall's Dominion Construction. In its heyday, which ended with the sale to Taylor in 1936, Shannon was a social and musical centre for the city. Mrs. Rogers was the main prop of the Vancouver Symphony Orchestra and a key contributor to the Vancouver Art Gallery.

Following Taylor's death, city arts organizations lobbied for the use of the estate as an arts centre, while most neighbours bitterly opposed redevelopment into apartments. In the late 1960s, Wall and Redekop Realty bought the property and developed plans to save the principal buildings as the centre of a garden-apartment complex. The revenue from the filming of *Carnal Knowledge* in 1970 was a boon to the project's financial survival. Following two more years of controversy, the city granted approval for rehabilitation of the old buildings and construction of low-profile townhouses, designed by Arthur Erickson, that hug the perimeter wall. A revolutionary project for the city at that time, Shannon Mews predated by 15 years the city's establishment of a heritage department and its willingness to engage with businessmen to retain historic buildings amidst complex modern redevelopments. The likely alternative scenario would have been the retention of bits of the exterior wall with an even grid of bland houses occupying the old building sites and the fine Italianate garden — the fate, by the way, of most of Victoria's old estates.

Shannon was not the only large property in South Kerrisdale. The land slopes up from the Fraser River to a crest between about 57th and 54th, offering wonderful views to the

BELOW *The parterre, probably designed by head gardener Thomas Moore, part of the beautiful formal gardens at Shannon about 1930. Fifty-Seventh Avenue was formerly called Shannon Road after a dairy farmer. (Photo probably by Elspeth Cherniavsky)*
JANEY GUDEWILL

NEXT PAGE *Two views of the ruined Shannon about 1969. The main house, designed by Somervell and Putnam in 1915 and finished by Bernard Palmer in 1925, has since been partially restored, with rented suites occupying its upper floor.*
SONIA WALL

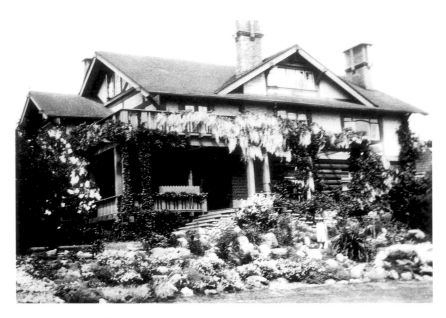

ABOVE *Oakhurst, now part of a townhouse development on 58th Avenue at Oak Street. The photograph is from the 1930s during its occupancy by the Maitland family and shows the rockery and wisteria on the south side.*
PATSY BAHR

NEXT PAGE ABOVE *The White Spot at 67th and Granville, familiar to generations of Vancouverites before a fire destroyed it in the 1980s. The postcard is from the 1950s and shows the murals – mainly coastal and farming landscapes – by Jim Osborne and Pete Hopkinson that provided a "view" for car-bound diners. (Photographer unknown)*

NEXT PAGE BELOW *The Fraser Arms Hotel at the foot of Granville, a modern-style motor inn with a contemporary modern foyer, opened the same year as the Oak Street Bridge, in 1957. The postcards, by unknown photographers, date from the mid-1960s.*

1 He was agent for the infamous *Komagata Maru* (page 27).
2 Interview with Patsy Bahr, 1991.

south and southwest, especially in the years between the logging of the original forest and the growth of the new urban one. A number of large properties still exist behind high hedges along 54th Avenue between Granville and Oak, although most of the historic buildings have been replaced by even larger new ones.

After decades of deterioration, Oakhurst, the old Gardiner Johnson property at 58th and Oak, was recently rehabilitated in the midst of a warren of small homes and townhouses. A Craftsman-style structure with log walls above river-rock foundations, it was a 1912 design by R. Mackay Fripp, who designed B.T. Rogers's first home on West Georgia more than 20 years before. Charles Gardiner Johnson was a shipping agent and the local representative of Lloyd's of London; he arrived in Vancouver in 1886 and became known as "the father of the Port of Vancouver."[1] He was one of the early group on the Fairview Slopes at "Bandra House" (page 157) but was probably driven away by the pollution and fog and, like other wealthy men, sought the sunnier southern slopes of the city. The year he completed Oakhurst, streetcar service began along Oak between Vancouver and Eburne, probably more a boon to his servants than him as he would doubtless have owned a car.

The property extended east from Oak Street between 57th and 59th. A later owner, realtor and yachtsman R.M. Maitland, gardened it extensively in the 1930s. It was so colourful that Kodak used a photograph of the rockery to demonstrate the capability of its new film.[2] As with so many other Vancouver mansions, it became a rooming house, then an old-age home, after which it deteriorated for many years on its overgrown meadow.

On the flat land below the old estates a mixed community developed, becoming more working class with proximity to the river and its sawmills and industrial works. Population growth pushed the old Eburne Station community northward onto a grid of streets slightly different from those in the main part of the city. To give itself a distinct identity, the community changed its name in 1916 to Marpole after CPR executive Richard Marpole (1850–1920), a puzzle given that the CPR's huge land grant ended at Park Drive, a dozen blocks to the north.

Hudson Street at Marine Drive was the main crossroads. The BCER's interurban from Vancouver stopped just south of the intersection at a station that was also the terminus of the Number 17 Oak tram line, then continued east for a few blocks where the track split, one line crossing the Fraser River to Bridgeport en route to Steveston, the other proceeding east along the riverbank, stopping at the various plywood mills and factories on the way to New Westminster. In 1912, an optimistic investor built the Grand Central Hotel

at the northeast corner of Hudson and Marine; lacking both grandeur and centrality, it promptly went bankrupt. It became the Provincial Home for Incurables in 1917, mainly housing tuberculosis patients in scandalously squalid conditions until its closure in 1965. Another landmark was the Marpole Theatre at 1370 South West Marine Drive; it became the Metro Theatre, the venue of an organization of local theatre companies, in 1963. Marpole was a compact community through which a lot of traffic passed, including anyone going to the airport on Sea Island or to Lulu Island via the Hudson Street swing span bridge (the alternative was the Twigg Island bridge at the foot of Fraser Street).

The popularity of automobiles by the 1920s began to whittle away at the old Marpole centre, as new businesses tended to locate on Granville Street. But the real change occurred in 1957 with the opening of the Oak Street bridge and the dismantling of the Hudson Street one. In only five years, 36 out of 56 stores had closed, leaving only a few cafes and scruffy nightclubs, such as one called Nino's La Botte, to cater to the mill workers and other entertainment-seekers. The *coup de grâce* occurred in 1975 with the construction of the Arthur Laing Bridge, which more or less replicated the route of the old Hudson Street one but whose elevated ramps and freeway ambience removed any possibility of a commercial rebirth.

Two Marpole businesses – the White Spot and the Fraser Arms Hotel – assumed a kind of iconic status while benefiting from the shift from compact community to car culture. The "Spot" was the hottest drive-in on the west side of the city in the 1950s and 1960s, a mobile feast of custom cars, slow-speed drive-throughs that were coded invitations to drag race on Granville, and every variation on the in-car date that didn't require the privacy of a drive-in movie.

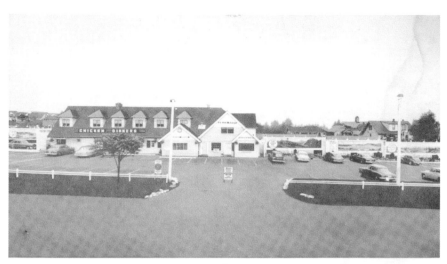

FAMOUS DINING RENDEZVOUS OF THE PACIFIC COAST — GRANVILLE AT 67th VANCOUVER, CANADA

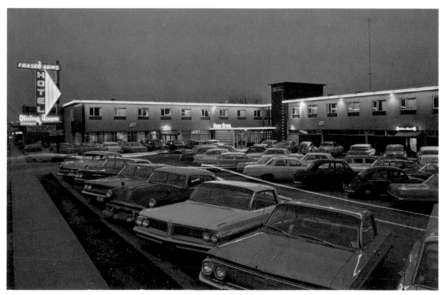

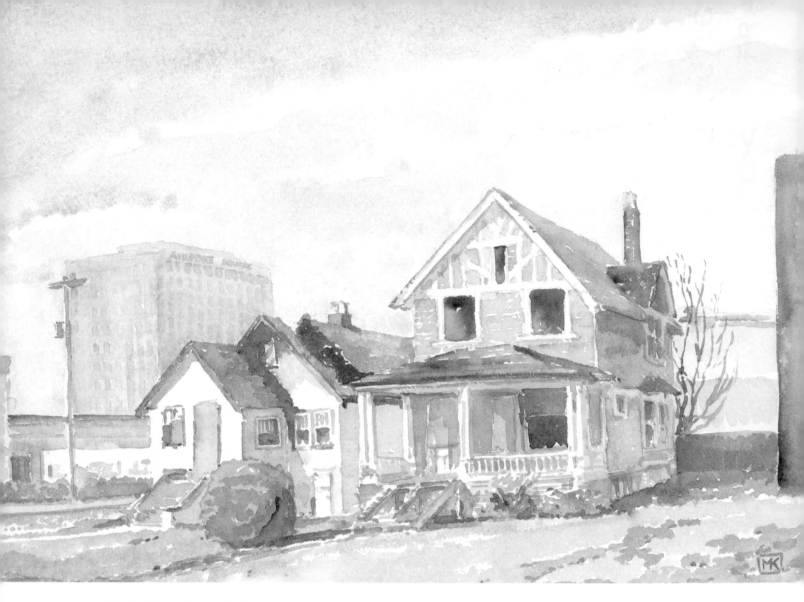

The last Eburne house – that is, the only survivor from the years before the community became Marpole in 1916 – stood at 8787 Oak opposite the bridge apron. Built in 1912 to take advantage of the opening of the Oak Street tram line, it was an investment by Samuel Flack of a part of a Klondike mining fortune that also paid for the Flack Block at 163 West Hastings. After watching its slow deterioration for years, I painted it in January 2006, a month before it was bulldozed.

1 Bailey's biography is *Triple-O, The White Spot Story* by Constance Brissenden (Opus, 1993).

Its owner, Nat Bailey (1902–1978), started his career selling peanuts at Athletic Park, then saw an opportunity to sell snacks off the back of a truck at the lookout on Marine Drive – the one commemorating Simon Fraser's 1808 journey to salt water – to motorists taking a Sunday drive on the loop around Point Grey. In June 1928, when he decided to open a permanent restaurant, Granville Street at 67th was a logical place to build.

The White Spot had a dining room that specialized in fried chicken – "Chicken in the Straw," a collection of batter-covered chests, legs and wings (in the era before broilers produced huge quantities of "boneless" breast meat) – but its great fame came from its burgers with their "Triple-O" sauce, chips soggy with vinegar and crusted with salt, and bitter coffee in china mugs, all served on a tray that clipped onto the car windows and extended across the front seat. Bailey was a tireless promoter of local baseball and one of the owners of the Vancouver Mounties in the 1950s; the former Capilano Stadium at Little Mountain bears his name. In 1968, General Foods bought his 13 White Spot restaurants, mostly drive-ins, then resold them to local owners.[1]

The "Arms" opened in 1957 toward the end of the era when Aboriginal culture was being erased from the Vancouver consciousness rather than celebrated. Although aimed at the airport trade, it rapidly became a nightly

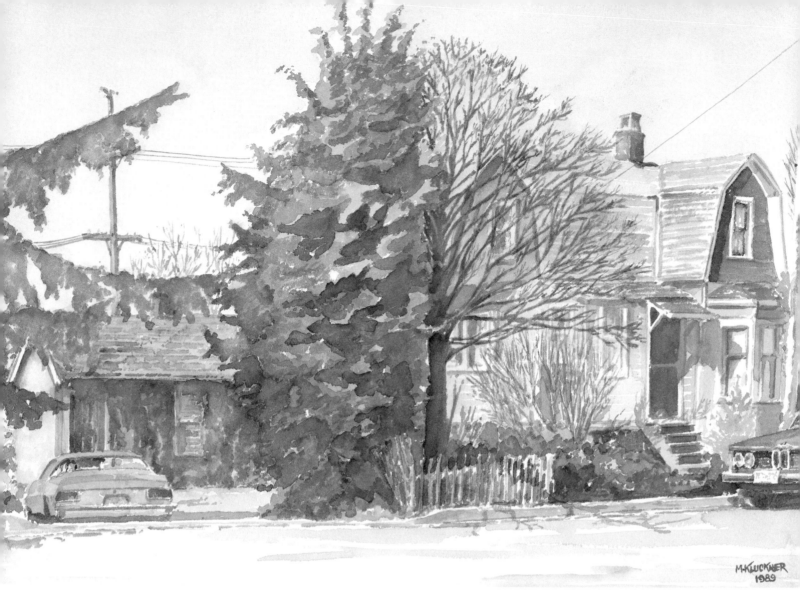

M•KLUCKNER
1989

pilgrimage spot for beer-swilling UBC students and workers from the surrounding factories. Long line-ups extended into the crowded parking lot on Friday and Saturday nights, cars burnt rubber and weaved out onto Granville Street, which fortunately had little traffic at the time. To keep a table, you were expected to drink at the guzzling pace set by the waiter or else vacate the place.

Were the hotel proposed now it would not have been built, as it sat on the edge of the Marpole Midden, an immensely significant 2,500-year-old garbage heap at what was once the mouth of the river. Because of the demands of the developer and the weakness of provincial heritage legislation, archaeologists and ethnographers had to work frantically to extract artifacts and knowledge from the site.

Road workers had stumbled upon artifacts and skeletons in the soil in 1892. Preliminary investigations by ethnographer Charles Hill-Tout (the namer of Kitsilano) led to a report to the Royal Society of Canada in 1895, describing the midden as occupying almost five acres at an average depth of five feet, with some spots being about 15 feet deep. The piles of clam and mussel shells and the bones and skeletons of fish, animals and humans provided a huge amount of information about everything from diet to medical treatments: some human skulls were trepanned – that is, drilled – in an attempt to cure mental illness.

The tiny gambrel-roofed Colbourne House at 8743 South West Marine was part of a landscape of cottages and market gardens when it was built in 1912. I painted it in 1989 when there was still a green cabin sharing its yard. The latter, with the tenant's Camaro muscle-car, hinted at the edgy quality of Marpole in those days – the $10,000 car in front of the $1,000 house. The city owned the property and leased it in 1995 to the Marpole Museum and Historical Society, which has so far restored its exterior.

Subsequent sporadic investigations uncovered material as old as any from ancient Greece, but the warnings by Hill-Tout and Harlan Smith to secure the site were ignored. Instead, the Historic Sites and Monuments Board of Canada installed a commemorative plaque in the little park at 73rd and Cartier, and access to the midden quickly disappeared under pavement and buildings. Recent proposals to reuse the industrial sites on the riverbank below the Fraser Arms, including the Translink plan to relocate its Oakridge Transit Centre, have led to calls by the Musqueam First Nation and archaelogists for better stewardship of the surviving unpaved lands. Ironically, the Musqueam First Nation now owns the Fraser Arms Hotel.

Marpole is an anomaly, as the wave of redevelopment and gentrification on the rest of the west side shows little sign of arriving. South of 70th Avenue, frame walk-up apartment buildings from the 1960s and 1970s line the quiet streets. The area has a "shabby genteel" quality to it, popular with pensioners and lower-income families. The old Firehall Number 22, now refitted to provide community programs, still frames the view looking north along Hudson Street. North of 70th, many of the small frame houses from earlier eras have been replaced by Vancouver Specials, so the neighbourhood looks more like an east-side one. The Granville Street commercial strip has been revitalized by a huge number of Chinese businesses with colourful signs. In a way, it's an average Vancouver neighbourhood in every respect – the mean income and age are typical of the city as a whole – but there are more renters than average.

Amidst the Vancouver Specials of Marpole, the modest Kogawa house gives little hint of its historical significance. Located at 1450 West 64th, a block east of Granville, it was author Joy Kogawa's childhood home, from which she and her family were exiled in 1942 at the beginning of the Japanese internment. The unassuming, quiet quality of the house reflects the personalities of most Japanese Canadians of the period, who just wanted to fit in and be part of Canadian society. As the house is an integral part of her novel Obasan – *one of the classics of Canadian literature – an effort began in 2004 to try to buy it as a writers' retreat. The campaign to purchase it, headed by The Land Conservancy of BC, succeeded in 2006.*

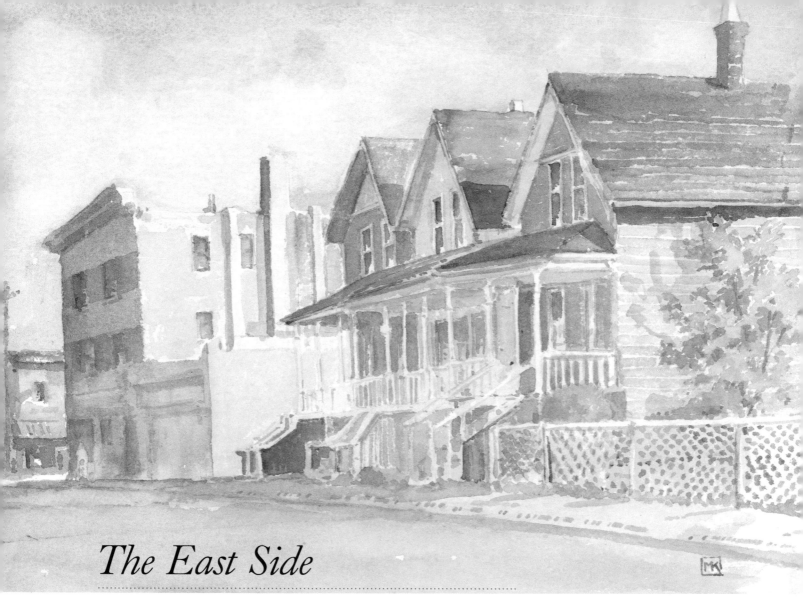

The East Side

Characterized by more ethnic diversity than the west side, the east side's mixed housing and neighbourhoods also lack the conformity that defines the typical west-side streetscape. This is a generalization, of course, but the east side looks (and is) poorer. Typically lots are small with few trees on them, street trees are smaller, both because they aren't as old as the west side ones and, by the time the city got around to planting them, species like the Japanese cherry were seen as more practical than huge maples and chestnuts. Some blocks are long, others short, and many streets zig and zag where the old surveys don't line up. There are, or at least were, a lot more single-storey bungalows – very small houses from the 1930s to 1950s that have been replaced by variations on the boxy two-storey Vancouver Special. Houses tend to be white and stuccoed; glazed brick is often used as a decorative highlight or facing on houses, and wrought iron is a common fence and balustrade material.

The brown brick pre–World War One schools, three storeys tall, tower above the surrounding houses, so that from any high point of land (of which there are many more on the hilly east side than on the west) you can see them anchoring the neighbourhoods as they have done for nearly a century. Houses stand out more distinctly on their lots than on the west side, where shrubbery softens the building edges and the English tradition has made gardening

Three houses on the south side of King Edward Avenue, with the Hopkins Building at Main Street in the background, all built in 1910. Narrow streets and short blocks characterize the enclave behind the houses, a contrast with the orderly subdivisions west of Ontario Street, which are newer and built on land controlled by the CPR.

either a pastime, an obligation or an obsession. The best tableaux to illustrate the difference between west side and east side is King Edward Avenue between Cambie and Main: on the west side at Cambie, neat bungalows on 50-foot lots retreat from the road behind clipped hedges and rockeries (page 202); at Columbia, one block west of the CPR's land boundary at Ontario, the treed boulevard disappears and the road narrows; between Ontario and Main, tall houses on narrow lots and apartment buildings crowd against the road edge (the water-colour on the previous page).

The tall houses of early Vancouver followed the streetcar lines south into Mount Pleasant and east through Strathcona in the 1890s. Grandview got a jump on other east side neighbourhoods, as it was both on the 1891 interurban line to New Westminster and within the city boundary. (Nanaimo Street was the eastern boundary of Vancouver until 1911, when Hastings Townsite joined it; 16th was the southern boundary until 1929, when South Vancouver joined too). Unlike the modern SkyTrain line, which exits downtown via False Creek, the interurban initially used Hastings, Campbell, Venables and Commercial Drive to reach Cedar Cottage, where its (and SkyTrain's) private right-of-way headed southeast to New Westminster parallel with Kingsway.

The Monarch Furniture Factory stood on 20th Avenue just east of Ontario, an odd, middle-of-nowhere location for an industrial plant and a demonstration of the working-class quality of the blocks near Main Street a century ago. I took the photographs in 1982.

The next push into the hinterland followed the Main Street tram southward in 1904 on its way, via 33rd Avenue, to the gates of Mountain View Cemetery at Fraser Street. Hillcrest, City Heights and Sunnyside were names applied to the district around King Edward and Main early in the 20th century. The Monarch Furniture Factory, with its office on the north side of 20th Avenue just east of Ontario and its factory on the lane behind, was an extreme example of do-as-you-please land usage, plunked in the middle of a residential area around 1910. Like small factories in dedicated industrial areas elsewhere, curiosities like Monarch had problems competing with the products from eastern Canada and overseas. The buildings disappeared about 20 years ago.

More typical of the east side than rogue factories were "stump farms." The war-depression-war cycle of the 1910s to 1940s left a lot of land vacant east of Main Street. A perusal of old directories and fire insurance maps shows that there were families even in the 1950s supplementing their incomes by producing food. Like the small farmers in Whalley or Newton in Surrey or Willoughby in Langley, who subsisted on small pensions and seasonal jobs, these families lived in frame houses, often four-roomers that were little more than cabins, on roughly cleared lots with a vegetable patch and a run for hens, selling the eggs to neighbours or corner stores. The Chinese and Sikhs were better organized, with market gardens scattered across the south slope and

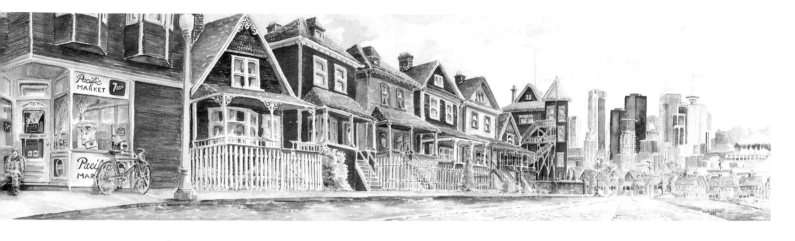

intensive vegetable farming on the river flats below Marine Drive. All have now disappeared from Vancouver; the Avalon Dairy on Wales Street just south of 41st is the only surviving agricultural relic.

At the point where the interurban swung southeast, near 18th and Commercial, a street of shops developed that a century ago looked like a small town. A hardware store, community hall, bank, post office and movie theatre provided a centre for Cedar Cottage, as the surrounding community of small holdings and suburban houses became known. Settler Arthur Wilson had a little cedar-shake home at Kingsway and Knight Street, later used by George Raywood for his Cedar Cottage brewery. Their water source was Gibson's Creek, which joined Jones Creek near Broadway and Clark and then – known by this point as China Creek – tumbled down the hill into False Creek. When the creek was forced into a culvert, the ravine below Broadway became a garbage dump, then the site of a beautiful banked velodrome built for the 1954 British Empire and Commonwealth Games. It is currently the King Edward campus of Vancouver Community College.

Grandview is the east side community that most evokes old Vancouver; like Kitsilano or Fairview Slopes a generation ago, its big houses and small Commercial Drive shops provide the perfect template for a vibrant counterculture and arts scene. There are several conflicting stories about its name. According to founding city archivist J.S. Matthews, the area was bushland until about 1893 and, if known at all, was referred to as District Lot 264A. Victoria Drive and Commercial Drive (originally called Park due to its connection from Hastings to Clark Park) were skid roads used to move logs to the water at what was then called Cedar Cove on Burrard Inlet at Victoria Drive. Matthews recalled first hearing "Grandview" about 1904 in the report of a meeting of local ratepayers, in which Professor Edward Odlum, one of the significant property owners, had agreed that it "would be an excellent name." Like the names Fairview and Mount Pleasant, it is hardly unique to Vancouver.

Prosperous settlers like Odlum bought multi-lot blocks, poorer ones bought individual lots, and syndicates subdivided their own blocks and built houses on spec to entice development. According to a 1936 book by the Templeton School

In 1985, I was one of four artists commissioned to paint an image of Vancouver for a centennial poster series, and I tried to find a location that combined old and new Vancouver. After searching in vain for an intact scene, I used the view from Frances Street at Victoria Drive, incorporating the corner store (but changing its name), the turreted house and the distant city view, but replacing the street's three-storey walk-ups with a representative sampling of Grandview homes. It was an assemblage of typical Vancouver elements. I was intrigued by the number of people at poster signings and public events that Centennial spring who said they had once shopped at the store or lived in one of the houses. The poster's publisher from New Orleans objected to the figure on the store steps, whom he perceived as a wino! The original watercolour now hangs with the others in the series, including ones by the late Toni Onley and Jack Shadbolt, in City Hall. Twenty years later, the corner building is still there but is boarded up.

Archivists Club, the BCER offered a year's streetcar pass to anyone establishing a home in the area. The *Province* advertised one especially imaginative promotion on December 22, 1906: purchasers of property in a subdivision bounded by Lakewood, Templeton, Venables and Parker had a chance of winning two Shetland ponies, a two-seater cart and a harness with brass fittings – a total value of $700!

The completion of the Burnaby Lake interurban line in 1912 triggered a later period of development. Officially known as the Fourth District of the BCER's interurban system, it had its terminus at Sixth and Commercial (the BCER tried unsuccessfully to obtain a right-of-way directly from there to downtown). The line ran eastward along First Avenue's boulevard, then followed the route of today's Highway 401 before swinging west – as does the SkyTrain Millennium Line – and heading for New Westminster. Speculators flocked to the newly accessible land, including Alvo von Alvensleben (page 66), who touted Grandview Heights lots between Nanaimo and Boundary Road.[1] Such subdivisions only attracted scattered buyers in the early days, with some lots remaining vacant for half a century.

The mansions of two Australian immigrant brothers provide a rags-to-riches-to-rags tale emblematic of early Vancouver. John ("J.J.") and William Miller speculated in real estate, prospered briefly and settled in Grandview, their legacy being the two massive houses called Kurrajong and Wilga. The Miller family were originally from Dorset but emigrated to New South Wales in the middle of the 19th century, where they settled in Cootamundra. There,

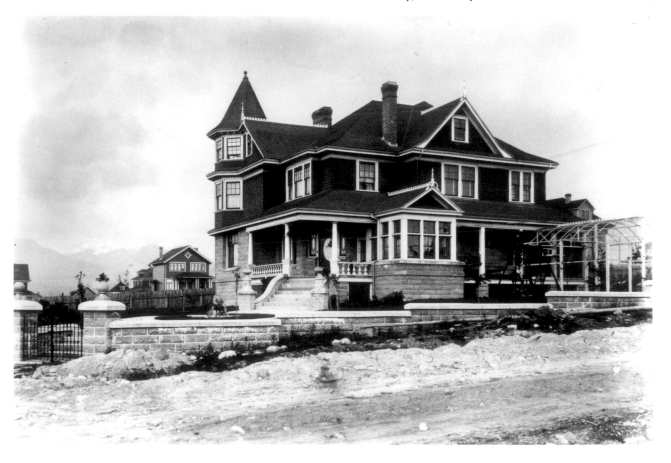

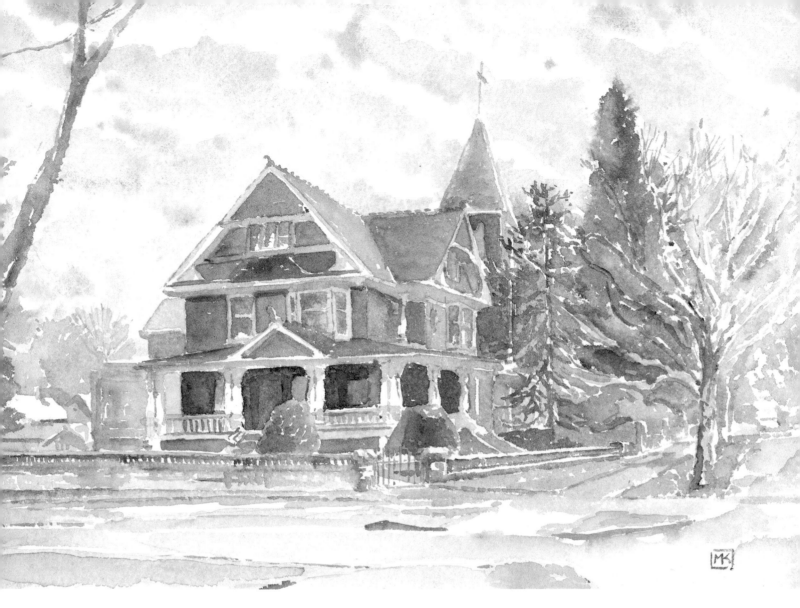

they established a sheep station called Littledale and became well known as stock agents. Five sons were born, beginning in 1860 with J.J., an ambitious young man who became the town's mayor at the age of 30. He took his role as the family's eldest son seriously and understood the value of a wife to a man of position; accordingly, he married the widowed mother-in-law of two of his brothers, thereby assuming responsibility for her six unmarried daughters! However, following a severe drought in 1902–04, the family agreed that the station could only support one son. Neville stayed, and ultimately became the most successful. J.J., William and two younger brothers made a stormy crossing in steerage class on the *Aorangi* and arrived in Vancouver on March 17, 1905.[2]

Drawing on their stockmen's experiences, J.J. and William entered the real estate business as auctioneers. A story survives of J.J. conducting an auction in Prince Rupert where, in the frenzied anticipation of the arrival of the Grand Trunk Pacific Railway, he sold town lots totalling $1,250,000 in a single day. With a great sense of irony, the brothers named their Grandview mansions after eastern Australian shrubs that provide valuable fodder during droughts.

J.J. brought his sense of civic responsibility with him to his adopted country. He retained his interest in the improvement of livestock and organized a local exhibition along the lines of those in Australia. When it became a success,

1 The maps in Bruce Macdonald's *Vancouver: A Visual History* chronicle the colourful names of the east-side neighbourhoods.

2 A similar emigration story with a twist: the impoverished Angus brothers of Manchester pooled their funds in the 1860s to send the brightest of them, Richard, to Canada to make a fortune. He became president of the Bank of Montreal, a director of the CPR and the co-owner of much of Vancouver (p. 23). He brought his extended family to Canada in 1883; they settled in Victoria.

ABOVE *Hillcrest, the 1905 Odlum house at 1774 Grant Street, was one of the earliest big homes in Grandview, and something of a trendsetter with its Queen Anne turret. Edward Odlum (1850–1935) was a widely travelled writer, a Renaissance man who developed electric arc lights, studied ethnology, lectured on immigration and history, and made a lot of money in real estate. (Photographer unknown)*
CVA BU. P. 649

BELOW *Looking south on "The Drive" in 1922. The turreted building at First Avenue still exists, minus its cone; the low building beyond it was a movie theatre. (Photo by Philip Timms)*
VPL 7399

NEXT PAGE ABOVE *The view in 1922 from the hose tower of the fire hall that stood at the corner of Charles and Salsbury, looking southeast and showing the well-utilized backyards of the residents. (Photo by Philip Timms)*
VPL 7424

NEXT PAGE BELOW *The Semlin Grocery, one of the city's increasingly rare mid-block shops, in 1992. It has since closed. The nearby blocks include a mix of grand houses such as Wilga and some old store buildings along Victoria Drive that evoke the compact, self-contained city neighbourhoods of another era.*

1 See *Vancouver's Fair: A Political and Administrative History of the Pacific National Exhibition* by David Breen and Kenneth Coates, UBC Press, 1982.

2 Interview with descendant Elinor Martin, 1991.

he negotiated the civic lease of Hastings Park, and his country fair evolved quickly into the Pacific National Exhibition.[1] Miller Drive on the PNE grounds is named for him. A highlight of his life was his trip to London to represent Vancouver at the coronation of George V in 1911; upon his return, he published his reminiscences in a book entitled *Vancouver to the Coronation*. He had adopted the clothes, beard and mannerisms of Edward VII, and enjoyed it when people commented on the resemblance.

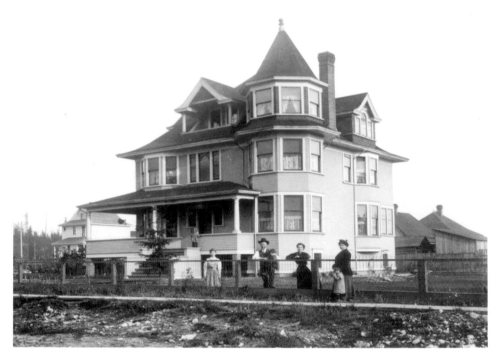

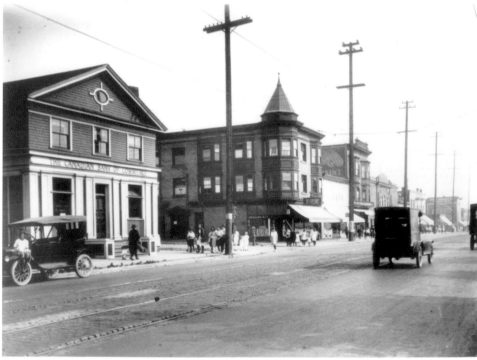

VANCOUVER REMEMBERED

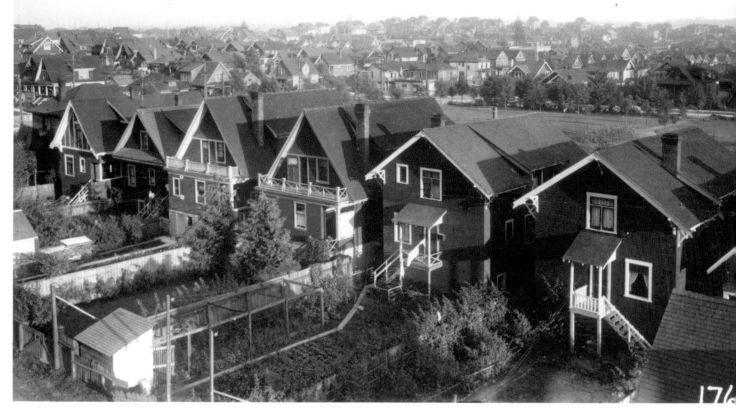

The brothers continued to speculate and lost their fortunes in the 1913–14 real estate crash. After the war, J.J. was forced to give up Kurrajong and live in a series of rented houses in North Vancouver and Hastings Townsite, before settling in a small house at 2331 Graveley Street, where he died in 1950. William managed to hang onto Wilga until the 1920s, then lived in rented houses on the east side before a daughter in Berkeley, California, took him in. He lived there from 1936 to 1944. Both would have been destitute without the support of their children.[2]

Remarkably, their houses and most of the others of the great "boomers" have survived, giving Grandview a nonpareil collection of turreted Queen Annes. Kurrajong became a private hospital; a co-operative bought Edward Odlum's Hillcrest long after its grounds were infilled with bungalows. A few grand houses dot Victoria Drive, still with their granite and concrete-block walls and a semblance of their period landscaping. As for Wilga, which originally occupied a property of about two acres laced with trails and featuring a garden, a tennis court and stables, it became the friary for La Chiesa di S. Francesco d'Assisi – the St. Francis of Assisi church – which stands just to the east of it. Until the 1990s, Wilga was rather a shabby building, having suffered both from cheap renovations and the loss of its decorative detailing. A restoration program undertaken by the church returned it to its original glory.

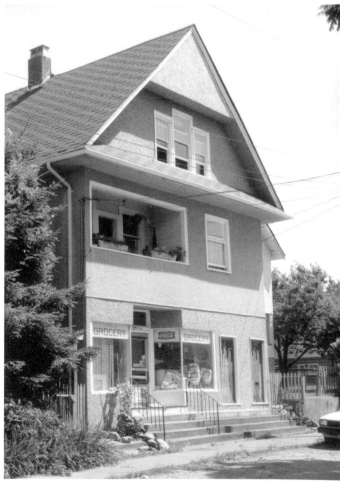

The largest tract of open land on Vancouver's east side is Mountain View Cemetery, purchased by the city in 1886 to replace its pioneer-era burial grounds at Brockton Point. In fact, it is the oldest piece of publicly owned open space in the city, predating Stanley Park's opening by two years. Either William Skene or Rev. Dr. Grant can take credit for the name Mountain View, which was agreed upon at a meeting of the city's health committee on June 17, 1903, and is the imaginative equal of such real-estate favourites as Grandview Heights and Fairview Slopes.

Occupying a high crest, miles south of the 16th Avenue city boundary, it was conveniently located on the North Arm Road (now Fraser Street), the only roadway opened between the River Road (Marine Drive) and the New Westminster Road (Kingsway). Although it is now something of a secondary route compared with Main or Knight, Fraser Street was very significant to early Vancouver when it was cleared in 1875. It was the lifeline for Gastown's fresh-food supply. In the early 1890s, a bridge (which survived until 1974) connected the south end of Fraser Street to Lulu Island/Richmond via Twigg Island. The area's first school opened at Marine Drive in 1885 for the children of local farmers. In 1892, the incorporators of the Municipality of South Vancouver chose the crossroads of Fraser Street with Wilson Road (now 41st) as their civic centre.

The Old Cemetery occupies about 15 acres of land southwest of the corner of 33rd and Fraser Street. Cleared in 1886 and groomed to receive interments, it had an inauspicious inauguration. The first burial was to be Simon Hirschberg, proprietor of the Leland Hotel, a large man who had allegedly committed suicide with an overdose of opium. The wagon carrying his coffin made it up Fraser Street to 33rd, but the pallbearers abandoned the effort of carrying it across the muddy, uneven ground, and buried him unceremoniously on the edge of the road right-of-way. Soon thereafter, however, on February 26, 1887, the coffin of a 10-month-old boy named Caradoc Evans made it to a resting place inside the cemetery grounds. His parents chose the highest point of land; the small gravestone, set flush in the grass, is still easily read. Significant graves nearby include the Tatlow, Cambie, Roedde and Eburne families, first mayor Malcolm MacLean and farmer Henry Mole, the namesake of Mole Hill (page 122).

Distinctive areas for racial and cultural groups emerged very quickly. An agreement between Chinese and Jewish groups resulted in the exhumation of some Chinese burials so that a Jewish area could be created; an ornamental fence was erected around it in 1907. That year, a man named Arajan Singh was granted a license to use the southwestern corner of the cemetery for Indian burials. The Chinese community built a ceremonial altar and pavilion in their section in 1910, which was rebuilt in 1973 and refurbished in 1998.

As the original cemetery filled, the city sought to expand it and purchased land to the south from realtor Henry Albert Jones for $5,500 in August, 1901. The *Province* reported on December 16, 1902, that the arrangement had been based upon a "hastily drawn plan on a sheet of brown paper . . . sketched out in lead pencil" which the city believed comprised 42 acres. It took 10 years of wrangling to conclude the deal.

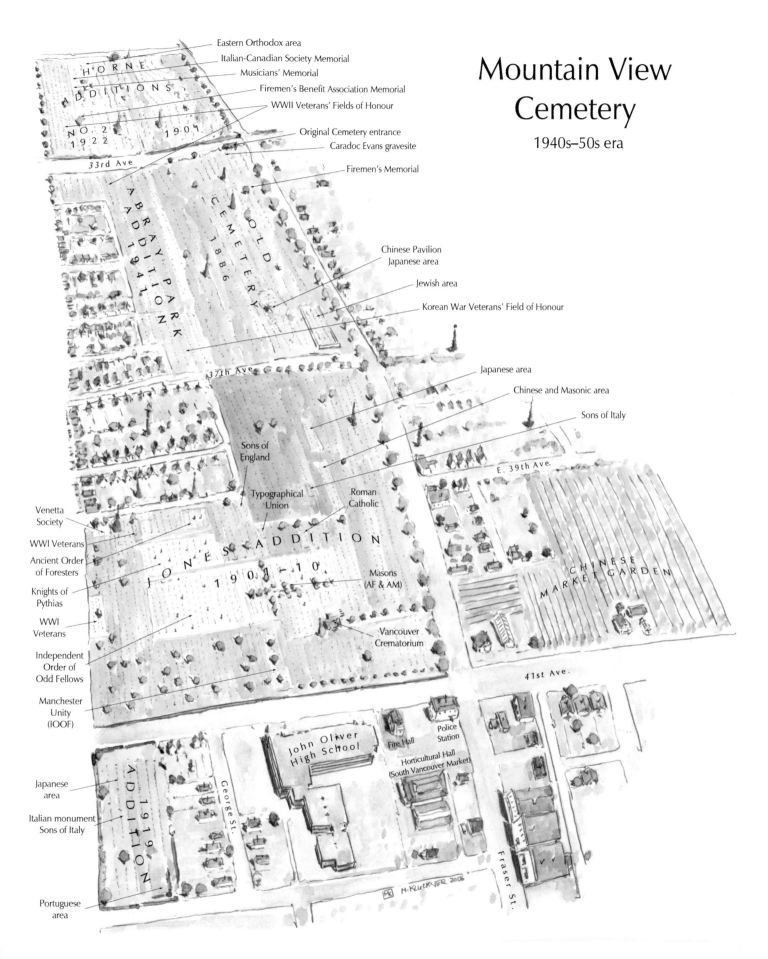

Mountain View Cemetery

1940s–50s era

Eastern Orthodox area
Italian-Canadian Society Memorial
Musicians' Memorial
Firemen's Benefit Association Memorial
WWII Veterans' Fields of Honour
Original Cemetery entrance
Caradoc Evans gravesite
Firemen's Memorial

HORNE ADDITIONS
NO. 2 1922 1901

33rd Ave.

ABRAY PARK ADDITION 1941

OLD CEMETERY 1886

37th Ave.

Chinese Pavilion
Japanese area
Jewish area
Korean War Veterans' Field of Honour

Japanese area
Chinese and Masonic area
Sons of Italy

E. 39th Ave.

Sons of England

Typographical Union

Roman Catholic

Venetta Society
WWI Veterans
Ancient Order of Foresters
Knights of Pythias
WWI Veterans
Independent Order of Odd Fellows
Manchester Unity (IOOF)

JONES ADDITION 1901–10

Masons (AF & AM)

Vancouver Crematorium

CHINESE MARKET GARDEN

41st Ave.

John Oliver High School

George St.

Fire Hall
Police Station
Horticultural Hall (South Vancouver Market)

1919 ADDITION

Japanese area
Italian monument Sons of Italy

Portuguese area

Fraser St.

M. KLUCKNER 2006

The Jones Addition, extending from 37th to 41st, contains areas dedicated to the numerous service and fraternal organizations that were a large part of the lives of middle-class Vancouverites a century ago. Groups including the Ancient Free & Accepted Masons (AF&AM), the Catholic Knights of Pythias and the Independent Order of Odd Fellows purchased areas for their members and in some cases paid for funerals. Many members of the Vancouver Establishment were Masons, and accordingly their area has the grandest monuments and the most formal layout. Old photographs show the land divided into grids using curbing, some of it marble, others concrete, some sections with family names incised. Unlike much of the rest of the cemetery, the Jones Addition has monuments and trees of a suitable scale for the available space. Mayors Fred Buscombe and James F. Garden, the Spencers, Bell-Irvings, Hornes, Europe Hotel builder Angelo Calori and city archivist J.S. Matthews rest there. One of the largest mausoleums holds the Hendry and Hamber remains.

Realtor J.W. Horne, builder of the Horne Block on Cordova in Gastown, is interred in the Jones Addition, even though he sold the city the Horne Addition – the land between 31st and 33rd. The city purchased "Old Horne," the several acres directly north of the original cemetery gate at Fraser Street, at the same time they began the negotiations for the Jones Addition. The graves of CPR executives Harry Abbott and Richard Marpole, Hastings Mill manager Richard Alexander, philanthropists Jonathan and Elisabeth Rogers (page 168) and writer-explorer Julia Henshaw rest there. The balance of the land to the west, a rather marshy plot that contains the headwaters of Brewery Creek, was added to the cemetery after Horne's death in 1922. The large area at the western edge is a "Field of Honour," an extension of the soldiers' section begun on the south side of 33rd in the Abray Park Addition.

Nonus Abray was a settler, something of an eccentric, and the brother of a member of Vancouver's original police force.[1] Following his death in 1937, his land west of the Old Cemetery was purchased by the Park Board, then traded for city-owned land along Sunset Beach. The north end was astutely designated as a soldiers' section; four years later, with the war underway, another section between 36th and 37th was likewise reserved. These "Fields of Honour" contain mainly small flat plaques that tell the devastating tale of loss in the Second and Korean wars. The graves of First World War soldiers occupy the western edge of the Jones Addition.

The small extension of the cemetery south of 41st Avenue was a city purchase in 1919 and contains the remains of many of the victims of the "Spanish flu" pandemic, which was at its worst in October 1918, although the high rate of death continued into the following spring.[2] Joe Fortes, the English Bay lifeguard (page 132), was buried there in 1922; two years later, Shaughnessy nanny Janet Smith, the victim of a notorious unsolved murder said to involve Vancouver's drug-addicted, wildly partying elite, was buried nearby.[3]

Compared with Victorian-era cemeteries like Victoria's Ross Bay or, most famously, Mount Auburn in Cambridge, Massachusetts, Mountain View lacks picturesque and reflective areas. It suffered greatly in the 1940s and 1950s from the "lawn cemetery" philosophy that emphasized ease of maintenance

1 Jackson Abray had an interesting second career as a hotel keeper in the Fraser Canyon. See *Vanishing British Columbia*, pp. 123–25.

2 See *Dr. Fred and The Spanish Lady: Fighting the Killer Flu* by Betty O'Keefe and Ian Macdonald (Heritage House, 2004).

3 The tale is told by Ed Starkins in *Who Killed Janet Smith?* (MacMillan, 1984).

Log booms and sawmills on Mitchell Island in 2005 – the view from the Knight Street bridge, which crosses the island on its way to Richmond. Such scenes of industrial waterways are becoming few and far between in the recreationally oriented, aesthetically driven modern city.

by small crews with motorized equipment. In 1964, new upright monuments were banned and many existing ones were laid flat or, in some cases, removed and reused (most notoriously in the Stanley Park seawall, where strollers in the 1960s became curious after seeing carved names in the granite rockwork). Large deciduous trees were discouraged in favour of small evergreens; curbs sank into the grass and disappeared; trees died and were never replaced. The city eventually came to realize that the cemetery was an underused public asset and set out to study how to make it viable for its second century. It commissioned a Master Plan that was completed in 2000 and adopted in 2004. Work has proceeded at a funereal pace since.[1]

1 I was the heritage consultant on the master plan, working primarily with landscape architects Philips Wuori Long Inc. and designers Pechet + Robb. Bruce Macdonald assisted me with my work. Lorraine Irving of the B.C. Genealogical Society is the expert on the cemetery's gravesites.

BELOW *Marine Drive and Kingsway were the auto court and motel strips of Vancouver. Built c. 1948, this one sat at 335 S.W. Marine, using the farmhouse and grounds of the Marpole (later Model) Dairy. The auto court heyday was the 1950s and 1960s, when families loaded their station wagons and set off to see North America. (Photo by George Weinhaupl)*

NEXT PAGE *A c. 1910 farmhouse on Byrne Road on the south Burnaby flats. I painted it in 2002, shortly before it was bulldozed, when it had developed the overgrown, crumbling character I remembered from decades before of other abandoned houses along the Fraser River east of the Oak Street Bridge and in Richmond and Delta. Weeping willows thrive in the damp ground. As the area flooded regularly, such farmhouses were always built well above grade.*

The River Road, which gradually evolved into Marine Drive, was cleared from New Westminster to the Musqueam village in 1862 by a crew that included Fitzgerald and Samuel McCleery, who became entranced by the possibilities of farming on the Southlands flats below Kerrisdale. The flats farther east along the Fraser River soon developed into a tapestry of market gardens, mainly tilled by Chinese farmers, before changing in the 1950s into the city's warehousing and industrial backyard. By the millennium, Vancouver's river foreshore had changed again, especially between Knight Street and Boundary Road, where the Riverside and Fraser Lands communities of apartments and townhouses developed on a mix of private and public lands. Above them on the slope are the veterans' community of Fraserview, from the 1950s, and Champlain Heights, a 1970s-era residential community on city-owned lands with a number of co-ops mixed in with rentals and subsidized housing. A few market gardens still survive on the Burnaby flats of the Fraser River between old Marine Drive and modern Marine Way. Below the latter is a floodplain landscape that until recently had a spooky hillbilly or biker quality, such as the Byrne Road house on the next page.

Stolen glimpses away from the traffic on the Oak and Knight bridges, such as the one on the previous page, reveal another world of sawmills, log ponds and tugs pulling sawdust-filled barges – a working scene reminiscent of False Creek before 1960. However, motorists passing along Marine Drive through South Vancouver see little but the facades of warehouses and, at Main Street, the Superstore that was to have been the harbinger of a number of conversions of industrial land to big-box retail.[1] The McDonald's drive-in at Manitoba Street opened in 1968, the year after Canada's first one opened in Richmond, with 18-cent burgers at a time when the White Spot's cost 45.

The Sikh community abandoned its 1908 Kitsilano temple in the late 1960s and moved to the grandly austere Khalsa Diwan temple at the corner of Marine Drive and Ross. Vancouver's south slope became the home of many Indo-Canadian families after the dispersal of its Fairview community (pages 27 and 148) and the arrival of waves of new immigrants. South Main and South Fraser are the commercial streets for the large Vancouver community, which is nevertheless dwarfed by the Surrey one.[2]

Kingsway, like the eastern part of Marine Drive, is an inseparable part of the automobile and commuting culture that erased the streetcar dependency of the pre-war years. Kingsway was the False Creek Trail of the 1860s even before Gassy Jack opened his saloon near Stamp's Mill. The King in question was Edward VII, at least for the part of the road between Main and Knight, which was improved

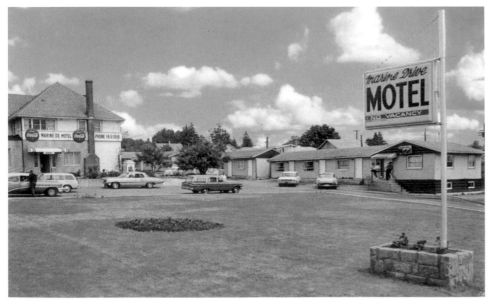

in 1906; by the time the balance of the road was paved out to Boundary in 1913, the automobile era had arrived and an enthusiastic group of motorists drove the length of it to celebrate.

Throughout the east side, communities like Cedar Cottage that had thrived on interurban traffic declined as businesses relocated to take advantage of the increased auto traffic. Other communities like Collingwood grew around their schools and celebrate their 1950s roots. The map overleaf highlights the car lots, auto courts, motels and other stopping places that had developed along the strip by the 1950s.

1 Hotly contested proposals for a Wal-Mart and Canadian Tire nearby were delayed by the COPE city council between 2002 and 2005.

2 Rattan Mall's essay on Indo-Canadians appears in *The Greater Vancouver Book*, p. 314.

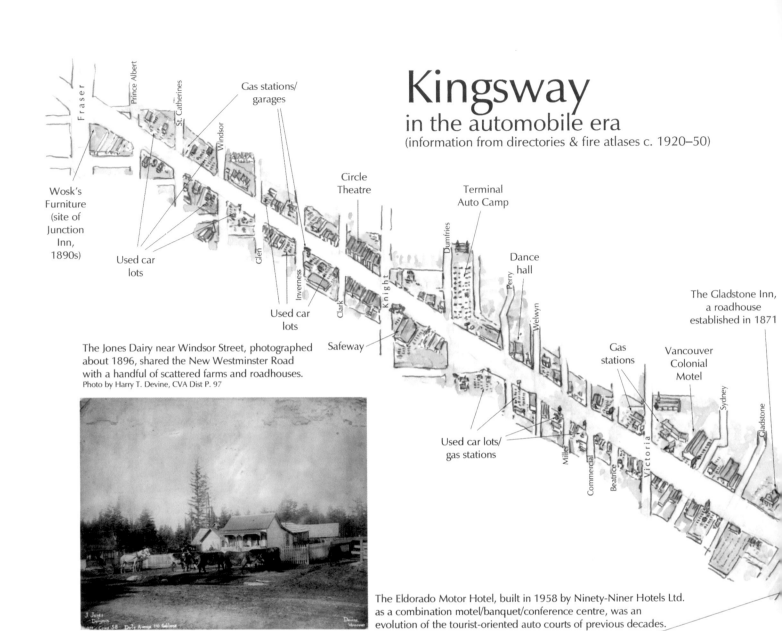

Kingsway
in the automobile era
(information from directories & fire atlases c. 1920–50)

Fraser

Prince Albert

St. Catherines

Windsor

Gas stations/
garages

Wosk's
Furniture
(site of
Junction
Inn,
1890s)

Used car
lots

Glen

Inverness

Used car
lots

Clark

Circle
Theatre

Safeway

Knight

Dumfries

Terminal
Auto Camp

Perry

Dance
hall

Welwyn

Miller

Commercial

Beatrice

Victoria

Gas
stations

Used car lots/
gas stations

Vancouver
Colonial
Motel

Sydney

The Gladstone Inn,
a roadhouse
established in 1871

Gladstone

The Jones Dairy near Windsor Street, photographed
about 1896, shared the New Westminster Road
with a handful of scattered farms and roadhouses.
Photo by Harry T. Devine, CVA Dist P. 97

The Eldorado Motor Hotel, built in 1958 by Ninety-Niner Hotels Ltd.
as a combination motel/banquet/conference centre, was an
evolution of the tourist-oriented auto courts of previous decades.

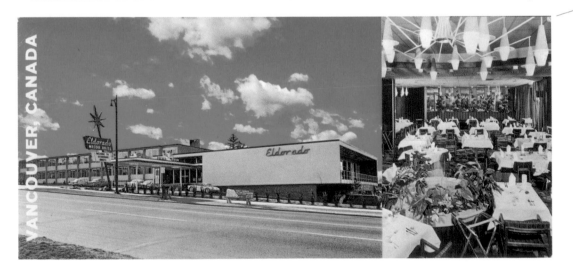

The Kingsway strip of auto courts and cafes continued through Burnaby, attracting car-owning revellers from around the region. One destination was the Gai Paree at Sperling; the group at the table were BC Electric employees, including my parents, the couple at the near end of the table facing the camera.

(Thanks to Joanne Enns for the souvenir card)

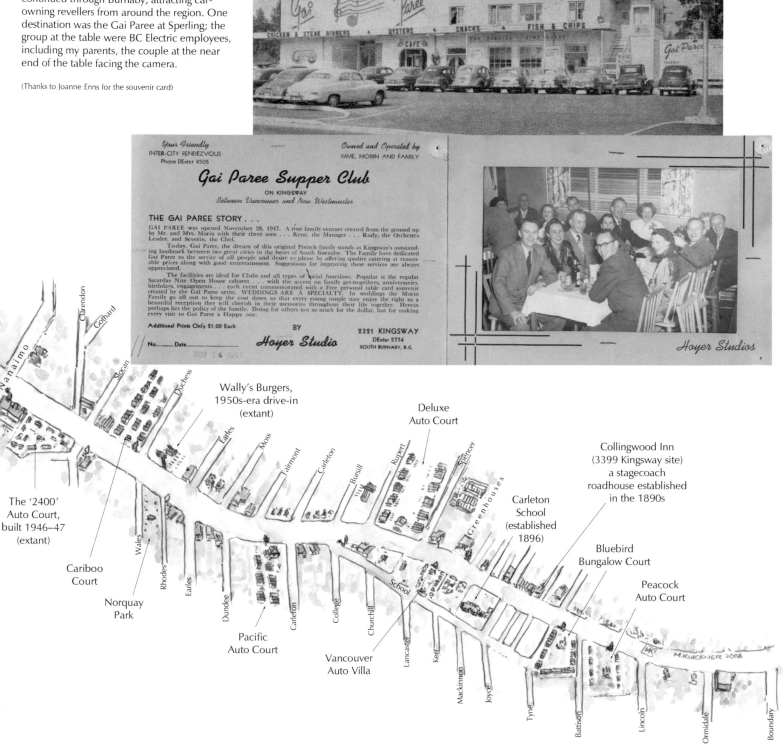

Your Friendly
INTER-CITY RENDEZVOUS
Phone DExter 4505

Owned and Operated by
MME. MORIN AND FAMILY

Gai Paree Supper Club
ON KINGSWAY
Between Vancouver and New Westminster

THE GAI PAREE STORY . . .

GAI PAREE was opened November 28, 1947. A true family venture created from the ground up by Mr. and Mrs. Morin with their three sons . . . Rene, the Manager . . . Rudy, the Orchestra Leader, and Severin, the Chef.

To-day, Gai Paree, the dream of this original French family stands as Kingsway's outstanding landmark between two great cities in the heart of South Burnaby. The Family have dedicated Gai Paree to the service of all people and desire to please by offering quality catering at reasonable prices along with good entertainment. Suggestions for improving these services are always appreciated.

The facilities are ideal for Clubs and all types of social functions. Popular is the regular Saturday Nite Open House cabaret . . . with the accent on family get-to-gethers, anniversaries, birthdays, engagements . . . each event commemorated with a Free personal table card souvenir created by the Gai Paree artist. WEDDINGS ARE A SPECIALTY. In weddings the Morin Family go all out to keep the cost down so that every young couple may enjoy the right to a beautiful reception they will cherish in their memories throughout their life together. Herein perhaps lies the policy of the family. Doing for others not so much for the dollar, but for making every visit to Gai Paree a Happy one.

Additional Prints Only $1.00 Each

No.......... Date..........

NOV 14 1951

BY
Hoyer Studio

2321 KINGSWAY
DExter 5774
SOUTH BURNABY, B.C.

Hoyer Studios

Nanaimo
Clarendon
Gothard
Slocan
Duchess

Wally's Burgers,
1950s-era drive-in
(extant)

Deluxe
Auto Court

Collingwood Inn
(3399 Kingsway site)
a stagecoach
roadhouse established
in the 1890s

Earles
Moss
Fairmont
Carleton
Bursill
Rupert
Spencer

Greenhouses

The '2400'
Auto Court,
built 1946–47
(extant)

Wales
Rhodes
Earles

Cariboo
Court

Norquay
Park

Dundee

Carleton

Pacific
Auto Court

College

Churchill

School

Vancouver
Auto Villa

Lancaster

Kerr

Mackinnon

Joyce

Carleton
School
(established
1896)

Bluebird
Bungalow Court

Peacock
Auto Court

Tyne

Battison

Lincoln

Ormidale

Boundary

M. KUCKNER 2006

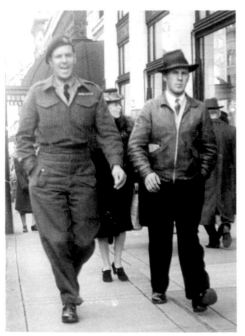

The Lawries were typical of the veterans' families for whom Fraserview was intended. John Lawrie was born into an impoverished family in Aberdeen and moved to New Westminster with his parents in 1920; like some of his siblings, he had suffered as a child from rheumatic fever, which weakened his heart, but he was nevertheless accepted into the Canadian army for active combat duty. Although shot in the stomach, he recovered and returned to duty in the service corps, driving fuel trucks until the war ended. Along the way he met a Sussex woman, Jean Bowes, and following their 1942 marriage two sons were born, one of whom died while they were still living in England. John returned to Vancouver late in 1945 while Jean came with the war brides on the *Mauritania* in February 1946, already six months pregnant. Her daughter, Barbara, born later that year, recalls her mother saying that she "jumped off the train and kissed the wrong mother-in-law."

They arrived in Vancouver in the midst of a full-blown housing crisis. The only accommodation they could find was "one room, two years, sixth floor" in the Citizens Rehabilitation Hostel, a.k.a. the old Hotel Vancouver (page 78). John was in and out of work, his health being too poor for much physical stress. To get away from the heat and crowding, Jean Lawrie would push her baby's pram all the way down Georgia and through Stanley Park to Lumbermen's Arch, where she would spend the afternoon by the pool. In 1948, they managed to rent an old house at 23rd and Fraser from the Central Mortgage & Housing Corporation, the federal government agency, but after two years, when they couldn't come up with the money to buy it, they had to move on. The CMHC had built apartments along Fourth Avenue and Broadway in Kitsilano, and opened up Renfrew Heights south of Grandview Highway at Boundary Road, but the Lawries couldn't get placed.

Their luck changed in 1950, when CMHC used a huge block of undeveloped land it had bought from the city in southeast Vancouver for a subdivision of curving streets cruelly dubbed "the workingman's Shaughnessy Heights." CMHC eventually built 1,137 homes there. Because of John's deteriorating health, they chose a single-storey cottage with a basement at 2250 East 54th, near the northwest corner of the community at Victoria Drive. Like its neighbours, the house was cheaply built and just plunked on the bare ground. It had three bedrooms but with four children there were constant lineups for the bathroom. When they weren't playing outside with the dozens of neighbourhood children, the young Lawries rollerskated around the wood-burning furnace which stood in the centre of the concrete basement; soot marked the upstairs walls above the heat outlets and there were regular chimney fires. The nearest telephone, which was a party line, was next door at Mrs. Quick's – a divorcee who modelled hats at the Bay downtown. On Victoria Drive, Spargo's, a butcher shop and general store established since 1915, was a lifesaver as it gave credit. John Lawrie died in 1953 after a few years when he'd only been able to work as a commissionaire at Shaughnessy veterans hospital.

Jean Lawrie, widowed at age 36 with four children, opened her home as a daycare for local working mothers – including many widows and divorcees. She learned how to do invisible mending and took in piecework before she got

FRASERVIEW HOMES

a job at Woodward's Oakridge when it opened in 1959. Later, she took commercial art courses at Vancouver School of Art and worked full-time doing paste-up for directories. After four years in England in the late 1960s, she returned but soon moved to Mission, where she ran a bookstore with her son Christopher. She died in 1989.[1]

The federal government's commitment to veterans lasted about a decade. Nearly one-third of the residents were able to buy their houses in 1959. Five years later, the CMHC provoked a nasty rent strike when it raised rents 18 percent to $72 a month for residents who wouldn't or couldn't pay $10,600

for their houses. "They're jerry-built – 15 years old in time but 65 years old in reality," said strike leader Alex Watson. Arthur Laing, later the minister of Northern Affairs, said while in opposition that the CMHC should make no profit on the veterans' houses and argued the price was $2,800 too high. Once in power he did nothing. CMHC, which had bought the Fraserview lands from the city for $175,000, was intent on recouping its supposed market value: $1.2 million. Today, the veterans' children are in their fifties and sixties and only a minority of the houses on Fraserview's streets are unaltered bungalows reminiscent of the tough post-war years. On the surface, the community is little different from the rest of the east side.

1 Interview with Barbara Lawrie Burwood, 2006.

Since 1910, the Pacific National Exhibition has brought people from all over the region to the fairgrounds at the city's northeast corner. Beginning as an agricultural fair in competition with one in New Westminster, it quickly grew to become the classic end-of-summer event in a city which, unlike today's, had little time for or interest in organized festivals. The combination of utter tackiness on the midway and thrilling rides, especially the venerable roller coaster, were an irresistible draw to children like me, who spent everything they had there and then saved earnestly to buy enough firecrackers for Hallowe'en.

The streetcar lines established to bring Vancouverites to the fair helped to settle suburbanites along east Hastings on the blocks above the port. The original fair buildings were impressive-looking but cheaply constructed; a second generation, including the Garden Auditorium and the Forum, were more substantial. The latter replaced the Vancouver Arena near Stanley Park (page 135) and brought professional sport onto the fairgrounds, complementing the long-established racetrack nearby.

The PNE grounds became the site of the track and field events for the British Empire and Commonwealth Games, held in beautiful summer weather in 1954. Empire Stadium, built on the site of the fair's pitch-and-putt golf course, was rushed to completion and shone in the world spotlight on August 7, when both victor Roger Bannister and John Landy broke the four-minute mile.[1] Of longer-term impact on the community was the creation of a football team, the Lions, who "will roar in '54." Thousands of Vancouverites spent

The British Empire Games marathon, run on August 7, 1954, traversed hill and dale on east-side Vancouver and Burnaby. The drawing is probably by W.M. Banks, who for many years illustrated such local publications as the B.C. Electric "Buzzer," available on streetcars and buses.

1 My father, Ralph, was chief of the announcing section for track and field, and called out the lap times on the loudspeaker during the race.

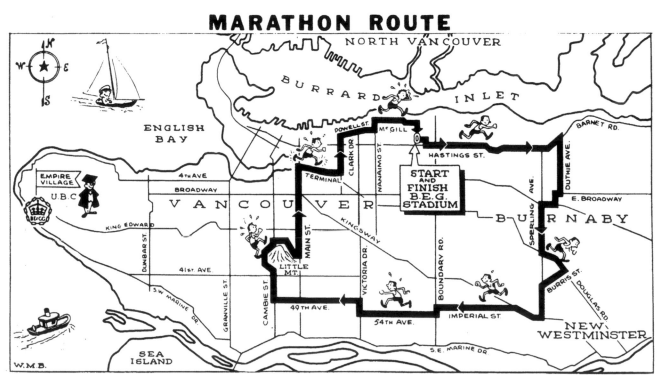

MARATHON ROUTE

The above map shows the route of the marathon that will be held on the final day of the B.E.G. The distance is exactly 26 miles 385 yards—the average winning time about two and a half hours. Runners will start from Empire Stadium on East Hastings and will face a steady but moderate incline until the sharp turn at Duthie Avenue. After a brief straight stretch they will resume climbing to east Broadway where they will level off until they reach Burris Street. The hill up to Kingsway is extremely steep, but after that the westward stretch of the marathon along Imperial, 54th and 49th will all be on a level. There is a slight incline along the side of Little Mountain after which the runner will follow Main Street downhill. They climb up again on Terminal to Clark and there is a slight climb on Powell. A final steep climb on the hill leads the runner back into the Stadium. The last 385 yards will circle the Stadium to the winning line.

chilly autumn evenings with their rugs, umbrellas, thermoses of coffee and hip flasks of rye, cheering on the local team. As professional sport developed, the stadium became outmoded and was demolished a decade after BC Place opened on the north side of False Creek in 1983. As with football, so with hockey. The construction nearby of the Pacific Coliseum in the late 1960s put Vancouver into contention for a national hockey league franchise; the Canucks moved to GM Place on False Creek 25 years later.

As the Hastings Sunrise community matured, a lobby group emerged in the 1980s to argue for the redevelopment of Exhibition Park as a more natural park space for the community. Developing remarkable political clout, it managed to get the city to rethink its commitment to the exhibition, Playland, and the permanent paved infrastructure of Hastings Park. Disputes between the province and the city over the use of the land and its management also threatened the long-term viability of the site, and much of the 1990s was spent in debates over a future PNE location. The leading contender for a time looked to be the Scott Road flats in Surrey, and the provincial government even considered the edge of the environmentally sensitive Burns Bog. The year 1998 was to be the last one, then 2000. Finally, in 2004, all the studies and plans were discarded and the PNE gained a new lease on life at Hastings Park under City of Vancouver ownership. The tradition of the great fall fair, bringing Vancouverites together "across the Great Divide" of east and west, will continue into a second century.

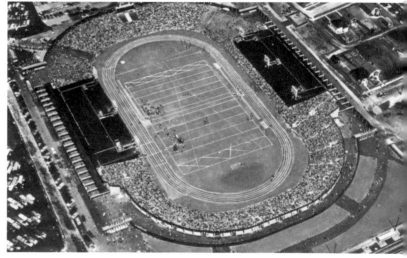

Empire Stadium, a Hastings Park landmark from 1954 to 1993. The top photo by Herbert L. McDonald dates from about 1965, when the BC Lions had stars like quarterback Joe Kapp and halfback Willie Fleming and won the Grey Cup. (Photo below by Natural Colour Productions)

Acknowledgements

Although I collected a large amount of historical material about Vancouver in the 1980s and continued to paint watercolours of city scenes, some for the Petley-Jones Gallery and others as a pastime, I had given little thought to writing another book in the style of *Vancouver The Way It Was*. However, when we were staying on Crete in the fall of 2005, an email unexpectedly arrived from Robert McCullough, publisher of Whitecap Books. Wasn't it time, he suggested, that you redo your old history book? *Vancouver Remembered* is the result.

I owe a debt of gratitude to the following people. In alphabetical order, they are Jessie Acorn, whom I never met, who collected Vancouver postcards for decades, and whose heir gave them to me; Sigrid Albert of Echelon Design, who allowed me to use her view for the watercolour on page 67; City of Vancouver Archives staff, especially photo curator Carol Haber; Christine Allen, my wife and best critic, who casts an eye over everything I do and tells me whether it makes sense or not; John Atkin, for the loan of the fire atlas and his collaboration over nearly 20 years on Vancouver heritage projects; Lynne Bryson of Rositch-Hemphill Architecture, who gave me access to the rooftop of their building at 120 Powell for the view on page 51; Barbara and Martin Burwood, for sharing memories of her Fraserview childhood; Barry Carlson, for recollections of busking, Xanadu and the High Street Band; George Chow (and John Wong) of the Chinese Benevolent Association, who allowed me access to their building's fire escape and the view from their roof (page 59); historian Joyce Diggins, who died before she was able to complete her history of Kerrisdale; Frances Fournier of SFU Archives, for information on early Vancouver photographers; Irene Howard, biographer of Helena Gutteridge; Elaine Jones, who copyedited this book, as she did *Vancouver The Way It Was* in 1984; Larry Killam, who described to me his role in the rebirth of Gastown; Craig McCaw, for information about Tanner Manor, a.k.a. the Arbutus Club, and the Poppy Family; George Miyazaki, for the family photo and memories on page 194; Steve Norris, for permission to use the cartoons by his father, Len Norris; Ray Spaxman, Vancouver planner extraordinaire; Eric Swanick of SFU Special Collections, for helping me track down copyright on Norris cartoons; Diane Switzer, executive director of the Vancouver Heritage Foundation, for information on the Leslie house; Anne and Ken Terriss, for sharing photographs and memories of their several decades in Kitsilano; Kathy Upton, for the photos and information on page 75; Sonia Wall, for the photographs of Shannon; Jim Wolf, for the use of the photograph on page 96.

PHOTOGRAPHERS

All uncredited photographs are by the author.

Photographs credited as CVA are from the City of Vancouver Archives.

Photographs credited as VPL are from Vancouver Public Library Special Collections.

Many of the postcard photographers were amateurs who sold images to companies such as Natural Colour Productions or Coast Publishing. I attempted to locate them with help from photographers Trevor Martin, Fred Herzog and Evangelos (Angie) Apostolides, former owner of Evangelos Photography and current owner of Beau Photo Supply. Frances Fournier of SFU Archives shared her information about photographers in her collection.

I was able to locate Dave Pryor of Ed Pryor Photographer, who gave me permission to use his Pacific Centre image on page 81, as did Merle Somerville for his image on page 87. I was unable to find any information on Rolly Ford, George Weinhaupl, Hasso Ebert, J.C. Walker, Ian Monserrat, Peter Rodger, Selwyn Pullan and Graham Warrington.

West Vancouver photographer Herbert L. McDonald left more of a record, as he published several books with his Graydonald Graphics Ltd. imprint in the 1960s. His *British Columbia: Challenge in Abundance* was the source of several images I used in this book. SFU Archives has a number of his photographs but has been unable to trace him or his descendants.

Sajiw-Terriss is the professional name of Anne Terriss, whose pictures of Kitsilano demonstrate her interest in photographing people.

Bibliography

Adachi, Ken. *The Enemy That Never Was.* Toronto: McClelland and Stewart, 1986.

Atkin, John. *Strathcona: Vancouver's First Neighbourhood.* North Vancouver: Whitecap Books, 1994.

Atkin, John, and Michael Kluckner. *Vancouver Walks.* Vancouver: Steller Press, 2003 and 2005.

Barman, Jean. *Stanley Park's Secret.* Madeira Park: Harbour, 2005.

Bell-Irving, Elizabeth. *Crofton House School: The First Ninety Years.* Vancouver: Crofton House School, 1988.

Berelowitz, Lance. *Vancouver and the Global Imagination.* Vancouver: Douglas and McIntyre, 2005.

Bingham, Janet. *More than a House: The Story of Roedde House and Barclay Heritage Square.* Vancouver: Roedde House Preservation Society, 1996.

Breen, David, and Kenneth Coates. *Vancouver's Fair: A Political and Administrative History of the Pacific National Exhibition.* Vancouver: UBC Press, 1982.

Brissenden, Constance. *Triple-O, The White Spot Story.* Vancouver: Opus, 1993.

Burkinshaw, Robert. *False Creek.* Vancouver: City Archives, 1984.

Carlson, Keith Thor, ed. *A Stó:lo-Coast Salish Historical Atlas.* Vancouver: Douglas and McIntyre, 2001.

Davis, Chuck, ed. *The Greater Vancouver Book.* Surrey: Linkman Press, 1997.

Dawson, Michael. *Selling British Columbia: Tourism and Consumer Culture 1890–1970.* Vancouver: UBC Press, 2005.

Francis, Daniel. *LD: Mayor Louis D. Taylor and the Rise of Vancouver.* Vancouver: Arsenal Pulp, 2004.

Ewert, Henry. *The Story of the BC Electric Railway.* North Vancouver: Whitecap, 1986.

Gourley, Catherine. *Island in the Creek: the Granville Island Story.* Madeira Park: Harbour, 1988.

Gutstein, Donald. *Vancouver Ltd.* Toronto: Lorimer, 1975.

Hardwick, Walter. *Vancouver.* Toronto: Collier-Macmillan Canada Ltd., 1974.

Hayes, Derek. *Historical Atlas of Vancouver and the Lower Fraser Valley.* Douglas and McIntyre, 2005.

Kalman, Harold. *Exploring Vancouver.* Vancouver: UBC Press, 1974 and 1978.

———. *A History of Canadian Architecture.* Toronto: Oxford University Press, 1993.

Kalman, Harold, Ron Phillips and Robin Ward. *Exploring Vancouver: The Essential Architectural Guide.* Vancouver: UBC Press, 1993.

Kluckner, Michael. *Vancouver The Way It Was.* North Vancouver: Whitecap, 1984.

———. *Vanishing British Columbia.* Vancouver: UBC Press, 2005.

———. *Vanishing Vancouver.* North Vancouver: Whitecap, 1990.

———, ed. *M.I. Rogers 1869–1965.* Privately published, 1987.

Lorimer, James. *A Citizen's Guide to City Politics.* Toronto: Lorimer, 1975.

Luxton, Donald, ed. *Building the West: The Early Architects of British Columbia.* Vancouver: Talonbooks, 2003.

Luxton, Donald, and Lilia D'Acres. *Lion's Gate.* Vancouver: Talonbooks, 1999.

Macdonald, Bruce. *Vancouver: A Visual History.* Vancouver: Talonbooks, 1993.

Mattison, David. *Eyes of a City: Early Vancouver Photographers 1868–1900.* Vancouver: City Archives, 1986.

McDonald, Herbert L. *British Columbia: Challenge in Abundance.* Victoria: Canadian Confederation Centennial Committee of British Columbia, 1966.

Miles, Fraser. *Slow Boat on Rum Row.* Madeira Park: Harbour, 1992.

Morley, Alan. *Vancouver: From Milltown to Metropolis.* Vancouver: Mitchell Press, 1961 and 1974.

Morton, James W. *The Enterprising Mr. Moody, the Bumptious Captain Stamp.* Vancouver: J.J. Douglas, 1977.

Nichol, Eric. *Vancouver.* Toronto: Doubleday Canada, 1978.

O'Keefe, Betty, and Ian Macdonald. *Dr. Fred and the Spanish Lady: Fighting the Killer Flu.* Surrey: Heritage House, 2004.

O'Kiely, Elizabeth, ed. *Gastown Revisited.* Vancouver: Community Arts Council, 1970.

Pauls, Naomi, and Charles Campbell. *The Georgia Straight: What the Hell Happened?* Vancouver: Douglas and McIntyre, 1997.

Perrault, Ernest. *Tong: The Story of Tong Louie, Vancouver's Quiet Titan.* Vancouver: Harbour, 2003.

Potter, Greg, and Red Robinson. *Backstage Vancouver: A Century of Entertainment Legends.* Madeira Park: Harbour, 2004.

Punter, John. *The Vancouver Achievement.* Vancouver: UBC Press, 2003.

Ravvin, Norman. *Hidden Canada: an Intimate Travelogue.* Red Deer, Alberta: Red Deer Press, 2001.

Rossiter, Sean. *The Hotel Georgia: A Vancouver Tradition.* Vancouver: Douglas and McIntyre, 1998.

Rushton, Gerald. *Echoes of the Whistle.* Vancouver: Douglas and McIntyre, 1980.

Schreiner, John. *The Refiners: A Century of BC Sugar.* Vancouver: Douglas and McIntyre, 1989.

Starkins, Ed. *Who Killed Janet Smith?* Toronto: Macmillan, 1984.

Steele, Richard M. *The Stanley Park Explorer.* North Vancouver: Whitecap, 1986.

Stubbs, Betty. *From Golf Course to Garden.* Vancouver: Vancouver Botanical Gardens Association, 1985.

Turner, Robert D. *The Pacific Empresses.* Victoria: Sono Nis Press, 1981.

Vancouver Art and Artists: 1931–1983. Vancouver: Vancouver Art Gallery, 1983.

Walker, Elizabeth. *Street Names of Vancouver.* Vancouver: Vancouver Historical Society, 1999.

Williams, David R. *Mayor Gerry: The Remarkable Gerald Grattan McGeer.* Vancouver: Douglas and McIntyre, 1986.

Wynn, Graeme, and Timothy Oke, eds. *Vancouver and Its Region.* Vancouver: UBC Press, 1992.

Yee, Paul. *Saltwater City: An Illustrated History of the Chinese in Vancouver.* Douglas and McIntyre, 1988 and 2006.

Index